THE WAKING DREAM

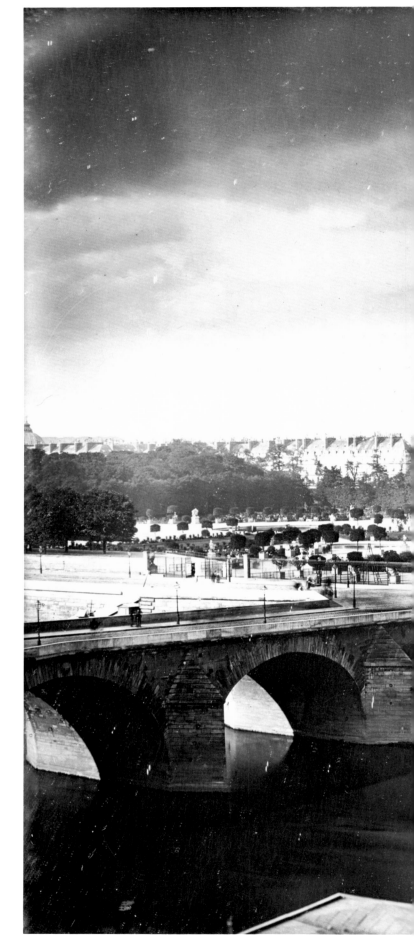

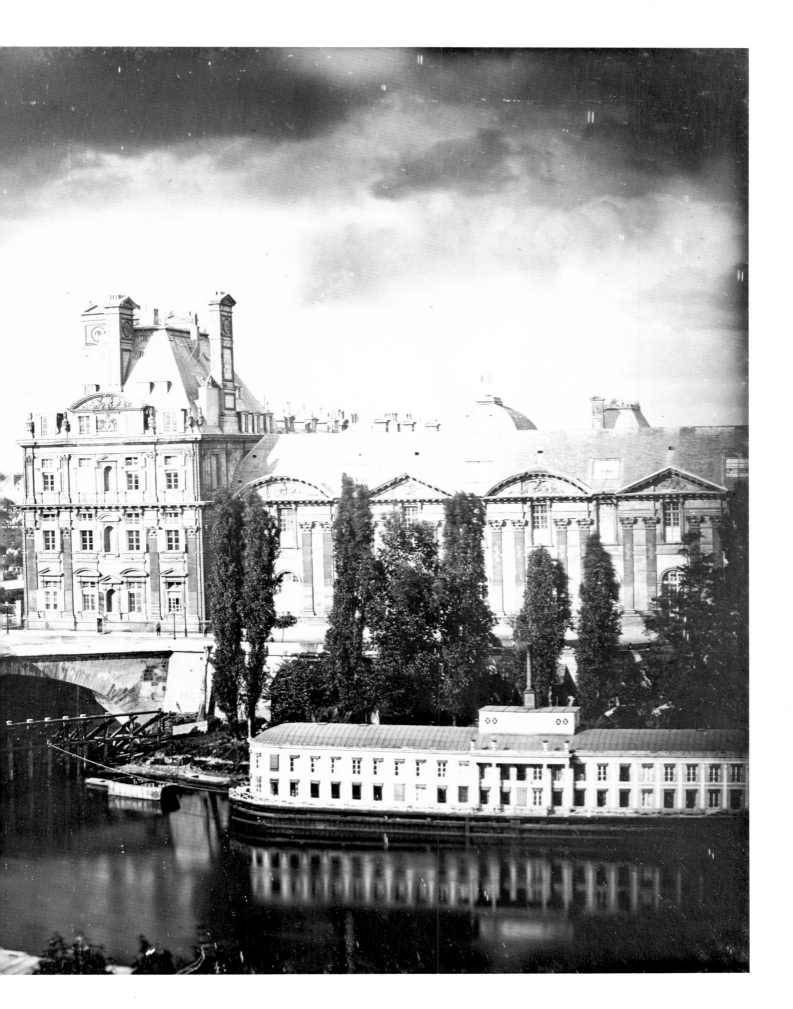

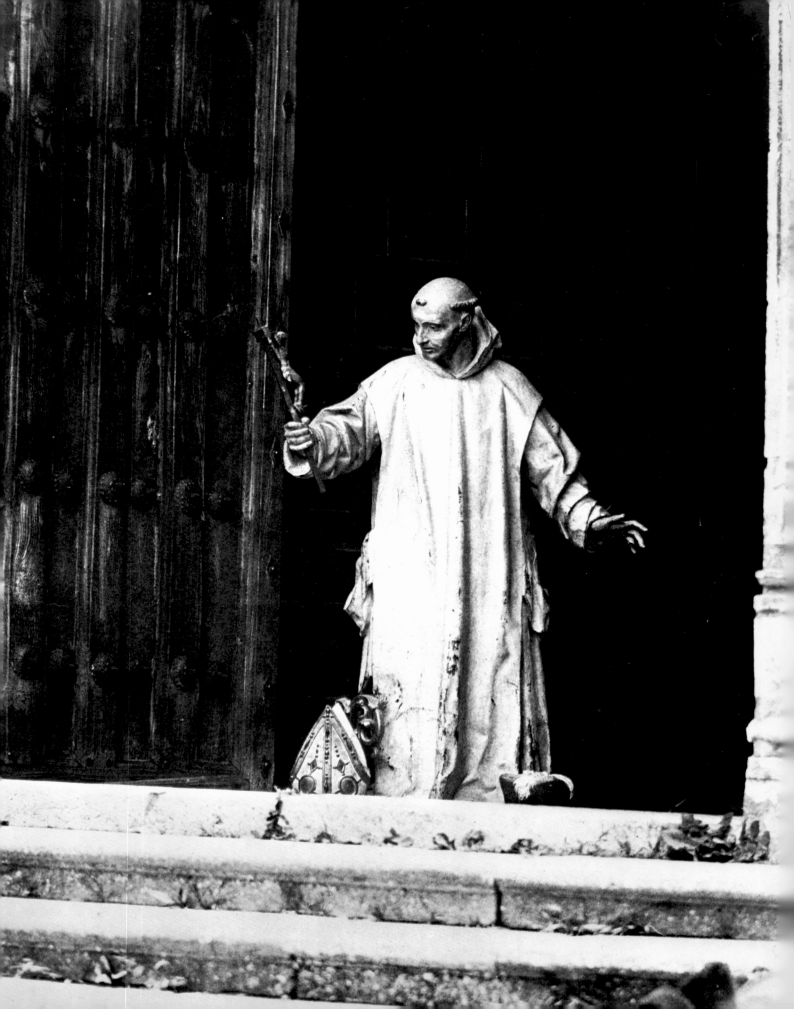

The Waking Dream

PHOTOGRAPHY'S FIRST CENTURY

Selections from the Gilman Paper Company Collection

Maria Morris Hambourg

Pierre Apraxine

Malcolm Daniel

Jeff L. Rosenheim

Virginia Heckert

THE METROPOLITAN MUSEUM OF ART

Distributed by Harry N. Abrams, Inc., New York

This publication is issued in conjunction with the exhibition
*The Waking Dream: Photography's First Century. Selections from the
Gilman Paper Company Collection*
The Metropolitan Museum of Art, New York
March 25–July 4, 1993

Edinburgh International Festival, City Arts Center, Edinburgh, Scotland
August 7–October 2, 1993

State Hermitage Museum, St. Petersburg, Russia, 1993–94

John P. O'Neill, Editor in Chief
Emily Walter, Editor
Yolanda Cuomo, with Trey Speegle, and Bruce Campbell, Designers
Susan Chun, Production

Set in Bodoni Book and Bauer Bodoni by U.S. Lithograph, typographers, New York
Printed on Phoenix Imperial demi-mat naturel, 150gms
Tritones by Thomas Palmer and Richard Benson
Duotones, color separations, and printing by Offset-litho Jean Genoud, S.A.,
Lausanne, Switzerland
Bound by Mayer et Soutter, S.A., Lausanne, Switzerland

Published by The Metropolitan Museum of Art, New York

LIBRARY OF CONGRESS CATALOGING-IN-PUBLICATION DATA

The Waking dream : photography's first century : selections from the
Gilman Paper Company collection / Maria Morris Hambourg . . . [et al.].
p. cm.
Includes bibliographical references and index.
ISBN 0-8109-6427-9 (Abrams). — ISBN 0-87099-662-2. — ISBN 0-87099-663-0 (pbk)
1. Photography, Artistic—Exhibitions. 2. Gilman Paper Company—
Photograph collections. I. Hambourg, Maria Morris,
II. Metropolitan Museum of Art (New York, N.Y.)
TR650.W26 1993 92-45131
779'.074'7471—dc20 CIP

Jacket/cover illustration
Onésipe Aguado (French, 1831–1893), Woman Seen from the Back, ca. 1862 (pl. 45)

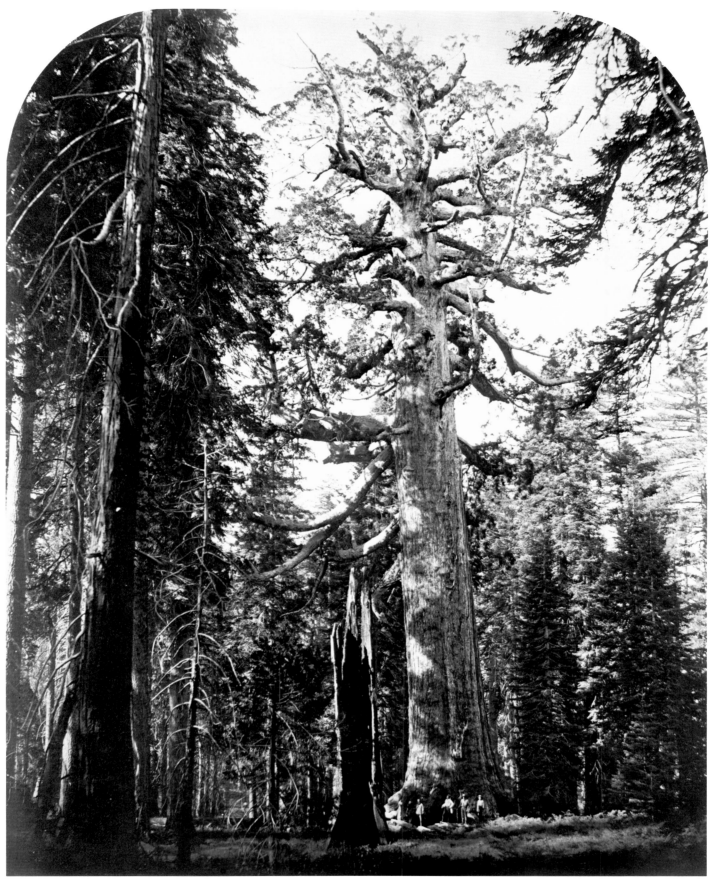

4

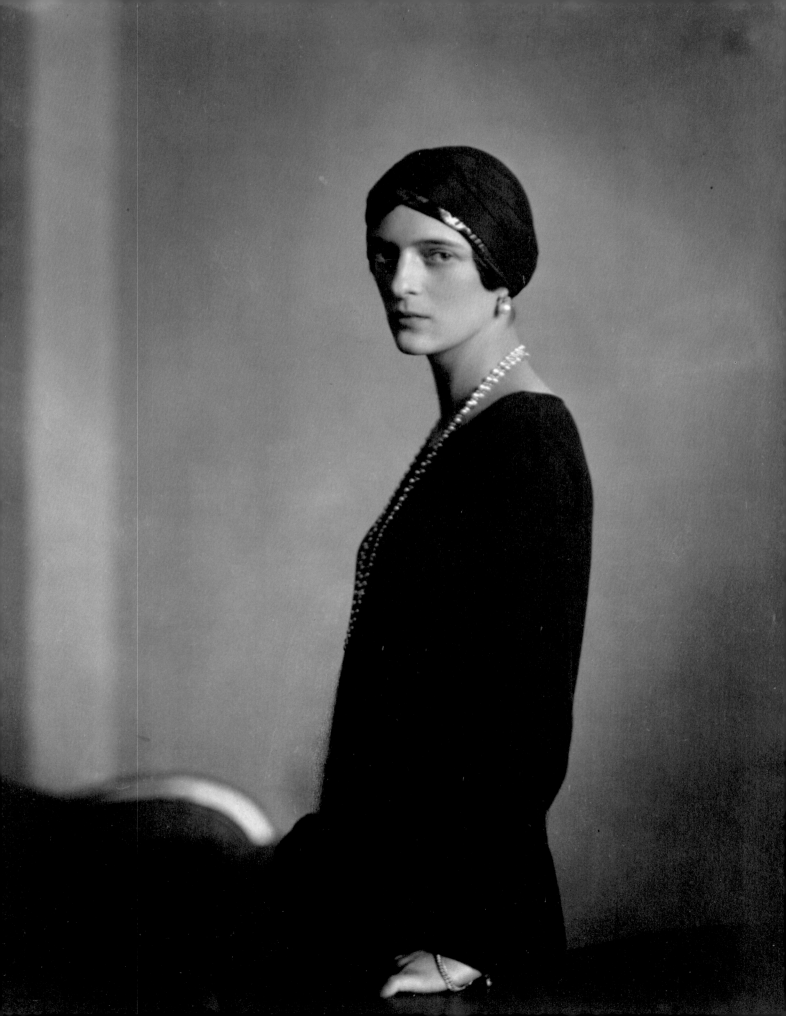

Contents

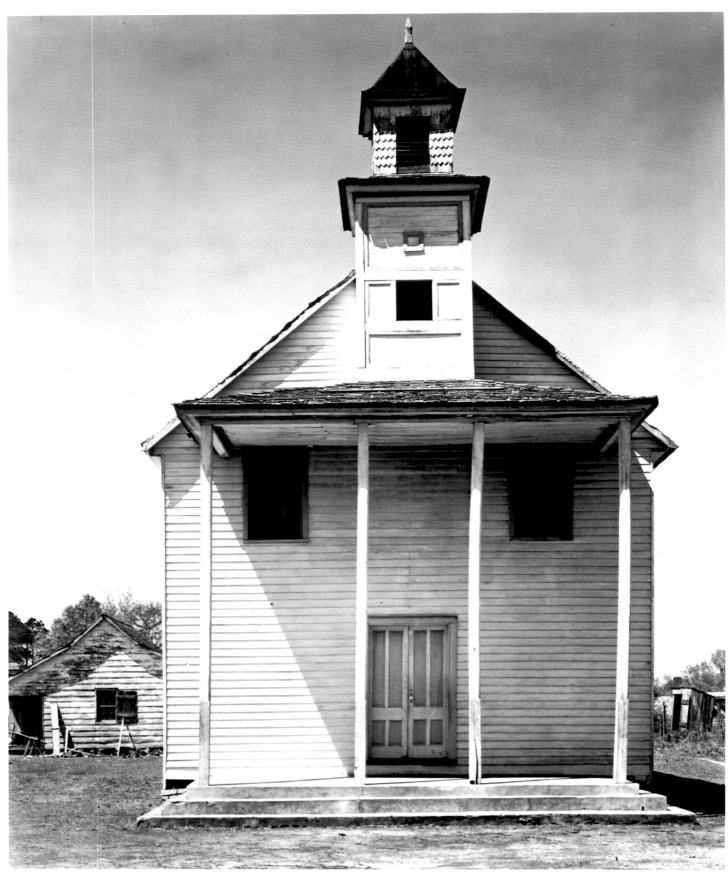

Preface

The Gilman Paper Company was founded by my grandfather Isaac Gilman, in 1884. An immigrant from Russia, Isaac Gilman arrived alone at the age of ten in New York, where he was to make his way and realize his dream of freedom. Starting with capital of only a hundred dollars, he became a dealer in overissue newspapers, at the time reused as wrapping. In the years that followed, he built a fully integrated forest-products company supplying Kraft paper, paperboard, and lumber to worldwide markets, with an operating organization of over two thousand employees. Isaac Gilman and his son Charles, my father, who took over leadership of the company in 1944, devoted their lives to the development and growth of the company, initially in New York City, then in what would become Gilman, Vermont, and ultimately, in southern Georgia and Florida, where the company's principal natural resources and manufacturing facilities are now located.

As a young man my grandfather was denied a proper education and easy access to culture. He was therefore particularly sensitive to the necessity of creating in his company an environment where people could enjoy the very advantages he had lacked but deemed essential. My father, besides instituting an active program of natural resource conservation, continued and expanded his father's policies to include health and medical research and the sponsorship of cultural and educational institutions. I, in my turn, have extended the concern of my predecessors to include the collecting of art, which I feel furthers my family's interest in conservation as well as my own. The concerns that most persistently draw my sympathy are the preservation of endangered species, the sustenance of the performing arts, and the collection of photography, of which so much has been lost through incomprehension and neglect.

I share with my generation a familiarity with the threats of global destruction, a heightened awareness of the fragility of life in all its forms, and a repeated acquaintance with history's potential for savage devastation. Against such a background, art collecting might seem to be a self-gratifying but meaningless hoarding if the collector were not sustained by the idea that he is only the transitory custodian of treasures it is his duty to preserve. He can be responsible to his personal pleasure only to the degree that he is able to share it with and preserve it for others. It is this idea that has informed the Gilman Paper Company Collection and that is the basis of this exhibition.

It is enormously gratifying to be able to share with the public the pleasures of the collector, and to do so within the walls of The Metropolitan Museum of Art, whose standards of stewardship enhance the work to the greatest degree and whose history parallels the history of our family in its rootedness in the city of New York and in its advancement of the best causes of our culture.

Howard Gilman
Chairman
Gilman Paper Company

Foreword

In writing introductions to catalogues of private collections one almost invariably draws on the words "one of"—one of the largest, one of the most discerning, and so forth. It is a special pleasure for me to be able to say that the photographs in the Gilman Paper Company Collection unequivocally constitute the finest private collection broadly representing the art of photography in Europe and the United States during the medium's first century. The collection is not an abridged conspectus, nor is it idiosyncratically indulgent; rather, it is a remarkable demonstration, both in its obvious scope and in its hidden depths, of the ability of photographers to create images that both illuminate and transcend their moment.

Comprising over five thousand images, with many concentrations of works by the most prominent artists, the collection provides conclusive evidence of Alfred Stieglitz's claim that great photographs are works as richly rewarding as those of any other fine art. Indeed, the Gilman Paper Company Collection, with its exceptional strengths in British, French, and American nineteenth-century photographs, marvelously complements our own holdings, which focus on the painterly works of the Photo-Secessionists and the structural innovations of the period between the World Wars.

As Maria Morris Hambourg's introduction makes clear, the collection was formed of a profound love for the material and a relentless pursuit of the very best. Large as it is, and despite its catholicity of subject, one senses a purposeful single-mindedness—the ubiquitous presence of the discerning eye of Pierre Apraxine, the curator of the collection, whose appetite for pioneering images and exquisite print quality reflects a rare degree of cultivation.

This exhibition marks a significant point in history, for it is the first major show to be organized by the newly established Department of Photographs at the Metropolitan Museum. Both the exhibition and the catalogue were masterfully orchestrated by the department's first curator in charge, Maria Morris Hambourg. We are deeply grateful to Howard Gilman for the opportunity to learn from his example and for the privilege of sharing his collection with the larger public.

Philippe de Montebello
Director
The Metropolitan Museum of Art

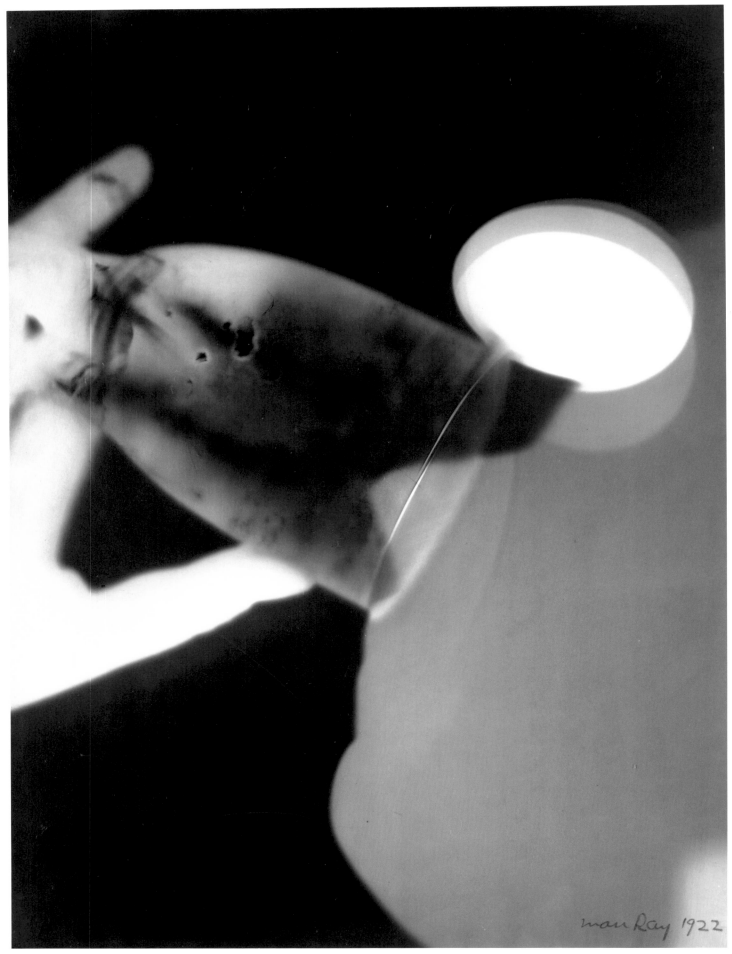

Introduction

The photographs in this book and the exhibition it accompanies are drawn from an unrivaled collection that was envisioned, begun, and nurtured by Howard Gilman. In this he was guided by the invaluable advice and expertise of an exceptional curator, Pierre Apraxine. Mr. Apraxine's interest in and knowledge of photography have been supported and shared for nearly two decades by Mr. Gilman and the Gilman Paper Company. The collection has been so formative in the evolving history of the medium and has so long set the standards for connoisseurship in the field that this corporate art collection has acquired an authority unlike any other we have known. Perhaps this is so because it was formed like a private collection, its constitution and character shaped by the direct and thoughtful dialogue between Messrs. Gilman and Apraxine, both of whom pursued their passion disinterestedly, seeking their sole reward in new knowledge and in the manifold pleasures of the photographs.

The collection began in the mid-seventies with contemporary architectural drawings of a visionary sort and conceptual art, including photographs by such artists as Richard Long and Gilbert and George. Before long, photography emerged as the collection's principal focus, the considerable challenges presented by the other two genres being foreclosed by their relatively narrow parameters. Photography, the medium that became the universal visual language of the modern epoch, offered unlimited scope. To quote Mr. Apraxine, "The limits of a collection are the limits of your imagination: to collect photography is to collect the world."

In forming the photography collection, Howard Gilman did not intend to endorse the accepted; he wanted rather to address something ubiquitous, familiar, and accessible, to explore how and when this elemental form of expression crossed the threshold of the ordinary into something finer, more provocative, and enduring. As a benefactor of the dance, he was experienced in recognizing and supporting the artists who transform movement, another common language, into exquisite expressions that are as poetry is to prose. Thus Gilman determined to encourage the perception and Apraxine to isolate the examples of photography as a demanding and creative art.

The aim of Messrs. Gilman and Apraxine was open-ended and provisional from the outset. From their involvement with the abstracted gestures

and formal structures of architectural drawings and conceptual art, they very soon recognized in the early modernist photographs of Walker Evans, Edward Weston, and Alfred Stieglitz a similar rigor of locution and an elegant formal refinement. They also saw that the genius of these photographers could not be summed up in a single image; by collecting groups of pictures they sought to compass the gamut of each artist's particular talents.

In the space of a couple of years, Gilman and Apraxine had amassed sufficient numbers of twentieth-century photographs that they could see a historical house under construction: through the portal of Pictorialism, upheld by Steichen and Stieglitz, one entered rooms of various modes of modernism— from Atget to Man Ray to Brassaï. The second floor, which would hold post–World War II photographs, was being erected too, beginning with a notable collection of images by Robert Frank. But just when one might have expected these two men, so easy with the cutting edge, to expand their investigation into contemporary photography, they stopped building the second story and turned instead to the foundation.

When we asked recently why the collection concentrates on the nineteenth century, Howard Gilman responded, "It was the greater challenge—more difficult to find, appreciate, and sort out. The field was a submerged continent, but it is essential as a foundation for the photography of this century." Pierre Apraxine elaborated, "At the time it seemed almost virgin territory. For us it all started with discovering Baldus's photograph of an afternoon in the country (pl. 50). I didn't know who Baldus was, but when you see something extraordinary like that, if you've been studying art for some time, you just know it is an overlooked masterpiece. I remember when I came back from that first visit [to France], I said, 'Howard, this is it, this is where we should go.'"

Beginning with French photography of the 1850s, Apraxine, with Gilman's encouragement, started exploring the nineteenth century, originally planning to acquire just forty great representative works. In this he had help from other collectors and dealers, of whom André Jammes and Sam Wagstaff were initially the most influential. Jammes, the preeminent French collector, introduced him to the ambitious artistry of the French photographers and to the sumptuousness of their prints; Wagstaff, who had also come to photography by way of contemporary avant-garde art, abetted the new direction. Recalling Wagstaff's generous, infectious enthusiasm, Apraxine described how the more experienced collector one day dropped an unknown name, like a common pebble, into the pool of his mind: "Have you heard of that Frenchman called Le Gray?" Sam Wagstaff asked.

The eddying stimulation continually expanded the collection beyond the provisional limits Gilman and Apraxine repeatedly attempted to place on it. Pursuing the ever-advancing frontier of their knowledge, their interests enlarged from masterpieces of self-conscious high art, such as Steichen's *Rodin—The Thinker* or Stieglitz's nudes of Georgia O'Keeffe, to include anonymous works, daguerreotypes, and the earliest experimental paper photographs by Talbot and his circle. As the aesthetics of the photographs they considered diversified and the subjects and personalities depicted in the images multiplied and cross-linked (e.g., pls. 138, 151a,b), they saw that the collection no longer resembled a house. It recalled something different, something, Mr. Apraxine suggests, like an intricate and expansive nineteenth-century novel whose braided insights describe both individual and collective frames of mind. As the focus of Gilman and Apraxine's empathic curiosity shifted to the specific personality of each picture, they naturally deserted the conceptual shell of a historic architecture.

The novel that Gilman and Apraxine are fashioning is no conventional history; it is a story in pictures that, like any true work of art, must be judged by its own rules. It cannot be compared to established overviews of the medium, because it does not evolve from a respect for history per se so much as from a passionate involvement with the character of the photographs and their authenticity of feeling. Never strident or lustless, anachronistic or démodé, Gilman photographs are individuated in their expression and often enfold a nut of mystery or entail something unexpected without divulging their secrets. And, while speaking in the current idiom of the topics of their day, they harbor truths that remain relevant as they come down to us through time. In short, these carefully considered photographs are not only beautiful, they are at the furthest remove from the trivial and the gratuitous; they matter.

Grouped together according to naturally occurring concentrations in time or place, the photographs comprise six episodes in a story that spans photography's first century, from 1839 to 1939. The first four chapters cover approximately the same period, from the birth of photography through its early maturity in the 1860s, in locales where the art most magnificently flourished: in England and France, on tours of the Mediterranean basin and beyond, and in the United States. In the last two chapters European and American photographers together tell of consecutive periods: the turn of the century (1885–1915) and the early modern era between the two World Wars.

Within these chapters the more innovative and ambitious photographers, the protagonists, occupy central places with groups of images—Roger

Fenton, for example, Gustave Le Gray, Carleton Watkins, and Man Ray. No attempt was made to represent the history of photography equitably, for the old story of technical and formal advancement has by now fractured into innumerable personal and theoretical perspectives. In addition, since inclusion in the collection was based on the availability of photographs for acquisition and on the character of the image, and as that character was judged by the tastes of Gilman and Apraxine, there are inevitably both saturated representations and lacunae in the historical record. For instance, Apraxine's "allergic reaction" to self-righteous Victorian sentimentality prompted his revealing selection of photographs by Lewis Carroll, as well as his choice of an unusually stark and psychologically powerful picture by Henry Peach Robinson rather than *Fading Away*, the mawkish composite picture made from it, usually considered this artist's masterpiece. Similarly, he saw in Heinrich Kühn's radiant autochromes and in snapshots of Bloomsbury girls dancing nude, idylls more visually persuasive than the usual Pictorialist efforts to make fine art using draped females and crystal globes.

This collection not only spares us the predictable and the specious, but by its example encourages the exploration of new dimensions. How gratifying, for example, to find that in evoking the American Civil War the present account does not pass over the abolition of slavery, and that the pictures selected to tell that central episode demonstrate a profound humanitarian regard. Similarly, the turn of the century and the modern era are refreshingly revealed from the inside out, as unprecedented psychic terrains whose exploration prompted new pictures.

Because Gilman and Apraxine are highly attuned to the artist's inner experience, many of the photographs they prize are visualizations of a *sens intime*. This accounts for the centrality of both emotional expressivity and physical presence in the imagery—the psychological and physiological basis of experience— and for the sensitive humanism underlying their selection.

•

The title of the book is taken from John Keats's "Ode to a Nightingale" (1819). Following a poetic reverie born in him by the bird's ecstatic song, Keats muses on the ambiguity of the imagery inspired by elusive beauty. "Was it a vision," he wonders, "or a waking dream?"

Exceptional photographs are also phantasms—impalpable, incommensurable. While their presence can have a disconcerting reality, it is a reality

that floats in an incorporeal realm in which past and present merge. Existing simultaneously in both dimensions they are afterimages, impalpable traces, of poetic visions into the heart of things.

If the Gilman Paper Company Collection is the finest collection of photographs of our generation, this may be in part because Howard Gilman intuitively recognized that great photographs are visions with the power of waking dreams. They are paradigms for human experience at its most engaged, insightful, and transcendent.

Maria Morris Hambourg
Curator in Charge
Department of Photographs

Acknowledgments

In fifty years, when it will be possible to write a book on photography's second century, that book will surely be based on more extensive published research than is currently available. The interest in photography has produced serious, in-depth scholarship only in the past fifteen years, and while we now have a critical mass of important books, much of what is known about the medium's first century is still uncollected and unpublished. As a consequence, the authors found that their questions could not be answered without the help of scores of specialists—connoisseurs, archivists, historians, collectors—each of whom had expert knowledge of some province of this rapidly enlarging field or of a subject of direct relevance to the photographs included here. Those whose names are listed below generously provided answers to our many queries.

Several individuals repeatedly advised us and helped make the information in the texts as complete and correct as possible. We counted upon Françoise Heilbrun, Philippe Néagu, François Lepage, and Gerard Lévy for their discriminating knowledge of French photographic history, just as we called upon Larry Schaaf's unparalleled expertise in early British photography. In the American field we benefited from the thorough research of Keith Davis, George Rinhart, and Dr. Stanley B. Burns. And in all categories of the Gilman Paper Company Collection covered in this book we relied upon the earlier work of Lee Marks, whose initial research on the collection was the basis of many of our entries.

The book was jointly designed by Yolanda Cuomo and Bruce Campbell. Its engaging picture sequencing was accomplished by Yolanda Cuomo, assisted by Trey Speegle. Mr. Campbell was responsible for the volume's handsome typography and the layout of the texts. The reproduction of the photographs was masterminded by Richard Benson, whose partner, Thomas Palmer, made the admirable halftones for the plates from transparencies made by Eileen Travell and Katherine Dahab. Jean Genoud and Daniel Frank are to be thanked for the exceptional printing. At the Metropolitan Museum, in the Editorial Department, under John P. O'Neill and Gwen Roginsky, Susan Chun efficiently oversaw the book's production. The book's best friend was Emily Walter, its editor, who greatly improved the prose and toned the shape of its contents.

Nora Kennedy and Betty Fiske provided expert conservation treatment of the original photographs, with assistance from Mindy Dubansky for the al-

bums and Yale Kneeland for certain objects. In the exhibition the frames and mats, individually designed for each of the photographs, were the inspiration of Jed Bark and were skillfully produced by the master craftsmen at Bark Frameworks; David del Gaizo and Martin Bansbach prepared and fitted the works at the Museum. The exhibition installation was designed by Daniel Kershaw, and the exhibition graphics were by Sue Koch; its practical orchestration was overseen by Linda Sylling. Norman Keyes, Nina Maruca, Willa Cox, Helen Otis, and many other members of the Museum staff contributed to the organization and presentation of the exhibition at the Metropolitan. Finally, Maria Umali at the Gilman Paper Company and Maggie Kannan in the Museum's Department of Photographs were the gracious facilitators of many of the procedures required to make this book and exhibition a reality.

We are profoundly grateful to all of these friends and associates for their unstinting application of their expertise and talents and for the generous spirit of their contributions. Without them, and all those listed below, *The Waking Dream* would be only a poetic notion.

Linda Bailey	Chris van der Decken	Norman Gechlik
Gordon Baldwin	Virginia Dodier	Christopher Gray
Eleanor Barefoot	Kevin Donovan	Sarah Greenough
Jared Bark	James Draper	Margaret Harker
Andrea Bayer	Sibylle Einholz	David Harris
Piero Becchetti	Scott Elliott	Noel Harrison
John Beck	Diana Epstein	Jonathan Heller
Hendrik Berinson	Michele Falzone del Barbaro	Brigitte Hiss
Pierre Bonhomme	Susan Fillen-Yeh	Edwynn Houk
Marta Braun	Kimberly Fink	Mary Ison
Lonnie Bunch	Paula Fleming	Ken Jacobson
Peter Bunnell	Lee Fontanella	Victoria Jahn
Norman Burns	Merry Foresta	Peter Jakab
Cornell Capa	Jeffrey Fraenkel	André Jammes
Sabine Charpentier	William Frassanito	Eugenia Janis
Suzanne Chippindale	Lee Friedlander	Brooks Johnson
Ken Cobb	Barry Friedman	Robert Kashey
Clare LeCorbeiller	Darrel Frost	Edward Kasinec
John Culme	Peter Galassi	Pat Kattenhorn
Susan Danly	Forrest Galey	Mark Kelman
Zina Davis	Philippe Garner	Claudia Kidwell

Karl Kilian

Steven Kossak

Hans Kraus

Claude Lannette

Florette Lartigue

Alexander Lavrentiev

John Lawrence

Joan Mertens

Pat Michaelis

Sylvain Morand

Ralph Morrow

Richard Moses

Joan Munkacsi

Marjorie Munsterberg

Margaret Nesbit

Doug Nickel

Leslie Nolan

Shelagh Palma

Donald Pfanz

Marcuse Pfeiffer

Bruce Brooks Pfeiffer

Christopher Phillips

Sally Pierce

Hélène Pinet

Pierre Richard

Pamela Roberts

Catharine Roehrig

Martha Ruff

Gerd Sander

Joanna Scherer

Terry Sharrer

Prince Alexis P. Sherbatow

Ann Shumard

Brent Sikkema

Will Stapp

Rex Stark

Lindsey Stewart

Walt Stock

Robert Storr

Edmund Sullivan

Roger Taylor

Sean Thackeray

Linda Thatcher

Julia Thompson

Donald Towle

Margarita Tupitsyn

Catharine Voorsanger

Virginia Lee Webb

Margaret Welch

Larry West

Stephen White

Andrew Wilkes

Carla Williams

David Wooters

Clark Worswick

Charles Young

The Authors

The Waking Dream

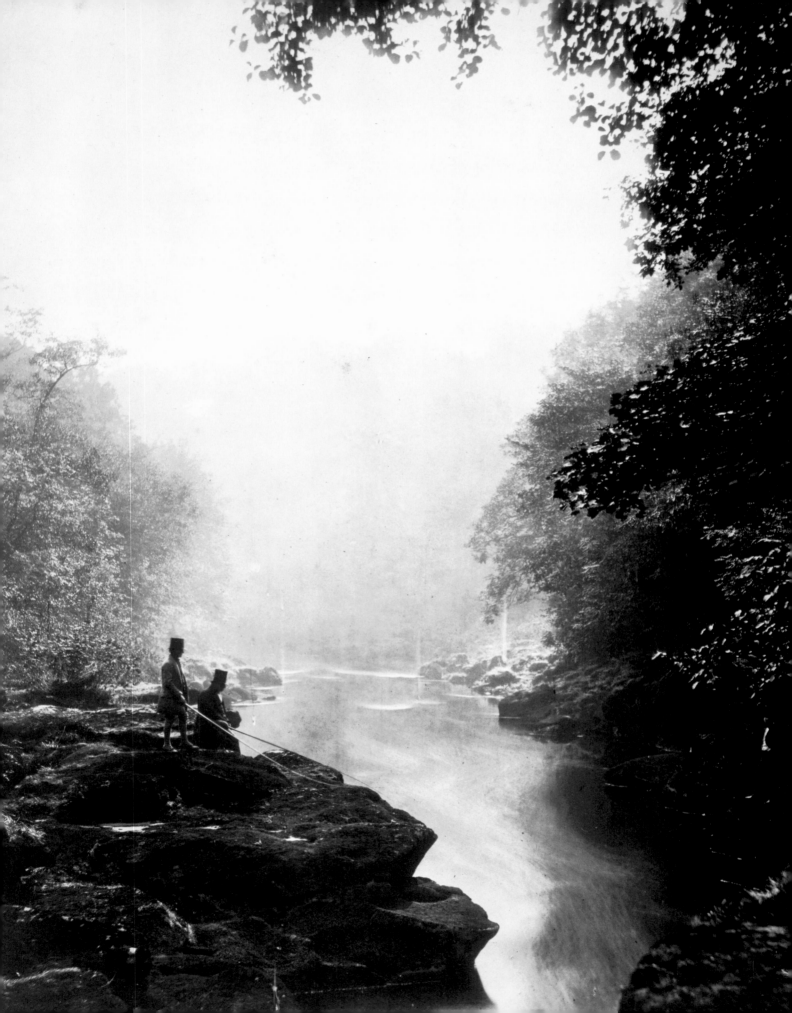

Picturing Victorian Britain

This book and the exhibition it accompanies begin with the invention of photography in England, not because it occurred there first, for it was invented in France at the same time, but because the birth of photography and its earliest art can only be *seen* in the works of the British photographer William Henry Fox Talbot.

Before the invention of photography, one could behold the world only by looking at it or at hand-made transcriptions of it. Then, in 1839, Henry Talbot revolutionized the experience of visual perception by fixing the world in images made by light on paper. The magical quality of that momentous event is today almost impossible to grasp; it was as if one of the thousands of images that flicker across the eye had alighted like a butterfly on a sheet of paper. Just as the retina receives light and forms images in the mind, so, it seemed, Talbot's astonishing optical and chemical process allowed the sun to draw pictures on paper.

Talbot made his first photographs by placing an object on paper sensitized with silver salts and putting both in the sun. When the object was removed, the exposed paper retained the silhouette of the object. Although Talbot attempted to fix the image on the paper, these first photographs were unstable. Talbot's sister-in-law wrote to him in 1834, "Thank you very much for sending me such beautiful shadows. . . . I grieved over the gradual disappearance of those you gave me in the summer."[1] Plate 1 represents one of the earliest of these evanescent "shadows," a delicate, just perceptible image, the trace of a small plant on a field of periwinkle blue.

The frustration of capturing and then losing the image led Talbot to find ways to fix the image, and then, using that image, to place it, instead of an

object, on another piece of sensitized paper. After exposure, the second piece of paper retained the light impression of the first. The first image, which had its tones reversed, was called the negative, and from it an unlimited number of prints, or positives, could be made. Another of Talbot's staggering ideas was to pin his photographic paper inside a camera obscura—a box with a lens—so that the exposure it received was not a direct impression of an object but an image focused by the lens of the larger world outside the box. Imagine that after placing his camera in front of a garden vase and waiting five minutes,

11

Talbot could see, on the paper inside his camera, its negative image. Although the print he made from the negative shows the vase floating in a cloud of lilac, this hovering, twilight image is a complete photographic picture. And, like the billions of photographs that followed, it is only an approximate rendering— a flat, implausible abstraction, tantalizingly close to reality, yet seductively different.

10

12

15

Together with Talbot's other photographs these early images are evidence of, or at least clues of a very real sort, to their maker's mind and to the world in which he lived. Talbot is often described as a country squire or gentleman amateur; as there were as yet no professional photographers, he could hardly have been an amateur, but he was a gentleman in the original sense of the word, and he lived at his family's ancestral home in Wiltshire. Born in 1800, closely tutored, graduated from Harrow and Cambridge, and widely traveled, Talbot was an acutely intelligent man interested in botany, mathematics, etymology, art, Assyriology, engineering, and optics. A natural scientist in the days before the professional fields were separate, he collected and propagated rare plants in his greenhouse (Sir John Herschel sent him specimens from the Cape of Good Hope), studied the molecular structures of crystals (Sir David Brewster dedicated to him his treatise on the microscope), delivered important papers on integral calculus and other subjects to the many learned societies of which he was a member—and all this in addition to inventing photography and a photoengraving process. Talbot was able to pursue these multiple ends not just because he had an agile mind, but because he was educated to believe that nothing was beyond its power of comprehension. In addition he had time, an invisible provision of the tithes of the tenant farmers on his estate.

While Talbot's accomplishments hinged on the unparalleled vitality of British science and industry, his pictures feel remote from that world. In their veiled, textured stillness, these pictures of plants and books and country life

seem more like products of the eighteenth century—precipitates of a slower, more contemplative life than photographs would later record.

Within a decade Talbot's process was superseded by another one, based upon it, which substantially altered the look of the image. Instead of slightly hazy pictures with blurred details, the new process, which used glass instead of paper negatives, provided a crystal-clear window on the world. Talbot's process could be turned to great advantage for atmospheric, painterly effects because the fibrous paper negative, like a spider's web, caught and connected anything intricate, rough, and indistinct, exalting the qualities the British termed "picturesque." But the new collodion-on-glass process was more reliable, better suited to portraiture, and better served the characteristic British esteem for objective utilitarian reports.

One of the first British photographers to use the glass plate to its fullest potential was Roger Fenton, the son of a northern industrialist, banker, and liberal member of Parliament. Fenton studied law and painting in London and Paris, and after witnessing the "Great Exhibition of the Works of Industry of All Nations" at the Crystal Palace in 1851, he turned his interests to photography. His great facility for organization he directed in 1853 to the establishment of the Photographic Society, and, enjoying the favor of Queen Victoria and Prince Albert, he was the following year appointed official photographer to the British Museum. In 1855 he departed for the Crimea to photograph the war for the government (nos. 98, 99). Although he had maintained his practice as a solicitor, Fenton was by this time the best-known and most accomplished professional photographer in England.

Between 1854 and 1858, Fenton also traveled in Britain, photographing architecture and landscape (nos. 17–21). His pictures of cathedrals and ruined abbeys are large and as impressive in their perfect articulation as in their subtle insistence on the noble heritage embedded in the old stones. Medieval architecture is seen here as the ideal confluence of history, community, and spirituality. Such desirable moral and patriotic connotations had the Middle Ages at the time that the new Houses of Parliament were built in neo-Gothic style. That official apotheosis of romance with the past Fenton knowingly related to the sixteenth-century residence of the Archbishop of Canterbury across the Thames (no. 21), as if his picture could link the democratic age with the grandeur of Tudor lineage.

If Britain's past conferred respectability upon the present, the present, as seen in the photographs of Robert Howlett, was unconscionably presumptu-

13

36

ous. Howlett's series documenting the launching of the *Great Eastern*, the largest ship built in the nineteenth century, testifies to an enormous admiration for the power of machines, for sheer size and quantity, pragmatism and progress. When these photographs were made in 1857, the tiny islands of Great Britain had spawned the widest-ranging empire the world has known; the great ship was a sign of her prowess and industry, a monument of pride built by a people who believed, as Thomas Carlyle wrote, that might is right. Howlett's portrait of Isambard Kingdom Brunel, the engineer who designed the boat, is an unforgettable expression of the Victorian regard for manliness, practical ingenuity, and hard work. The series as a whole exults in the sense of power conveyed by the men of industry. "It might be rather rampant in its display and savor of boasting," Elizabeth Gaskell wrote, "but still they seemed to defy the old limits of possibility, in a kind of fine intoxication caused by the recollection of what had been achieved, and what yet should be."[2]

The rampant boastfulness of the empire also took form as a surfeit of possessions and a sense of entitlement to the bounty of the land, both domestic and foreign. As most mid-Victorians lived in cities but had been born in rural villages, escape from materialism and the problems of urban life was often expressed as a yearning for the simple peace of the countryside, for something more natural. Certainly this was the inspiration for Thomas Keith's anthropomorphized "portrait" of two trees and for Fenton's shimmering landscape with its buttoned-up, top-hatted citizens fishing in the River Wharfe, a scene of pastoral escape bathed in a golden light that joins heaven and earth in a rapturous Claudian reverie.[3]

In this hardworking, well-organized, pragmatic age, space for the psyche was circumscribed by the dogmatism of right thinking. Extravagant expressions of individuality, promiscuity, even poverty could be construed as disorders of the soul. By contrast, home and family were refuges of the heart, feminine realms solemnly invested with the positive value of connectedness. Isolated from the anxieties of the man's world the domestic, like the rural, might be imbued with peaceful connotations. That this isolation could also be confining accounts for a certain hothouse atmosphere detectable in many of the depictions of women.

The appeal of the preindustrial age engendered a cult of innocence, of seeing, as Ruskin put it, "with the large eyes of children, in perpetual wonder, not conscious of much knowledge."[4] Thus the delight taken by an Oxford don in young girls was not suspect, even though his photograph of Alice Liddell,

the original Alice of the stories he wrote under the pseudonym Lewis Carroll, [28] displays her as a scantily clad child seductress. And in this age of obfuscating prudery, sex was a secret and passion was necessarily coated in sentimentality. For example, Henry Peach Robinson, in his photograph of a young woman [20] supposedly dying of unrequited love, evokes the dire emotional state by staging it as in an amateur theatrical.

Indeed, playacting and make-believe were popular pastimes, parlor games for creative escape. To illustrate Alfred Lord Tennyson's *Idylls of the* [34] *King*, Julia Margaret Cameron rented suits of armor for King Arthur and Sir Lancelot, had a fallen tree dragged in from Tennyson's property, and pressed her family and friends and even strangers into posing before her camera. In his recasting of the Arthurian legends Tennyson foresees the decline and fall of a civilization that has lost its code of purity—a thinly veiled warning against the pride, greed, and sexual hypocrisy of Victorian society. Cameron's enthusiasm for these poems was characteristic of a civilization that looked to the past for noble thoughts and aspired to moral rectitude with religious fervor.

Perhaps the only thing desired more passionately was spiritual greatness —the result of genius, the virtuous life, or both. Cameron's portraits of her contemporaries are embodiments of her ardent quest for inspiration and her admiration of intellect. Her niece, Julia Duckworth, mother of Virginia Woolf [30] and Vanessa Bell, was worshiped by her second husband, Sir Leslie Stephen, as "a living image of a saint"—precisely as she is depicted in Cameron's portrait. Sir John Herschel and Philip Stanhope Worsley loom large—"illustrious," "re- [32] vered," "immortal heads," she wrote. Manifestly, these are exemplars—a vir- [35] tuous mother, a scientist, and a translator of Homer—heroes for an age of great accomplishments and antidotes for its difficult transitions.

Maria Morris Hambourg

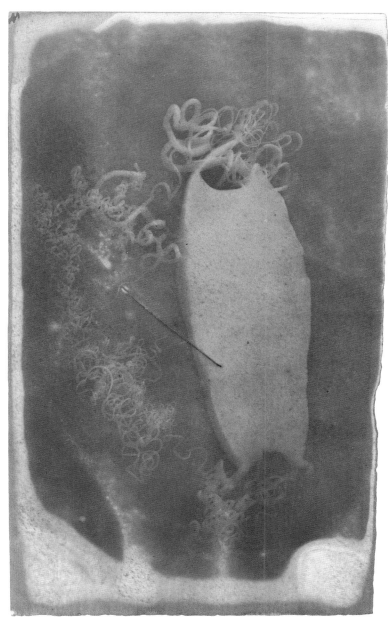

9. Anonymous, Shark Egg Case, 1840–45 (no. 2)

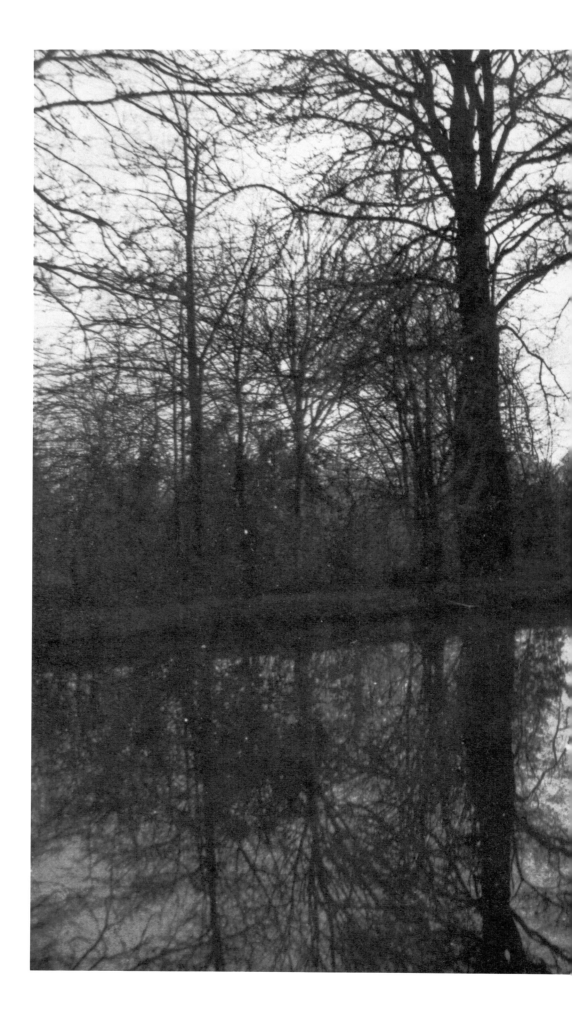

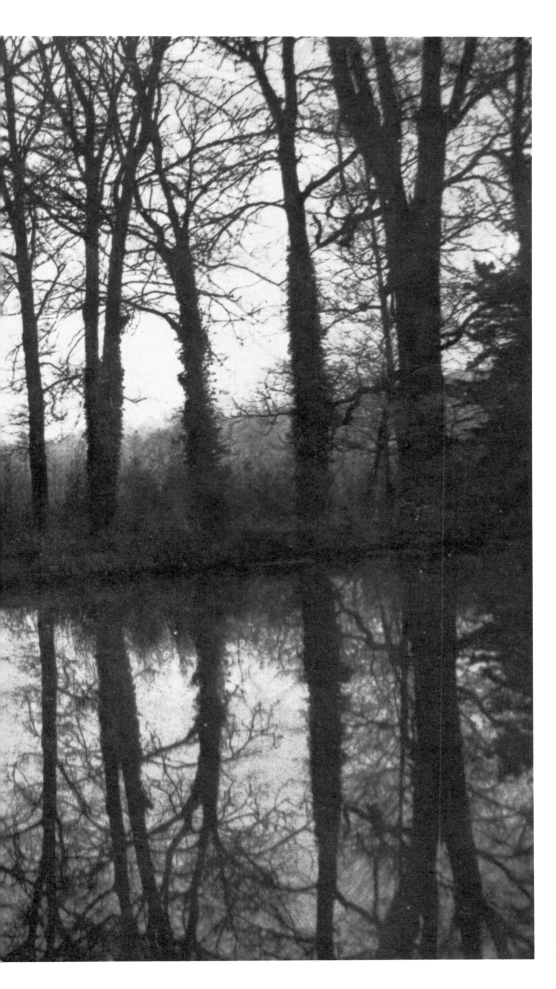

10. William Henry Fox Talbot,
Trees with Reflection,
early 1840s (no. 10)

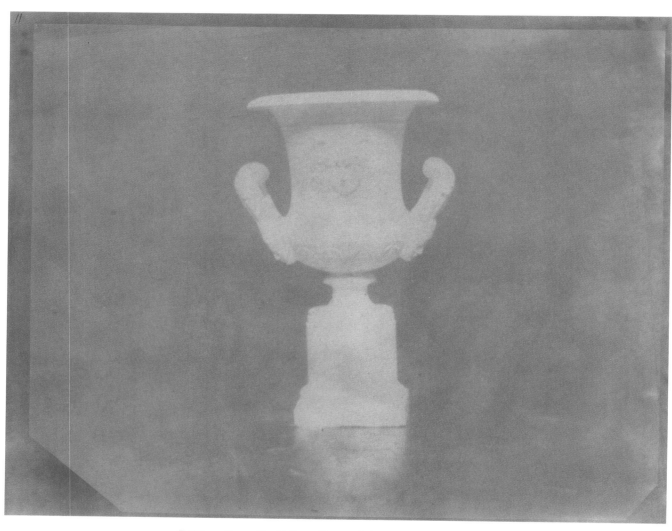

11. William Henry Fox Talbot, Vase with Medusa's Head, 1840 (no. 3)

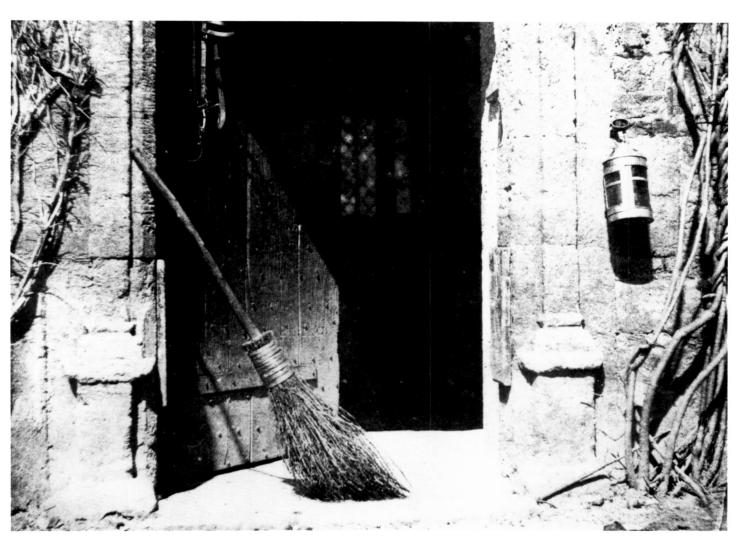

12. William Henry Fox Talbot, *The Open Door*, 1843–44 (no. 7)

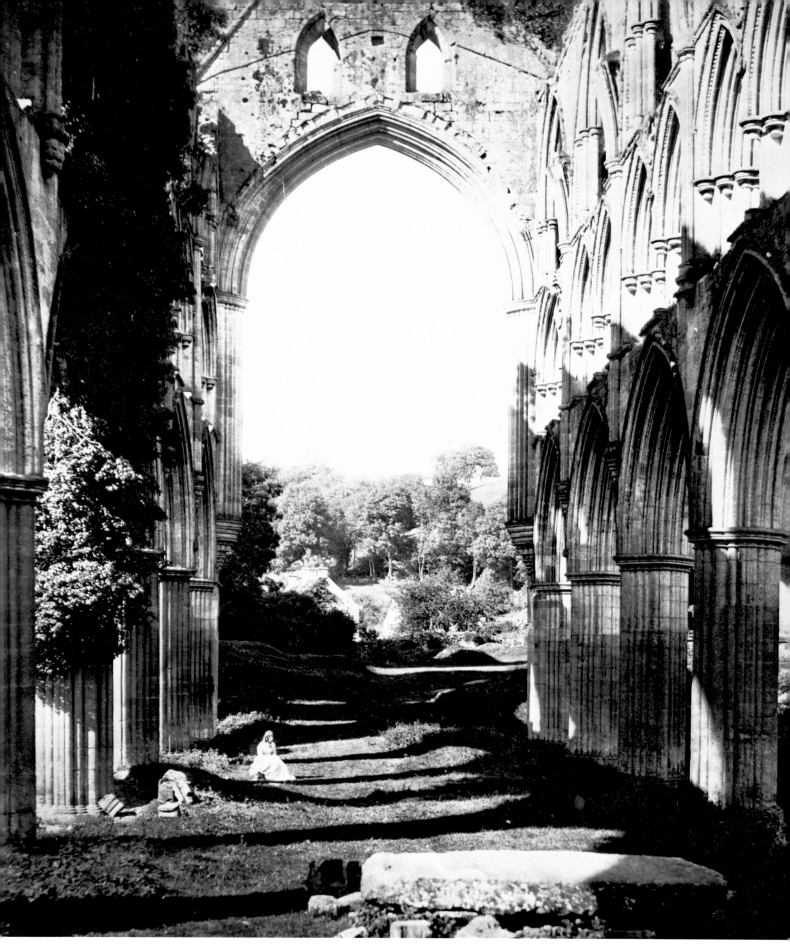

13. Roger Fenton, Rievaulx Abbey, 1854 (no. 18)

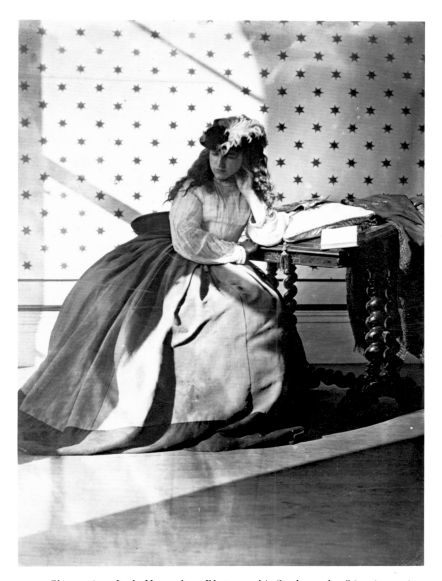

14. Clementina, Lady Hawarden, *Photographic Study*, early 1860s (no. 34)

15. William Henry Fox Talbot,
The Fruit Sellers,
ca. 1845 (no. 6)

16. John Dillwyn Llewelyn, *Thereza*, ca. 1853 (no. 15)

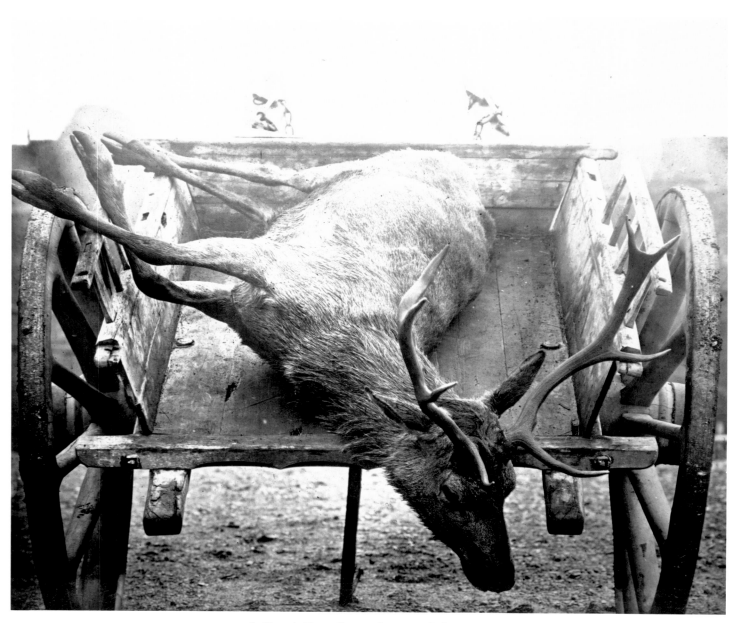

18. Horatio Ross, Stag in Cart, ca. 1858 (no. 27)

19. Horatio Ross, Tree, ca. 1858 (no. 28)

20. Henry Peach Robinson,
"She Never Told Her Love,"
1857 (no. 29)

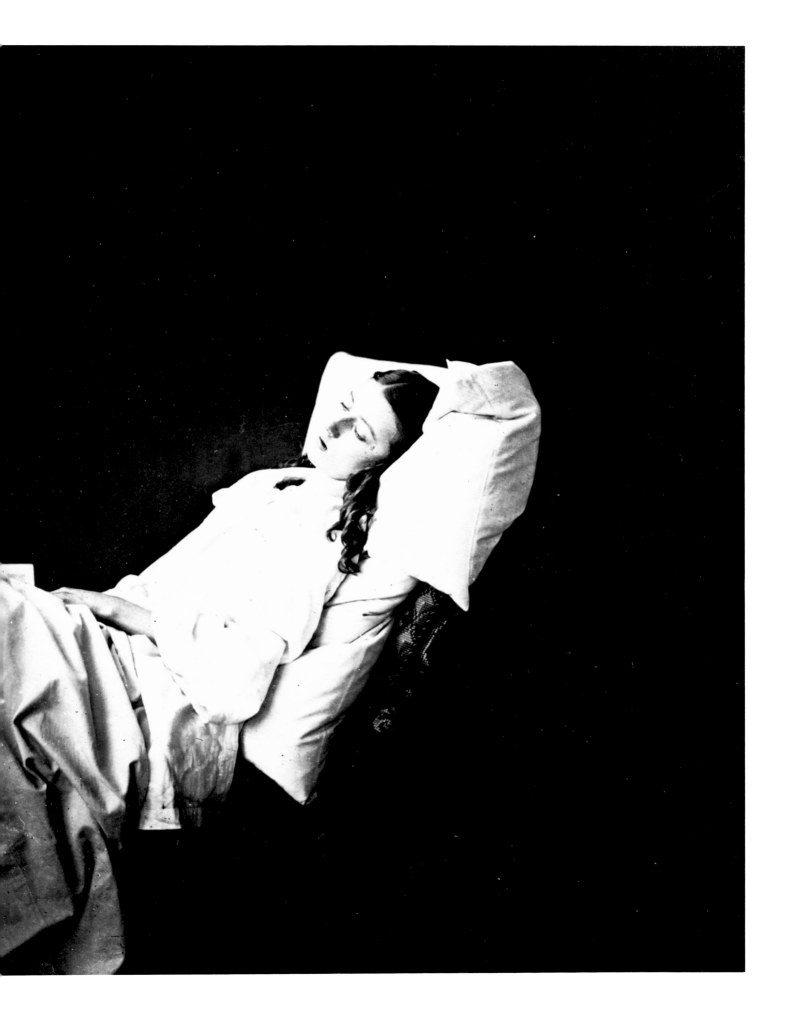

21. Calvert Richard Jones, Young Man, late 1840s (no. 13)

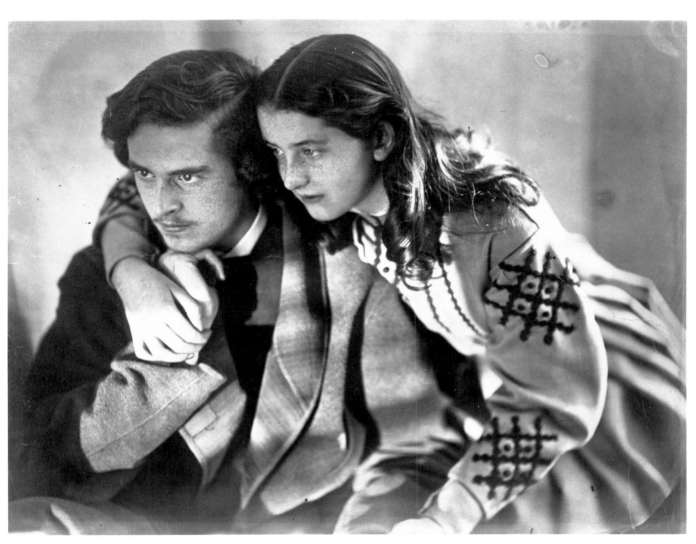

22. Oscar Gustave Rejlander, *Mr. and Miss Constable*, 1866 (no. 35)

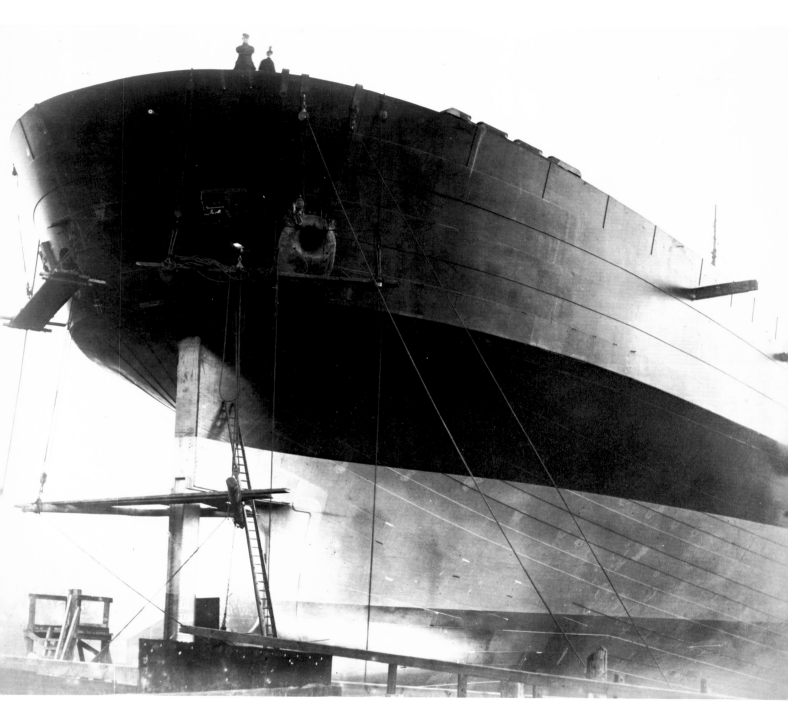

23. Robert Howlett, The Stern of the *Great Eastern*, 1857 (no. 24)

24. Robert Howlett, Isambard Kingdom Brunel Standing Before
the Launching Chains of the *Great Eastern*, 1857 (no. 22)

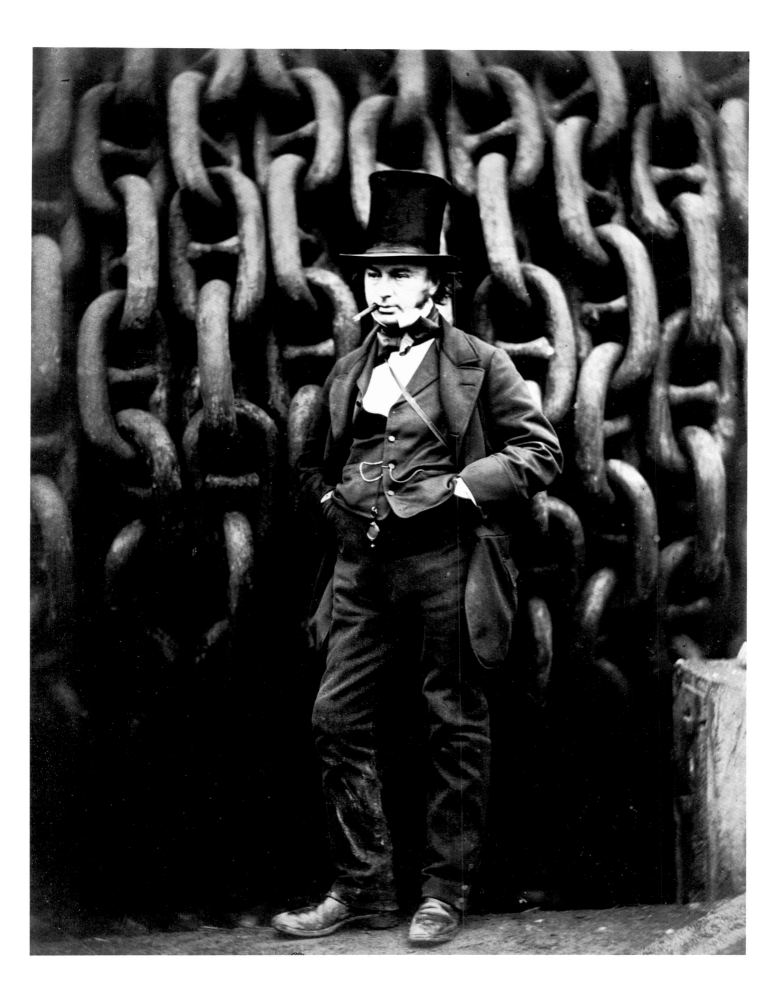

25. Robert Howlett,
The Bow of the *Great Eastern*,
1857 (no. 23)

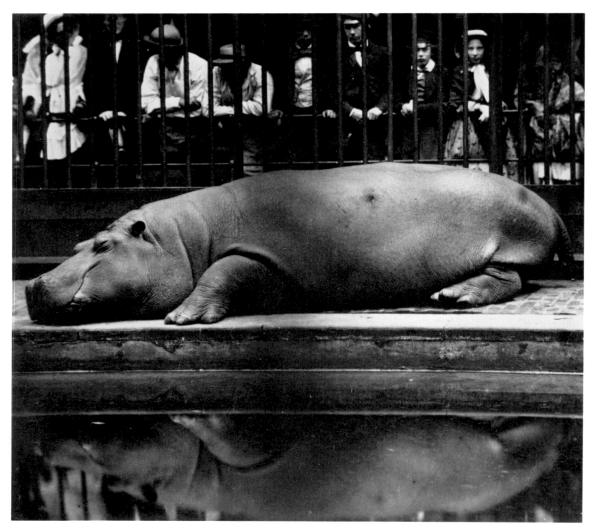

26. Count de Montizon (Juan Carlos María Isidro de Borbón),
The Hippopotamus at the Zoological Gardens, Regent's Park, 1852 (no. 25)

27. Roger Fenton, Still Life with Fruit, 1860 (no. 26)

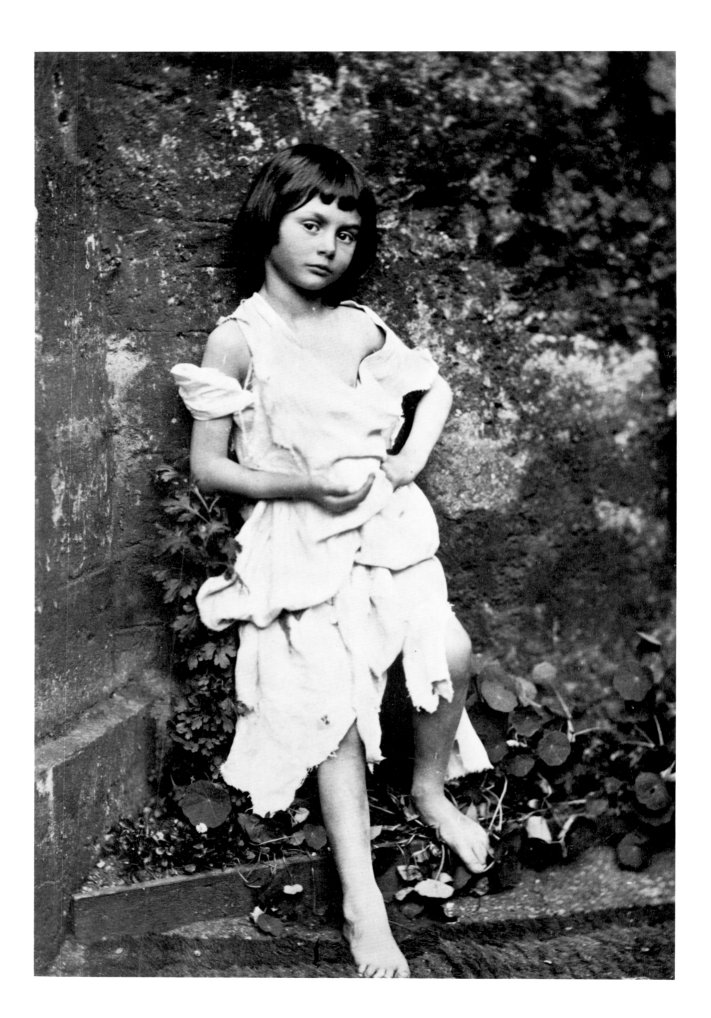

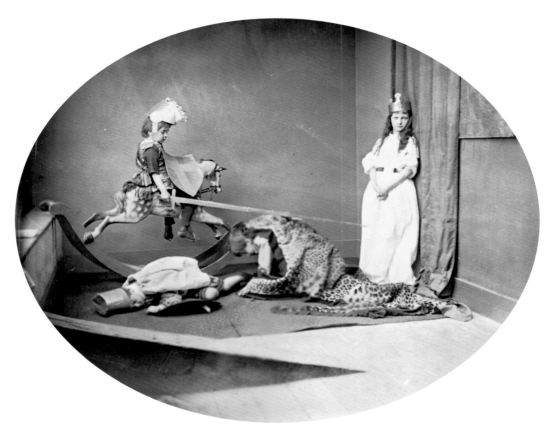

29. Lewis Carroll (Charles Lutwidge Dodgson), *St. George and the Dragon*, ca. 1874 (no. 32)

28. Lewis Carroll (Charles Lutwidge Dodgson),
Alice Liddell as "The Beggar Maid,"
ca. 1859 (no. 31)

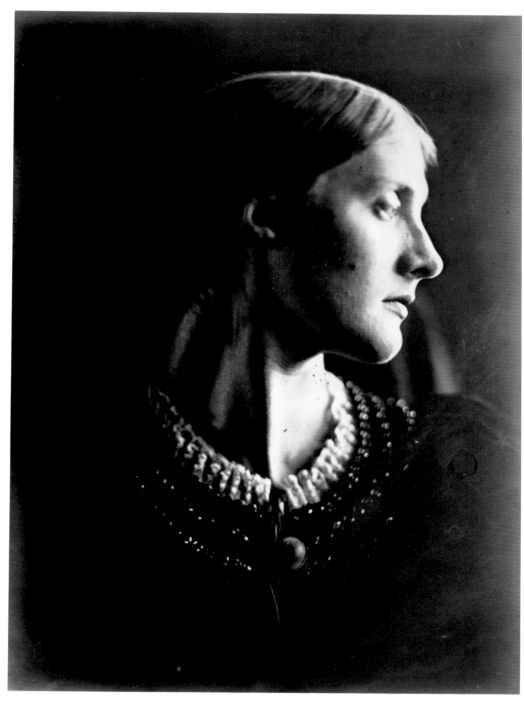

30. Julia Margaret Cameron, *Mrs. Herbert Duckworth*, 1867 (no. 37)

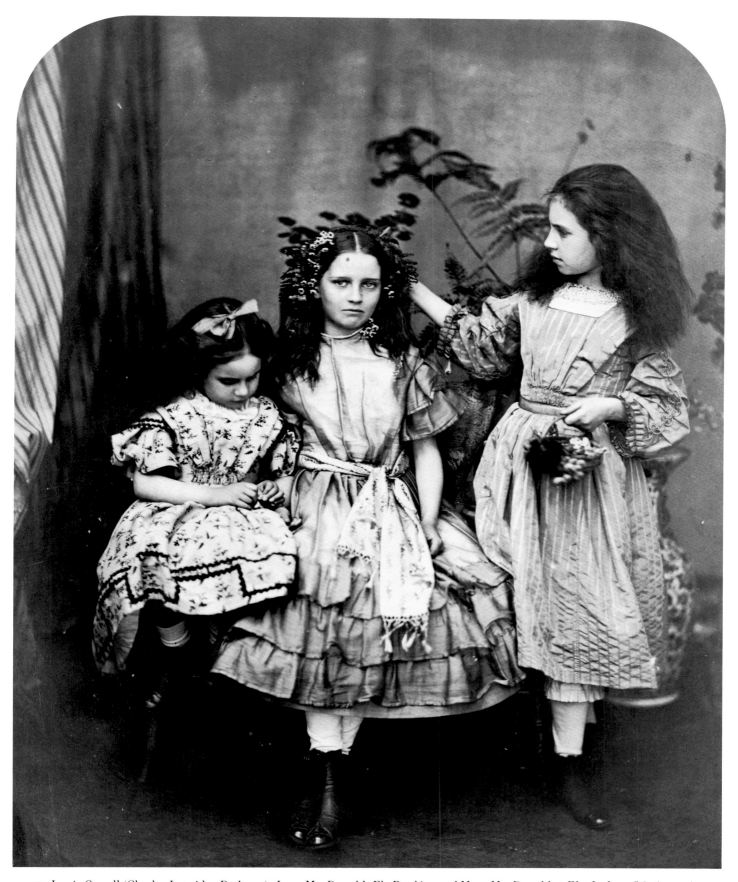

31. Lewis Carroll (Charles Lutwidge Dodgson), *Irene MacDonald, Flo Rankin, and Mary MacDonald at Elm Lodge*, 1863 (no. 33)

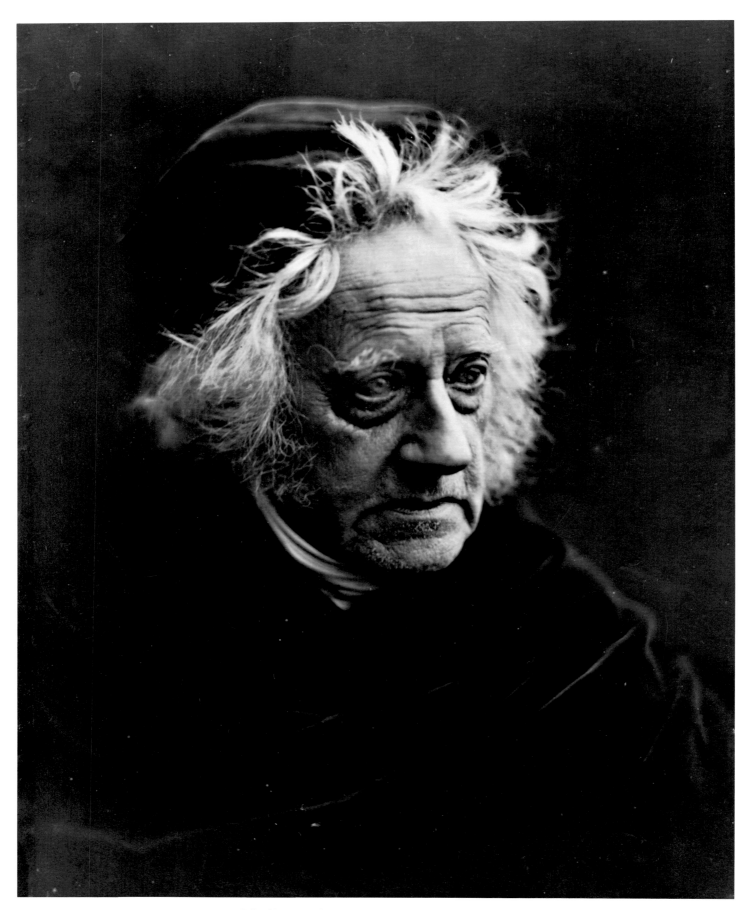

32. Julia Margaret Cameron, *Sir John Herschel*, 1867 (no. 36)

33. Hugh Welch Diamond, Patient, Surrey County Lunatic Asylum, 1850–58 (no. 30)

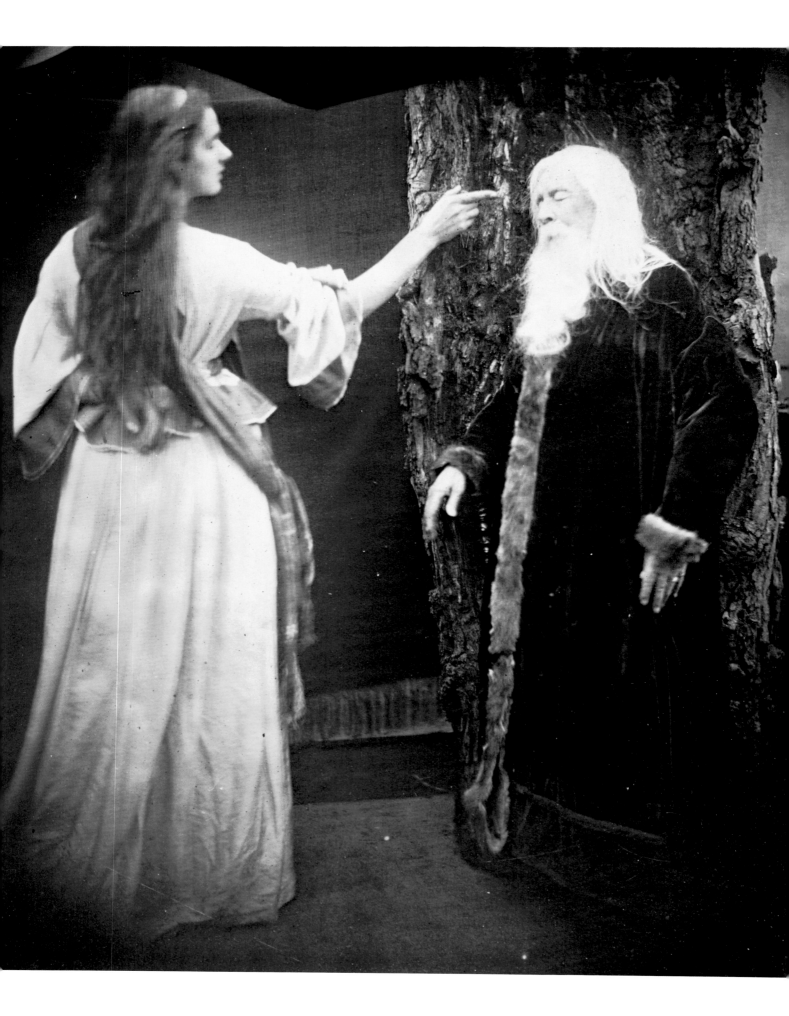

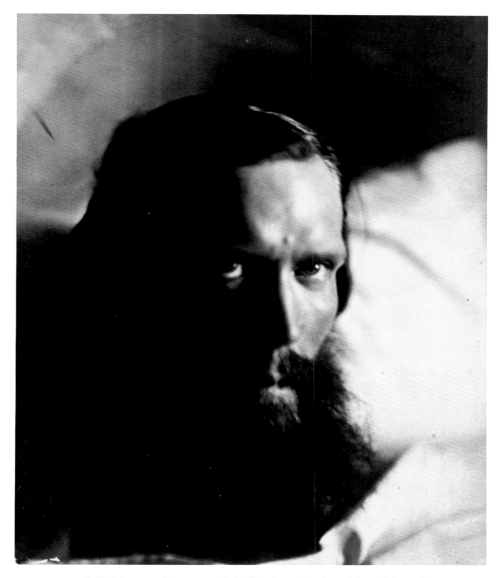

35. Julia Margaret Cameron, *Philip Stanhope Worsley*, 1864–66 (no. 38)

34. Julia Margaret Cameron,
Vivien and Merlin,
1874 (no. 39)

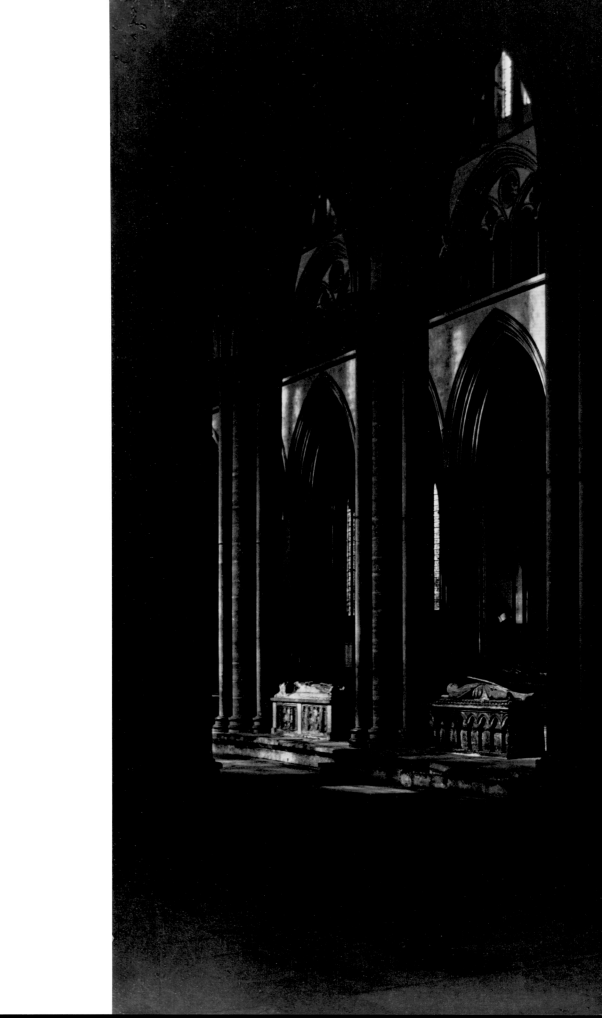

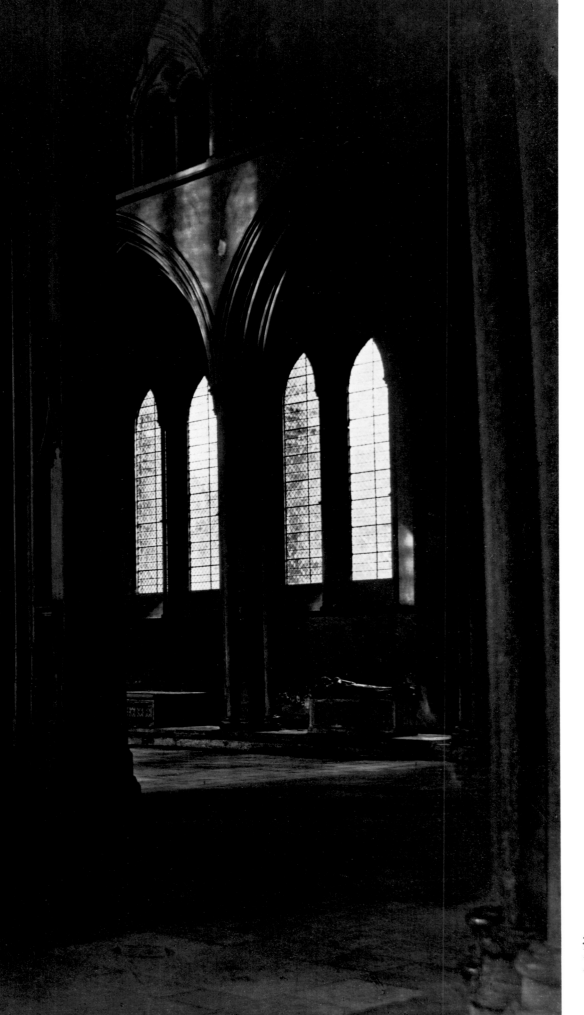

36. Roger Fenton,
Interior, Salisbury Cathedral,
ca. 1858 (no. 20)

Photography as Art in France

While Henry Talbot was inventing paper photography in the garden of his sixteenth-century manor in the Wiltshire countryside, the painter and scene designer Louis Daguerre was in his rooms in the theater district of Paris, around the corner from his Diorama—an ingenious illusionistic spectacle of light and painting—perfecting his second, and more important, invention, a kind of "metallic photography."[1] By 1838, Daguerre had achieved success in this endeavor and began showing his results to members of the artistic and scientific community as well as to the press, with the result that even before its public disclosure, the mysterious new invention of the master showman had become the talk of the town. On the mirrorlike surface of his little silvered plates Daguerre captured pictures of the world with a preternatural minuteness and exquisite delicacy, as if "drawn by the invisible pencil of Mab, the queen of the fairies."[2] A government committee investigated the miraculous claims and found that the daguerreotype was not chimerical magic, but an eminently useful device; in fact, the chemist Louis Joseph Gay-Lussac wrote, "M. Daguerre's process is a great discovery. It is the beginning of a new art in an old civilization."[3]

By the time the state had acquired Daguerre's process and revealed it to the world in August 1839, the public's appetite for the invention had reached such a peak that opticians and stationers could not keep daguerreotype apparatus and manuals in stock. Although the requisite chemical manipulations and long exposures dampened some of the wildest enthusiasm, by 1842 improvements had shortened exposure time sufficiently that the use of the daguerreotype was soon widespread, primarily in the field of portraiture. In this arena the small-scale reflective surface and the fact that each image was unique and could not be faithfully replicated were only slight drawbacks, amply compen-

37. Bisson Frères, *Portal of Saint-Ursin, Bourges*, ca. 1855 (no. 74)

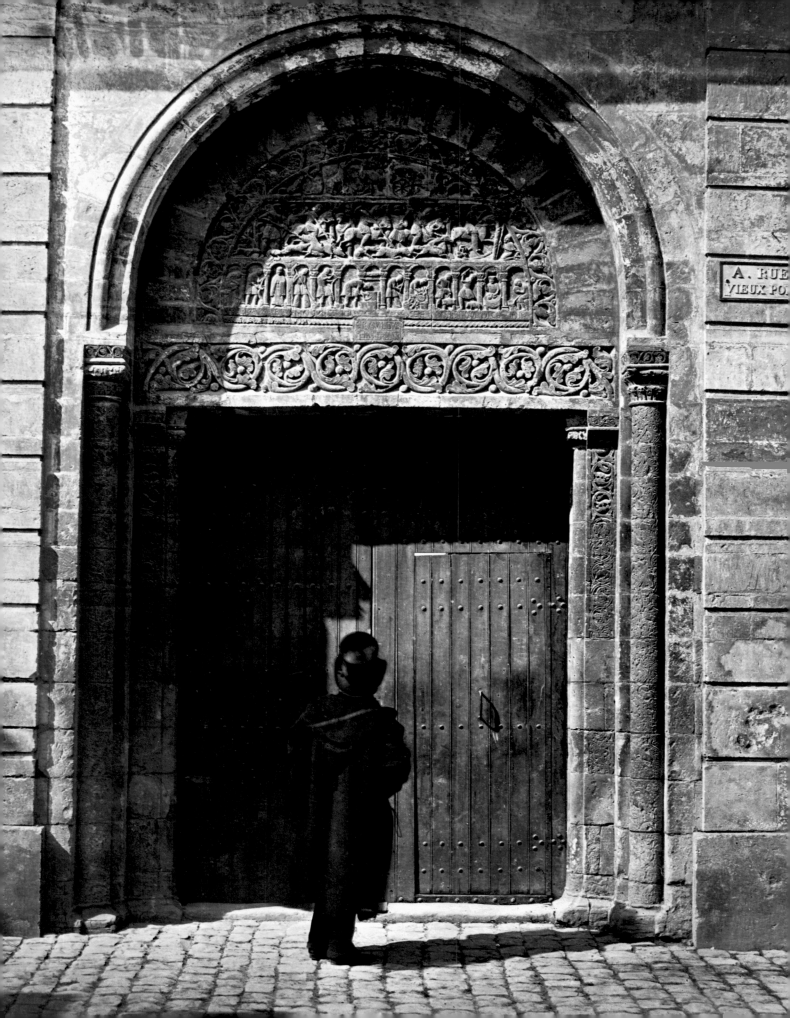

sated by the extraordinary fidelity of the representation. The same middle-class public that flocked to Daguerre's Diorama now swarmed to the photographic studios, many of which were lavishly appointed rooms on the top floors of buildings lining the *grands boulevards*. The spectacle of the street, of seeing and being seen, was expanding to the photographers' ateliers—migrating from the sidewalks and cafés up four flights of stairs to this new form of theater, where the audience was the self and everyman the star.

Although the painters of miniature portraits were distressed by the daguerreotype's usurpation of their livelihood, their opposition could not fore-stall its popular success. Daguerreotypes were utilized in the service of science and art, and for recording views at home and abroad, but the overwhelming majority of daguerreotypes made between 1842 and 1855 were portraits, a fitting parallel to the rise of the middle class and the exercise of universal male suffrage, resurrected in 1848 from the ashes of the Revolution.

Until 1851 photography in France was, generally speaking, restricted to daguerreotypy and was practiced as a popular art and as a technique in the service of the higher professions. But when practicable photography on paper appeared, the results looked less like family keepsakes than like drawings, aquatints, and lithographs—in short, like pictures traditionally regarded as works of art. Moreover, since most of those who made the paper photographs had been trained as painters, and as they practiced their calling in a decidedly artistic fashion, the position of photography shifted from that of a technical métier and boulevard industry to a new status, a status that was hotly disputed.

According to an age-old political split between the monarchy and the fine arts in one camp, and the bourgeoisie and the applied, technical arts in the other, it was presupposed that the mechanical and chemical processes of photography could not produce art. The French bias against the technical was two centuries strong, and it was from the unexamined shadow of that ancient contempt, as well as from their experience of the popular daguerreotype, that Delacroix, Baudelaire, and many other artists and writers initially rejected the medium's claims to art. Just as naturally, the photographers working with paper perceived their activity as artistic, and not just for the ennobling connotations. More important, because they had been trained as painters, they could not fail to recognize that the exquisite sensual qualities and limitless variables of personal and material expression inherent in paper photography were precisely the malleable stuff from which a rich pictorial art could be fashioned. This recognition, like the photographic practice that resulted from it, was rooted in

the enormous value French culture placed on art and in the acute discrimination of expressive facture that resulted. Thus, in spite of the traditional split between art and industry, and also because of it, France at mid-century became the site of an exuberant blossoming of artistic photography that has rightly been called a golden age.

It began with improvements to Talbot's process which shortened the exposure time, increased the sensitivity of the negative, and made the prints more governable and permanent. After Louis-Désiré Blanquart-Evrard demonstrated these advances in 1847, Henri Regnault and Gustave Le Gray experimented further. Unlike Blanquart-Evrard, a merchant from Lille who worked to achieve practical replication and accordingly set up a photographic printing establishment, Regnault and Le Gray proceeded with their experiments in order to turn the medium into the responsive vehicle of their pictorial ambitions.

Regnault, a distinguished scientist who experimented with Talbot's process as early as 1841, directed the Sèvres porcelain factory from 1852 to 1871. There, on the outskirts of the city, at the edge of a forest that was formerly the royal preserve surrounding the châteaus of Versailles and Saint-Cloud, he pursued paper photography. Among his coterie was Louis Robert, a painter who headed a workshop at Sèvres. Legend has it that Regnault and Robert turned their full attention and talent to photography during a lull in work engendered by the Revolution of 1848.

In trying out their new techniques on fellow workers and members of their families, Regnault and Robert produced portraits whose strong light and dark contrasts resembled those of David Octavius Hill and Robert Adamson (no. 12). Rather than transmute the tenebrous quality of the medium into a seventeenth-century Dutch style, as had the two Scots, the Frenchmen explored the agency of light and the structure of paper to discover their own distinctive language. In portraying his daughter Henriette, for example, Robert found that dark areas lacking detail could provide not Rembrandtesque drama but gathering intimacy, and that light could fuse together discrete pieces of the world. Here the light welds Henriette's head and torso to the fabric behind her; they are of one piece, like a fragment of sculpture with a chunk of the wall still attached. Thus the photographers of Sèvres learned how the structure of the paper negative eased the grip of reality and cast resemblance into that indeterminate space furnished by the imagination.[4]

The indistinct, incomplete quality of this kind of rendering was easier to employ in landscape, where the notion of the sketch was well ensconced.

41

49

51

63

Those accustomed to plein-air painting could accept that the individual trees at Saint-Cloud should rustle together in a froth of foliage, and that an old tree and the rough-hewn trough and wooden bucket at its roots should share an undifferentiated air of family. Le Gray's early photographs in Fontainebleau Forest (no. 62) are virtuoso investigations of the intricate mesh of associations possible with paper negatives. He wielded this syntax brilliantly, weaving lichen-splotched rocks, glimmering leaves, and dancing shadows into a stippled carpet of close harmonies. And once he had the knowledge of the place and of his materials, he could assemble the tones into larger masses, setting the viewer on a journey with a symphonic swell of darkness and moving him along, with diminishing chords, toward the light beyond the rise.

This way of seeing, in which the clear delineation of some detail was sacrificed to a larger unity, was a notion central to the practice of the Romantic painters. The critic Francis Wey articulated this "theory of sacrifices" for photography in 1851, and it was restated by Le Gray in his influential treatise on his waxed-paper process.[5] In January of that year Regnault, Le Gray, Wey, and three dozen other enthusiasts of photography formed an association called the Société Héliographique (from *helios*, the Greek for "sun"). Through the regular meetings of the group, and the publication of its biweekly paper *La Lumière*, the photographers and critics shaped an aesthetic dialogue for the new art.

Also in early 1851 the government provided an opportunity for five of the artists in the Société to demonstrate their medium on a grand scale. Under the leadership of Prosper Mérimée, the Commission des Monuments Historiques assigned Baldus, Bayard, Le Secq, Le Gray, and Mestral to photograph the principal historic monuments of the country. Since the Revolution churches, in particular, had fallen into disrepair, and in an effort of patriotic consolidation the government was beginning to restore them, not only to save the structures, but also to reclaim the past glories of French civilization—which they symbolized—to buttress the present regime.

39

As the "before" pictures for a campaign of restoration, the photographs indeed documented the sad state of conservation of the architectural patrimony. But they were also magnificent testimony of the capacities of the medium. In the photograph of Carcassonne by Le Gray and Mestral the light subtly models the massive Visigothic walls in graded nuance, a quality that Wey, borrowing from Delacroix, called the sensation of color, "the kind of accentuation that allows disparate nuances to be visible on the same plane."[6] He continued, "By profusely aerating everything, by softening the swarming details without oblit-

erating the contours, [the paper negative] presents to the delighted eye monuments as great as their counterparts in reality, and sometimes even greater."[7]

The early French photographers were children of the Romantic era. They revealed this heritage not only by catching the colorful ambience of textures in light, but also by their preference for the Gothic, the picturesque, and the fragmentary, particularly in the form of the vignette. Characteristic of the lithographs and woodcuts that illustrate Romantic books, vignettes are images that coalesce in the middle but shade off at the edges.[8] Unlike a grand Salon painting, the unassuming vignette, composed around a central detail with only peripheral regard for the frame, offered an intimate glimpse of a corner of the world. As seen in Le Secq's and Pec's views of Chartres and Bourges, the detail selected might be as imposing as the historic statues of the church fathers or as humble as the beggars by the door (no. 49).

40
54

The first generation of French photographers brought forth marvelous pictures from the atmospheric, fragmentary, old, and natural, and through their luscious prints they proved without question that photography was a marvelously flexible artistic medium indeed. But the marked Romanticism embedded in their aesthetic began to look rather démodé once the curtain had risen on the swirl of pomp and industry generated by the self-consciously modern Second Empire (1852–70).

Louis-Napoleon, the nephew of Napoleon, was elected president in 1848, but he and most Frenchmen soon came to believe that the threat of repeated revolution justified a coup d'etat "reestablishing imperial dignity." During the ensuing decade of virtual autocracy, Napoleon III returned France to a position of political power in Europe and made Paris not only the center of capitalist enterprise and parvenu elegance, but also, once again, the capital of art, society, and sensuality in the Western world. The emperor provided luster through lavish ceremonies and balls, stoked materialism and capitalism through new forms of credit, advanced industry by helping to build railroads and canals, endorsed lasciviousness through his own behavior, and established a monopoly on the urban spectacle by his modernizing transformation of Paris.

The French economy expanded and Paris doubled in size during the Second Empire. The middle class, from petit bourgeois to grand, now found a degree of prosperity and leisure. They dined out, attended the theater, and mingled with the dandies, prostitutes, soldiers, and students who strolled the *boulevards*. Baudelaire noted the genres and pronounced it *moderne* to be a passionate yet distanced spectator, a voyeur alone, yet at home, in the crowd.[9]

Like Balzac and Daumier, Baudelaire recognized the necessity of making modern life the subject of art, and he saw in military parades and carriages in the park, in the distinctive cut of each dress and collar, the imprint of the age. The bourgeois desire to be recognizable, not subsumed by the anonymous river of humanity, gave rise to an intense focus on personal adornment and on the gait, glance, and gesture that characterized each individual. It was this heightened interest in the expression of the self that fed the fascination with caricature and pantomime, and that brought the public in such numbers to the photographers' studios. Indeed, it was the sharp eye of a caricaturist and the esprit of the boulevardier that made Nadar the greatest portraitist of this self-obsessed age (no. 57).

59

The insistence of the spectator's gaze is surely the implicit subject of Aguado's extraordinary portrait of a woman seen from the back. "Where is the man who, in the street, at the theatre, or in the park," asked Baudelaire, "has not in the most disinterested of ways enjoyed a skilfully composed toilette, and has not taken away with him the picture of it which is inseparable from the beauty of her to whom it belonged, making thus of the two things—the woman and her dress—an indivisible unity?"[10] That this woman, immobile as a bejeweled icon, is photographed from the back, her bare neck and shoulder exposed to fetishistic adoration, makes her an object of desire. Aguado's photograph is the perfect illustration of Degas's notion, as expressed by Edmond Duranty, that "a back may reveal a temperament, an age, a social condition."[11]

45

The inverse of Aguado's aloof lady of society who withholds her face from the viewer is the easy *bohémienne* in Nadar's photograph. Unlike the suave odalisque of Vallou de Villeneuve and the discreet nude by Eugène Durieu, the woman in Nadar's photograph gives herself completely; turning to meet our startled gaze, she holds us hostage to her compliance.

60

46

62

By the mid-1850s many of the photographers who had begun with paper negatives had either found ways to make them exceedingly fine or opted for transparent glass plates, both of which resulted in crisper detail. They also made larger pictures, appropriate in scale for their rising importance in society and for the frequently official nature of their projects. Le Gray, Baldus, and the Bisson brothers were the masters of a grand style: a manner broad, grave, and sure, sometimes rigid, occasionally rhetorical, and laden, even in lighter moments, with the weight of French cultural heritage. In terms of technique the photographs were flawless and, in terms of *matière*, the prints possessed both vigor and exceptional tonal finesse. Having some fifteen years' experience, the

47

64

photographers were fully mature artists whose ambitions met the needs of the imperial court and its merchant princes.

Le Gray's suite of pictures documenting the maneuvers of the emperor's army at a newly inaugurated military camp near Paris is a good example of the services the photographers rendered. In addition to the requisite portraits of generals, records of the ritual banquets and Sunday Masses, and a sweeping panorama, Le Gray managed to make some stunning pictures that reduce all 58 the specifics of the Imperial Guard and the Camp de Châlons, and all the propagandistic rationale for military display, to the essentially artistic question of where to place the slightly sloping horizon and how to balance it with precisely the proper number of horsemen.

Baldus, too, could not help making gorgeous pictures, even when the subject was a disaster. Commissioned by the government to photograph the aftermath of the Rhône floods in 1856, he returned with skillfully composed images of the shattered buildings and pell-mell chaos left behind by the torrents of muddy water that coursed through sections of Lyons, Avignon, and Tarascon. He also produced exquisite panoramas showing sheets of serene water from which poignant details emerge—trees, carts, fences, an abandoned bed—as if 55 drawn by a master calligrapher in minute scale on pale lavender satin.

All but absent in this description of the Second Empire are the proletariat and the peasants, the backbone of the nation. The grandeur of the empire and its capitalist policies hardly touched their lot, although the virtual completion of the railroads (no. 75) by the end of Napoleon's reign did eventually stitch their existence into a unified economy. The portraits of these people are not told in the high art of the official photographs; their faces were taken for granted, or were limned in the inexpensive little cartes de visite that were popular by 1860. When the working classes do appear in the artistic photography of the period (no. 66), it is by happy accident. Even the newly established grand bourgeois class occupies the stage but rarely, and then, as in Baldus's 50 photograph taken in the park of a château, they are separated from the viewer and from one another by a stiff self-consciousness that presages the immobile modern profiles in Seurat's *La Grande Jatte*.

The preferred image of the Second Empire man is the one in the Bisson brothers' photograph of a medieval doorway in Bourges. As indicated by his hooded cape, this man is a traveler, perhaps having come by the railroad from 37 Paris, and his new top hat indicates that he has the aspirations of a gentleman. He knows what is worth his attention, namely, the august heritage of his great

nation. By interpolating the contemporary citizen within the framework of the past—like a sundial's needle telling the hour of the day—the Bisson brothers brought their century's romantic youth into line with the present regime, and went far toward summarizing the entire program of their age.

Maria Morris Hambourg

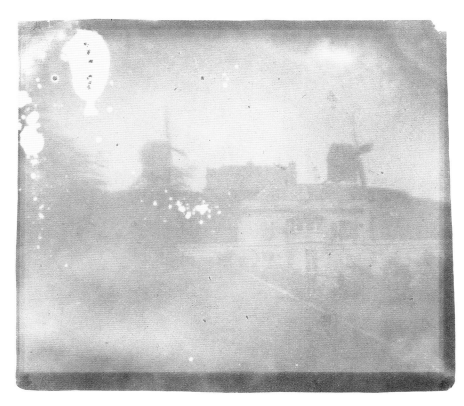

38. Hippolyte Bayard, Windmills, Montmartre, 1839 (no. 45)

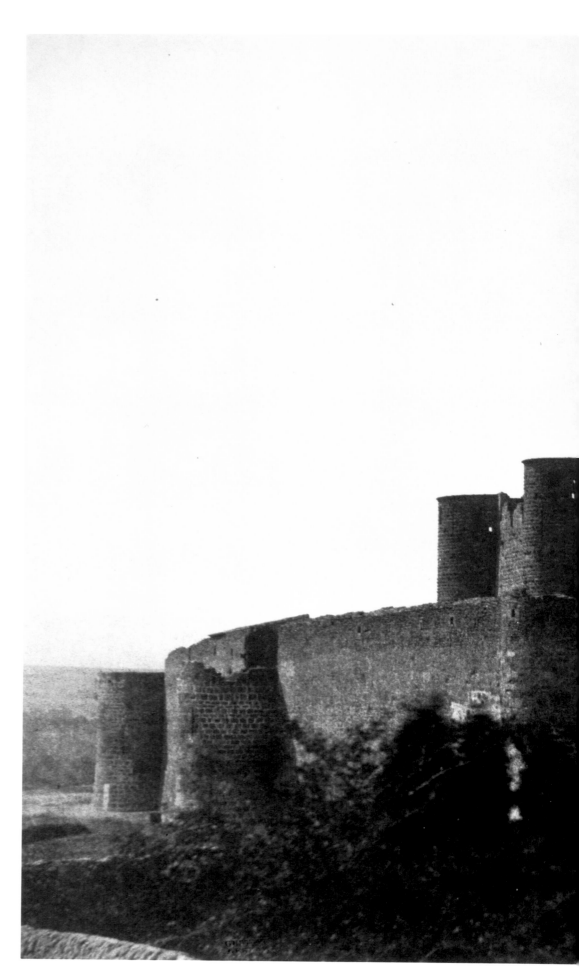

39. Gustave Le Gray
and O. Mestral,
The Ramparts of Carcassonne,
1851 (no. 47)

Gustave le Gray et Mestral.

40. Henri Le Secq, *Wooden Staircase at Chartres*, 1852 (no. 48)

41. Louis-Rémy Robert,
Henriette Robert,
ca. 1850 (no. 46)

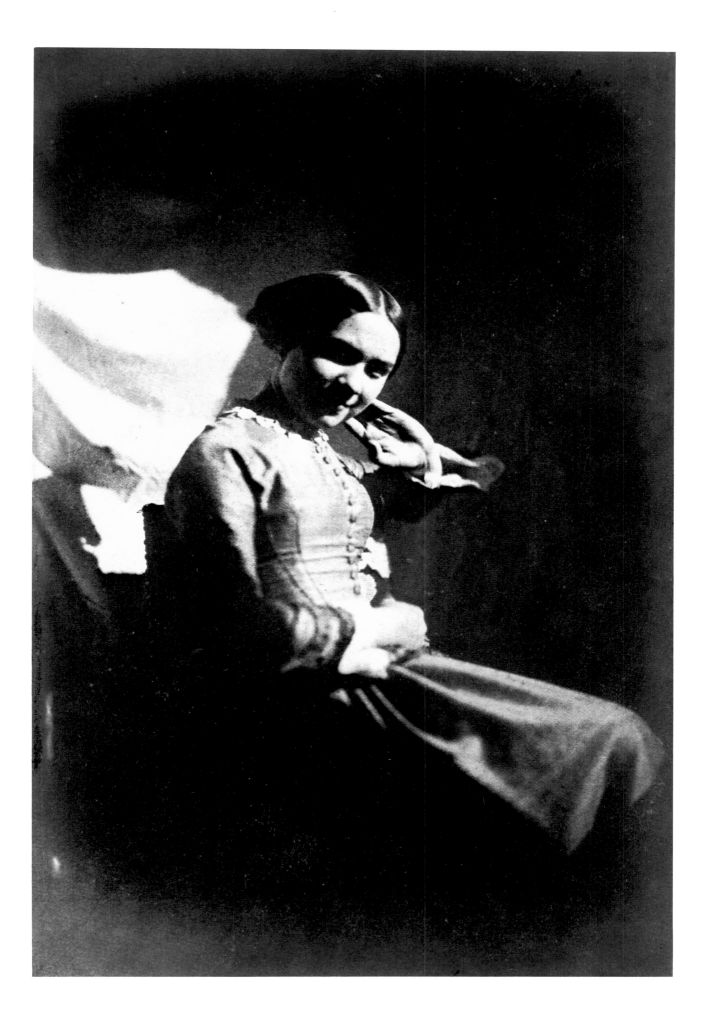

42. Louis-Auguste Bisson, Dog, 1841–49 (no. 41)

56

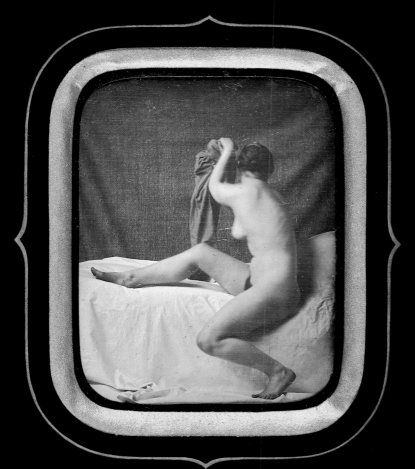

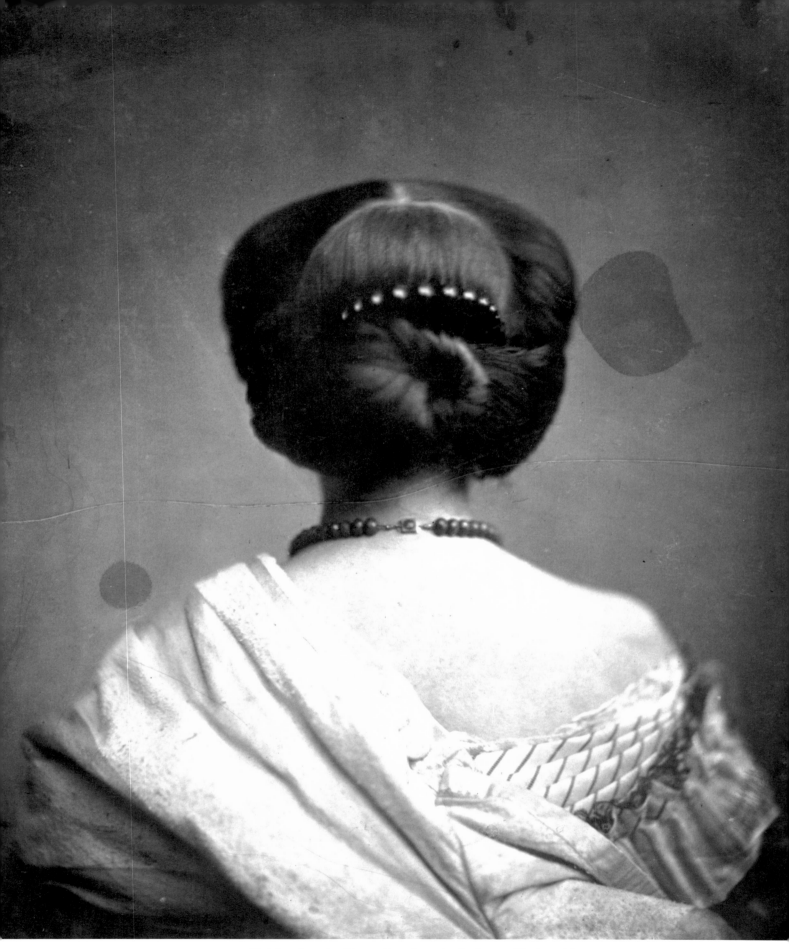

45. Onésipe Aguado, *Woman Seen from the Back*, ca. 1862 (no. 61)

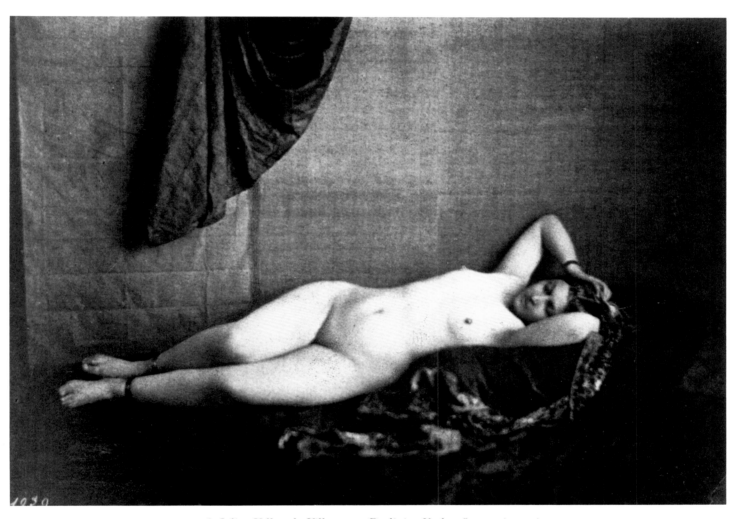

46. Julien Vallou de Villeneuve, Reclining Nude, 1851–53 (no. 54)

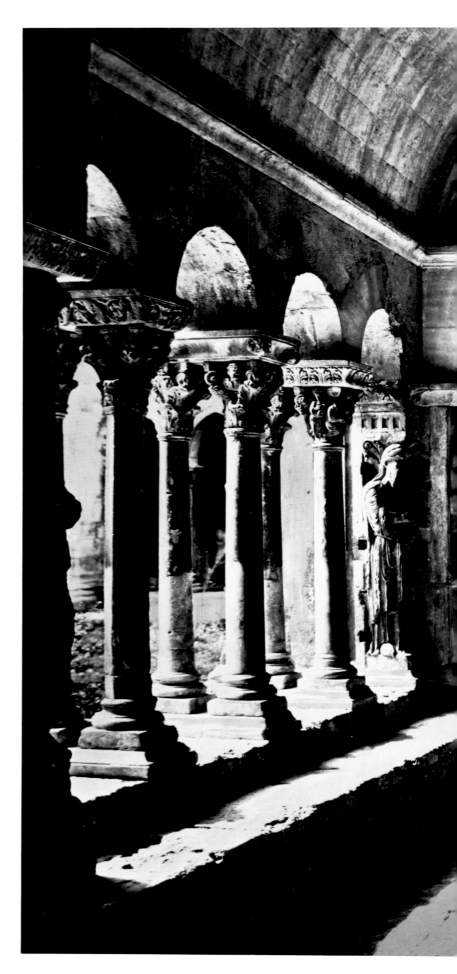

47. Édouard-Denis Baldus,
Cloister of Saint-Trophîme, Arles,
ca. 1861 (no. 76)

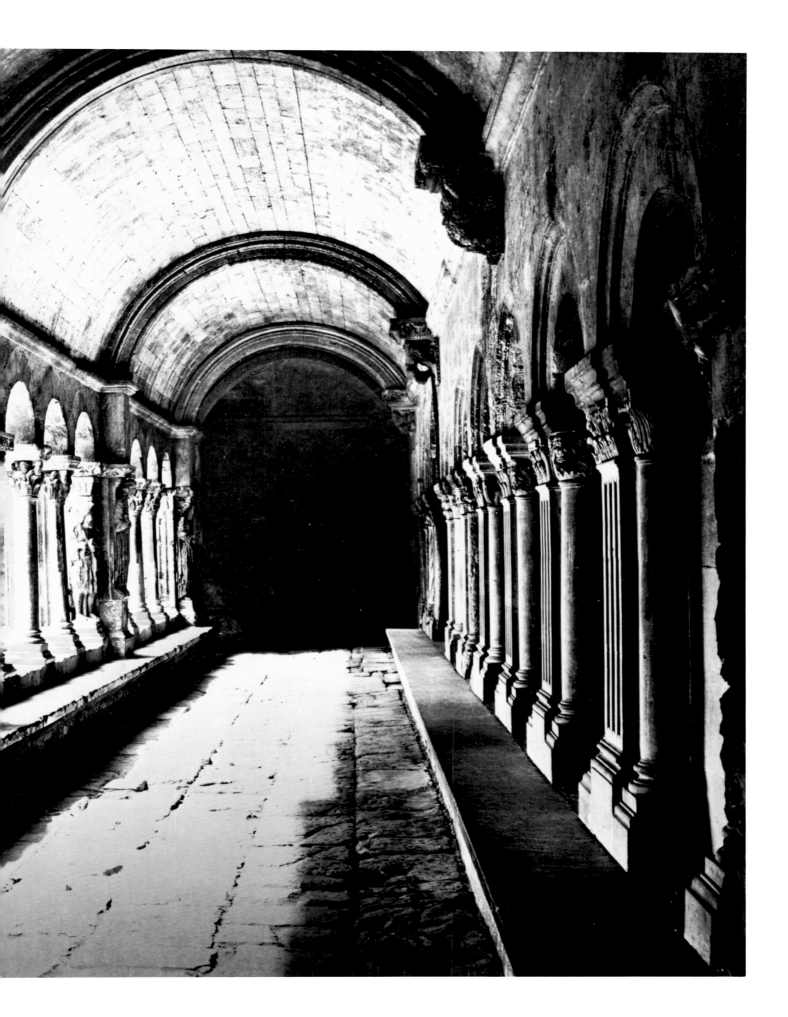

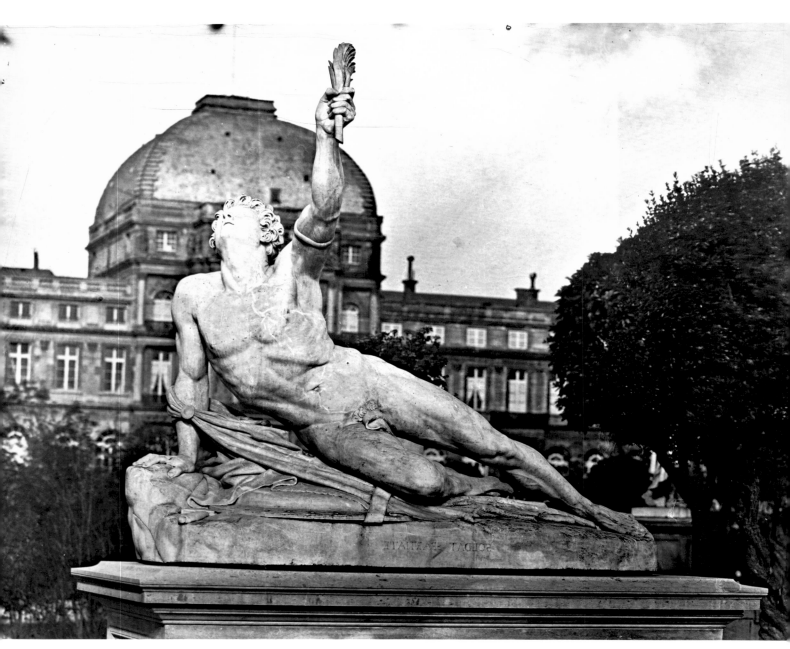

48. Charles Nègre, *Spartan Soldier*, 1859 (no. 73)

49. Henri-Victor Regnault, Gardens of Saint-Cloud, before 1855 (no. 53)

50. Édouard-Denis Baldus,
Group at the
Château de la Faloise,
1857 (no. 71)

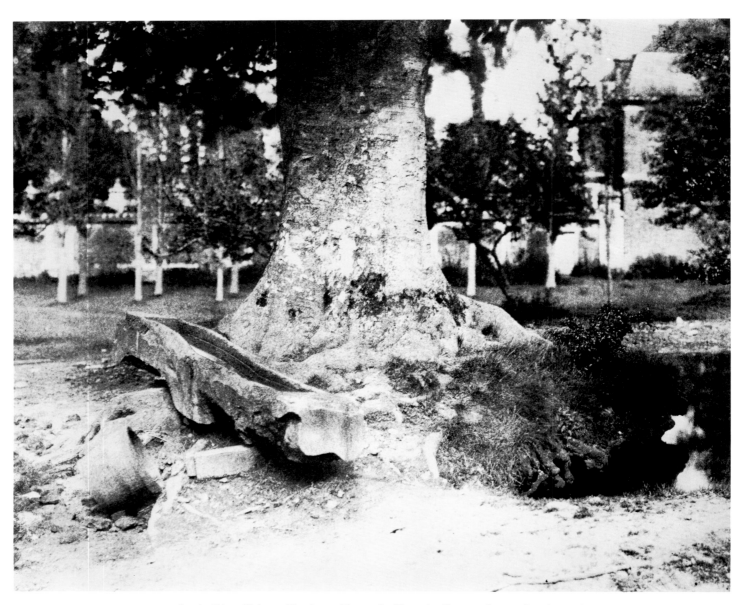

51. Louis-Rémy Robert, The Large Tree at La Verrerie, Romesnil, ca. 1852 (no. 52)

52. Adrien Tournachon, Self-Portrait, ca. 1855 (no. 59)

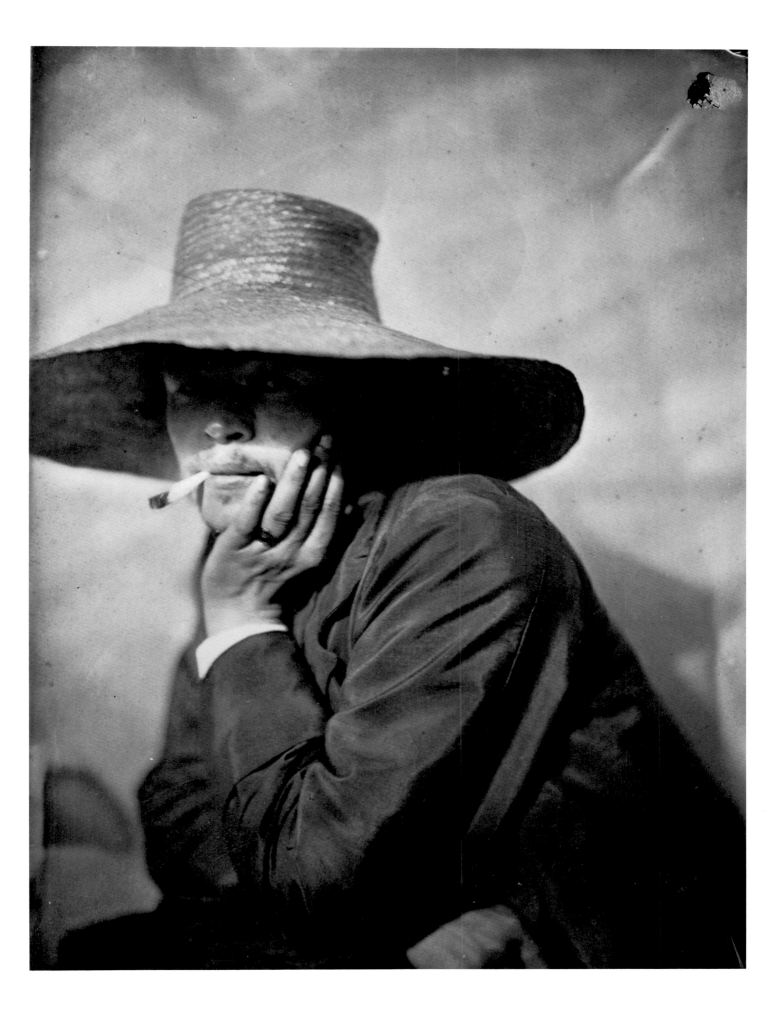

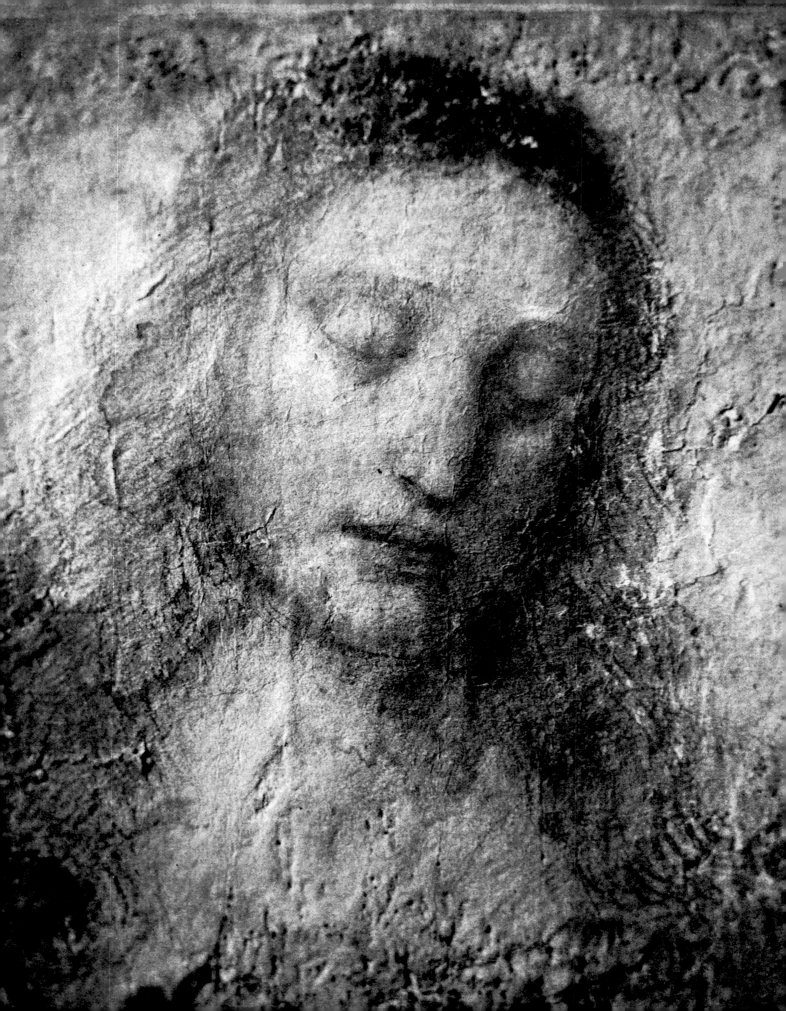

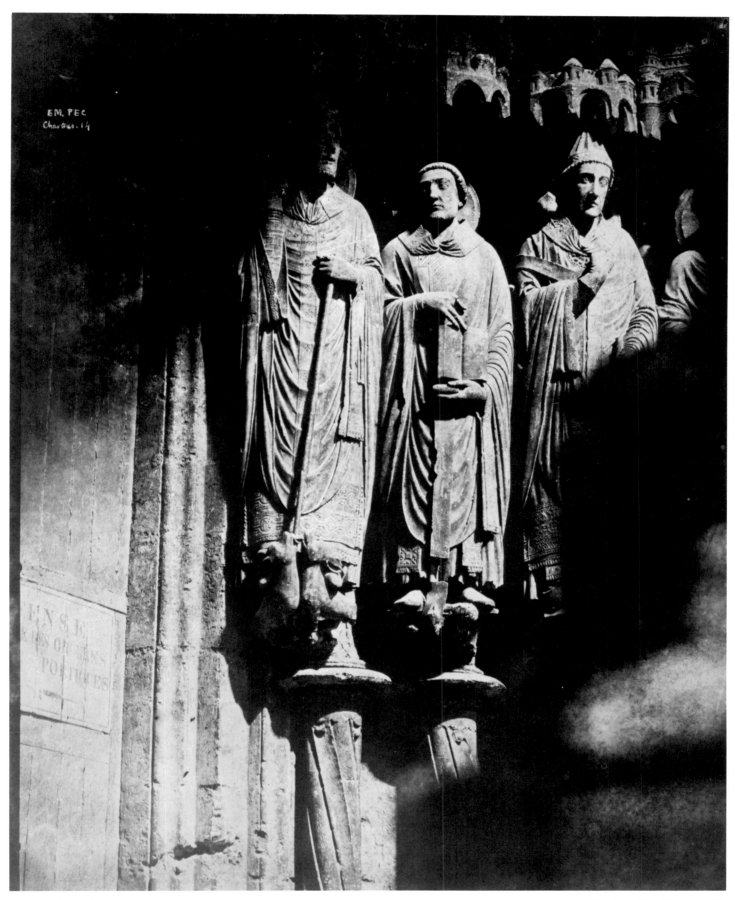

53. Léon Gérard,
Leonardo da Vinci, Drawing for Christ in "The Last Supper,"
1857–61 (no. 72)

54. Em. Pec (Em. Peccarère?),
Chartres,
1850–52 (no. 50)

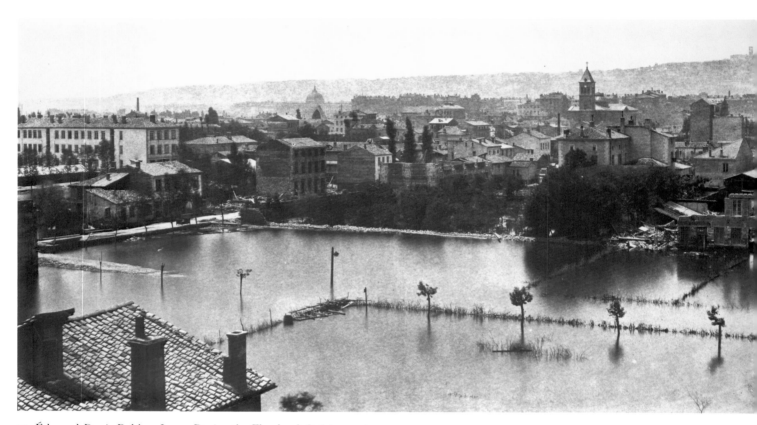

55. Édouard-Denis Baldus, Lyons During the Floods of 1856 (no. 70)

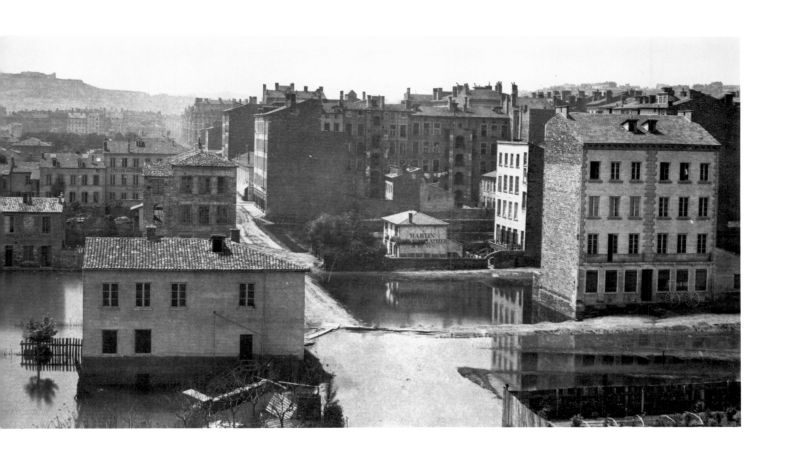

56. Louis-Pierre-Théophile Dubois de Nehaut, *Another Impossible Task*, 1854 (no. 67)

57. Louis-Pierre-Théophile Dubois de Nehaut, *Promenade in Malines*, 1854–56 (no. 68)

Overleaf: 58. Gustave Le Gray, Cavalry Maneuvers, Camp de Châlons, 1857 (no 65)

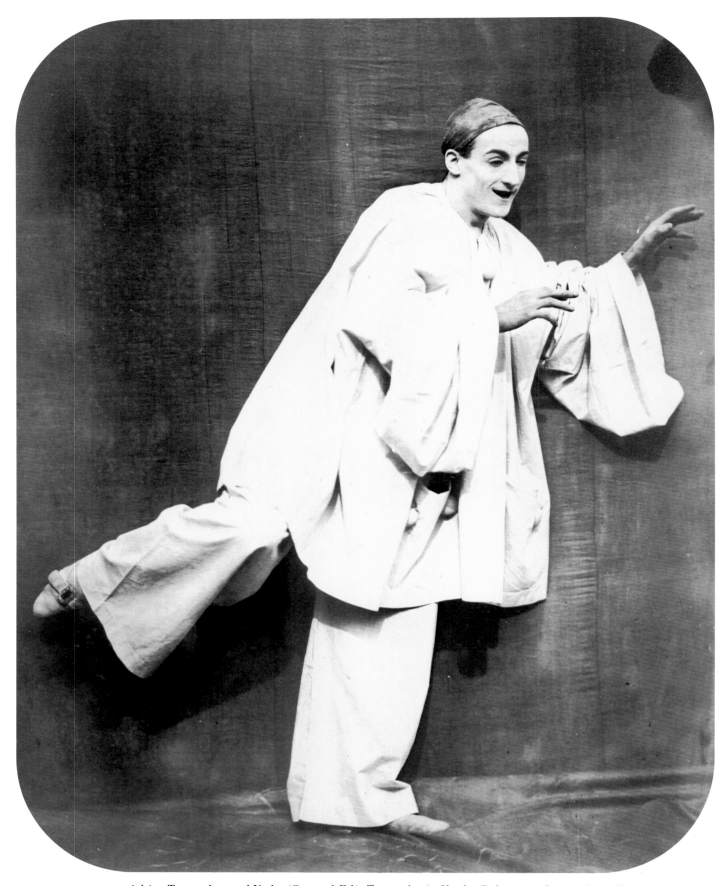

59. Adrien Tournachon and Nadar (Gaspard-Félix Tournachon), Charles Debureau, 1854–55 (no. 58)

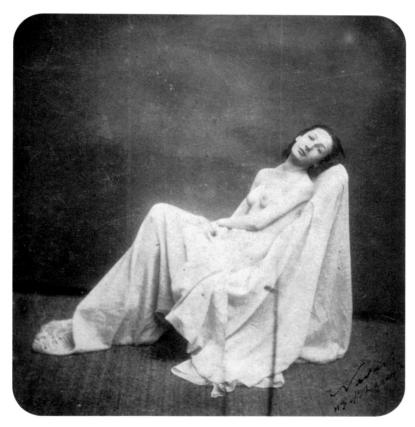

60. Nadar (Gaspard-Félix Tournachon),
Seated Model, Partially Draped, ca. 1856 (no. 56)

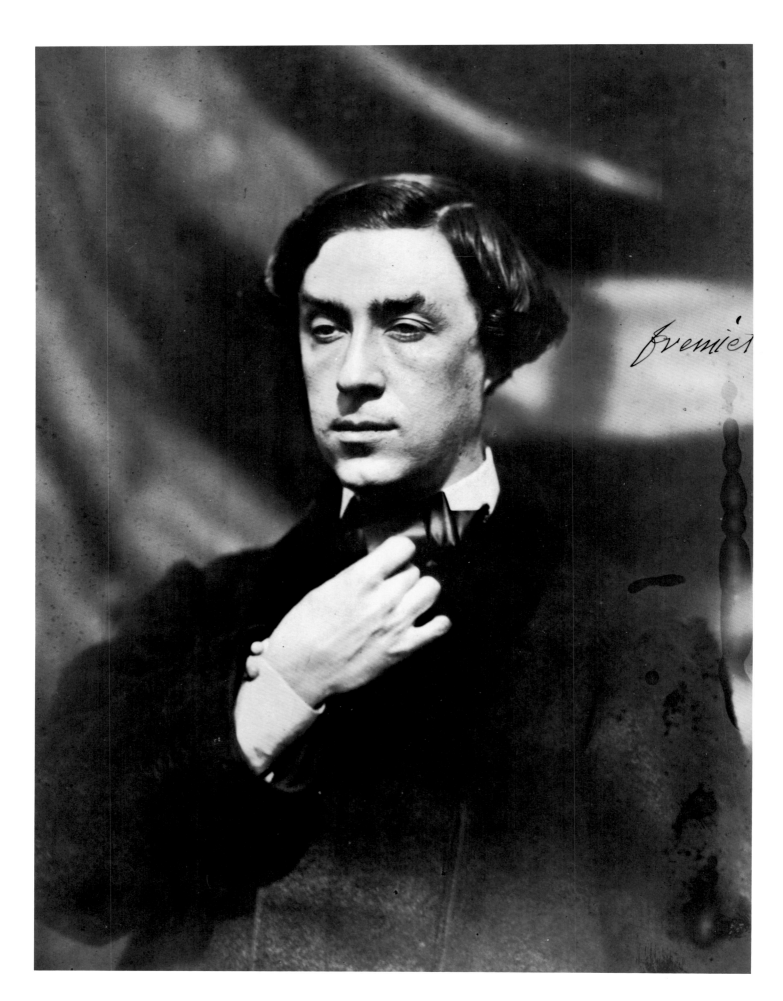

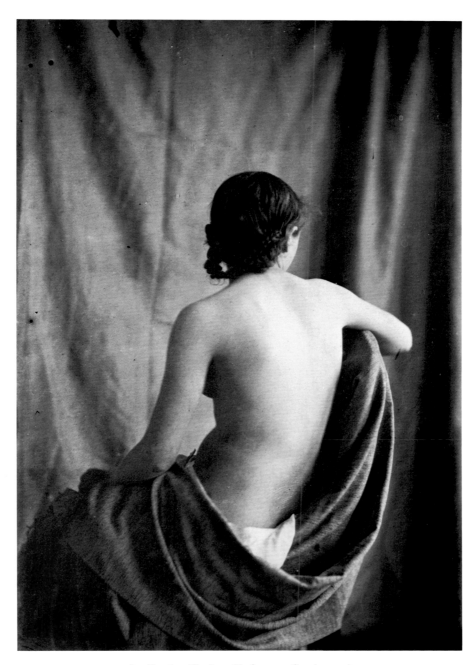

62. Eugène Durieu, Nude, ca. 1854 (no. 55)

61. Adrien Tournachon,
Emmanuel Frémiet,
1854–55 (no. 60)

63. Gustave Le Gray,
Forest of Fontainebleau,
ca. 1856 (no. 63)

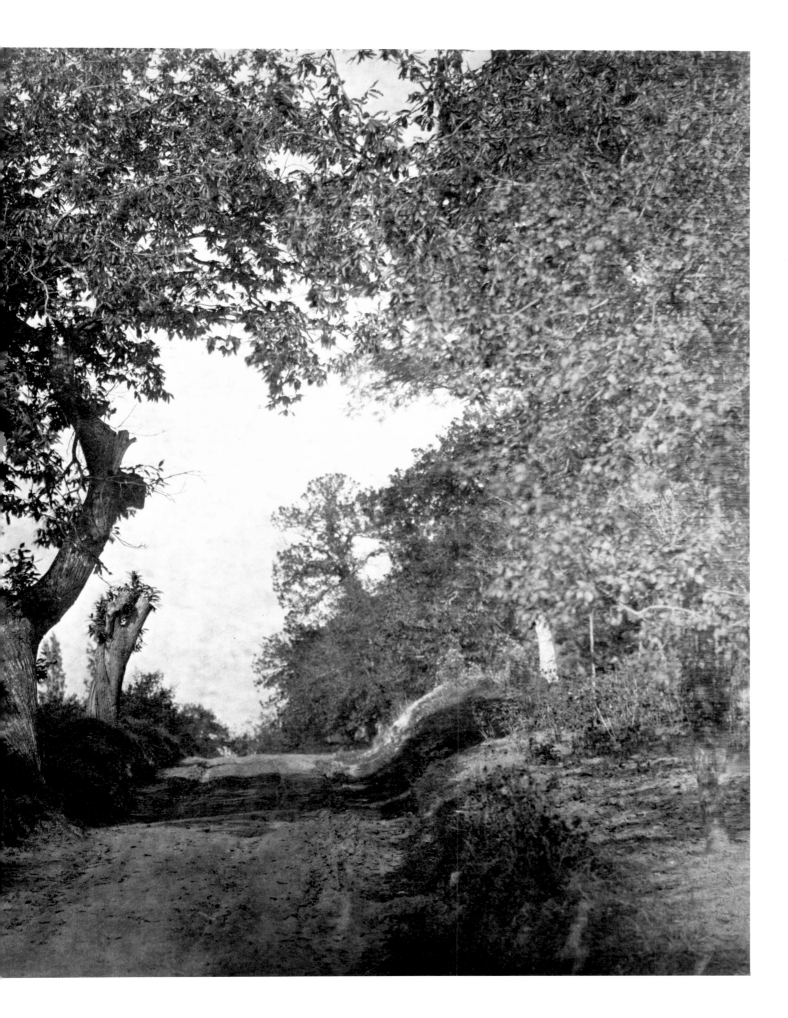

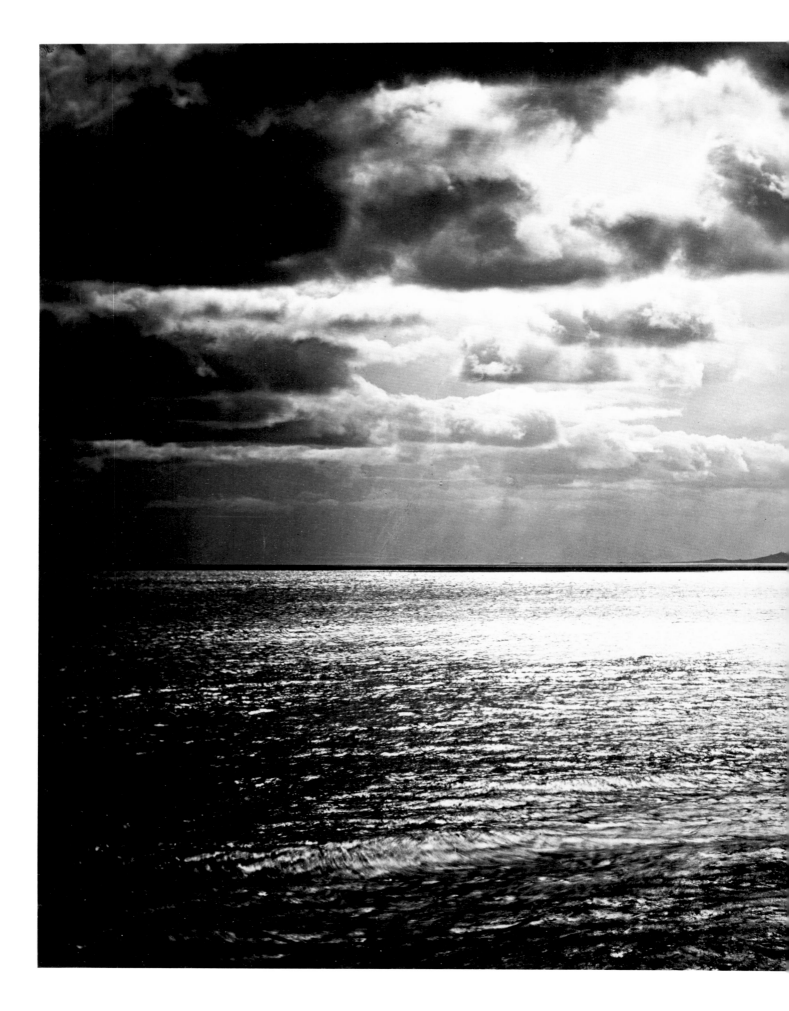

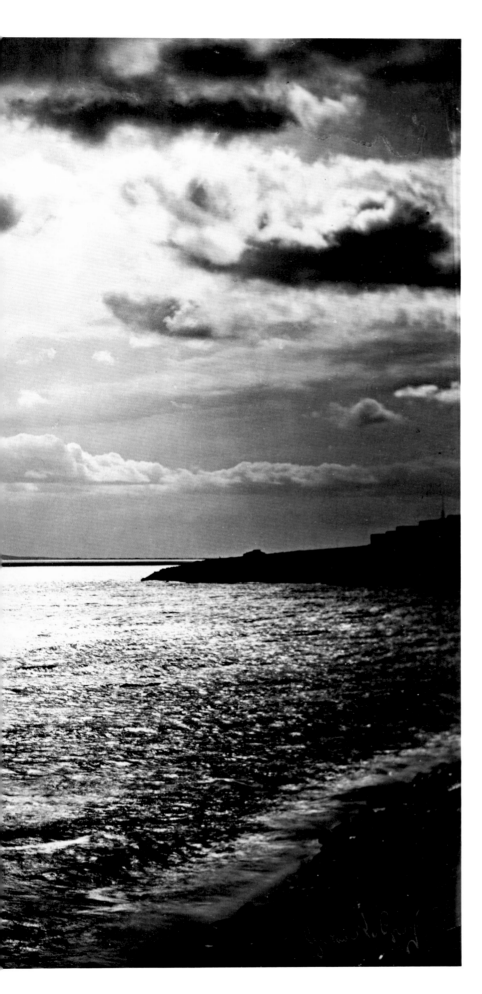

64. Gustave Le Gray,
Mediterranean Sea at Sète,
1856–59 (no. 64)

Extending
the Grand Tour

Since the seventeenth century the British had traveled the Continent, gradually institutionalizing the Grand Tour; the objective was for the gentleman to get to sunny Italy and to stay as long as possible soaking up classical culture before returning home via Switzerland and, usually, France. During the early years of the nineteenth century the Napoleonic wars prevented such travel and the "tourist," a word born of that moment, was obliged to travel farther afield—to Greece and Spain and other points around the Mediterranean Sea. The lure of the south and of Italy, so long the focus of northern Europeans, was not supplanted but extended, at first to the Mediterranean Basin, the homeland of the West. Then, when the ghostly frontiers of the Roman Empire had been retraced and the shores of the Mediterranean were resettled in the European imagination, the beckoning horizon was farther east, in the distant Orient.

As soon as photography was invented travelers equipped themselves with cameras to take on itineraries established by historical tradition and by the parameters of their country's influence. Perhaps the most prolific early touring photographer was George Bridges, who took instruction from Henry Talbot before embarking on a six-year voyage (1846–52) during which he made some seventeen hundred negatives. "The grand object of all travelling is to see the Shores of the Mediterranean," Bridges wrote. "On these Shores were the four great Empires of the World, the Assyrian, the Persian, the Grecian, and the Roman. All our Religion, almost all our Law, almost all our Arts, almost all that sets us above savages, has come to us from the Shores of the Mediterranean."[1] He neglected to mention that his travel plans were arranged to coincide with the voyages of his son, a British sailor on a tour of duty in the Mediterranean. Thus, Bridges left England under the wing of her Navy to reclaim with his

65. Maxime Du Camp, *Westernmost Colossus of the Temple of Re, Abu Simbel*, 1850 (no. 83)

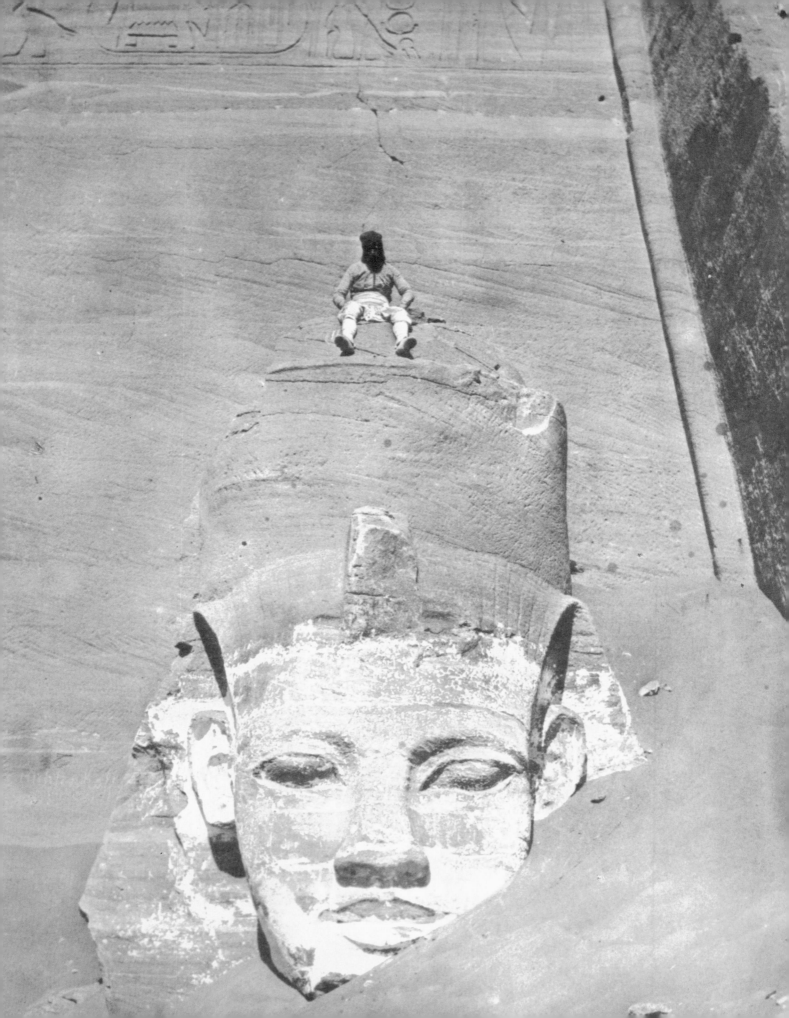

camera the ancient cradle of her culture. This context flavored his views; in a photograph made on the Acropolis in 1848, Bridges shows us the recently restored temple of Athena Nike with a British sailor, probably his son William, lounging proprietarily on the steps.

If a certain imperiousness is often expressed in their pictures, the early traveling photographers were not animated by imperialistic designs but by conquest of another sort. Like Byron, Goethe, Chateaubriand, Lamartine, and Nerval, they sought to appropriate the foreign and exotic as antidotes to their highly civilized lives. Byron's "land of lost gods," Lamartine's "homeland of [the] imagination," and Nerval's "country of dreams and illusion" were all the same place—a visionary recess away from familiar Europe, from strictures on behavior, cold climates, and busy enterprise. This remote locus floated in "a great peacefulness of light," Ruskin wrote, its many countries "laid like pieces of a golden pavement into the sea-blue."[2]

Part of the fantasy was release into a more sensual realm, in the lap of which lolled the Mediterranean woman, imagined to be inherently sensual and caressed by the sun. The delicious languour of this wondrous creature is embodied in Giacomo Caneva's photograph of a recumbent model. Another pleasure was to fold up the map of the present and to wander into a mazy past crowded with overlapping myths and memories, the vestiges of lost cultures. The deep satisfaction of the storied accumulation of superjacent epochs is surely the subject of Robert Macpherson's view of the Theater of Marcellus, just as his photograph of the Cloaca Maxima concerns not Roman plumbing but the persistence of the grotto as a garden retreat for overcivilized souls.

Suggestive, highly colored romantic dreams are not depicted in most of the photographs made around the Mediterranean in the 1850s, for such notions were primarily the stimulus to travel, usually disappointed by the reality of the visit. Rather, the photographers' typical terrain was a vast expanse of time and space—a silent, immutable continuum stretching out under the sun, down beneath the sand, and back to the very origins of human civilization. Napoleon invoked the invisible perspective for French troops standing on the verge of the Egyptian desert in 1798 when he said: "Forty centuries look down on you from the top of the Pyramids."[3]

Interface between Africa and Europe and between Europe and Asia, and home of one of the most ancient Mediterranean cultures, Egypt had been annexed by all the major empires. Although Napoleon dreamed of repeating Alexander's feat, he failed to conquer Egypt; his incursion, however, brought

70

72

74

73

86

the country directly within the sphere of European knowledge, initially through the team of savants he took on his campaign. The detailed results of their studies were published in twenty-three huge volumes lavishly illustrated with engravings, the *Description de l'Égypte* (1809–28). And the Société Asiatique, founded in 1822, made the investigation of Egyptian hieroglyphics, art, and archaeology a major preoccupation of French learning for the rest of the century.

The conquest of Egypt and the Near East through knowledge was the formative rationale for many of the photographs included here. The engineer Félix Teynard set out to update the *Description* with photographs, while Auguste Salzmann intended his pictures to settle a dispute concerning the Greek or Judaic origin of specific artifacts in Jerusalem (no. 90). Louis de Clercq began *66* his photographic tour of the Mediterranean to help illustrate an archaeologist *78* friend's study of the Crusader castles (no. 91), and Maxime Du Camp's expedition to Egypt and the Near East in 1849–51 enjoyed direct government patronage.

The journalist Du Camp first traveled to Egypt in 1844, realizing an adolescent dream born of a conversation with one of Napoleon's translators. Upon his return Du Camp persuaded his friend Gustave Flaubert to accompany him on a second visit and wrangled an assignment from the Ministry of Agriculture and Commerce for the young writer. This Flaubert merely regarded as a diplomatic passport without any bearing whatsoever on his essentially ruminative activities. Du Camp, having studied photography with Gustave Le Gray, secured a commission from the Ministry of Public Education to gather on his travels, "with the aid of this marvellous means of reproduction, views of monuments and copies of inscriptions."[4] The brief went on to specify that the government was interested neither in scattered sketches typical of those made by tourists nor in seductive photographic effects, but rather in faithful documents useful for study.

The difference between Flaubert's and Du Camp's response to Egypt is instructive, for it reveals the distinction between inspiration and factual accountability. In Egypt Flaubert dressed in a long loose shirt, and with his head shaved and wrapped in a tarboosh (no. 84), he soaked up impressions of "the old Orient, land of religions and flowing robes. . . . I live like a plant, suffusing myself with sun and light, with colors and fresh air."[5] Du Camp, for his part, worked at accomplishing his commission. His photographs essentially conform to the official line, forgoing the picturesque and impressionistic for the frontal, literal, and readily comprehensible. The most famous of his images is of the head of one of the rock-hewn effigies of Ramesses II beside the Nile at *65*

Abu Simbel. Swallowed to the chin by a mountain of sand, the colossus survives time; what is more, this still-potent past gazing on the present is as little affected by the human in its headdress as the eons would be by a blink in time. And yet Du Camp and his Corsican assistant, Sassetti, together representing contemporary Europe, are in the victor's seat, jauntily dominating king and kingdom for the camera and for its extended public. In 1852 one hundred twenty-five of Du Camp's photographs were published in the first commercially distributed volumes in France illustrated with original photographs.

69 Félix Teynard and John Beasley Greene, each working on his own, produced photographs that further advanced Orientalist studies, but however conscientious they may have been to make faithful documents, they frequently framed views that seem decidedly eccentric. Greene was a serious Egyptologist. At Medinet Habou he made papier-mâché impressions of inscriptions he had unearthed, which he also photographed, waiting patiently for the feeble light in the temple's recessed arcades to sufficiently expose his negatives. As the product of a student of archaeology, how, then, do we explain a photograph *68* such as *Dakkeh*, in which a deep, jagged shadow wholly obscures the bottom half of the temple wall and threatens to engulf the figure of the pharaoh? As Greene did not crop or minimize the shadow, he presumably chose to make the picture as it is. What he shows us is the transit of the sun on the face of an ancient narrative, the shadow of a daily drama tracing time itself in an image that is less an archaeologist's notation than a poetic evocation of the demise of a civilization.

 While the photographers' primary intentions were to unveil early civilizations, their photographs met expectations only halfway. Many of them actually unsettled the accepted accounts. What had been classified and measured and noted, what had been drawn in scrupulously detailed archaeological reconstructions—what was, in sum, agreed to be *known* about the sites—was now replaced with evidence that was contingent, fragmentary, and unquantifiable. Although these photographs constituted a growing museum without walls, the supposedly faithful "documents" that composed it were rife with subjective impressions and inflections of European culture—so much so that it would be fair to say that the archaeology and geography of the photographers' imaginations had the upper hand on objective science.

 The attitudes infused in the pictures have generally eluded detection because the best of these photographs are composed with an exquisite lapidary authority and because the age and monumentality of their subjects are easily

confused with an unimpeachably august truth. But when the photographers left the Mediterranean for regions farther east, their Eurocentrism could no longer be disguised by the near-familiar, nor so comfortably reside in the architectonic and the ancient. And as they moved out of generalized spheres of cultural influence and into main currents of Western political ambition that were more blatantly ethnocentric and dominative, the attitudes embedded in their photographs became more obvious.

Roger Fenton's photographic campaign during the Crimean War is an interesting case in point. One photograph (no. 98) shows Balaklava harbor, a beachhead where supplies were unloaded from British ships, and the partially completed railroad that would supply the army several miles inland. Another photograph (no. 99) shows a sweep of trackless, arid land surveyed by military officers—a terrain hardly desirable in itself but fiercely contested in the struggle of the French and English to defeat the Russians in their effort to gain control of the Black Sea and to extend their influence in the Middle East. Like the other photographs in Fenton's series, these tell very little about the Crimea, but they are eloquent of the dirty process and the inspiring vision of extending Western hegemony in the East.

Enraptured with the notion of material progress and capitalist enterprise, Western powers invested commerce with a divine right which justified their forceful incursions into other countries. The initial, partial conquest of India by the British was made by the East India Company, a mercantile venture. Many of the impressive photographs made in India in the 1850s were taken by men who worked for the company army. Notable among them were Dr. John Murray and Captain Linneaus Tripe (no. 103), whose large views of Indian art and architecture were made to enlighten the West about the culture they were colonizing. When people appear in these photographs they do so in anonymity, for while India's magnificent past enriched the empire, its contemporary society was judged wanting by Western standards of material success and industrial mastery.

In 1857, when British-trained Indian soldiers rose up in the first large Asian revolt against the West, the British, who fully believed in their civilizing mission, regarded the uprising as a mutiny. A sympathetic portrait of Lord Canning, the governor general who put down the rebellion and became the first viceroy of India in 1858, shows him fully invested in his role as an entitled "Lord of Humanity." By contrast, the shocking pictures of the slaughtered Chinese defenders of Beijing in the second of Britain's Opium Wars to secure

80
81

Chinese trade were the first photographs to open Western eyes to the horrific other side of imperialism.

The painstaking and costly practice of large-scale artistic photography by amateurs such as Murray and professionals such as Tripe reached its zenith in the late 1850s. The demise of this first flowering of travel photography coincided not only with shifts in imperialist economics and politics,[6] but also with the rise of commercial photographic firms, which, in turn, were threatened by tourists armed with cameras of their own. By 1870, Samuel Bourne, the best commercial photographer in India, saw that the artist's notion of quality—of the superbly crafted singular view—was being rapidly replaced by the public's pursuit of quantity. But, protested Bourne, "*One* good large picture that can be framed and hung up in a room is worth a hundred little bits pasted in a scrap book."[7]

Instead of publishing impressive tomes of large views, as Du Camp, Teynard, Greene, and De Clercq had done, the commercial photographer made pictures that were smaller in scale and easier to handle, and left the choice and order of the images up to the tourist. In the last quarter of the nineteenth century these firms rarely explored new lands, but rather made it their business to package the idea of "otherness." Though rarely imbued with great artistic merit, the photographs of picturesque sites pasted in travelers' albums by the thousands nevertheless made the very notion of "otherness" familiar, ultimately bringing exotic landscapes and faces into a common patrimony.

By the end of the century the boundaries of the West had merged with those of other continents and what had been truly foreign was absorbed. One of the most salient registers of this continuing condition is the vast photographic encyclopedia of travel that subjects every monument, landscape, and people to its curious gaze and offers the armchair traveler a vicarious tour of the memory theater of the world.

Maria Morris Hambourg

66. Louis de Clercq, *Entrance Portal, Dendera*, 1860 (no. 92)

67. John Beasley Greene,
The Nile,
1853–54 (no. 88)

68. John Beasley Greene, *Dakkeh*, 1853–54 (no. 89)

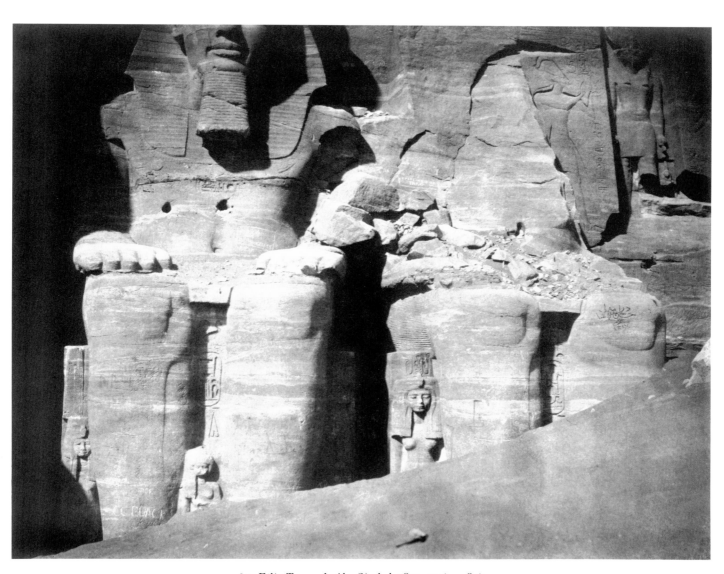

69. Félix Teynard, *Abu Simbel*, 1851–52 (no. 85)

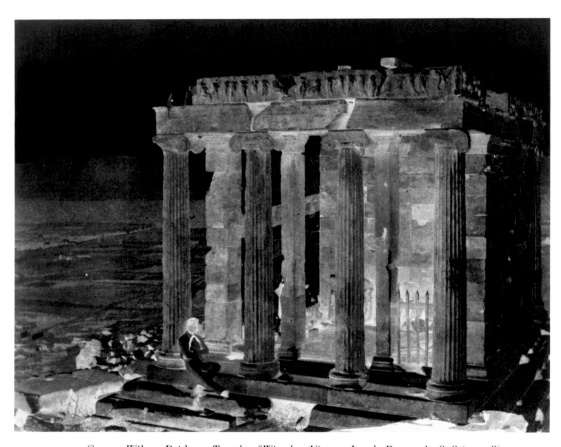

70. George Wilson Bridges, *Temple of Wingless Victory, Lately Restored*, 1848 (no. 78)

71. Anonymous,
The Calf-Bearer and the Kritios Boy
Shortly After Exhumation on the Acropolis,
ca. 1865 (no. 79)

72. Giacomo Caneva,
Carlotta Cortinino,
ca. 1852 (no. 80)

73. Robert Macpherson, *Cloaca Maxima*, 1858 or earlier (no. 81)

74. Robert Macpherson,
The Theater of Marcellus, from the Piazza Montanara,
1858 or earlier (no. 82)

75. Charles Clifford,
*Courtyard of the House Known
as Los Infantes, Zaragoza,*
1860 (no. 95)

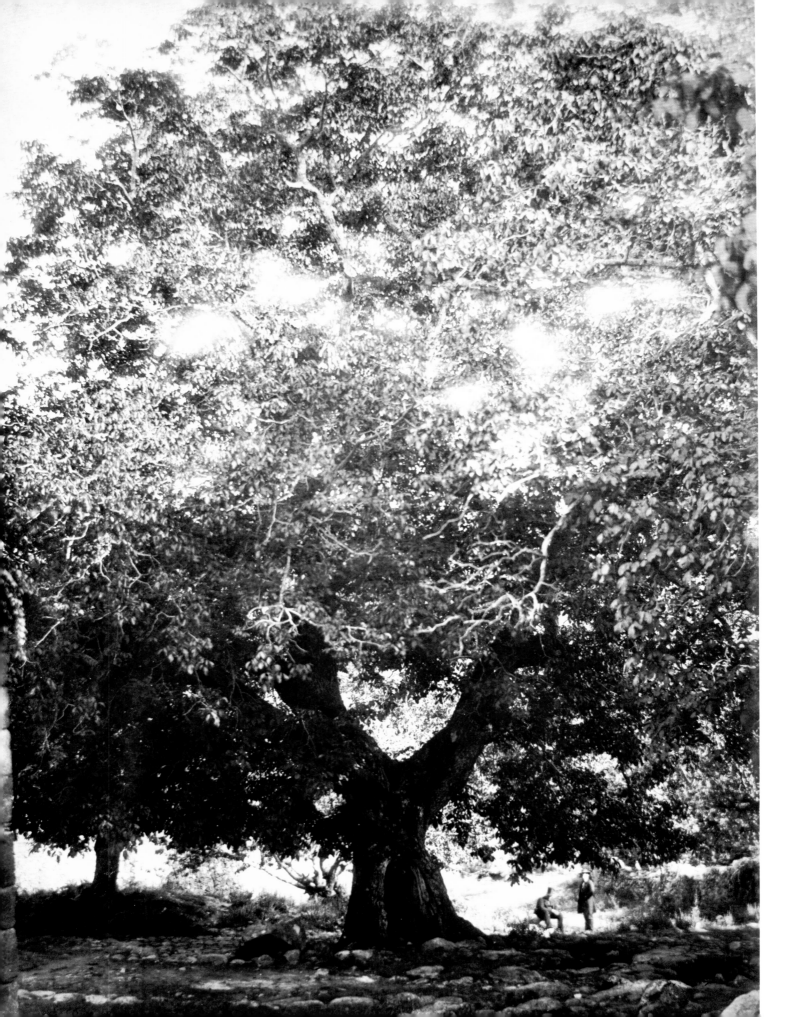

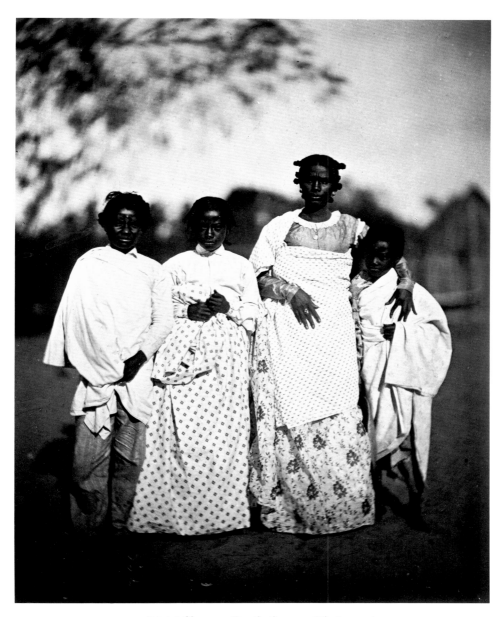

77. Désiré Charnay, Family Group, 1863 (no. III)

76. Charles Clifford,
The Walnut Tree of Emperor Charles V, Yuste,
1858 (no. 96)

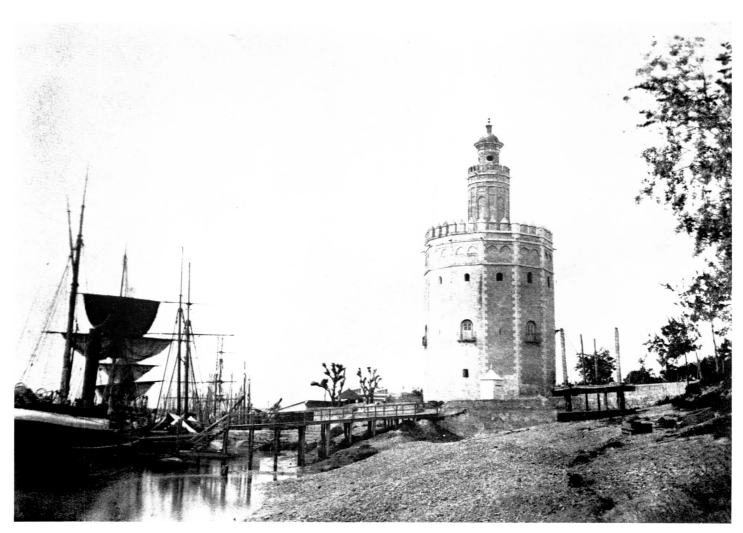

78. Louis de Clercq, *The Tower of Gold, Seville*, 1860 (no. 93)

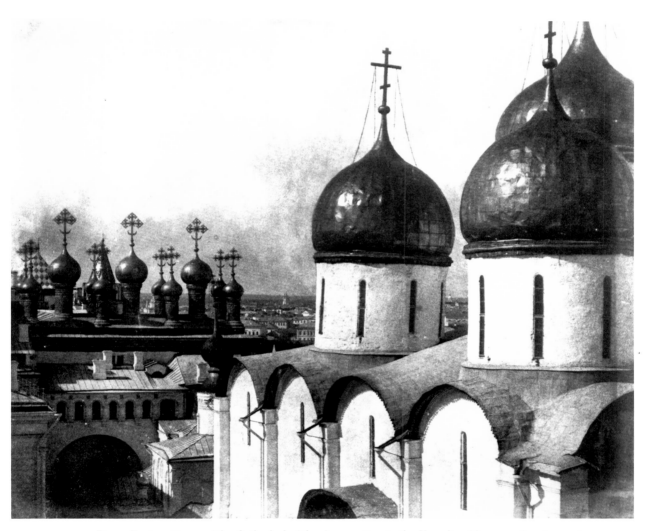

79. Roger Fenton, Dome of the Cathedral of the Assumption in the Kremlin, Moscow, 1852 (no. 97)

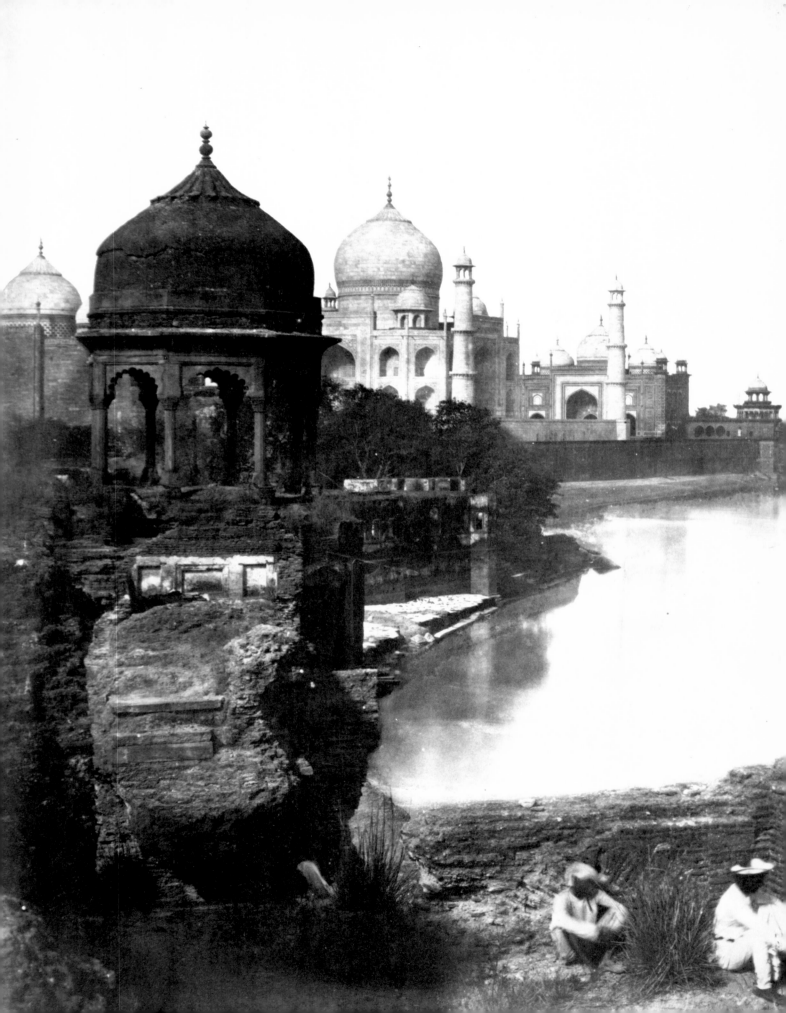

80. John Murray,
*The Taj Mahal from
the Bank of the River, Agra,*
ca. 1858 (no. 102)

109

81. John Murray,
Main Street at Agra,
1856–57 (no. 101)

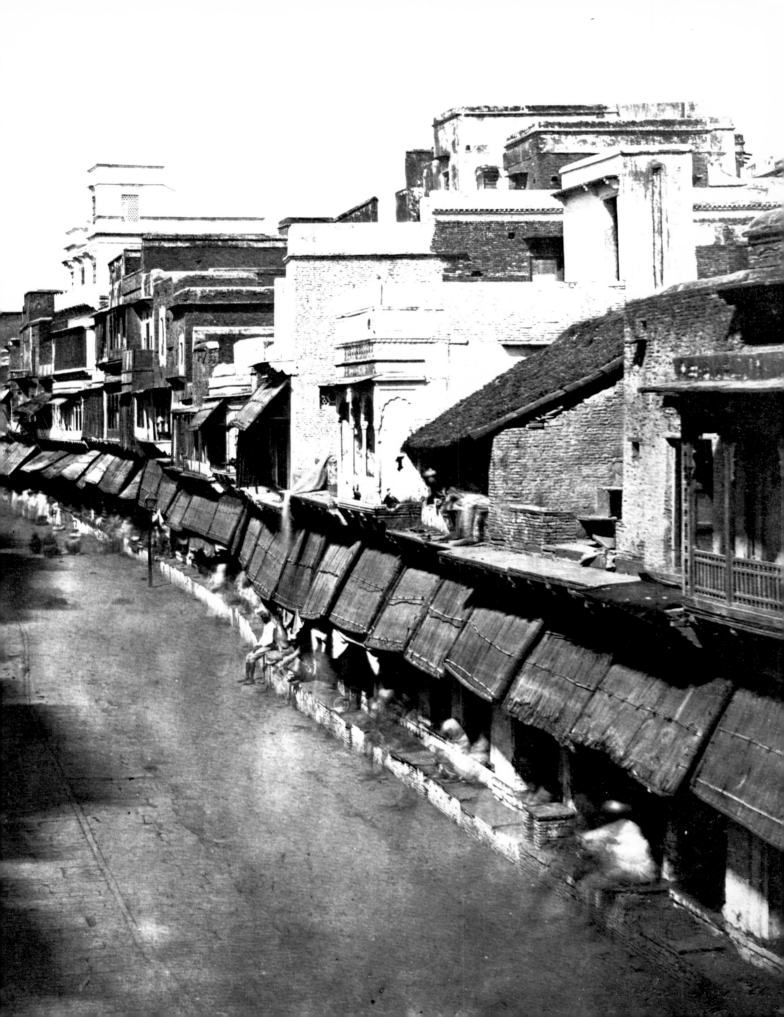

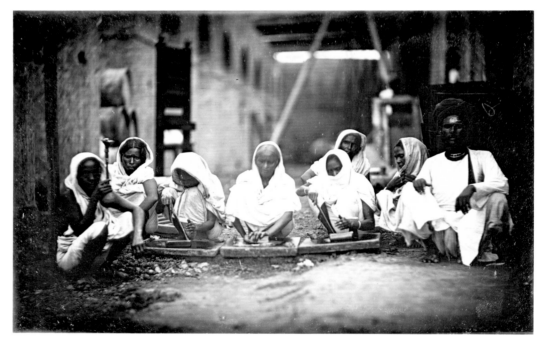

82. Anonymous, Women Grinding Paint, Calcutta, ca. 1845 (no. 100)

83. Anonymous, *The Earl Canning, Barnes Court, Simla*, 1861 (no. 104)

84. Felice Beato,
After the Capture of the Taku Forts,
1860 (no. 108)

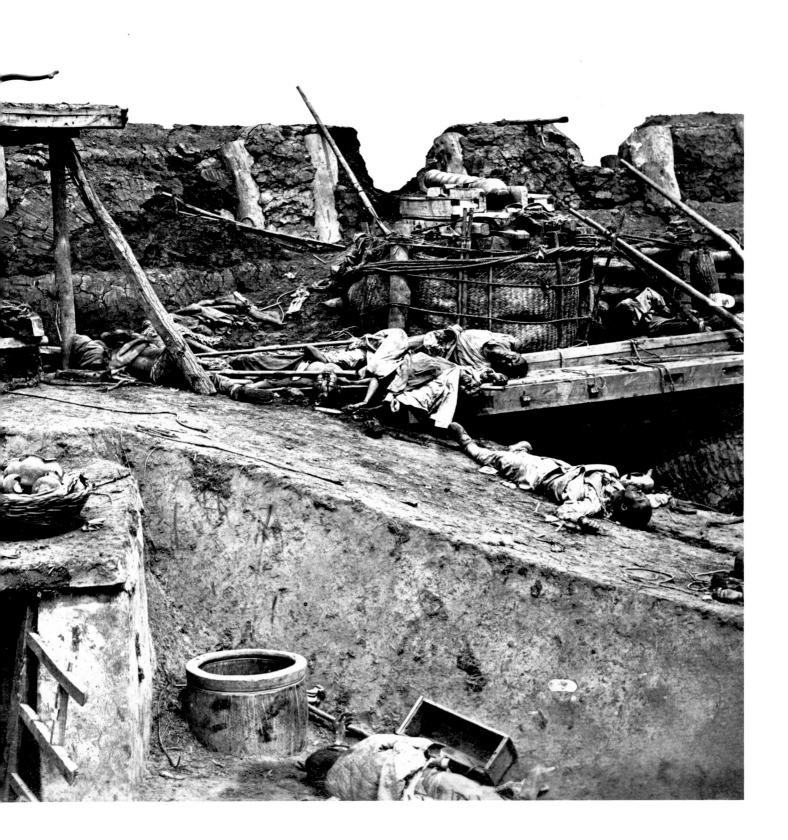

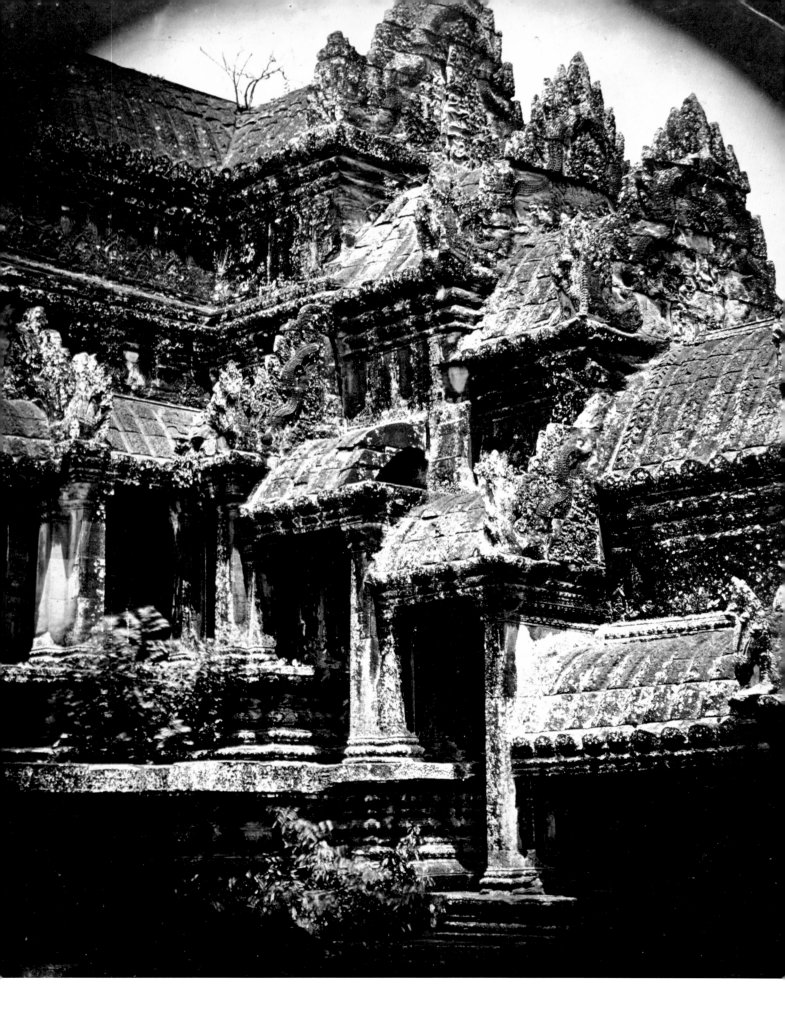

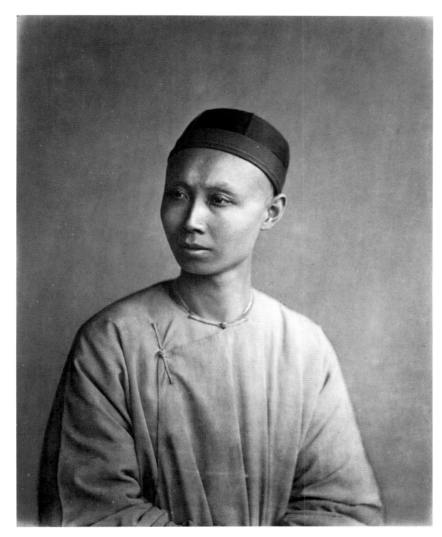

86. Anonymous, *Interpreter for the Austro-Hungarian Legation*, 1870s (no. 109b)

85. M. Gsell,
Angkor Wat, Cambodia,
1866 (no. 107)

America: An Insistent Present

The United States of America was barely more than fifty years old when photography was invented. By the standards of the Old World civilization from which it had seceded, the young country had no past—no knights, no kings, no cathedrals—and whatever resembled ancient legacy Americans were quick to repudiate. They preferred to see history as a proposition of the future: "The divine gift is not the old," Emerson wrote, "but the new."[1] In place of tradition Americans embraced nature and their own vigorous progress in taming and subjecting it to their Manifest Destiny, a national doctrine of westward expansion advancing the known on the unknown, the civilized on the aboriginal, and spanning sea to shining sea.

The progress and expansion were products of a rampant, unrestrained growth predicated upon seemingly inexhaustible natural resources, especially land, wood, and waterpower, and inexpensive or enslaved labor. In the first half of the century the country's population and physical size quadrupled, and the industrial output of the Northeast almost caught up with that of Great Britain. By 1860 the country was crisscrossed with 30,000 miles of railroad—more track than existed in the rest of the world combined.[2] A year later the revolutionary telegraph, invented in 1837, spanned the continent, providing instantaneous communication between East and West coasts.

122

Photography entered the country by virtue of the telegraph and spread quite as quickly. When the inventor of telegraphy, Samuel F. B. Morse, went to Paris in 1839 to promote his invention, he met Louis Daguerre and was witness to *his* new invention. Remembering his own failure decades earlier to fix the image of the camera obscura, Morse was highly enthusiastic and within weeks arranged to have Daguerre elected an honorary member of the National Acad-

emy of Design. As soon as Daguerre's manual became available in New York, Morse began experimenting with the process in the hope of using the "faultless facsimiles" as models for his portrait paintings. He also recognized that the invention, once perfected, would be of broader scope, and he disseminated his knowledge by personally instructing the first generation of American daguerreotypists in the new art, notably Mathew Brady and Albert Southworth.

As in France, the daguerreotype flourished in the United States as a form of popular portraiture. The passionate regard for the keepsake, which lodged near the heart of the American love of the daguerreotype, encouraged the increase of studios in the cities and spurred itinerant practitioners to travel the rural roads, providing even far-flung country folk with their permanent mirror image. Inserted into satin- or velvet-lined leather cases originally designed for miniature paintings, the silvery daguerreotype portraits were jewels of memory, easily portable in their intimate little coffins.

Marveling, as Morse wrote, in "the exquisite minuteness of the delineation" and in the daguerreotype's "identity of aspect with the thing represented," as Edgar Allan Poe described it, Americans saw the clear, plainspoken evidence in these images as tantamount to truth.[3] And not only objective truth; they also recognized the process as a form of revelation that mirrored an inner truth. In this sense daguerreotypy was not unlike hypnotism, spiritism, alchemy, and other forms of black magic that mysteriously transmuted materials, transmitted emanations, and mesmerized attention.[4] In capturing in both the outer likeness and the inner essence that which was elusive and transcendent, the daguerreotype was also like art.

Thus uniting scientific accuracy, impartial truth, magical revelation, and transcendental expression, the daguerreotype was peculiarly appropriate to a society focused on the present; for the present was a democratic flux, a congeries of personalities, potentials, and consciousnesses that anyone with a camera could intercept and fix—each daguerreotype a mirror of preternatural fidelity, each specific moment immutable, each individual a worthy representative of the age. In a period of rapid change and movement, the daguerreotype portrait attested to one's existence with a demonstrable permanence; this small, neat package of leather and metal, this *graspable* thing, was proof that there had been a moment when, in the words of Thoreau, "for the least point of time, we cease to oscillate, and coincide in rest by as fine a point as a star pierces the firmament."[5]

In the mid-1850s, when collodion-on-glass negatives enabled count-

less paper prints to be made from a single exposure, daguerreotypy, which produced only unique images, began to lose popularity. Paper photography removed most of the intimacy and mystery associated with daguerreotypes, and in their place offered a collective familiarity with distant events and places and many famous personalities. Against this flood of visual imagery and the industry that supported it emerged a shrewd artist who contradicted the popularization of photography even as he took advantage of it.

Mathew Brady became the most celebrated American photographer of the nineteenth century by virtue of his artistic standards and canny enterprise, and because of his belief that photographic portraits were literally imprints of character. After he had photographed the "morally insane" at Sing Sing prison as part of a study of personality disorders, Brady conversely saw that portraits of those who had attained social and intellectual prominence might inspire the viewer to emulate high moral character. He turned the anterooms of his studios into galleries of illustrious personages and invited the public to study their *90* dignified portraits. Counteracting the tawdriness of the freaks and curiosities on view in P. T. Barnum's American Museum across the street and the ambiguity of the characters one chanced to meet on the sidewalk, at "Brady's of Broadway" the viewer was offered the visible shape of the noble soul.

Brady was hardly alone in believing that innate character was detectable in the shape of the skull and in facial expression; those who studied phrenology and physiology were scouring the same physical terrain. Yet the recognition of character was becoming ever more difficult as the population grew and changed. Three million immigrants arrived in America between 1845 and 1855, and during the next two decades the numbers increased sixfold; these waves of unknown people naturally complicated societal strata. In addition, the democratic ideal of equality and the mass production of clothing made it possible for a person of ill-will to dress like a citizen of standing, making it increasingly problematic to winnow the good from the bad.

Although photography further conflated the confidence man and the man of true confidence,[6] much trust was placed in the medium as a faithful *96* witness. In a fascinating album of rogues created in 1860 by an exiled Hungarian named Samuel Szabó, murderers, thieves, abortionists, and the like appear in nicely composed oval portraits. Their proper attire and inscrutable expressions tell less of their wonts than Szabó's brief notes. Indeed, the top-hatted pickpocket Little Hucks looks far less villainous than the grim, hatchet-faced man in the Brady studio portrait, who turns out to be the distinguished Senator Lane *95*

from Kansas. Despite such confusions photographs began to serve police intelligence from this time on, a need sharpened by an immediate civil emergency.

On April 15, 1861, President Lincoln called up seventy-five thousand militiamen to put down an insurrection of Southern states. Brady secured permission from Lincoln to follow the troops in what was expected to be a short and glorious war; he saw only the first engagement, however, and lost his wagons and equipment in the tumult of defeat. Deciding to forgo further action himself, Brady instead financed a corps of field photographers who, together with those employed by the Union military command and by Alexander Gardner, made the first extended photographic coverage of a war.

The terrible contest proceeded erratically; just as the soldiers learned to fight this war in the field, so the photographers improvised their reports. Because the battlefields were too chaotic and dangerous for the painstaking wet-plate procedures to be carried out, photographers could depict only strategic sites (nos. 136, 137), camp scenes, preparations for or retreat from action, and, on rare occasions, the grisly aftermath of battle. The commemorative photographs of Wilderness Battlefield are an interesting exception, for even though taken months after the battle, they strangely evoke its appalling conditions: a dark (solarized) sky broods over ravaged trees and human skeletons, recapturing the choking darkness of the tangled forest where, in the dense smoke of artillery and forest fires, men fought—virtually blind—to the death.

The causes of wars are more difficult to depict than their casualties, but a number of photographs that relate to the abolition of slavery do provide evidence of the central issue that drove the Confederacy to secede from the Union, that rallied the North around Lincoln, and that prolonged the bitter conflict for four years. Lincoln was not initially an abolitionist, but he recognized that "a house divided against itself cannot stand," and for this political reason as much as for his belief in the rights of man, he took his stand for the Union and against slavery. Photographs of a group of emancipated slaves and of an unidentified African-American youth eloquently confront the rationale for the existence of the "peculiar institution." An equally remarkable portrait taken of Lincoln just after his nomination reveals the intense intellect and tenacious will of a grave man painfully conscious of the consequences of his decisions.

Among the six hundred thousand casualties of the war must be counted Lincoln himself, assassinated by John Wilkes Booth and a conspiracy of Southerners. Following this grievous end the tragedies of the survivors and the memory of those who had perished persisted in preventing the wounds from

healing. So, too, did the humiliated men of the South, who, unable to swallow either emancipation or defeat, cloaked themselves as spirits of the Confederate dead and brutalized the freed slaves. *102*

If the Civil War was the great test of the young republic's commitment to its founding precepts, it was also the watershed in its history. The feudal agrarian way of life gave way to the dominance of the industrialized North, which now turned its well-oiled centralized organization and genius for engineering toward the West, launching across the continent wave upon wave of migration and exploration, consolidation and appropriation. "We debouch upon a newer mightier world," wrote Walt Whitman in 1865:

> We primeval forests felling
> We the rivers stemming, vexing we and piercing deep the mines within,
> We the surface broad surveying, we the virgin soil upheaving,
> Pioneers! O Pioneers!⁷

Whereas Whitman and other Easterners saw no conflict between nature and technological progress, Native Americans, whose lands were being expropriated and despoiled, did. Since the Removal Bill of 1830, indigenous populations had been pushed relentlessly westward, alienated from land that was their birthright but which they did not presume to own. Despite their resistance and their retaliations against the whites, the government's punitive campaigns and treaties with the scattered tribes, as well as internecine warfare, disease, famine, and demoralization, eventually reduced their defiance. *120*

If we see but few Native Americans here, it is not because they were invisible, but because they were valued much less than the lands they so tenuously occupied. Following the discovery of gold at Sutter's Mill in 1848, additional mining claims in California and Nevada (no. 155) drew speculators like magnets. Thus, in the West exploration and settlement proceeded apace while the war consumed the eastern states. Unscathed by the national conflict, California developed into a land of opportunity where natural bounty and man's progress seemed to form a consensual union for the good of mankind. *117*

In Carleton Watkins, one of the finest landscape artists of any time, the West had a most talented interpreter. His photographs of Yosemite—a magnificent and then almost wholly unknown valley in the Sierra Nevada mountains—struck the disbelieving world as waking dreams. These awesome visions helped convince a beleaguered President Lincoln to designate the valley inviolable. Watkins's *121* vistas of a serene and underpopulated land, rationally composed by an unerr- *122*

124
125

ing eye, demonstrate with crystalline clarity an ideal harmony between man and nature. The controlled grandeur of his views of the sublime is encoded not only with classical ideals of simplicity, geometry, and measure, but also with a perception of the West as the primordial theater of an authentically American place.

Between Yosemite and Denver stretched a vast tract of relatively uncharted land that four governmental expeditions were organized to survey after the Civil War. Under the civilian geologist Clarence King, Lieutenant George Wheeler, and others, these exploratory surveys included artists and photographers, whose views filled the gaps left by topographical measurement and scientific analysis. While the published reports were rigorous and complete, the information contained in them has been superseded; the photographs, however, remain as impressive today as when they were taken, especially those made by Timothy O'Sullivan.

115

O'Sullivan's view of the Humboldt Hot Springs shows a stretch of rocky, desolate land on the edge of a steaming sea rimmed in the distance with still more barren mountains. In this vast waste beneath an unfathomable sky the photographer's converted ambulance and portable developing box are dwarfed, yet intriguingly proclaim victory over the space as decisively as a footprint on the moon. It is not just man's scientific enterprise that is triumphant here; it is his artistic conception that has gained sovereignty over this primeval scene, stretching beyond time and now cast into the present tense.

In 1893, when Frederick Jackson Turner spoke of the peculiar cycle from primitivism to civilization that recurred along the continually advancing frontier, he isolated attributes that had been engendered in the American character along the way.[8] Among these were strength, acuteness, and acquisitiveness; an expedient, practical mind with a masterful grasp of material things; individualism, exuberance, and restless energy. His roster of traits equally well describes the nineteenth-century American photographer. If we were to add to the list a general lack of sentimentality, a predilection for the actual over the imagined, a confidence in fact and in the eloquence of clear exposition, we might see how the challenge of depicting a new world without a long tradition of visual models engendered a realistic, vernacular style of plain expression.

Nineteenth-century American photography never embraced the paper negative and never underwent a picturesque phase. The only past it acknowledged was timeless and virgin, and the only past that encroached upon it was the prickle of passage implicit in an insistent present.

Maria Morris Hambourg

88. John Adams Whipple, Hypnotism, ca. 1845 (no. 113)

89. Samuel F. B. Morse,
Portrait of a Young Man, 1840 (no. 112)

90. Mathew B. Brady,
Cornelia Van Ness Roosevelt,
ca. 1860 (no. 123)

93. Albert Sands Southworth, Self-Portrait, ca. 1848 (no. 116)

92. Attributed to Alfred Rudolph Waud,
A Woman in an Interior,
ca. 1870 (no. 145)

95. Brady Studio,
Senator and Mrs. James Henry Lane,
1861–66 (no. 125)

94. Mathew B. Brady,
Portrait of a Man,
ca. 1857 (no. 124)

Overleaf: 96. Samuel G. Szabó, *Rogues, a Study of Characters*, ca. 1860 (no. 126)

44

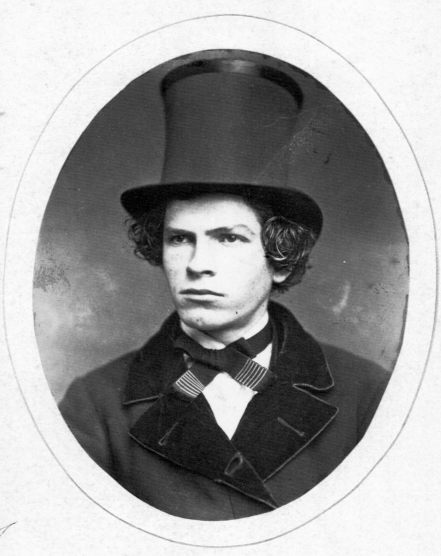

John McNauth alias Keely alias little Chucks
Pick Pocket

45.

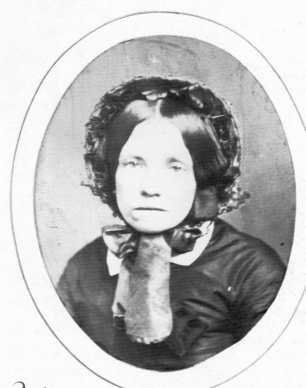

Mrs Hudson
Abortionist

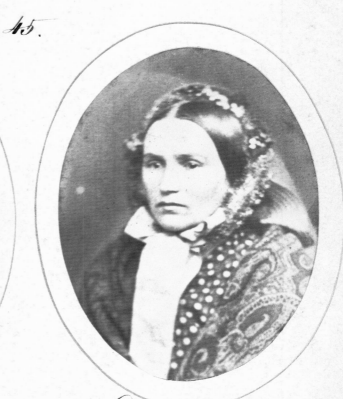

Mrs Deitze alias Baker
Lifter

Esther Redding
pick pocket ny.

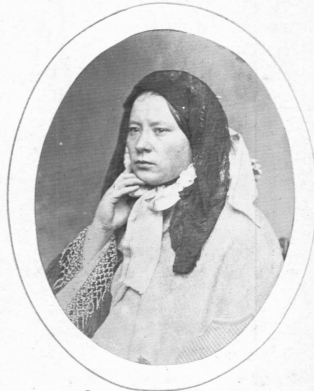

Lavina Adran
Lifter

98. Attributed to Henry Rhorer, *View of Cincinnati*, 1865–66 (no. 146)

97. William Langenheim and Frederick Langenheim, Eclipse of the Sun, May 26, 1854 (no. 118a–g)

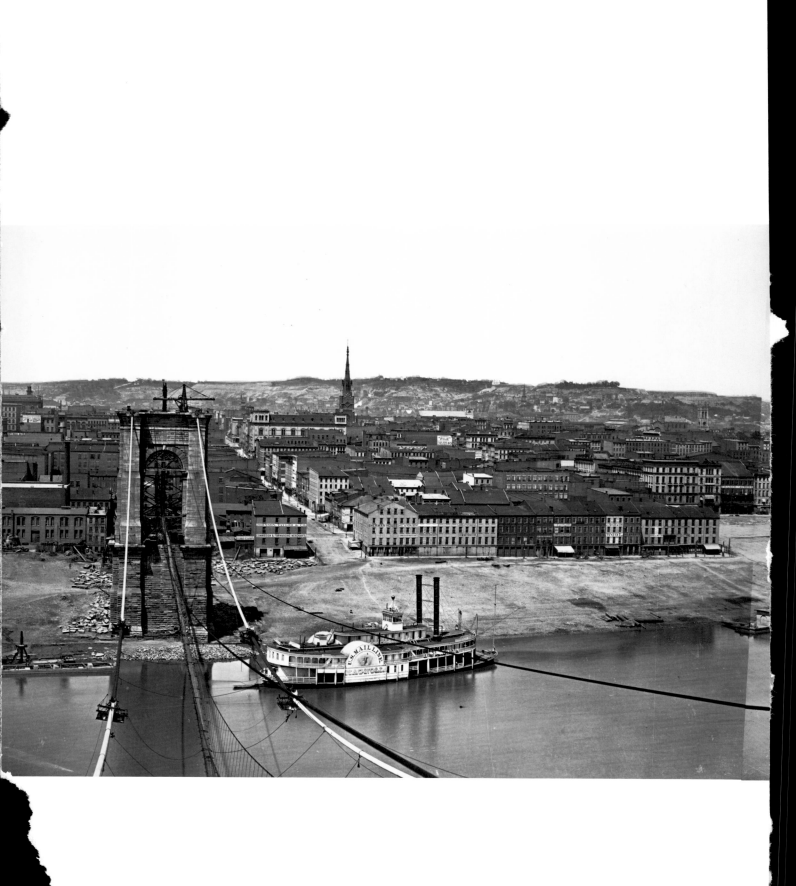

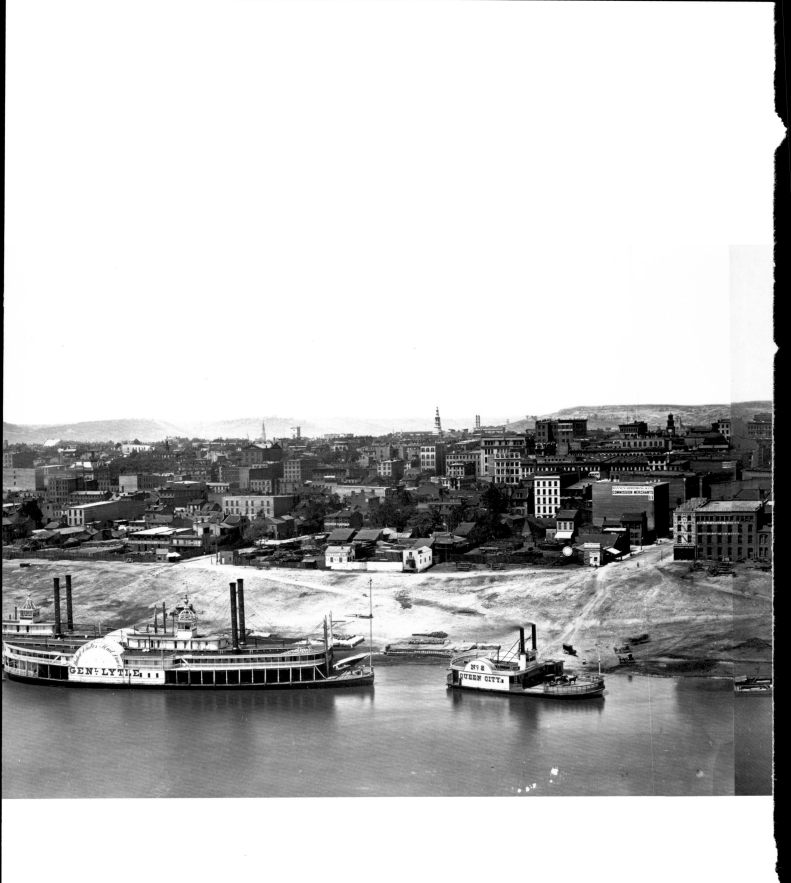

99. Anonymous,
Family Group,
1861–65 (no. 134)

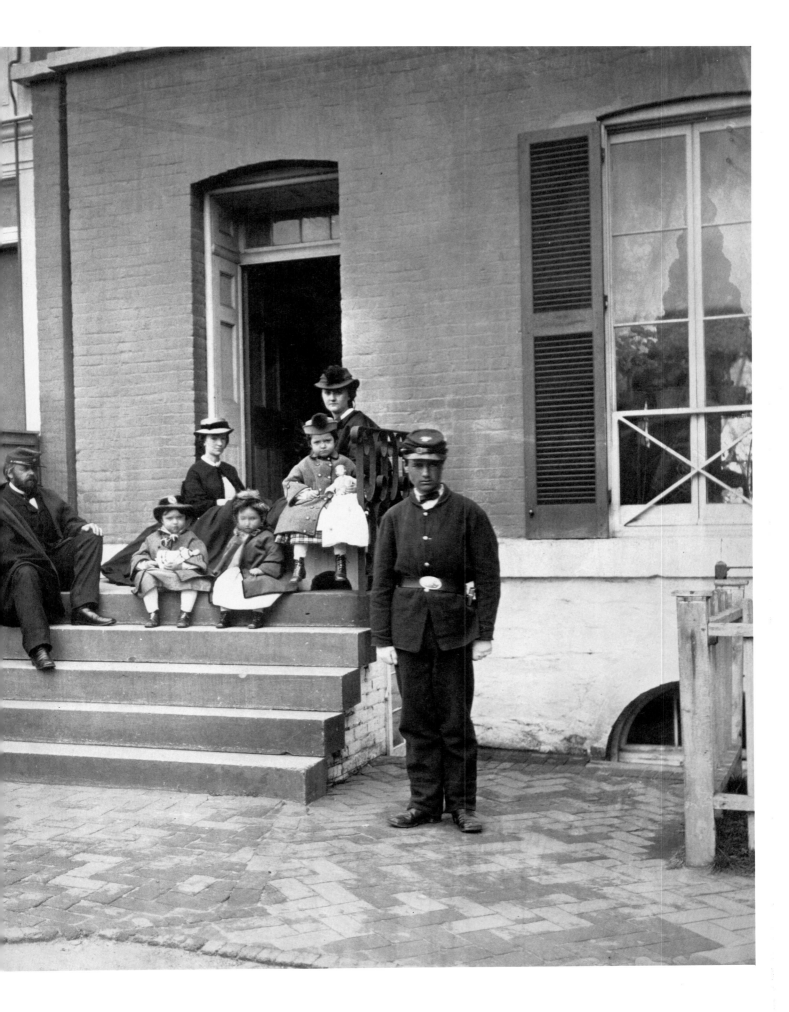

100. Anonymous, Portrait of a Youth, 1850–60s (no. 128)

101. Anonymous, Abolitionist Button, 1840s–50s (no. 115)

102. Anonymous, Ku Klux Klansman, ca. 1869 (no. 144)

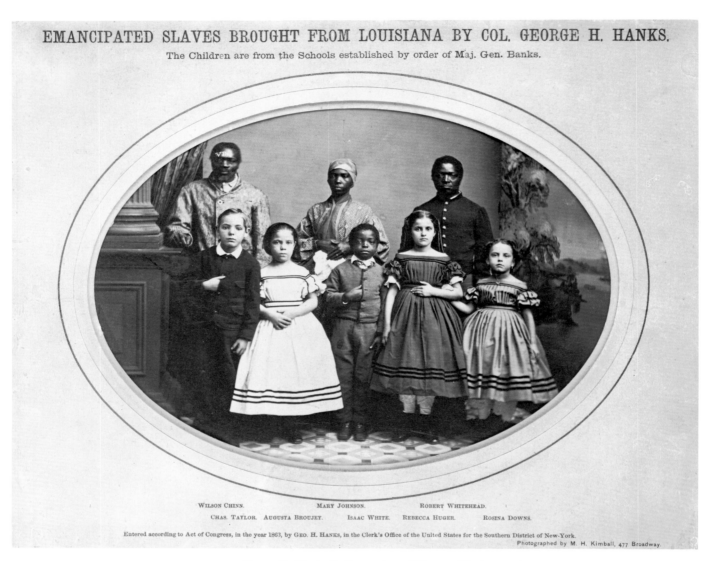

EMANCIPATED SLAVES BROUGHT FROM LOUISIANA BY COL. GEORGE H. HANKS.

The Children are from the Schools established by order of Maj. Gen. Banks.

WILSON CHINN. MARY JOHNSON. ROBERT WHITEHEAD.

CHAS. TAYLOR. AUGUSTA BROUJEY. ISAAC WHITE. REBECCA HUGER. ROSINA DOWNS.

Entered according to Act of Congress, in the year 1863, by GEO. H. HANKS, in the Clerk's Office of the United States for the Southern District of New-York.

Photographed by M. H. Kimball, 477 Broadway.

103. Myron H. Kimball, *Emancipated Slaves*, 1863 (no. 132)

104. William Marsh,
Abraham Lincoln,
1860 (no. 129)

Abraham Lincoln 1861

105. Andrew Joseph Russell, *Slave Pen, Alexandria, Virginia*, ca. 1863 (no. 131)

106. Alexander Gardner, Antietam Battlefield, 1862 (no. 130)

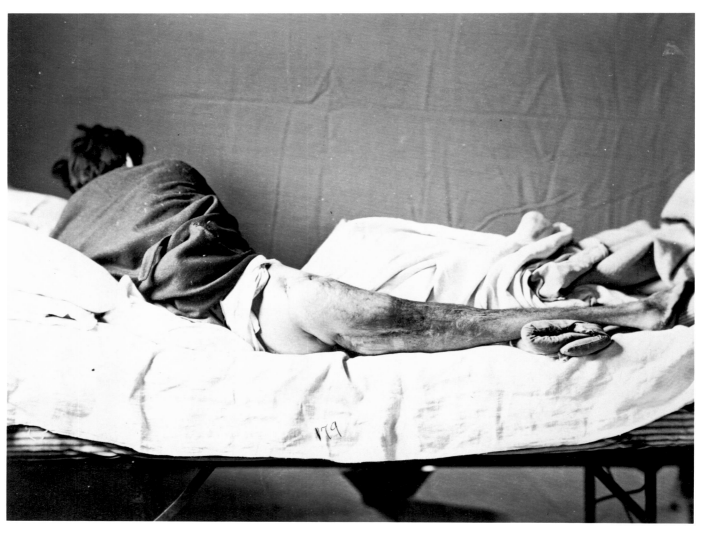

107. William Bell, *Private George Ruoss (Partially Consolidated Gunshot Fracture of the Upper Third of the Right Femur)*, 1867 (no. 143)

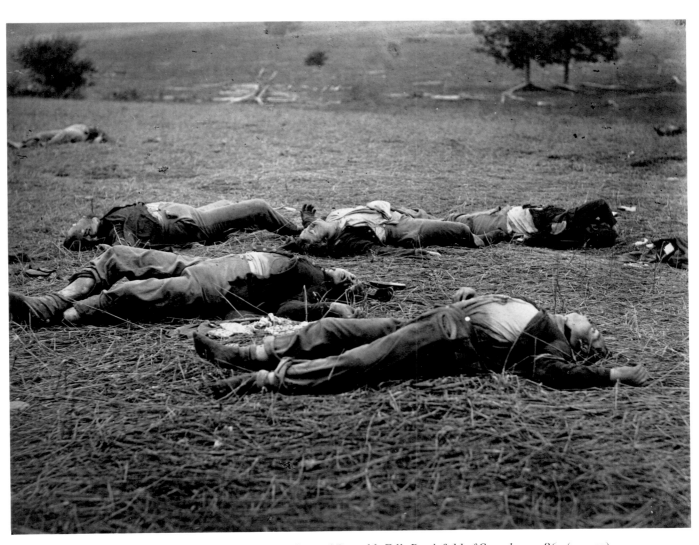

108. Timothy H. O'Sullivan, *Field Where General Reynolds Fell, Battlefield of Gettysburg*, 1863 (no. 133)

109. Brady Studio, Andersonville Still Life, 1866 (no. 142)

110. Anonymous, The Wilderness Battlefield, 1865–67 (no. 135a)

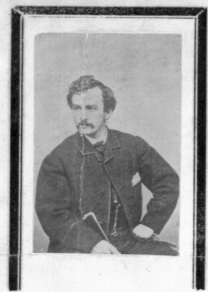
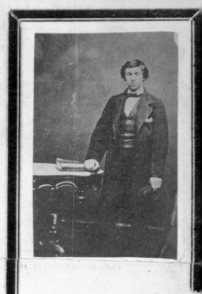

SURRAT. BOOTH. HAROLD.

War Department, Washington, April 20, 1865,

 # $100,000 REWARD!

THE MURDERER

Of our late beloved President, Abraham Lincoln,

IS STILL AT LARGE.

$50,000 REWARD

Will be paid by this Department for his apprehension, in addition to any reward offered by Municipal Authorities or State Executives.

$25,000 REWARD

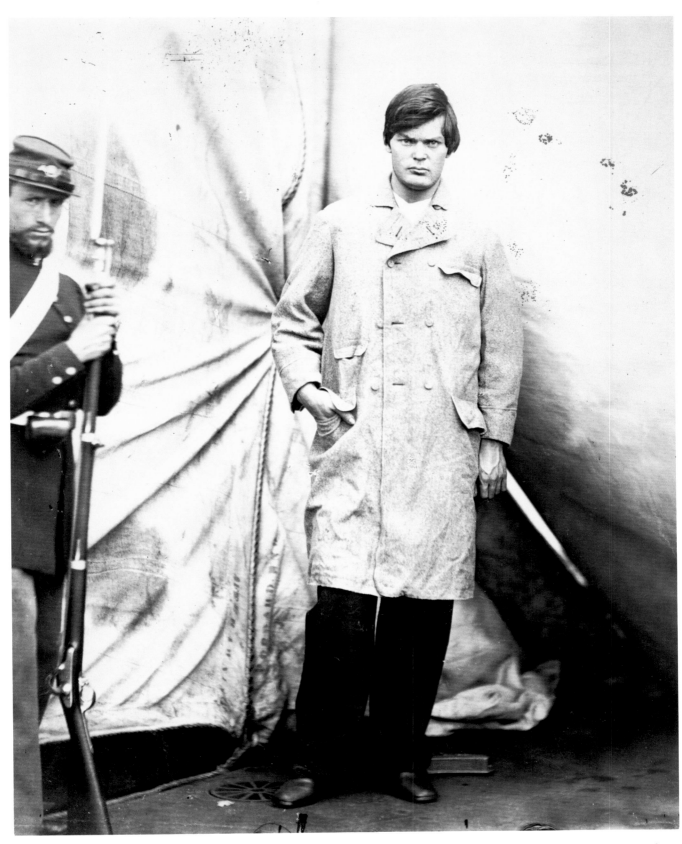

112. Alexander Gardner,
Lewis Paine,
April 27, 1865 (no. 139)

111. Anonymous,
Broadside for Capture of Booth, Surratt, and Herold,
April 20, 1865 (no. 138)

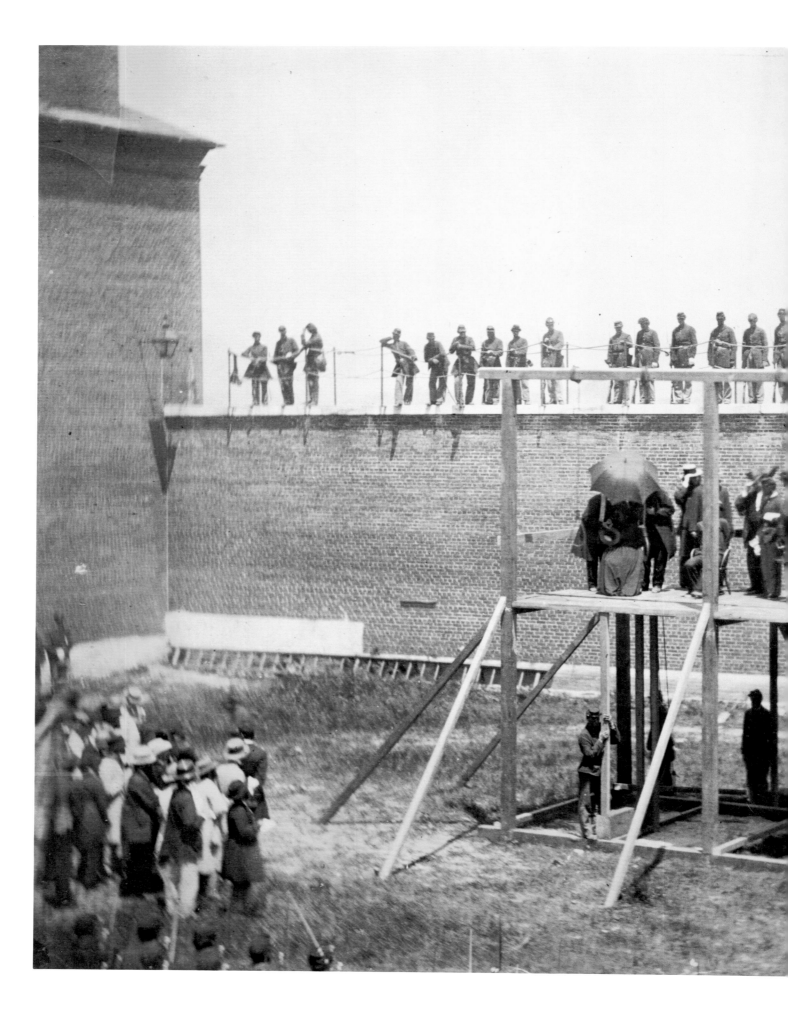

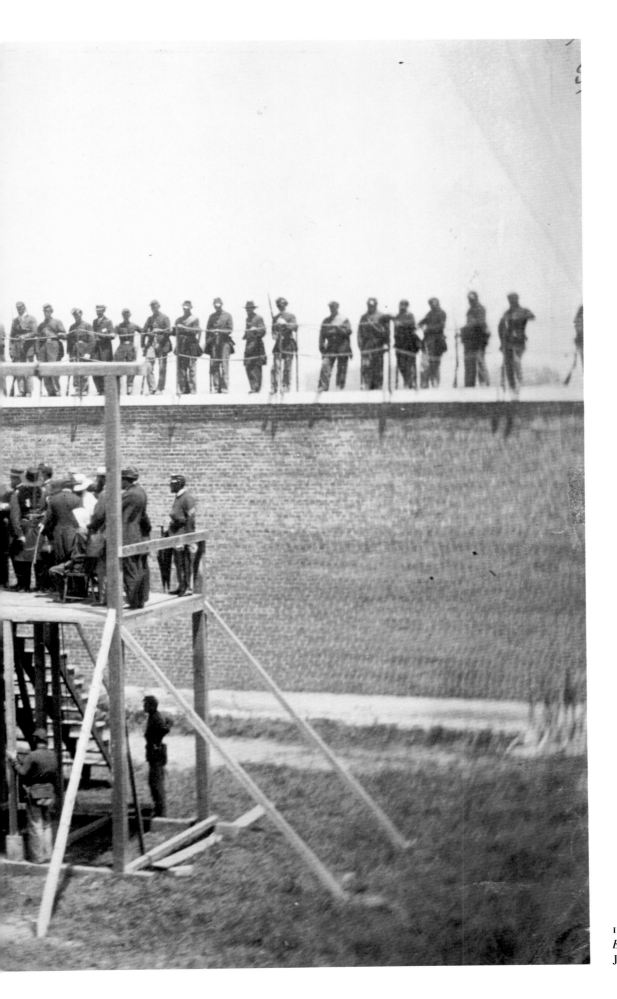

113. Alexander Gardner,
Execution of the Conspirators,
July 7, 1865 (no. 140)

114. Timothy H. O'Sullivan,
Fissure Vent of Steamboat Springs, Nevada,
1867 (no. 154)

115. Timothy H. O'Sullivan, The Humboldt Hot Springs, 1868 (no. 150)

116. Anonymous, A Frontier Home, 1860s–1870s (no. 149)

117. Timothy H. O'Sullivan,
Shoshoni,
1867–72 (no. 151)

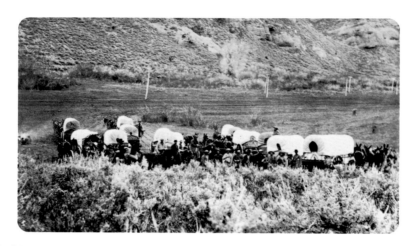

118. Charles William Carter, *Mormon Emigrant Train, Echo Canyon*, ca. 1870 (no. 148)

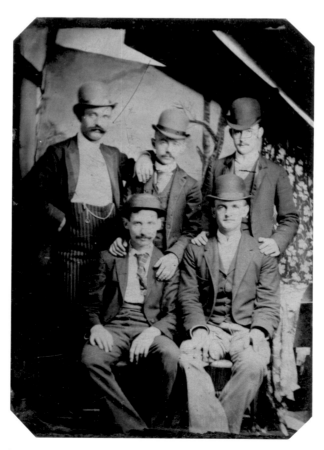

119. Anonymous, Five Members of the Wild Bunch, ca. 1892 (no. 162)

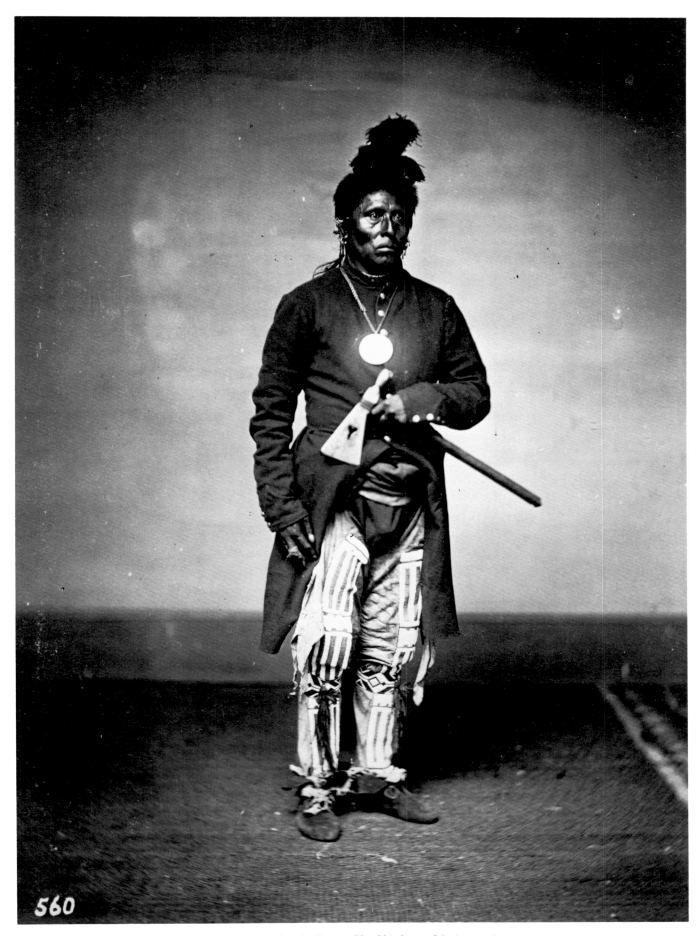

560

120. Attributed to Edric L. Eaton, *Sky Chief*, ca. 1867 (no. 147)

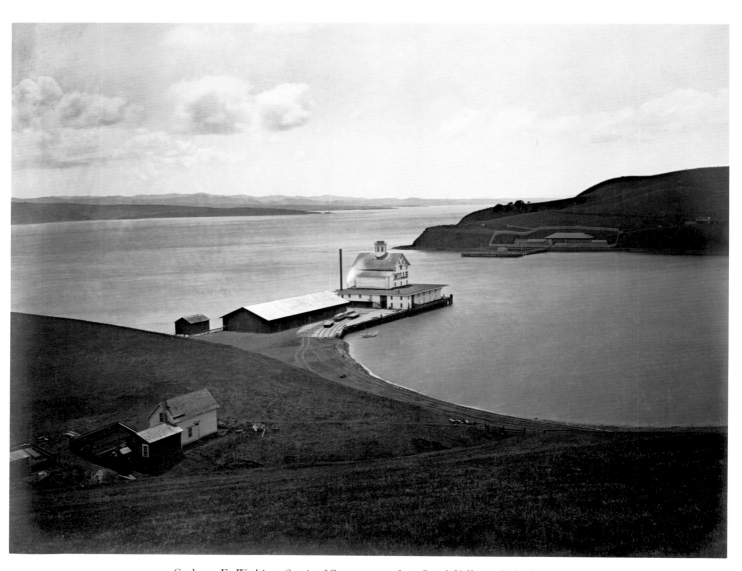

121. Carleton E. Watkins, *Strait of Carquennes, from South Vallejo*, 1868–69 (no. 160)

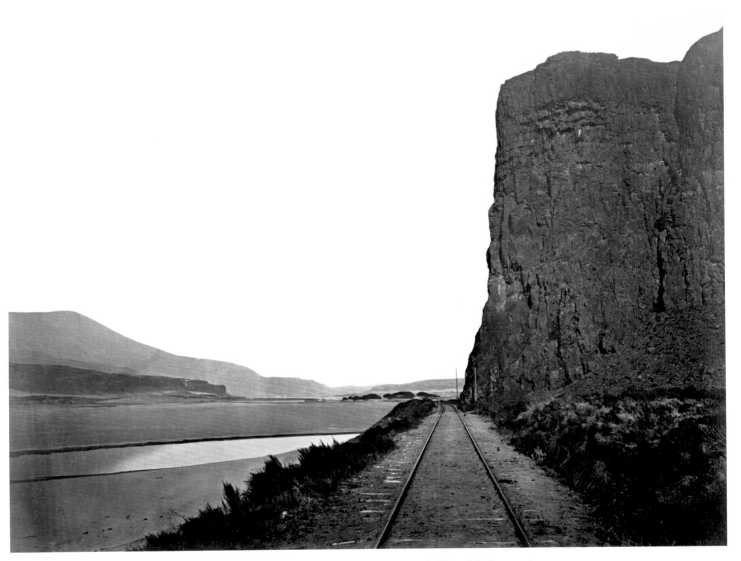

122. Carleton E. Watkins, *Cape Horn near Celilo*, 1867 (no. 159)

123. William Bell, *Cañon of Kanab Wash, Looking South*, 1872 (no. 153)

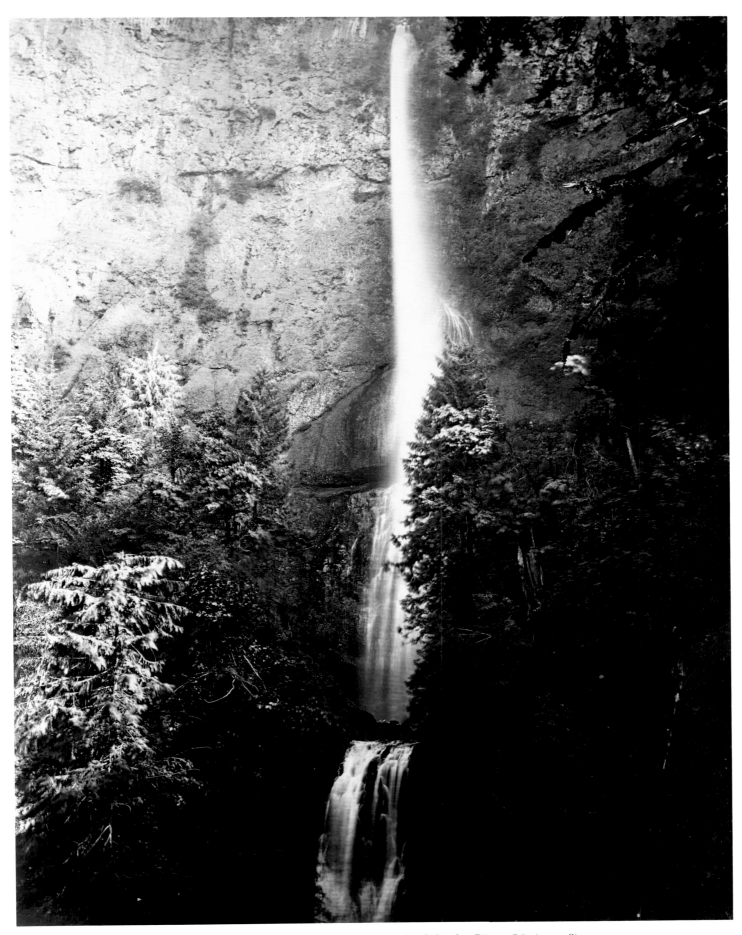

124. Carleton E. Watkins, *Multnomah Falls Cascade, Columbia River*, 1867 (no. 158)

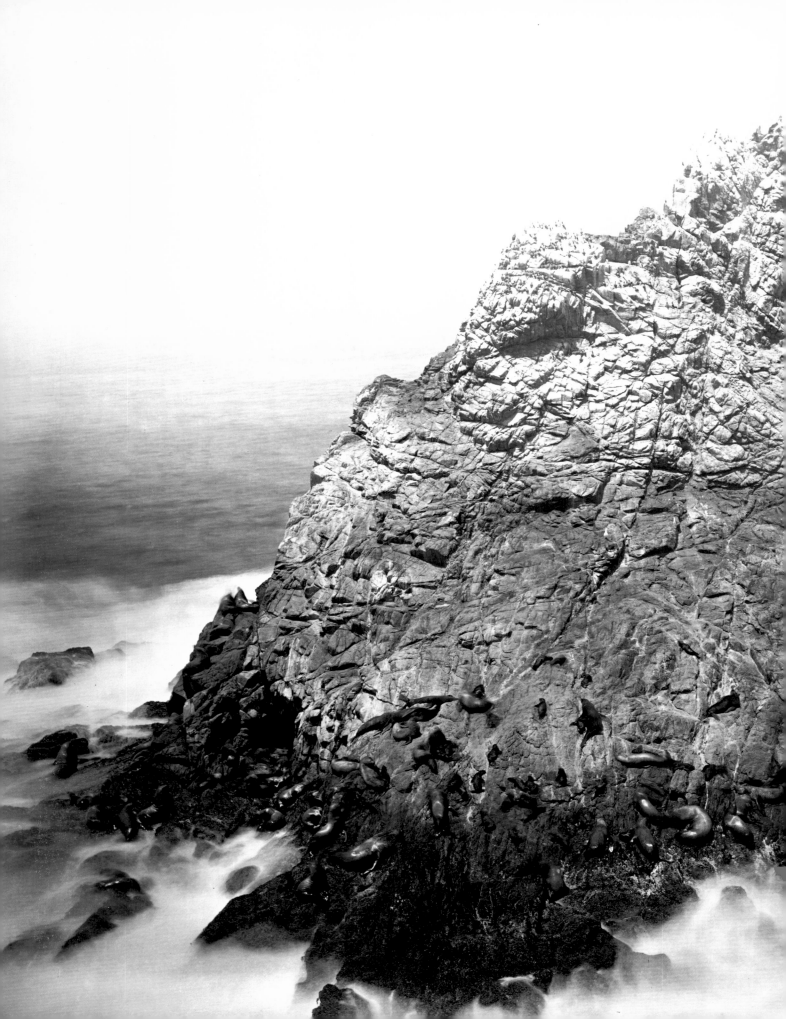

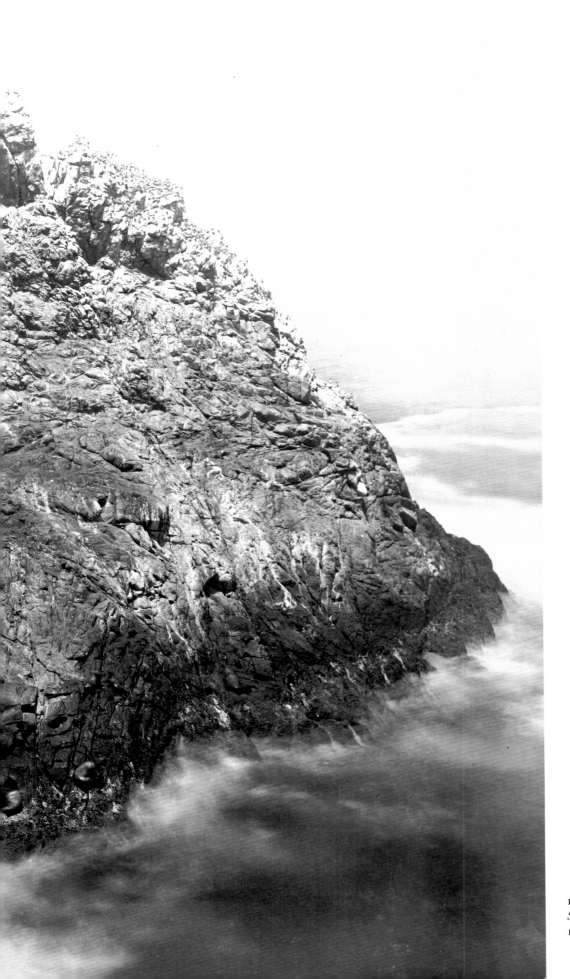

125. Carleton E. Watkins,
Sugar Loaf Islands, Farallons,
1868—69 (no. 157)

Turn of the Century: Chrysalis of the Modern

122

146

For the photographers who matured as the nineteenth century closed, the crisp, exquisite articulation of Carleton E. Watkins's heroic vision of nature had little to offer; it seemed as useless as an old map that charted a terrain altered beyond recognition. Instead, pictures such as Edward Steichen's *The Pond —Moonlight* presented inchoate and depthless landscapes, floating magmas of sky, trees, earth, and water. The virtuoso printing technique, rather than clarifying the subject, mystified it. The landscape had become an inscape, a projection of the inner world of the photographer who, seeming to forsake the natural course of photographic vision—the progressive elucidation of appearances—had interposed between reality and its rendition the screen of his own subjectivity.

This new kind of picture reflected a major shift in the very idea of what constituted reality. For contemporaries of the great explorers of consciousness —Friedrich Nietzsche, William James, Henri Bergson, and Sigmund Freud— objective description that did not take into account irrational, emotive modes of thought and perception was no longer acceptable. If photography was to continue to describe reality, artists had to abandon naturalistic styles shaped by positivism and scientism and acknowledge that the boundaries between the external world and the psyche were porous, and that consciousness, mobile and enigmatic, was the only essential factor in the determination of the real. Photographers also had a compelling reason to insist on the priority of inner vision and to advocate the medium's capacity to express subtle poetic states. By the end of the 1880s, through a series of technical advances that greatly simplified its practice, photography had expanded from being the province solely of the specialist into an activity accessible to the millions. To define photography as a

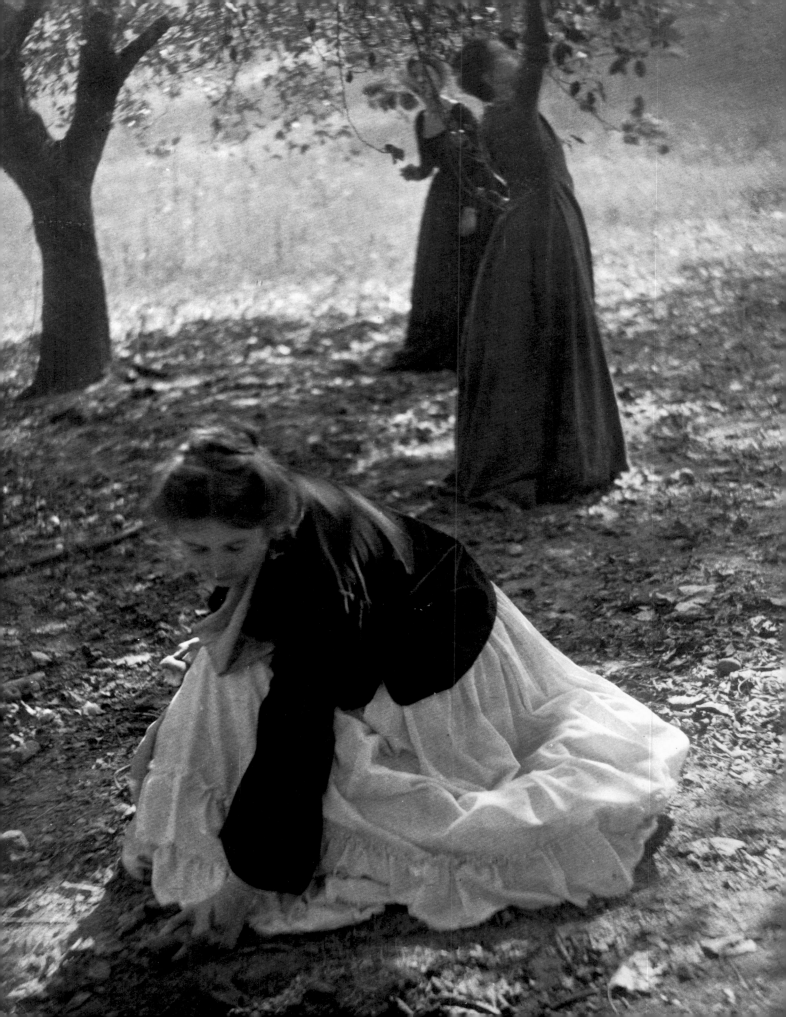

discipline distinct from its casual, commercial, and scientific applications became the overriding goal of artists at the turn of the century, who claimed for it a place commensurate with those artistic endeavors that celebrated the complex, irreducible subjectivity of their makers.

The first to subvert the notion of photography as a crystalline reflection of reality, P. H. Emerson modeled his photographic style on what he understood to be optical vision, which focuses in a selective manner on specific objects, relegating the surrounding field to a peripheral blur (no. 164). Emerson's influential *Naturalistic Photography for Students of the Art* (1889) and the Pictorialist movement it initiated encouraged photographers to transcend the mechanistic verisimilitude of the lens in the pursuit of a new truth understood as "the verification of all things through human consciousness, and their statement through human feeling."[1]

In response to the industrial age, its machinery, and mass production, the Pictorialists extolled the photograph as an original, handcrafted object, giving paramount importance to its manner of presentation and to the refinement of the printing technique. Rather than promote a unified aesthetic, they deemed that no approach was unworthy if it could produce an object that was beautiful and unique. Inward-looking and elitist, the Pictorialists banded into societies —the Linked Ring Brotherhood in London (1892), the Paris Camera Club (1894), the Photo-Secession in New York (1902)—that clustered in coteries around the men who animated them: Frederick Evans, Robert Demachy, and Alfred Stieglitz. The exhibitions designed by Evans in London and by Steichen in New York, Stieglitz's exquisitely produced journal *Camera Work* (1903–17), and the critical appraisal and lively exchange of ideas it engendered all contributed to the perception of photography as serious and exacting and capable of eliciting sensual as well as aesthetic enjoyment. If the Pictorialists appear at times self-indulgent and gimmicky their essential contribution, which was to reinstate sensibility at the core of photographic investigation, provided an incubating matrix for modernism.

Landscape, women in nature or in interiors, and portraiture were the subjects the Pictorialists selected as best suited to the projection of individual consciousness. In their search for an approach that would be intuitive and emotive they turned to Symbolism, the multifaceted movement, or rather mood, born of a dissatisfaction with the complacent materialism of the fin de siècle. Encouraging introspection rather than observation, Symbolism proceeded by allusion and used forms suggestive of a larger, spiritual realm; it advocated a

withdrawal into the life of the imagination and gave primacy to the irrational, the unconscious, and the dream. In America the Symbolist aesthetic informed the vision of such painters as Albert Pinkham Ryder and Arthur B. Davies and suffused much of the work of Pictorialists such as Steichen, George Seeley, F. Holland Day, and Clarence White. In depicting nature photographers looked for sites devoid of any remarkable feature so as to better charge them with soulful atmosphere; their landscapes exemplified a retreat from concrete reality and a moving away from specific temporal and spatial description. *144*

Pictorialist images of woman were also heavy with Symbolist overtones. If European photographers sometimes offered an intriguing glimpse of woman as lustful destroyer, the American Pictorialists generally depicted her as the embodiment of either purity or selfless maternity, a nurturing force bound to the earth and imbuing the environment with a civilizing softness. The recurring image of a woman bending to gather fruit or flowers presented the eternal feminine as part of the cycle of nature. Clarence White's *The Orchard* offers *126* one of the most eloquent illustrations of this theme. The gesture of the woman in the foreground binds her to the land, while the women in the background, their columnar forms with arms upraised, recall branch-bearing trees.

In their attempt to express the fluid character of their personal reality, the Pictorialist photographers turned to the graphic art of Japan for compositional structures that unhinged conventional illusionistic representation. They took from Japanism a seemingly casual, unexpected hierarchy of motifs, the use of the surprising angle and cropping, and the concept of pictorial space as a planar field of energy—devices welcomed by artists eager to depict their own floating world. It is no coincidence that the painter Edgar Degas, whose art borrowed so much from Japan, was himself an enthusiastic photographer. Indeed, the aesthetic of Japan became so well integrated into the fabric of Western art that by the turn of the century it was pervasive, informing the work of photographers as diverse as Heinrich Kühn, Paul Strand, Frank Lloyd Wright, *129* and William James Mullins (no. 166). Its influence extended to the presenta- *158* tion of individual prints, the care lavished on mounts and frames, and the uncluttered installations of photographic exhibitions.

The perception of the external world as inseparable from the domain of the inner self found its most realized expression in portraiture. Photographic portraits had until this time been studies of the social self, a self now called into question. The two great literary works that opened and closed the period —Oscar Wilde's *Picture of Dorian Gray* (1891) and Marcel Proust's final vol-

umes of *A la recherche du temps perdu* (1913–28)—both depict the deceptive artifices of the persona and end in unmaskings. Reflecting psychology's new interest in the irrational and the instinctive, the art of photographic portraiture underwent a considered reevaluation. Setting themselves the task of exploring the psyche, photographers looked for features and countenances that would be signposts of the complex, mobile terrain of the inner self. Soft focus, dark shadows, and the absence of a clear delineation between sitter and background all helped to describe the individual within the cocoon of the self, the chrysalis of an acutely vulnerable sensitivity. Not surprisingly, the Pictorialists' most successful portraits were self-portraits and pictures of individuals with whom they shared a richly textured psychological life—artists, writers, aesthetes, and women such as Lady Ottoline Morrell and Countess Greffulhe, who made the cultivation of the self their overriding preoccupation.

138

But successful photographic portraiture was not confined to Pictorialism; the portraits of the period that continue to hold our attention comprise all those which, by accident or by design, contribute to the exploration of the psychological realm. The more than seven hundred portraits staged by the notorious Countess de Castiglione between 1857 and 1895, in which the countess assumed personalities as diverse as an eighteenth-century marquise and a drunken derelict, suggest that photography was for her more than simply a conduit for playful exhibitionistic fantasies. The images, which display her obsession with self-contemplation, seem in retrospect to be so many bulletins charting her pitiful disintegration in the throes of an all-consuming narcissism. Although most of the photographs were made before the 1880s, the myth of Narcissus which they so vividly evoke embodies the spirit of this later age.

147
148

From the time that Nietzsche first postulated that the unconscious was the essential part of the individual, its presence loomed larger and larger as the century drew to a close; its dynamics were still only dimly perceived, however, when Freud's *Interpretation of Dreams* was published in Vienna in 1899. A few photographers alluded to the unconscious by the introduction in their portraits of the cryptic figure of the double, symbolizing the dormant, often threatening, other self. In Otto's stylish portrait commissioned by Countess Greffulhe, whose allure so beguiled Proust, inspiring his character the Duchesse de Guermantes, the subject's double, eyes closed as in a trance, brings to mind the spectral figures invoked at séances. F. Holland Day's self-portrait, in which a barely visible nude figure of a man echoes with a pensive pose the elegant gesture of the photographer, brings to the fore the latent preoccupation with homosexual-

136

137

ity in fin de siècle culture and states the theme of the unknowable, ever-present alter ego in nearly confessional tones. And Alphonse Mucha's study of two models owes its fascination to its allusion to the unceasing struggle waged by *150* divergent psychic forces forever locked in a divided self.

Other images went even further in their revelations, addressing the notion that identity itself was transient, a succession of shifting, sometimes overlapping, roles. Rudolf Balogh's portrait of Nijinsky in *Le Spectre de la rose* *149* follows the dancer in the process of erasing his own personality to assume the essence of a sexless, floral being. In the years preceding the Great War psychological investigation turned into vivisection. Stanislaw Ignacy Witkiewicz, having exhausted his panoply of subterfuges and evasions, shows a naked self stripped of any protective shell and conscious only of his existential anguish—a *160* harrowing image of twentieth-century man.

Turning their searching gaze from portraiture to the representation of the human body, photographers found in the sculpture of Auguste Rodin and in *145* the movement of the dance forms expressive of the fluid dynamism of psychological processes and the restless mobility characteristic of the modern age. The dance, which emerged at the turn of the century as an independent artistic language, presented photographers with a particularly daunting challenge, since they were not able to record the actual flow of movement—the flights of Nijinsky, the whirling veils of Loie Fuller, the rhythmic patterns of Isadora Duncan— *135* but only to allude to them in fragmentary, arrested sequences. Their best images, like those taken by Lady Ottoline Morrell of her daughter and friends *151a,b* abandoning themselves in the nude to pagan celebration, were construed as diagrams of explosive, vital energy. In a world increasingly obsessed by speed, dancers taught photographers that human beauty was no longer to be found in marmoreal stillness but had to be caught in flashes, in glimpses of revelatory motion.

Among the technical innovations of the first years of the twentieth century, the invention of the autochrome process deserves special mention as the first generally accessible rendering of color in photography. Made commercially available in 1907 by its inventors Auguste and Louis Lumière in the form of glass transparencies, the autochrome retrieved the natural color of things in a slightly dimmed palette and registered light with the diffuse, grainy quality of a Pointillist painting. Endowing subjects with an insistent, albeit fragile, presence, autochromes preserved their precious, momentary beauty as though suspended in amber. They were unique, expensive, technically demanding, and *133*

131 difficult to reproduce. Most photographers were content to let the magic of the process speak for itself. But an artist such as Kühn used it to explore delicate emotive states, creating images of particular radiance.

128

156 If autochromes induced nostalgic reveries, snapshots, which made their appearance in the late 1880s with the invention of the hand-held camera, buoyantly celebrated the here and now. Picturesque worlds in miniature, such as those conjured up by Count Primoli, or jagged, distorted fragments seized by Jacques-Henri Lartigue, snapshots captured life in its trivial and intimate, as well as in its exalted, moments. At the opposite pole of the premeditated Pictorialist synthesis of fact and feeling, snapshots were spontaneous, indiscriminate, unjudgmental reports on the fragmentary character of modern experience. Produced in the millions, they were, in the hands of most visually illiterate amateurs, crude and naive; but in their casual artlessness they encompassed the ephemeral, the accidental, and the contingent and moved these categories, hitherto seldom explored, to the forefront of photography's aesthetic. Observing themselves in the process of living, amateur photographers, grand

139 duchesses, and homemakers alike embraced the snapshot as the autobiographical medium par excellence, and their albums replaced diaries as the format best suited to chronicle both the exuberance and the disjointed, accelerated tempo of contemporary life.

By the beginning of the twentieth century photography was well on its way to becoming the visual language it is today, the pervasive agent of democratic communication. Photographers used its growing influence to expose society's evils, which the prosperous, self-indulgent Belle Époque chose

161 to ignore: the degrading conditions of workers in big-city slums, the barbarism

159 of child labor, the terrorism of lynching. Stieglitz's 1910 retrospective of Pictorialism at the Albright Art Museum in Buffalo, New York, turned the page on the movement. The age of electricity, the automobile, the telephone, and the airplane would not recognize itself in the contemplative cast of the Pictorialists. The outside world was disorderly and brutal, but it was also a place too tantalizing, too variegated, too challenging to be ignored. As the salons of the Old World, oblivious to their governments' headlong rush into war, enjoyed a last display of aristocratic graces, a new aesthetic, reconciling mind, machine, and the aspirations of the masses, waited impatiently to be born.

Pierre Apraxine

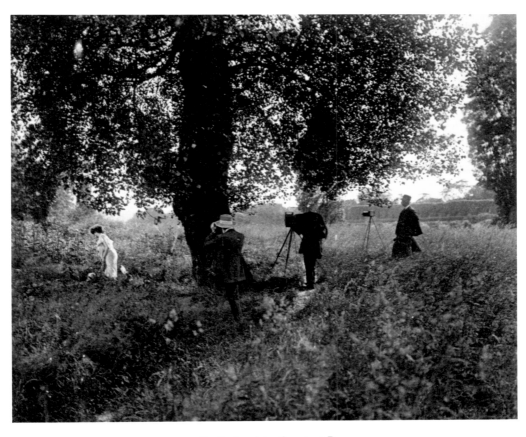

127. Emile Joachim Constant Puyo,
Puyo, Robert Demachy, and Paul de Singly with Model, 1909 (no. 182)

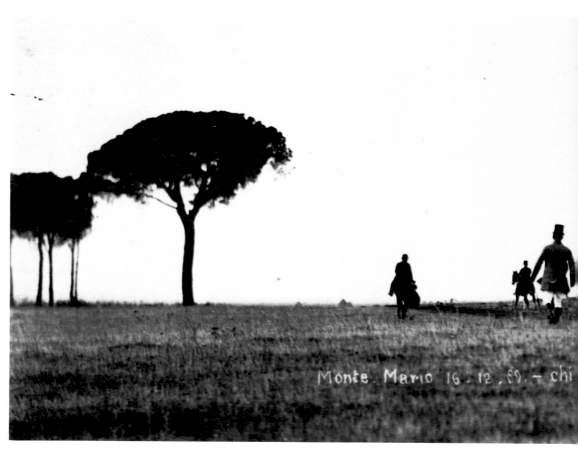

The text within the image reads: "Monte. Mario 16. 12. 89. – chi"

128. Giuseppe Primoli, *Monte Mario—Who Are They?*, 1889 (no. 165)

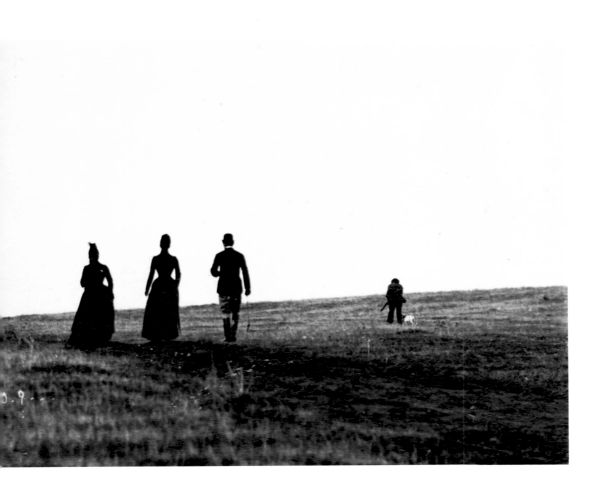

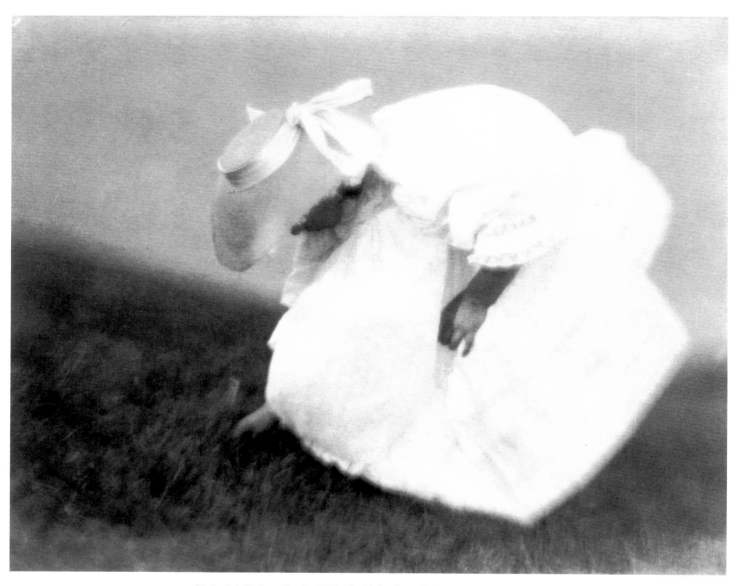

129. Heinrich Kühn, *On the Hillside (A Study in Values)*, before 1910 (no. 176)

130. Heinrich Kühn,
Miss Mary and Lotte (?) at the Hill Crest,
ca. 1910 (no. 180)

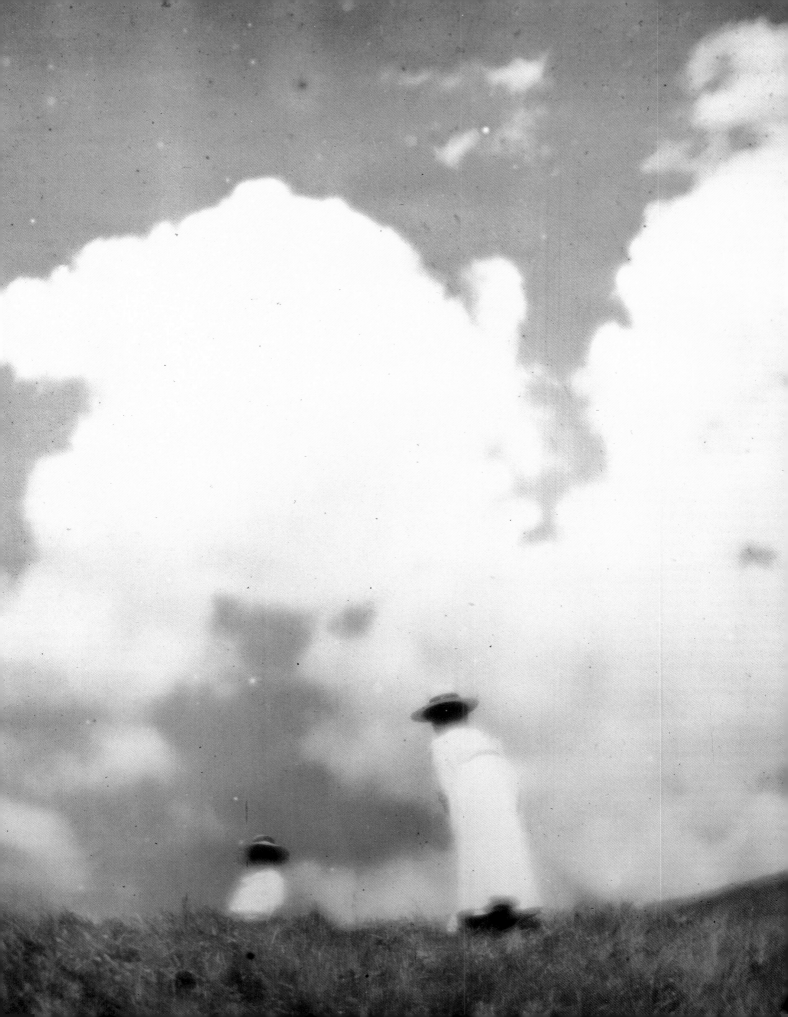

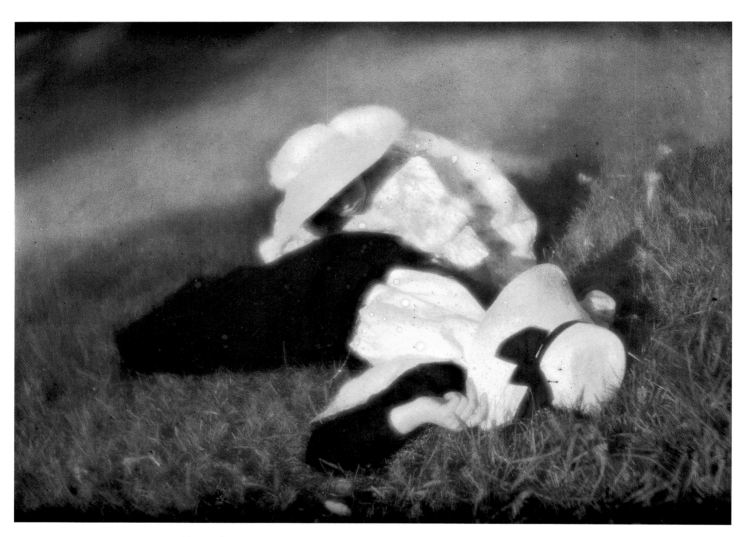

131. Heinrich Kühn, Miss Mary and Edeltrude Lying on the Grass, ca. 1910 (no. 179)

132. Heinrich Kühn, Flowers in a Bowl, 1908–10 (no. 178)

133. Adolph de Meyer, Tamara Karsavina, 1911–14 (no. 181)

134. Alfred Stieglitz, Two Men Playing Chess, 1907 (no. 175)

136. Otto (Otto Wegener),
Countess Greffulhe,
1899 (no. 184)

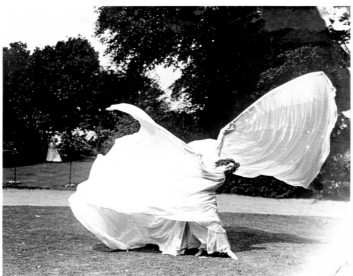

188

135. Samuel Joshua Beckett, Loie Fuller Dancing, ca. 1900 (no. 183a, b, c)

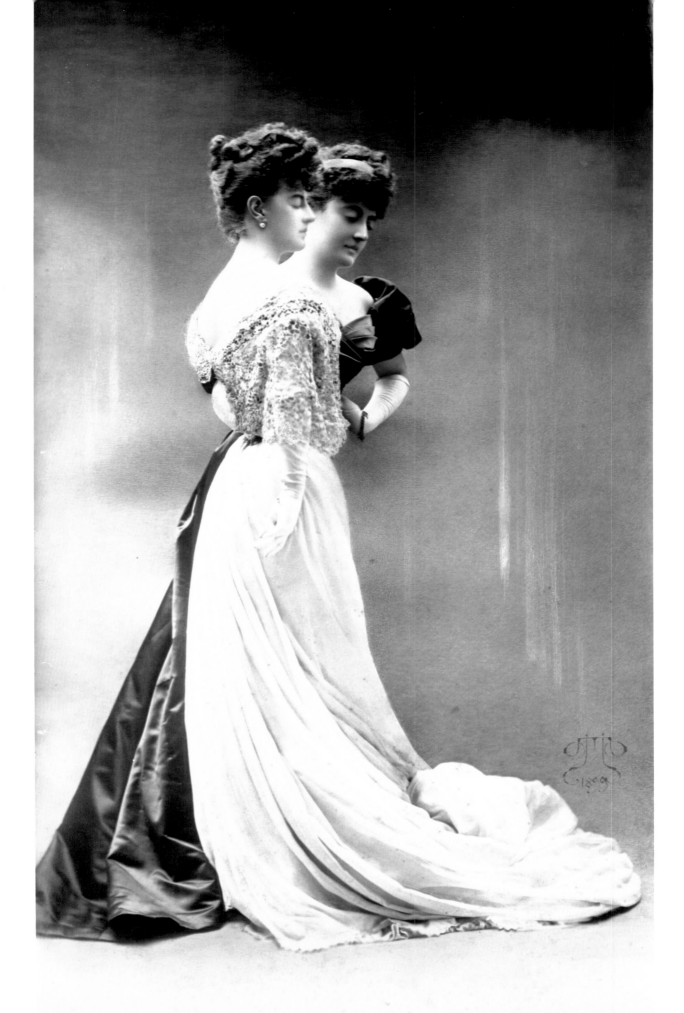

137. F. Holland Day, Self-Portrait, ca. 1897 (no. 191)　　　　　　　138. Adolph de Meyer, Lady Ottoline Morrell, ca. 1912 (no. 189)

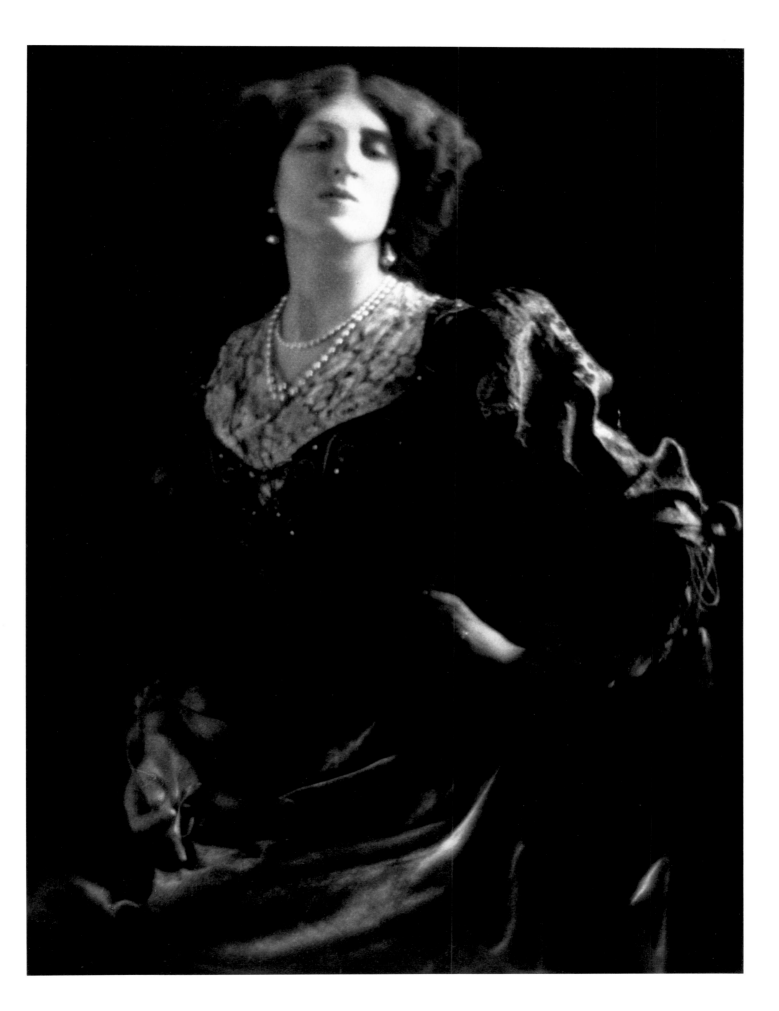

Прогулка въ Ратопьевской линейкъ.

Прогулка 21 Мая на моторъ.

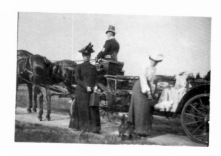

 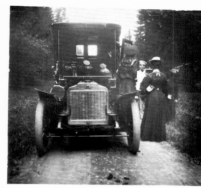 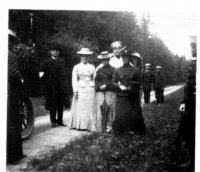

Прогулка 29го Мая.

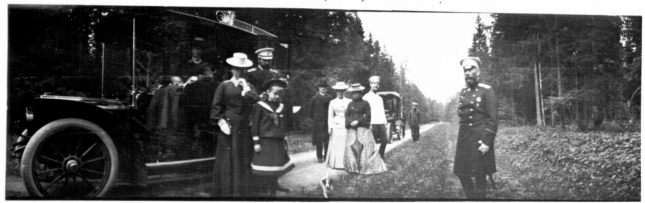

 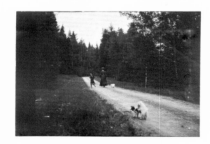

Preceding pages:
139. Grand Duchess Xenia
Alexandrovna of Russia and Others,
Outings at Gatchina,
1905 (no. 194)

141. Frederick H. Evans, *Aubrey Beardsley*, ca. 1894 (no. 188a)

140. Napoleon Sarony,
Oscar Wilde,
1882 (no. 187)

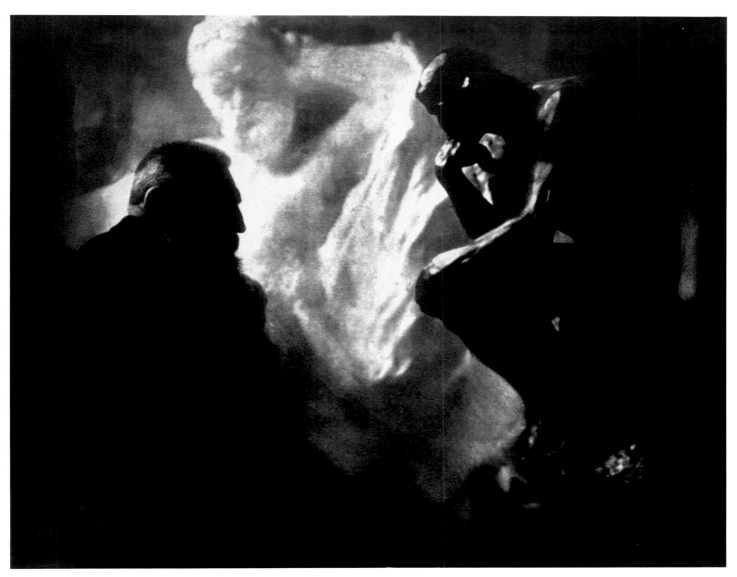

143. Edward Steichen, *Rodin—The Thinker*, 1902 (no. 169)

142. Anonymous,
Study of a Sculpture,
ca. 1900 (no. 171)

144. George H. Seeley, *Winter Landscape*, 1909 (no. 173)

145. Eugène Druet, The Clenched Hand, before 1898 (no. 170)

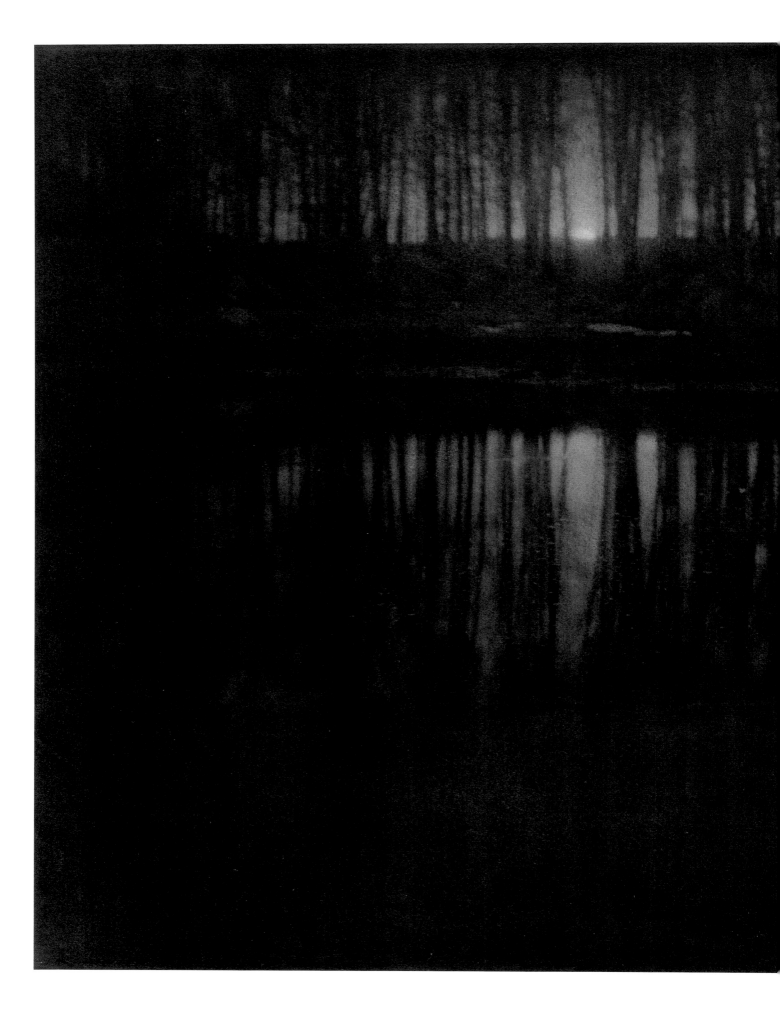

146. Edward Steichen,
The Pond—Moonlight,
1904 (no. 168)

1/ Serie des Roses
de Noisy,
des Tuilleries,
de Compiègne.
d. Muy fois
... éprise
... ... roque
1895

... ... le
... ... reprise
... ... noir
... ... qu'elle
... ... frisée

147. Pierre-Louis Pierson,
Countess de Castiglione (*The Gaze*),
ca. 1857 (no. 185)

148. Pierre-Louis Pierson,
Rose Trémière, from *Série des roses*,
ca. 1895 (no. 186)

150. Alphonse Mucha, Study for a Decorative Panel, 1908 (no. 193)

151a, b. Lady Ottoline Morrell, Cavorting by the Pool at Garsington, ca. 1916 (no. 190a, b)

152. Heinrich Kühn,
The Artist's Umbrella,
1908 (no. 177)

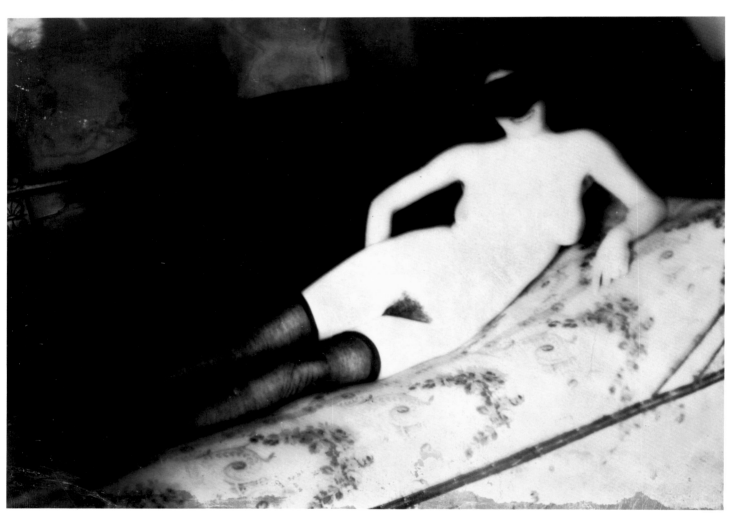

153. E. J. Bellocq, Nude with a Mask, ca. 1912 (no. 202)

154. Paul and Prosper Henry, *A Section of the Constellation Cygnus (August 13, 1885)* (no. 195)

155. Anonymous, Alfred Stieglitz Photographing on a Bridge, ca. 1905 (no. 197)

156. Jacques-Henri Lartigue, *The Grand Prix of the A.C.F.*, 1912 (no. 196)

157. William Mayfield, Orville Wright, 1913 or later (no. 199)

158. Frank Lloyd Wright,
Romeo and Juliet,
ca. 1900 (no. 167)

159. Minor B. Wade, Lynching, Russellville, Kentucky, 1908 (no. 198)

160. Stanislaw Ignacy Witkiewicz,
Self-Portrait,
1912 (no. 203)

161. Lewis Hine, *A Sleeping Newsboy*, 1912 (no. 200)

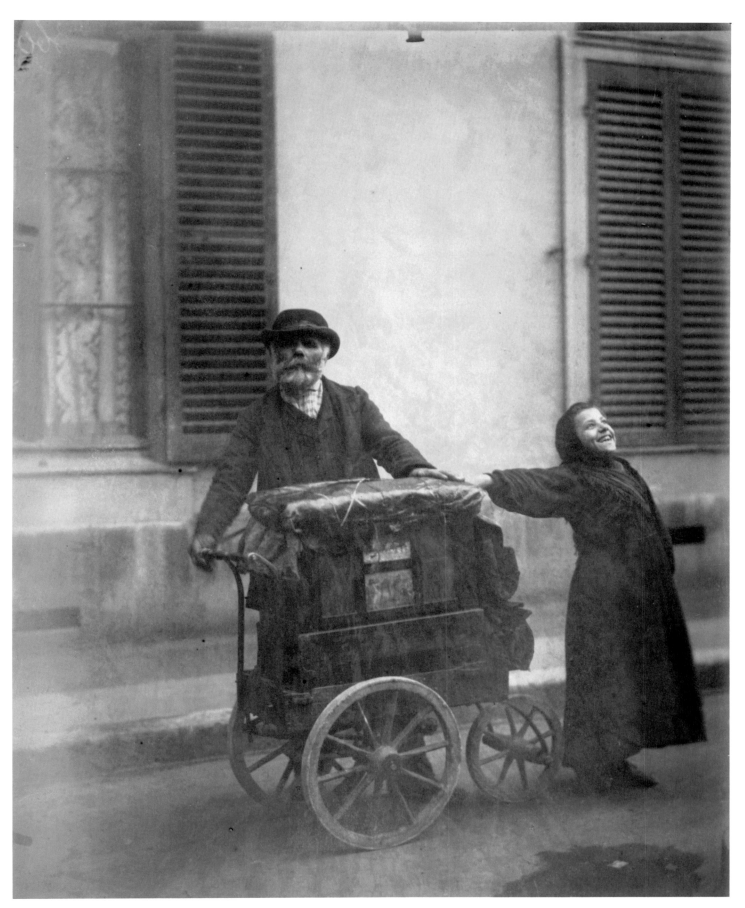

162. Eugène Atget, *Organ-grinder*, 1898–99 (no. 201)

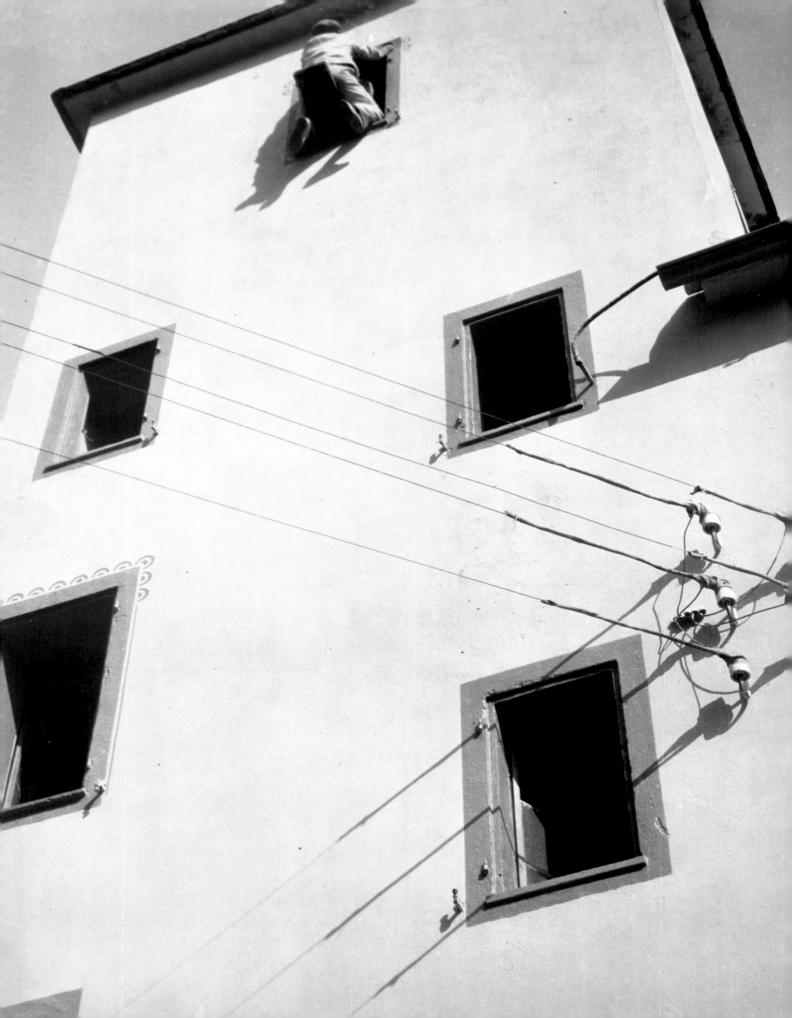

Modern
Perspectives

As the cataclysm of World War I ripped apart the social fabric of Europe, the storm gathering in the world of art erupted as well, exploding revolutionary ideas on traditional aesthetic codes. Provocateurs such as Marcel Duchamp, *184* Tristan Tzara, and Raoul Hausmann attempted to bring about the rebirth of *187* society through new forms of free expression that utilized typography, photography, performance, and other media not contaminated by high art. The dire conditions of this rebirth and its source in the nihilistic violence of the war are reflected in a Dada manifesto of 1920: "The highest art will be that which in its conscious content presents the thousandfold problems of the day, the art which has been visibly shattered by the explosions of last week, which is forever trying to collect its limbs after yesterday's crash."[1]

With the accelerated tempo of life wrought by the automobile, telephone, and other technological inventions, time itself became a focus of art. The Italian Futurists were the first to consider the temporal trajectory of a movement as its essential quality. Anton Giulio Bragaglia's photodynamic stud- *186* ies, in which bodies dissolve into smears of suspended motion, are apt embodiments of the radical new conception of life as perpetual change and of art as articulated energy.

The desire to create a universally relevant art that would express the process of change and the expansion of human consciousness engendered a rash of photographic experiments that suppressed concrete forms and delimited space in favor of plastic, free-floating realms. X rays, for example, brought *176* invisible regions to light, while photograms—made by placing objects directly on the photographic paper—registered tangible things as elusive, disembodied *7* forms suspended in a mysterious, infinite zone. Although invented by Talbot,

the photogram was now perceived as a new kind of art—not a representation of visual experience, but a positional register of the artist's physical activities. In one of Man Ray's most extraordinary images, the background is a field of indistinct fluid shapes, the tracks of chemical solutions he poured in convoluted rivulets over the landscape of the paper. Above this space without horizon or gravity float incandescent geometric forms—building blocks of art laid on a map of an inchoate world—a prodigious parallel analogy of artistic and cosmic creation.

181

Utopian artistic visions of the immediate postwar period were most prevalent in Russia, where the Revolution of 1917 had effectively swept away the old order. Like his colleague Kasimir Malevich, El Lissitzky wanted to build a new art for the new age: poised in multidimensional space-time rather than grounded in perspectival space, this art would comprise new forms that were symbolic concretions of patterns of energy. Lissitzky found photography's malleable space the perfect element in which to deploy his vision. In a self-portrait made in 1924–25 while he recuperated from tuberculosis, the artist portrayed himself as both the architect and the casualty of a brave new world. Above vibrating spheres of metropolitan energy (labeled London, Paris, Berlin) the designer's compass floats, and between its scalpel-like arms hovers the artist's head in a surgical cap or bandage. A dematerialized projection of a romantic figure both strong and suffering, it is the very image of the heroic constructor-artist.

191

Photography was three-quarters-of-a-century old when such artists as Man Ray, Lissitzky, and László Moholy-Nagy explored its capacious plasticity and enriched the practice with an unparalleled expansion of expressive possibilities. The heady sense of a rich magazine of novel creative resources in a nontraditional medium made photography (and photocollage) the preferred vehicle for many of the most unconventional strategies of the European avant-garde. At the same time, this mechanized age saw photography's mechanical precision and its meticulous, seemingly irrefutable realism as straight paths to absolute truth.

190

The crisp details and clear contours of Charles Sheeler's eidetic rendition of an ocean liner (no. 237) provide the syntax for the classic mode of modern photographic objectivity. Framing his view to accentuate the ship's underlying abstract structure, Sheeler demonstrated how photography "account[s] for the visual world with an *exactitude* not equaled by any other medium."[2] Whereas the Dadaists had seen aesthetic pleasure as a danger to be avoided,

the objective modernists were in fact romantics highly invested in the sensuous qualities of the objects they described. Edward Weston's famous photograph of a toilet (no. 222) has none of the irony of Duchamp's 1917 urinal; instead, it strokes the glacial beauty of the ceramic sculpture, presenting the fixture as an expurgated form whose swelling contours and forward movement reminded the photographer of the Victory of Samothrace. And, though they make no parallel between industrial product and classical art, nudes by Weston and Stieglitz are *179* similarly imbued with the artist's delectation of the object of his regard. In the *185* face of on-running time, this reductive, ordered mode of seeing rigidly asserts formal coherence and, by concentrating on the specific and the tangible, paradoxically reveals the typical and the classical.

Maintaining the putative solidity and rational order of the world was an uncomfortable proposition for many artists of the time. A generation nurtured on simultaneity in art and literature, and marked in early maturity by the nihilism of war, the novel spaces of Constructivist art, and the ironies of Dada and Surrealism, did not always find great significance in meticulous records of the surfaces of discrete forms. Many artists, among them Henri Cartier-Bresson, Moholy-Nagy, and Walker Evans, recognized their subjective experience as the live filament that gave the world a meaningful charge and thus sought to integrate that response with photographic description.

Moholy-Nagy's *Dolls on the Balcony* presents a tangible reality within *177* an unsettling cage of shadow, as if to demonstrate the absence of any distinction between his perception and the external world. Similarly, he saw the fa- *163* cade of a house being painted as a careening plane where a birdlike painter is crazily perched. Walker Evans visually laminated dangling ex-votos with signs *178* for sweets hanging down the street, coolly coupling symbols religious and profane.

The master of the contingent, discontinuous context was Cartier-Bresson, *194* who persistently disrupted expectations of a coherent world with disjunctive incidents that his pictures keep in perpetual play. Compared to the ideal, static, transparent, and atemporal work of the romantic modernists, this way of seeing is inclusive, time-saturated, and antiromantic, and while highly subjective, it is so unnervingly detached as to seem impersonal.

In the years between the world wars photography also came to occupy a central place as the visual record of social consciousness. The mores of the people, the landscape of their lives, and "the thousandfold problems of the day" were the principal subject matter for photographers as diverse in their

styles as Eugène Atget, André Kertész, Brassaï, Dorothea Lange, and Alexander Rodchenko. Atget was heralded by Man Ray and the Surrealists for his photographs of window displays that melded reflections of the street with artifacts for sale, and for his pictures of places that seemed like so many theatrical stages pregnant with imminent action. His keen observations of the moments when today's traffic intersects society's immemorial concerns demonstrated far beyond Surrealist circles how photography could succinctly and evocatively describe cultural values as pervasive and almost as invisible as air.

165
169

The focus of the photographer's attention was frequently more pointed, topical, or political than Atget's. Kertész, for example, saw a confrontation between the proletariat and a gentleman and made it implicit in the structure of his picture. The impeccably attired bourgeois, a member of the Establishment, is planted like a tree on the quay, while the approaching workers, framing the dockside cranes, walk surely forward on the vector of the insistent perspective. Dorothea Lange's incisive glances into a crowd of demonstrators in San Francisco in 1933, like Robert Capa's indelible depiction of sudden death (no. 249), relay more urgent political messages.

167

193

Whether tracking current events or elliptically encoding less clamorous manifestations of social conditions, this kind of photograph works best when it conveys the impression that it owes nothing to the photographer—when it pretends to be an independent, even self-generated, objective report. This is why Rodchenko's photograph of asphalt pavers in Moscow appears so ambiguous. While intended as positive propaganda celebrating the construction of the people's state, the picture's unusual, canted vantage draws attention to itself—so much so that this startling visual strategy graphically conveys not enterprising progress but the impending destruction of a doomed race.

192

By the time photography was a century old artists, professionals, and amateurs had explored a wide gamut of the medium's creative and documentary capacities. The surprising inversions, suspensions, time-lapse distortions, bold contrasts, and exceptional plasticity of the medium so popular in the 1920s became part of contemporary visual language mostly through publication in the illustrated press. Through rotogravure reproduction the impact of photography was so greatly magnified that a widely disseminated image became more potent than type. Our present world, in which the photographic simulacrum is a frequent stand-in for reality—and often swallows up and replaces it altogether —was born in the years between the wars.

The emergence of this condition is nowhere more evident than in the

portraiture of the period. Correctly presuming that the public's appetite for fashion would be sharpened by images of the famous and the glamorous, Condé Nast hired Edward Steichen (no. 238) in 1923 to illustrate the pages of *Vanity Fair* with portraits of celebrities. A master packager of personalities, Steichen understood better than anyone before him how to turn to advantage the medium's seamless tonal scale, descriptive richness, and disingenuous fidelity. In his portrait of Princess Yusupov, for example, every detail is considered: the column of light to echo her sleek shape; the gleaming arc of the chair to point up the diamonds circling her wrist, the pearls draping her neck, and the iridescent band wrapping her forehead; the partial eclipse of her lunar face; and her modishly flattened (airbrushed) slanting belly. Whatever her actual character may have been, the suavely alluring yet distanced image presents a slightly sad but impenetrable persona.

The photographer and his subject may collude to present confections of any sort, but unless the basic artifice of the commercial portrait is revealed, the resulting picture becomes an impervious presentation, a mask held up to the larger world. Those portraits that dare to reveal the person behind the persona were generally not produced for public consumption but for private contemplation. The subtler and more vulnerable expressions of the sitters defy generalization; yet in Marsden Hartley's shell-shocked sensitivity (no. 211), James Joyce's introspection (no. 219), and the veteran worker's perseverance (no. 252), we catch a glimpse "behind the assurance of recorded history . . . towards the primitive terror."[3] Surely when they made these portraits, Stieglitz, Berenice Abbott, and Walker Evans recognized the mutuality of their condition, but trusted their art to transcend their common fate.

As malleable and various as thought itself, photography exposed the mind of the early modern epoch: its preoccupation with the present, its challenge of traditions and daring crossing of frontiers, its exalted and inherently unstable energies. If modern photographic vision seems unpredictable, vacillating between poles of realism and abstraction and between classicism and dynamism, it is because it mirrors an unruly time caught between violent memories and utopian hopes and again on the brink of war. It seems altogether fitting that photography's first century should come to full maturity only after the dissolution of the old world and the youthful visions of the new one were replaced by the complex actualities of the contemporary age.

Maria Morris Hambourg

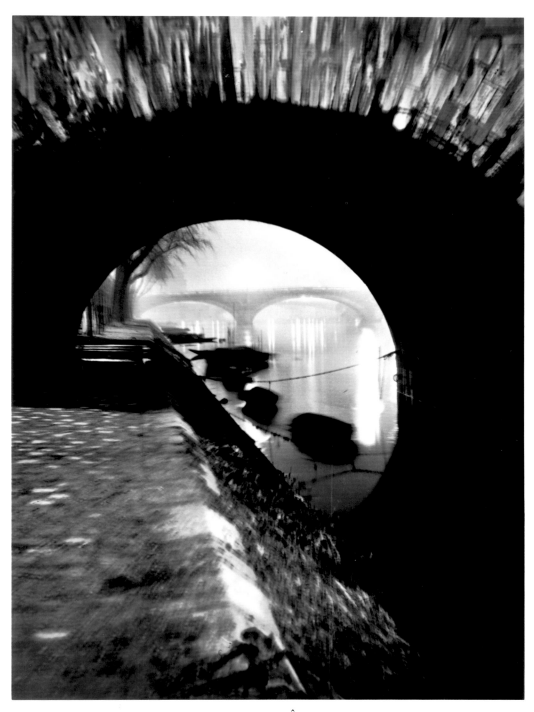

164. Brassaï (Gyula Halász), Pont Marie, Île Saint-Louis, ca. 1932 (no. 245)

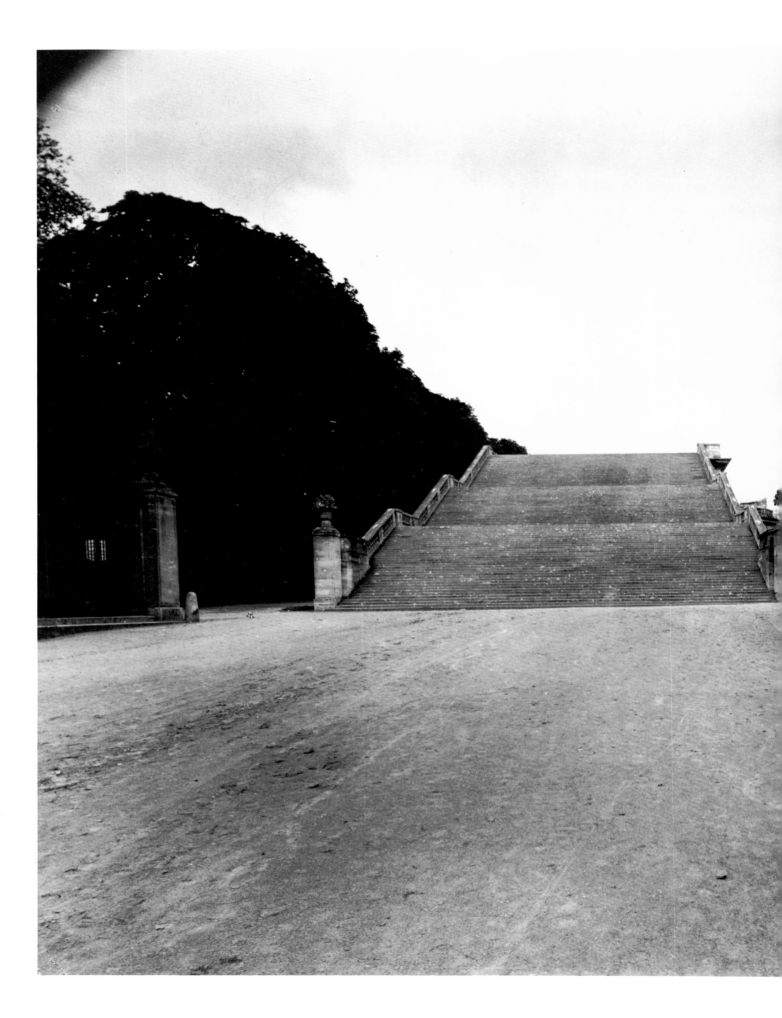

165. Eugène Atget,
Versailles, The Orangerie Staircase,
1901 (no. 204)

166. Eugène Atget, *Rue Asselin*, 1924–25 (no. 206)

167. André Kertész,
Afternoon Constitutional of M. Prudhomme, Retired,
1926 (no. 243)

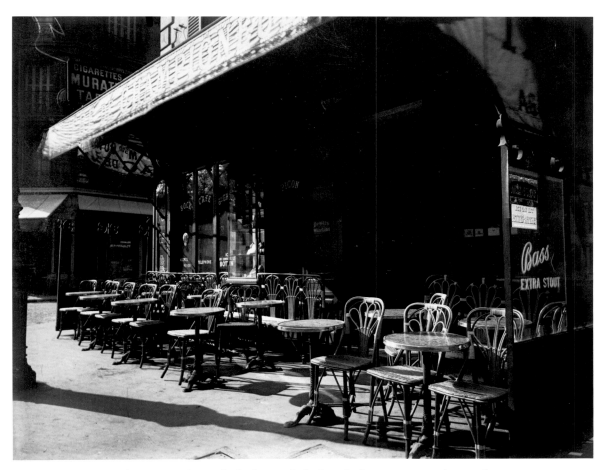

169. Eugène Atget, *Café, Avenue de la Grande-Armée*, 1924–25 (no. 205)

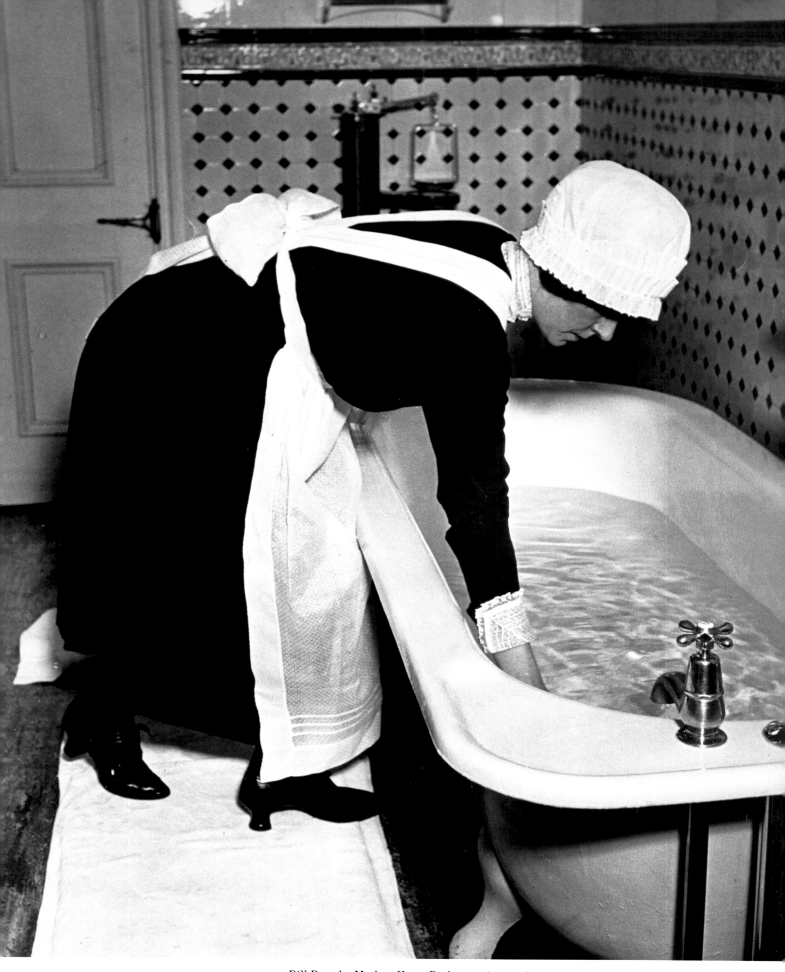

170. Bill Brandt, *Madam Has a Bath*, 1934 (no. 242)

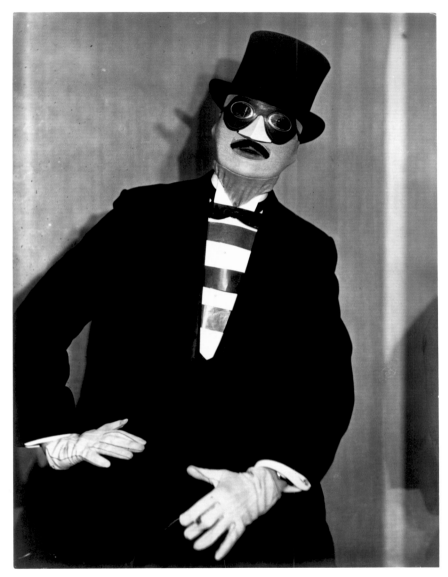

171. Paul Outerbridge, Self-Portrait, ca. 1927 (no. 241)

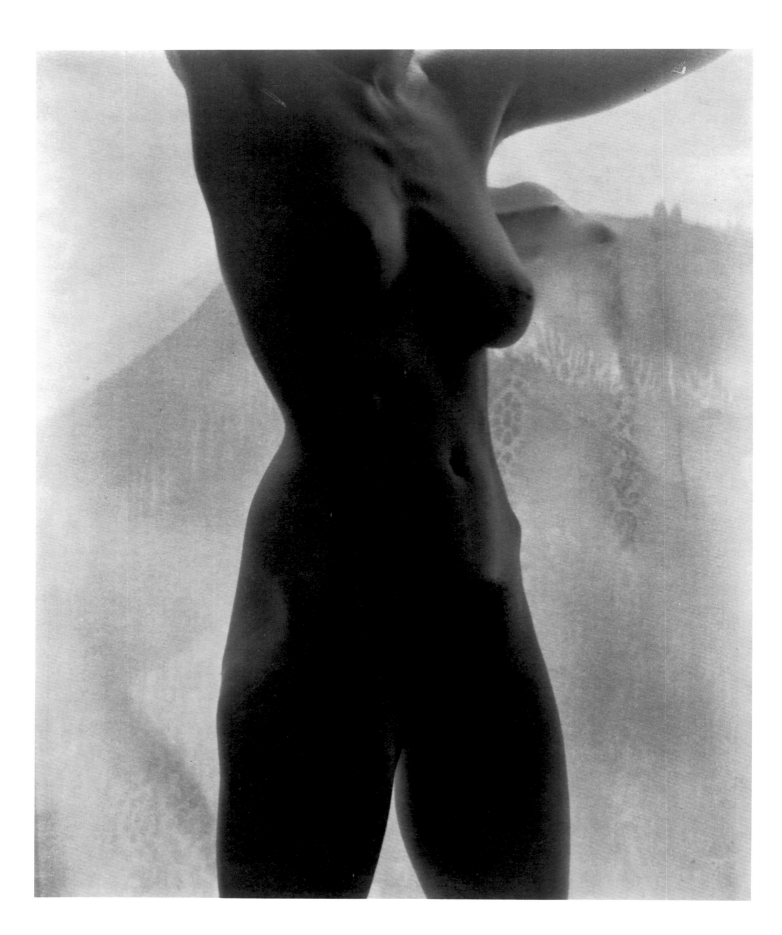

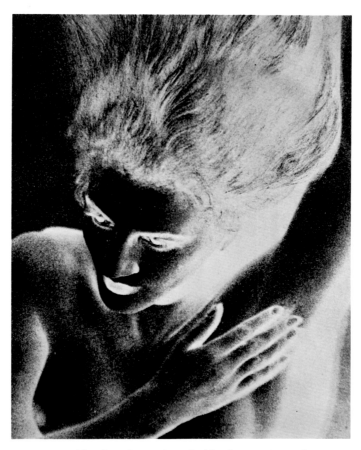

173. Man Ray, Jacqueline Goddard, 1930 (no. 218)

172. Alfred Stieglitz,
Georgia O'Keeffe,
1919 (no. 213)

175. Alexander Rodchenko, *Foxtrot*, 1935 (no. 228)

174. Alexander Rodchenko,
Morning Wash,
1930 (no. 227)

176. Anonymous, X Ray, 1916 (no. 208)

177. László Moholy-Nagy, *Dolls on the Balcony*, 1926 (no. 231)

179. Edward Weston, Nude, 1925 (no. 220)

178. Walker Evans,
Votive Candles, New York City,
1929–30 (no. 251)

180. Paul Strand, Pears and Bowls, 1916 (no. 209)

181. Man Ray, Rayograph, 1923–28 (no. 217)

182. Man Ray, *Woman*, 1918 (no. 214) 183. Harold Leroy Harvey, Self-Portrait with Camera and Model, ca. 1930 (no. 240)

184. Man Ray, *Marcel Duchamp*, ca. 1920 (no. 215)

185. Alfred Stieglitz, Georgia O'Keeffe, 1918 (no. 212)

186. Anton Giulio Bragaglia, *Change of Position*, 1911 (no. 207)

187. August Sander,
Raoul Hausmann,
1927–28 (no. 223)

189. Lux Feininger,
Eurythmy, or *Jump Over the Bauhaus*, 1927 (no. 232)

188. Martin Munkacsi,
Fun During Coffee Break,
1932 (no. 248)

191. El Lissitzky, Self-Portrait, 1924–25 (no. 229)

190. Mieczyslaw Berman, *Lindbergh II*, 1927 (no. 236)

192. Alexander Rodchenko, *Asphalting a Street in Moscow*, 1929 (no. 226)

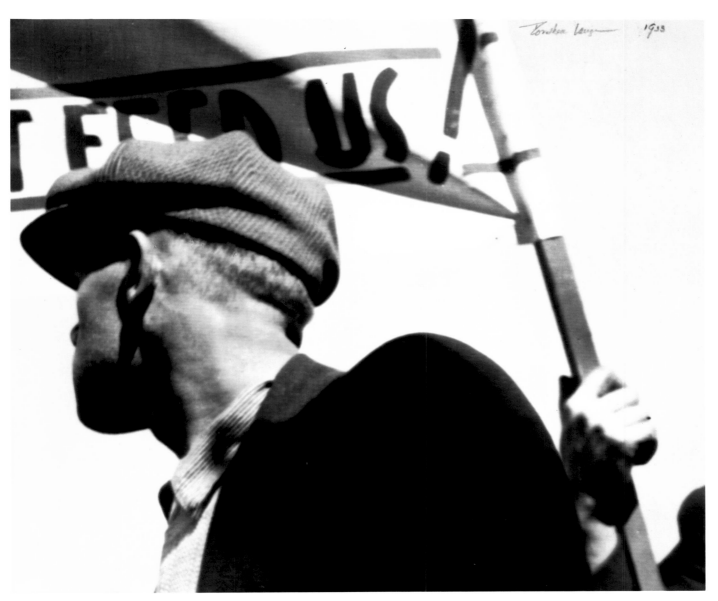

193. Dorothea Lange, Demonstration, San Francisco, 1933 (no. 250)

Overleaf: 194. Henri Cartier-Bresson, *Valencia, Spain,* 1933 (no. 247)

195. Gyorgy Kepes, *Shadow of a Policeman*, 1930 (no. 234)

196. Umbo (Otto Umbehr),
Night in a Small Town,
ca. 1930 (no. 233)

Catalogue of the Photographs

Note to the Reader

Titles in *italics* are those given by the artist.

Measurements for the photographs, given in centimeters and inches, height preceding width, are those of the image, not of the photographic paper, mount, or album page. For daguerreotypes, the measurements refer to that portion of the image visible through the presentation mat.

Authors are identified at the end of each entry by their initials:

JLR Jeff L. Rosenheim
MD Malcolm Daniel
MMH Maria Morris Hambourg
PA Pierre Apraxine
VH Virginia Heckert

1. William Henry Fox Talbot
British, 1800–1877

Botanical Specimen, 1835 (?)
Cameraless salted paper print
18.3 x 10.7 cm (7¼ x 4¼ in.)
Ex coll.: Harold White
Plate 1

This evanescent trace of a botanical specimen is among the earliest photographs known, dating from William Henry Fox Talbot's first period of experimentation with images produced solely by the action of light and chemistry. These earliest successful trials were cameraless images —what today we would call photograms. Here the plant itself was laid directly on top of a sheet of photosensitized paper, blocking the rays of the sun from darkening those portions it covered and thus leaving a light impression of its form.

To make his photogenic drawings (as he called this invention), Talbot used carefully selected writing paper prepared with a light coating of salt and brushed with a solution of silver nitrate. The lilac tone of this sheet is characteristic of his early prints, in which common salt was used to stabilize the photographic image after exposure.

Leaves, ferns, grasses, and other plants were often the subject of these early photogenic drawings, for Talbot was a serious and enthusiastic amateur botanist and he envisioned the accurate recording of such specimens to be among the important practical applications of his invention.

[MD]

2. Anonymous

Shark Egg Case, 1840–45
Cameraless salted paper print
18.6 x 11.4 cm (7⅜ x 4½ in.)
Ex coll.: Henry Bright
Plate 9

This sheet was mounted with other photogenic drawings of flowers, leaves, and keys on one page of an album of prints, drawings, and photographs assembled by the British watercolorist Henry Bright (1814–1873). It records the form of an egg case from the Scyliorhinidae family of sharks, native to the North Atlantic. Because the marine specimen did not lie flat against the photosensitized paper as a pressed leaf or flower would, the light passed over and around portions of its long tendrils, giving the illusion of the egg case still floating amid the vegetation of the sea bed.

[MD]

3. William Henry Fox Talbot
British, 1800–1877

Vase with Medusa's Head, 1840
Salted paper print from paper negative
16.9 x 21.1 cm (6⅝ x 8¼ in.)
Plate 11

Although photogenic drawings made from direct contact with objects constituted Talbot's first success, the impetus for his photographic experiments came from his desire to capture images seen in a camera obscura. This optical device, invented in the seventeenth century and in common use as a draftsman's aid by the eighteenth, consisted of a wooden box fitted with a lens that projected an image that could be traced on thin paper. Frustrated by his lack of facility as a draftsman as he sketched at Lake Como in 1833, Talbot recalled his use of a camera obscura a decade earlier and mused "how charming it would be if it were possible to cause these natural images to imprint themselves durably, and remain fixed upon the paper!"[1]

Sculpture and plaster casts were ideal subjects for Talbot's photographic experiments with the camera obscura; they reflected the sun well and remained motionless during the long exposures required for the lens-projected image to register on the sensitized paper. The camera image thus produced was tonally reversed—it was, in the words of Talbot's colleague Sir John Herschel, a "negative." To make a "positive" image, the negative made in the camera was itself placed in contact with photogenic drawing paper and exposed to sunlight. Although Talbot's process had the potential of producing hundreds of identical prints from a single negative, he printed very few positives of his 1839 and 1840 camera images. This print is thus one of the earliest and rarest of photographs, the tentative beginnings of a process destined to pervade modern life.

[MD]

4. Attributed to William Henry Fox Talbot and Nicolaas Henneman
British, 1800–1877; Dutch, 1813–1898

The Reading Establishment, 1846
Two salted paper prints from paper negatives
18.6 x 22.4 cm; 18.6 x 22.3 cm
(7⅜ x 8⅞ in.; 7⅜ x 8¾ in.)
Ex coll.: Harold White

The widespread distribution of large editions of photographic prints was the promise of Talbot's negative-positive process and its principal advantage over the contemporaneous French daguerreotype. In early 1844, in an effort to encourage the mass production of paper photographs, Talbot supported Nicolaas Henneman, his former valet, in

4

the creation of the first photographic printing firm. Situated in the town of Reading, the enterprise was equidistant from Talbot's London residence and his ancestral home at Lacock Abbey, in Wiltshire.

The activities of the Reading establishment are shown in this two-part image. Talbot, operating the camera at the center, makes a portrait of a seated gentleman, while at the right Henneman photographs a sculpture of the Three Graces. Other employees are shown copying an engraving, at left; standing with a second camera-back loaded with sensitized paper; and attending the racks of glass frames in which negatives and photographic paper are sandwiched for printing in sunlight. At the far right a man handles a focusing device, the precise function of which is no longer known.

This pair of prints was formerly in the collection of Harold White, who spent some thirty years at Lacock Abbey after World War II investigating the life of Talbot, salvaging and organizing documents related to the early history of photography, and preserving and classifying the photographs housed there. During his early years at Lacock, White chemically intensified some of Talbot's most faded prints in an attempt to retrieve their original appearance, a practice understandable in the context of the time but no longer favored by connoisseurs and historians of photography. The print on the right is one such example. [MD]

Talbot's photographic process was destined to change the art of the book and the dissemination of knowledge as had no other invention since movable type. Demonstrating the medium's potential, Talbot produced *The Pencil of Nature*, the first commercially published book to be illustrated with photographs. Issued in six fascicles from June 1844 through April 1846, it contained a total of twenty-four plates printed at Henneman's Reading establishment, as well as an introduction that described the history and chemical principles of Talbot's invention. The images and brief accompanying texts proposed, with extraordinary prescience, a wide array of applications for the medium.

An exceptional student first at Harrow and later at Cambridge, Talbot was a man of great learning and broad interests. Mathematics, astronomy, physics, botany, chemistry, Egyptology, philology, and the classics were all within the scope of his investigative appetite. *The Philosophical Magazine*, *Miscellanies of Science*, *Botanische Schriften*, *Manners and Customs of the Ancient Egyptians*, *Philological Essays*, *Poetae Minores Graeci*, and Lanzi's *Storia pittorica dell'Italia* are among the volumes represented

5. William Henry Fox Talbot
British, 1800–1877

A Scene in a Library, 1843–44
Salted paper print from paper negative
13.3 x 18 cm (5¼ x 7⅛ in.)

in this photograph, which appeared as plate 8 in *The Pencil of Nature*. Paradoxically, *A Scene in a Library* was taken out of doors, where the light was stronger. [MD]

6. William Henry Fox Talbot
British, 1800–1877

The Fruit Sellers, ca. 1845
Salted paper print from paper negative
17.1 x 21.1 cm (6¾ x 8¼ in.)
Plate 15

Talbot was not only a man of learning and a Fellow of the Royal Society, he was also a member of Great Britain's landed gentry. Following the death of his father, six-month-old Henry Talbot was named the sole heir to the sprawling and somewhat ruinous estate known as Lacock Abbey. Established in 1232, the abbey was converted into a private residence and its church demolished after the dissolution of the monasteries by Henry VIII in 1539. The fifteenth-century cloisters of the abbey are the setting for this scene, which may have been set up by Talbot's close friend and photographic disciple Calvert Jones.

 Portraiture and figure studies became a viable subject for photography only after Talbot's second important discovery. On September 23, 1840, Talbot had found a way to chemically excite—or develop, as we would say—the latent image that had registered on a sheet of photosensitized paper during an exposure too brief to imprint itself visibly. With this new process, patented by its inventor as the calotype or talbotype, exposure times could be reduced from minutes to seconds. [MD]

7. William Henry Fox Talbot
British, 1800–1877

The Open Door, 1844
Salted paper print from paper negative
14.3 x 19.4 cm (5⅝ x 7⅝ in.)
Ex coll.: Harold White
Plate 12

Among the most widely admired of Talbot's compositions, *The Open Door* is a conscious attempt to create a photographic image in accord with the renewed British taste for Dutch genre painting of the seventeenth century. In his commentary in *The Pencil of Nature*, where this image appeared as plate 6, Talbot wrote, "We have sufficient authority in the Dutch school of art, for taking as subjects of representation scenes of daily and familiar occurrence.

A painter's eye will often be arrested where ordinary people see nothing remarkable." With this concept in mind, Talbot turned away from the historic buildings of Lacock Abbey and focused instead on the old stone doorframe and simple wooden door of the stable and on the humble broom, harness, and lantern as vehicles for an essay on light and shadow, interior and exterior, form and texture. [MD]

8. William Henry Fox Talbot
British, 1800–1877

Hungerford Suspension Bridge, ca. 1845
Salted paper print from paper negative
16.9 x 21.3 cm (6⅝ x 8⅜ in.)
Ex coll.: Harold White

The newly completed Hungerford suspension bridge (1841–45), designed by Isambard Kingdom Brunel (see no. 22), was a powerful sign of Victorian engineering and industry and surely constituted, for Talbot, a dramatic counterpoint in this photograph to the old boats drawn up on the bank of the Thames in the foreground. Only fifteen years after its completion, this bridge was demolished and replaced by the Charing Cross railway bridge. Such was the pace of Victorian technology. [MD]

9. William Henry Fox Talbot
British, 1800–1877

View of the Boulevards at Paris, 1843
Salted paper print from paper negative
15.1 x 19.9 cm (6 x 7⅞ in.)

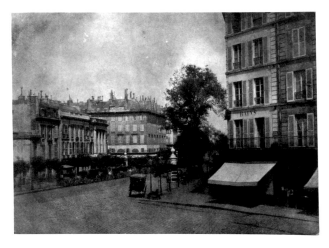

Talbot traveled to Paris in May 1843 to negotiate a licensing agreement for the French rights to his patented calotype process and, with Henneman, to give firsthand instruction in its use to the licensee, the Marquis of Bassano.

No doubt excited to be traveling on the continent with a photographic camera for the first time, Talbot seized upon the chance to fulfill the fantasy he had first imagined on the shores of Lake Como ten years before. Although his business arrangements ultimately yielded no gain, Talbot's views of the elegant new boulevards of the French capital are highly successful, a lively balance to the studied pictures made at Lacock Abbey. Filled with the incidental details of urban life, architectural ornamentation, and the play of spring light, this photograph, unlike much of the earlier work, is not a demonstration piece but rather a picture of the real world. The animated roofline punctuated with chimney pots, the deep shopfront awning, the line of waiting horse and carriages, the postered kiosks, and the characteristically French shuttered windows all evoke as vivid a notion of mid-nineteenth-century Paris now as they must have when Talbot first showed the photographs to his friends and family in England.

A variant of this scene, taken from a higher floor in Talbot's Paris hotel, appeared as plate 2 in *The Pencil of Nature*. [MD]

10. William Henry Fox Talbot
British, 1800–1877

Trees with Reflection, early 1840s
Salted paper print from paper negative
16.5 x 19.2 cm (6½ x 7½ in.)
Plate 10

For some pictures Talbot turned his camera toward subjects traditionally thought suitable for artistic representation, scenes of picturesque beauty or sites of historic interest. For others he arranged objects or people in aesthetic

tableaux. For still others, such as this one, Talbot must surely have viewed the world through his camera and found on its ground glass an abstract composition that he would not have envisaged as a picture without the framing and spatial flattening characteristic of photographic observation. [MD]

11. Attributed to William Henry Fox Talbot
British, 1800–1877

Carpenter and Apprentice, ca. 1844
Salted paper print from paper negative
15.5 x 14.9 cm (6⅛ x 5⅞ in.)
Ex coll.: Harold White

Though lacking the absolute precision of the daguerreotype and later photographic processes, the paper negative admirably rendered blocks of tone, describing form and space in terms of shaded planes, a quality exploited here to enhance the highly geometric structure of the image. Even with the reduced exposure time of Talbot's calotype process instantaneous, or "stop-action," views were beyond the grasp of the nascent medium; instead, Talbot sometimes sought the illusion of spontaneity through staged scenes such as this one. [MD]

12. David Octavius Hill and Robert Adamson
British, 1802–1870; 1821–1848

Cottage Door, 1843
Salted paper print from paper negative
19.5 x 14.1 cm (7⅝ x 5½ in.)

Calvert Jones applied his considerable experience as a watercolorist and amateur daguerreotypist to his use of the calotype process, but he struggled with the required manipulations and formulations and finally sought instruction directly from Talbot and Henneman in 1845. Clearly grasping the potential of photography to bring the world to the armchair traveler, Jones was eager to master the calotype before setting sail for Malta and Italy later that year in the company of Kit Talbot, a cousin of Henry Talbot. It was Kit, a friend and Oxford schoolmate, who introduced Jones to the calotype process. More adept at composing his pictures than at printing them, Jones sent most of his Maltese and Italian negatives to Henneman's Reading establishment for printing and sale.

Given Jones's greater attention to the negative than to the positive, it is not surprising to find that this image, made after his return to England, is far more legible and engaging than most paper negatives. Waxed and ironed for extra translucency, the negative yields nearly all its detail and sculptural presence, as if it were itself a positive print. The young man, perhaps Jones's gardener David Roderick, appears in many of his photographs. [MD]

Taken by the painter David Octavius Hill and the calotypist Robert Adamson in the first year of their brief but prolific partnership, *Cottage Door* is among the first of some 130 images the two would make that show the inhabitants of Newhaven and other small but vital fishing villages near Edinburgh. The project, entitled *The Fishermen and Women of the Firth of Forth*, constitutes the first sustained use of photographs for a social documentary project.

While the fishermen's work at sea was largely beyond the ken of the camera, the women's labor—baiting lines, unloading and cleaning the catch, hauling loaded willow baskets up the hill to Edinburgh, and hawking their fish—was highly accessible, and extensively documented by Hill and Adamson. The calotype, with its rough texture and strong contrasts of light and shadow, was the perfect medium to translate into graphic terms the patterning of the traditional striped aprons of the fishwives, their woolen petticoats, the woven baskets, and the line of fish hung out to dry in the sun.

Hill and Adamson's project seems intended to present Newhaven, in the age of the Industrial Revolution and its attendant social problems, as an exemplar of village life—a community bound by tradition, mutual support, honest labor, and continuity of generations. [MD]

13. Calvert Richard Jones
British, 1802–1877

Young Man, late 1840s
Paper negative
20.9 x 15.8 cm (8¼ x 6¼ in.)
Plate 21

14. Calvert Richard Jones
British, 1802–1877

Sleeping Cat, 1850–55
Salted paper print from glass negative
8.1 x 10.2 cm (3¼ x 4 in.)

Many of Jones's pictures were made with commercial distribution in mind; the photographer hoped to contribute images to Talbot's *Pencil of Nature* and to the stock of prints for sale at Henneman's Reading establishment. In this picture, however, we see the opposite aspect of Jones's

production, the work of an amateur delighting in the camera's ability to capture the intimate aspects of domestic life and to translate them into novel pictorial terms.

[MD]

15. John Dillwyn Llewelyn
British, 1810–1877

Thereza, ca. 1853
Salted paper print
23.2 x 18.9 cm (9⅛ x 7½ in.)
Plate 16

Within a week of Talbot's public presentation of the photogenic drawing process, John Dillwyn Llewelyn was trying his hand at the new technique. He owed his early introduction to the invention to his wife, the inventor's first cousin Emma Thomasina Talbot. This page from an album belonging to Llewelyn's daughter Emma Charlotte (1837–1929) combines the two principal means of photographic picture-making invented by Talbot: an image made by direct contact with an object (see no. 1) and a camera image printed from a negative. The picture presents two characteristic pursuits of educated Victorian women, art and science, the dual poles that also characterized amateur photography itself.

Many nineteenth-century pictures were surrounded by decorative borders of lace, cut paper, or ink and watercolor, often the inventive product of a young woman of leisure. In a clever variation of this convention, Llewelyn's border records the shadow of a lacy wreath of maidenhair fern. In the central vignette we see Thereza (1834–1926), another of the photographer's daughters, shown with books, botanical specimens, and scientific apparatus. Typical of well-educated and well-to-do Victorian women, Thereza pursued varied interests, including botany, microscopy, astronomy, and photography.

Llewelyn seems to suggest a relationship between the floral border and the view seen by his daughter—between the lens of the camera and that of the microscope—prompting the viewer to muse on the parallel means of optical discovery.

[MD]

16. Thomas Keith
British, 1827–1895

Trees, ca. 1854
Salted paper print from paper negative
30.3 x 22.1 cm (11⅞ x 8¾ in.)
Plate 17

Thomas Keith's introduction to photography most likely came through his father, a minister and founder of the Free Church of Scotland, who was photographed by David Octavius Hill. Keith apparently developed a friendship with Hill, emulating the eminent photographer's use of the calotype, collecting his prints, and photographing some of the same sites in and around Edinburgh.

A surgeon and gynecologist by profession and a photographer by avocation, Keith applied his medical habits of orderly procedure and exactitude to the execution of his photographs: he prepared his paper negatives in advance, at night, and allowed himself to photograph only when the limpid early morning or late afternoon light guaranteed a successful result. His pictorial sensibility, however, was not bound by such prescripts; often, as in this picture, he appears to have reveled in the harsher, more disorderly elements of the Scottish countryside, in aspects of nature not immediately beautiful. Here, as he trod the scruffy woodland path and simple plank crossing a dry streambed, Keith saw aesthetic—and, one may surmise, human—value in the cant of a tree, its roots undermined by earlier torrents, as it leans into the embrace of its more substantial partner.

[MD]

17. Roger Fenton
British, 1819–1869

Rosslyn Chapel, South Porch, 1856
Salted paper print from glass negative
35.8 x 43.3 cm (14⅛ x 17 in.)

Roger Fenton is a seminal figure in the history of British photography as much for his advocacy of the highest standards for the new medium through the founding of the Photographic Society in London in 1853 as for his own

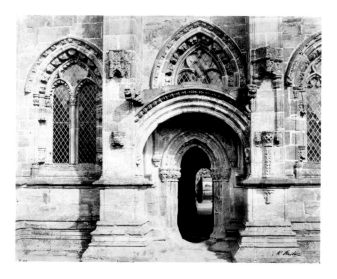

artistic achievements. In his early years he pursued, simultaneously, studies in both law and painting in London and in Paris. As a photographer he achieved public recognition mainly as an accredited photographer of the Crimean War, in 1855. Fenton was very much aware of the technical advances being made in France. He was also impressed by the concern of the French government for the preservation of historic sites, and the commissioning, in 1851, of photographic surveys of the country's architectural heritage. As such patronage did not exist in Great Britain, Fenton made his architectural studies on his own initiative, traveling extensively throughout England, Scotland, and Wales.

Fenton photographed Rosslyn Chapel, a site celebrated in verse by such poets as Sir Walter Scott, Wordsworth, and Lord Byron, during his first photographic expedition to Scotland. Erected in 1466 by William St. Clair, earl of Rosslyn, the chapel, a striking example of Late Gothic ornamentation, is the choir of a collegial church that was never completed. In Fenton's image the wall rises as a forbidding mass, abruptly blocking one's path; the narrow portal, however, allows the eye to enter and bore through the dark interior before reaching the sunlit countryside beyond. In this interplay between mass and space, dark and light, Fenton brings to his picture the very tensions of the architecture he describes.

The print bears the photographer's rare signature.

[PA]

18. Roger Fenton
British, 1819–1869

Rievaulx Abbey, 1854
Albumen silver print from glass negative
35.6 x 29.8 cm (14 x 11¾ in.)
Plate 13

From 1854 onward Fenton made repeated visits to the great Cistercian abbeys of Fountains and Rievaulx, in Yorkshire. Of Rievaulx, dating to 1230 and renowned for the purity of its architecture, only parts of the transept and the early Gothic choir remain. Fenton chose for his vantage point an elevated position in the apse so that his lens could encompass the majestic procession of the choir pillars, and frame through the grand arch of the transept the pleasant disorder of the rural view. To enhance the relation between the Gothic structure and its site, Fenton photographed the view at the precise moment when the morning sun would sharply delineate the base of the triforium on the right, aligning it with the contour of the distant hill.

Rather than offering an archaeological or picturesque description of the architecture, Fenton here attempts to convey the stillness of the scene, the vastness of the enclosure, and the smallness of the individual amid the

grandeur of nature and the weight of history. The young woman, who serves as a stand-in for the viewer in all the Rievaulx pictures and whose presence is essential to the perception of scale, is thought to be Fenton's wife, Grace.

[PA]

19. Roger Fenton
British, 1819–1869

The Wharfe and Pool Below the Stride, 1854–58
Albumen silver print from glass negative
34.5 x 28.2 cm (13⅝ x 11⅛ in.)
Plate 8

The river Wharfe in Yorkshire was a favorite with tourists in Fenton's time. The setting of Bolton Priory (known as Bolton Abbey) on a promontory overlooking the river inspired Turner and was praised by Ruskin. Fenton may have made this image on his first photographic expedition through Yorkshire in 1854. He showed his views of Bolton and its surroundings, together with those of Fountains and Rievaulx, at the annual exhibition of the Photographic Society in January 1855. These photographs established him as a master of architectural and landscape photography.

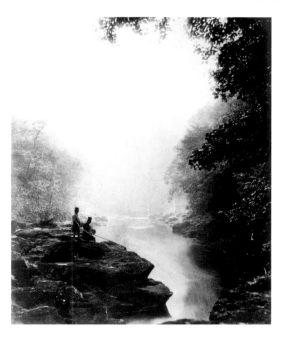

Boldly facing into the sun, Fenton chose to focus his lens on that part of the river where the water, after rushing through the turbulent pass of the Stride, a rocky channel a few feet wide, slows down and settles into a pool. Emulating Turner, he conceived of his subject in terms of light, here light trapped between the banks of the river, uniting sky and water in a continuous flow. As in the paintings of

Turner, Fenton's figures are present mainly to animate the foreground. The photographer would seek similar painterly effects in other landscapes, but this image, with its faintly modulated expanse of airy emptiness, remains one of his most radical. [PA]

20. Roger Fenton
British, 1819–1869

Interior, Salisbury Cathedral, ca. 1858
Albumen silver print from glass negative
30.2 x 31.1 cm (11⅞ x 12¼ in.)
Plate 36

The dark interiors of Gothic cathedrals posed a particular challenge to early photographers. By leaving the shutter open perhaps as long as several hours, Fenton achieved the technical tour de force of making clearly legible the cathedral's lofty ordinance while at the same time registering the nuances of semidarkness peculiar to the Gothic space.

Salisbury Cathedral, in Wiltshire, is seen here from the south transept looking northwest. Built over the unusually short period of only thirty-six years, from 1220 to 1256, it stands out among the English cathedrals for the uniformity and harmony of its design. The interior, however, is generally thought to lack warmth, the result of the loss of the original stained-glass windows and of the radical restoration carried by James Wyatt in 1788–89, in which screens and chapels were removed and funerary monuments rearranged in tidy rows. Ironically, these unfortunate changes may well have contributed to Fenton's success with the photograph. The absence of stained glass made for more light, and the order brought to the interior exposed its essential lines. [PA]

21. Roger Fenton
British, 1819–1869

Lambeth Palace, 1857
Albumen silver print from glass negative
33.9 x 42.2 cm (13⅜ x 16⅝ in.)

One of the most striking alterations to London's mid-nineteenth-century architectural landscape was the erection in 1837–50 of the new Houses of Parliament, designed by Sir Charles Barry in association with Augustus Pugin, in the Gothic perpendicular style. Fenton made several photographs of the new building, beginning with general views that he took moving downstream from Lambeth Palace on the opposite bank of the Thames and ending with close-ups that show ornamental details. In this

image, which opens the series, the photographer has focused his attention on the south gate of the palace. The powerful Tudor edifice, built from 1486 to 1501, the official residence of the Archbishop of Canterbury, contrasts in its mass and tonal values with the delicate, lacy outline of the new Parliament buildings, showing the Clock Tower still unfinished; the arches of the old Westminster Bridge in the distance provide a graphic link between the two. The scene—with its barren foreground, and in the mid-ground the photographer's van, his assistant, a palace guard, and a lone sightseer—is like a stage set, the old building with its primitive simplicity facing, across the Thames, the self-assured elegance of the new. [PA]

22. Robert Howlett
British, 1831–1858

Isambard Kingdom Brunel Standing Before the Launching Chains of the Great Eastern, 1857
Albumen silver print from glass negative, 1863–64
28 x 21.5 cm (11 x 8½ in.)
Plate 24

Robert Howlett photographed Isambard Kingdom Brunel at the time of the launching of the *Great Eastern*, or, as he called it, his "great babe." More than anyone else of his generation Brunel had been responsible for the transformation wrought upon Britain by the Industrial Revolution, building railways, terminals, tunnels, dry docks, piers, and bridges. Two steamships of his design were the largest ships afloat. The *Great Eastern*, which incorporated many novel solutions to shipbuilding, was intended to be his crowning achievement. It proved, however, to be unsuccessful as a passenger ship and, after several runs on the Atlantic line, was used to lay telegraphic cables.

The photographer posed the engineer in front of the giant chains that were wound around the huge checking

drums to serve as restraints in the launching. A man of modest stature and strength but of great nervous energy, Brunel was seldom seen in public without a cigar and the cigar box he carried on a strap over his shoulder. The pose and expression convey self-assurance and determination, and the mud-spattered trousers and boots show a man of action involved in all the aspects of the job. A memorable depiction of the engineer as hero, this portrait, which bears Brunel's facsimile signature, was published as a memento in 1863–64, after the deaths of both the photographer and the subject. [PA]

Robert Howlett, a partner at the Photographic Institution, a leading professional studio in London, was commissioned by the London *Times* to document the ship's construction. He made this image sometime before November 3, 1857, the official day of the launching. On January 16, 1858, nine engravings based on Howlett's photographs were published in a special edition of the *Illustrated Times* devoted to the *Leviathan*, as the ship was then known. A close variant of this image, dated November 2, 1857, is in the collection of the Victoria and Albert Museum. [PA]

23. Robert Howlett
British, 1831–1858

The Bow of the *Great Eastern*, 1857
Albumen silver print from glass negative
27.9 x 36.5 cm (11 x 14⅜ in.)
Ex coll.: Isambard Kingdom Brunel
Plate 25

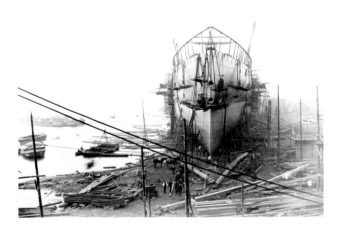

The bow of the *Great Eastern*, still embedded in its matrix of scaffolding and timber, looms like a cliff over the marshy landscape of the Isle of Dogs. Designed by Isambard Kingdom Brunel, arguably the greatest engineer of his time, the giant ship had been four years in the making and had generated unabated interest and controversy. Six hundred ninety-two feet in length and weighing 22,500 tons, it was six times the tonnage of any ship yet built and was to be propelled by all the technology then available —screw, paddle, and sail. Because of its size, it had to be moved sideways, foot by foot, and it would take an unprecedented three months to launch. Its success was seen as a matter of national pride, a confirmation of Britain's supremacy at sea.

24. Robert Howlett
British, 1831–1858

The Stern of the *Great Eastern*, 1857
Albumen silver print from glass negative
28.3 x 34.1 cm (11⅛ x 13⅜ in.)
Ex coll.: Isambard Kingdom Brunel
Plate 23

The stern of the *Great Eastern* fills the page with the elegant perfection of a form new to the age. Until this time the beauty of the purely functional had not yet been deemed a worthy subject for art. Howlett's dramatic presentation foreshadows the homage photographers would pay in the following century to the aesthetics of the machine. [PA]

25. Count de Montizon (Juan Carlos María Isidro de Borbón)
Spanish, 1822–1887

The Hippopotamus at the Zoological Gardens, Regent's Park, 1852
Salted paper print from glass negative
11 x 12.2 cm (4⅜ x 4¾ in.)
Plate 26

Although his childhood was spent at the court of his uncle Fernando VII, the king of Spain, Prince Juan de Borbón spent the major part of his life in England, in exile following his father's violent challenge to the succession of Fernando's daughter Isabel II in 1833. Apparently harboring no royal ambitions, Juan assumed the somewhat obscure title of Count de Montizon in public and, when the dubious title of pretender to the Spanish throne passed to him from his elder brother, he renounced all claim in favor of Queen Isabel. His passions, instead, ran to physics, chemistry, and natural history; photography, it seems, was an appropriate amateur pursuit that combined all three interests.

This photograph was the Count de Montizon's contribution to *The Photographic Album for the Year 1855*, a publication of the Royal Photographic Society's Photographic Exchange Club. The accompanying text reads: "This animal was captured in August 1849, when quite young, on the banks of the White Nile; and was sent over to England by the Pasha of Egypt as a present to Queen Victoria. He arrived at Southampton on May 25, 1850; and on the evening of the same day was safely housed in the apartment prepared for him at the Zoological Gardens, where he has ever since been an object of great attraction."

The animals of the Zoological Gardens were a favorite subject for the count's demonstrations of photography's capacity to arrest movement in photographs "taken on collodion with a double lens, by instantaneous exposure" (as he wrote in the technical caption for this picture). If the notion of instantaneity seems incongruous in this picture of a sluggish and corpulent hippo, it is perhaps better seen in the curious spectators who, from the photographer's vantage point, appear to be the zoo's caged inhabitants. [MD]

26. Roger Fenton
British, 1819–1869

Still Life with Fruit, 1860
Albumen silver print from glass negative
35.2 x 43.1 cm (13⅞ x 17 in.)
Plate 27

As the appointed photographer of the British Museum from 1854 to 1860, Fenton had ample opportunity to develop his skills photographing stationary objects of various sizes and materials, from antique busts to skeletons of animals and birds. In 1860 he embarked on a series of about forty still lifes of fruits and flowers arranged on marble or on fabric. The presence of the same fruits in more than one image suggests that the studies were made during a relatively short period of time. In the best examples flowers and fruit are grouped together in tight compositions, either in casual heaps or as a wall of berries and petals. Here, photographing at close range and at eye level, Fenton conceived of his subject as a study in textures, piling detail upon detail and heightening its tactile diversity: the prickly scales of the pineapple, the pocked skin of the strawberry, the delicate transparency of the white currant, the heaviness of the black grapes. The abundance of sensory information in the compressed photographic space attracts and disturbs at the same time, injecting a disquieting and characteristically Victorian horror vacui into a centuries-old theme.

These still-life studies, also published as stereoscopic cards, were exhibited in 1861. They were to be Fenton's last effort. After ten years of practice, without explanation, he abandoned photography. [PA]

27. Horatio Ross
British, 1801–1886

Stag in Cart, ca. 1858
Albumen silver print from glass negative
26.7 x 32.6 cm (10½ x 12⅞ in.)
Plate 18

Far better known in his own day as an athlete and a sportsman than as a photographer, Horatio Ross was, even in his sixties, judged the finest shot in Scotland. For more than sixty years he excelled in deerstalking, which he described as "the most fascinating of all British field-sports."[2] Keen on the challenge of pitting his knowledge, stamina, and experience against the superior senses of smell, sight, and hearing in deer, Ross nevertheless possessed a gentlemanly concern for avoiding undue suffering in his kills and for maintaining the forest.

Proud of his ability, Ross photographed this trophy with a remarkable directness unsettlingly unromanticized in its four-square presentation and extreme realism. The stag, antlers pointed toward the viewer, seems not only to spill out of the tilted cart but out of the picture itself. [MD]

28. Horatio Ross
British, 1801–1886

Tree, ca. 1858
Albumen silver print from glass negative
24.7 x 30.7 cm (9¾ x 12⅛ in.)
Plate 19

Essential to the stalker's success, one reads in Alexander MacRae's *Handbook of Deer-Stalking* (1880), with an introduction by Ross, is an intimate knowledge of the terrain, a practiced ability to judge distance, exceptional attentiveness in observation, and an unhurried strategy of undetected advancement. Just such qualities seem to have informed Ross's view of the landscape through the spreading branches of a tree. [MD]

29. Henry Peach Robinson
British, 1830–1901

"She Never Told Her Love," 1857
Albumen silver print from glass negative
18 x 23.2 cm (7⅛ x 9⅛ in.)
Plate 20

Consumed by the passion of unrequited love, a young woman lies suspended in the dark space of her unrealized dreams in Henry Peach Robinson's illustration of the Shakespearean verse "She never told her love,/ But let concealment, like a worm i' the bud,/ Feed on her damask cheek" (*Twelfth Night* II, iv,111–13). Although this picture was exhibited by Robinson as a discrete work, it also served as a study for the central figure in his most famous photograph, *Fading Away*, of 1858.

Purportedly showing a young consumptive surrounded by family in her final moments, *Fading Away* was hotly debated for years. On the one hand, Robinson was criticized for the presumed indelicacy of having invaded the death chamber at the most private of moments. On the other, those who recognized the scene as having been staged and who understood that Robinson had created the picture through combination printing (a technique that utilized several negatives to create a single printed image) accused him of dishonestly using a medium whose chief virtue was its truthfulness.

While addressing the moral and literary themes that Robinson believed crucial if photography were to aspire to high art, this picture makes only restrained use of the cloying sentimentality and showy technical artifice that often characterize this artist's major exhibition pictures. Perhaps intended to facilitate the process of combination printing, the unnaturally black background serves also to envelop the figure in palpable melancholia. [MD]

30. Hugh Welch Diamond
British, 1808–1886

Patient, Surrey County Lunatic Asylum, 1850–58
Albumen silver print from glass negative
19.1 x 14 cm (7½ x 5½ in.)
Plate 33

A medical doctor, antiquarian, and collector of prints, Hugh Diamond is a prime example of a gentleman amateur who furthered the development of the new medium of photography. He made his first photograph in April 1839, only three months after Talbot's demonstration of the invention, was instrumental in founding the Photographic Society in 1853, and through publications and informal gatherings taught many photographers, including Henry Peach Robinson, to use both the calotype and the collodion processes.

Following Sir Alexander Morison as the superintendent of the Surrey County Lunatic Asylum, from 1848 to 1858 Diamond updated—with photographs—his predecessor's

atlas of engraved portraits of the patients. Working in the belief that mental states are manifested in the physiognomy and that photographs are objective representations of reality, Diamond described himself as a photographer as one who "catches in a moment the permanent cloud, or the passing storm or sunshine of the soul, and thus enables the metaphysician to witness and trace out the connexion between the visible and the invisible."[3]

This photograph may have been made to identify the patient or, by recording a phase of the disease, to serve the doctor's diagnosis. Because the image is not annotated the viewer may, like the metaphysician, muse on whether the woman's engaging but ambiguous smile and almost cocky pose denote a state of madness, a return to health, or a challenge to society's parameters of sanity. [MMH]

31. Lewis Carroll (Charles Lutwidge Dodgson)
British, 1832–1898

Alice Liddell as "The Beggar Maid," ca. 1859
Albumen silver print from glass negative
16.3 x 10.9 cm (6⅜ x 4¼ in.)
Plate 28

Known primarily as the author of children's books, Lewis Carroll was also a lecturer in mathematics at Oxford University and an ordained deacon. He took his first photograph in 1856 and pursued photography obsessively for the next twenty-five years, exhibiting and selling his prints. He stopped taking pictures abruptly in 1880, leaving over three thousand negatives, for the most part portraits of friends, family, clergy, artists, and celebrities. Ill at ease among adults, Carroll preferred the company of children, especially young girls. He had the uncanny ability to inhabit the universe of children as a friendly accomplice, allowing for an extraordinarily trusting rapport with his young sitters and enabling him to charm them into immobility for as long as forty seconds, the minimum time he deemed necessary for a successful exposure. The intensity of the sitters' gazes brings to Carroll's photographs a sense of the inner life of children and the seriousness with which they view the world.

Carroll's famous literary works, *Alice's Adventures in Wonderland* (1865) and *Through the Looking Glass and What Alice Found There* (1872), were both written for Alice Liddell, the daughter of the dean of Christ Church, Oxford. For Carroll, Alice was more than a favorite model; she was his "ideal child-friend," and a photograph of her, aged seven, adorned the last page of the manuscript he gave her of *Alice's Adventures Underground*. The present

image of Alice was most likely inspired by "The Beggar Maid," a poem written by Carroll's favorite living poet, Alfred, Lord Tennyson, in 1842. If Carroll's images define childhood as a fragile state of innocent grace threatened by the experience of growing up and the demands of adults, they also reveal to the contemporary viewer the photographer's erotic imagination. In this provocative portrait of Alice at age seven or eight, posed as a beggar against a neglected garden wall, Carroll arranged the tattered dress to the limits of the permissible, showing as much as possible of her bare chest and limbs, and elicited from her a self-confident, even challenging stance. This outcast beggar will arouse in the passer-by as much lust as pity. Indeed, Alice looks at us with faint suspicion, as if aware that she is being used as an actor in an incomprehensible play. A few years later, a grown-up Alice would pose, with womanly assurance, for Julia Margaret Cameron.

[PA]

32. Lewis Carroll (Charles Lutwidge Dodgson)
British, 1832–1898

St. George and the Dragon, ca. 1874
Albumen silver print from glass negative
11.6 x 14.8 cm (4⅝ x 5⅞ in.)
Plate 29

In 1872, Carroll had a studio built above his rooms at Christ Church so that he could make photographs even in inclement weather. With trunks full of toys and costumes from the Drury Lane Theatre, the "glass house" was a paradise for children. Xie (Alexandra) Kitchin, a beautiful and photogenic child, was Carroll's muse in the 1870s. Born in 1864, she was the daughter of George William Kitchin, a colleague and an old friend from Carroll's student days at Oxford. Carroll photographed Xie more than any other of his models, often dressed in exotic costume.

In this tableau vivant, Xie plays the princess to her brother's St. George. Another knight-brother has fallen prey to the leopard-skin dragon. The princess, clearly the focus of the picture, is ready for sacrifice, though St. George's sword seems the only threat. The photographer here casts the children in the roles of adults, creating a seemingly innocent vignette; it is, however, one that the modern viewer will find fraught with double entendres.

[PA]

33. Lewis Carroll (Charles Lutwidge Dodgson)
British, 1832–1898

Irene MacDonald, Flo Rankin, and Mary MacDonald at Elm Lodge, 1863
Albumen silver print from glass negative
22.2 x 18 cm (8¾ x 7⅛ in.)
Plate 31

Irene and Mary MacDonald were two of the five children of Scottish novelist and poet George MacDonald. Carroll was a friend of the family, and the children affectionately called him "Uncle." It was the MacDonalds, to whom he read the manuscript of *The Adventures of Alice*, who urged him to publish the work. Carroll photographed the family on several occasions. This photograph, which includes the children's friend Flo Rankin standing in the middle, was produced during the photographer's stay at Elm Lodge in Hampstead the week of July 25, 1863.

When not disguising his sitters, Carroll preferred to photograph them posing naturally in everyday attire. Perhaps the elaborate dress Flo was wearing on her visit prompted Carroll to create this unusual set piece, which alludes to the figure of Flora in Botticelli's *Spring* and to the mythologizing work of his Pre-Raphaelite painter friends Dante Gabriel Rossetti and Arthur Hughes. Young girls arrayed in wild flowers signified the purity and innocence of childhood, a concept dear to the Victorians. The lens, however, has unwittingly denounced the conceit of such an unsullied universe. The figure of Flo Rankin may be adorned as a child, but it is a young woman sure of her appeal who locks gazes with the viewer, on her lips the ironic flutter of a smile.

[PA]

34. Clementina, Lady Hawarden
British, 1822–1865

Photographic Study, early 1860s
Albumen silver print from glass negative
20 x 14.4 cm (7⅞ x 5⅝ in.)
Plate 14

Clementina, Lady Hawarden, is a poetic, if elusive, presence among nineteenth-century photographers. As a devoted mother, her life revolved around her eight children. She took up photography in 1857; using her daughters as models, she created a body of work remarkable for its technical brilliance and its original depiction of nascent womanhood.

Lady Hawarden showed her work in the 1863 and 1864 exhibitions of the Photographic Society. With the exception

of a few rare examples, her photographs remained in the possession of her family until 1939, when the more than eight hundred images were donated to the Victoria and Albert Museum. Only recently have they been the objects of research, publication, and exhibition.

Clementina Maude, her mother's preferred model, is seen here in a reflective pose against a star-studded wall. The casual placement of the shawl on the table and the girl's loose hair contribute to the feeling of intimacy. In the airy room time seems to be suspended. The sensuous curves of the table legs, the soft weight of the crushed velvet, and the crispness of the starry wallpaper are enhanced by the skillful handling of the collodion technique. The composition, devoid of Victorian clutter, brings together light, shadow, and compositional elements in a spare and appealing interplay. In contrast to the prevailing fashion of giving literary or sentimental titles to portraits of young women, Lady Hawarden titled her works simply *Photographic Study*. [PA]

35. Oscar Gustave Rejlander
Swedish, active England, 1813–1875

Mr. and Miss Constable, 1866
Albumen silver print from glass negative
17 x 21.9 cm (6¾ x 8⅝ in.)
Plate 22

Oscar Gustave Rejlander took up the camera in 1853 because he could not support himself from the proceeds of his portrait paintings. Although he photographed nudes, expressive heads, and other subjects for painters to copy, he pursued his own art as well. To that end he concocted elaborate genre scenes and moral allegories that made him famous (and when tastes shifted, infamous), but he also made photographic portraits that have yet to go out of style.

Behind his London house Rejlander built an unusual studio with five oddly shaped, judiciously placed windows that gave him virtual command of his illumination. Like a film director Rejlander posed his sitters informally and obliquely in the filtered light, sparing them the glare and self-conscious interrogation of direct camera confrontation. The freshness and vivacity he thus achieved are evident in this portrait of a brother and sister, gazing as on their future in a glowing hearth. Clasped in affectionate embrace, the well-dressed Constable children had clearly attended that "school of sympathy, tenderness, and loving forgetfulness of self" which was the ideal Victorian family.[4] [MMH]

36. Julia Margaret Cameron
British, 1815–1879

Sir John Herschel, 1867
Albumen silver print from glass negative
31.8 x 24.9 cm (12½ x 9¾ in.)
Plate 32

Julia Margaret Cameron arrived in England from Calcutta in 1848 with her husband and six children. She was the eldest of eight sisters who enchanted London society with their beauty and eccentricity, attracting Thomas Carlyle, Charles Darwin, John Ruskin, the Pre-Raphaelites, and other original minds of the day. Her closest friends and mentors were the poets Henry Taylor and Alfred, Lord Tennyson, the painter G. F. Watts, and the astronomer John Herschel (1792–1871), the subject of this photograph.

Cameron first met Herschel at the Cape of Good Hope in 1836–37, and they corresponded in the ensuing years when Herschel was helping advance the photographic experiments of his friend Henry Talbot. It was natural that upon receiving a camera from her daughter in 1863, Cameron would turn for technical and artistic advice to her old friend, who was to her "as a Teacher and High Priest."[5]

Cameron's photographs were unlike any that had been seen before. Whereas other Victorian photographers (in accord with the Pre-Raphaelite painters) desired precise rendering of specific detail, Cameron preferred a soft focus and cared little for perfect technique. She aspired not only to a realistic but to an idealistic art, which portrayed noble emotions. In this she enlisted her family and friends, posing them—often draped or costumed, in the fashion of Rembrandt or Raphael—for long (one-to-seven-minute), carefully lit exposures to enhance expressive content.

Among Cameron's subjects were men of high renown, heroes she ardently admired. For this picture she traveled to Herschel's house and had him wash his hair so that a brilliant halo would encircle his head. Of the three exposures, Herschel preferred this one, which portrayed him, he thought, as an "old Paterfamilias."[6] Less heroic and idealized than the other two, the photograph presents an ordinary man, somebody's dear old grandfather—who just happened to have catalogued the stars. [MMH]

37. Julia Margaret Cameron
British, 1815–1879

Mrs. Herbert Duckworth, 1867
Albumen silver print from glass negative
32.8 x 23.7 cm (12⅞ x 9⅜ in.)
Plate 30

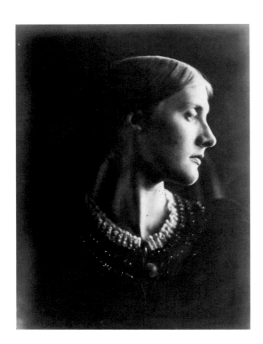

Julia Margaret Cameron rarely made portraits of women; rather, when she photographed them, they appeared as representations of some biblical figure or as a mythological muse, a sybil, or a saint. One exception was her niece, Mrs. Herbert Duckworth, née Julia Jackson, whom she portrayed some twenty times without guise. This portrait, which is usually trimmed to an oval, suggests an antique cameo carved in deep relief. Its success lies partly in its subject's actual beauty, and partly in the way the photographer modeled it to suggest Christian and classical ideals of purity, strength, and grace.

This photograph was made the year of Julia's marriage to Herbert Duckworth, when she was twenty-one. Three years later she was a widow, and the mother of three children. Her second marriage, in 1878, to the great Victorian intellectual Sir Leslie Stephen, produced the painter Vanessa Bell and the writer Virginia Woolf. In her novel *To the Lighthouse* (1927), Virginia portrayed her mother as the searching, sensitive Mrs. Ramsay, ever suspended in thought. She "bore about with her, she could not help knowing it, the torch of her beauty; she carried it erect into any room that she entered."[7] [MMH]

38. Julia Margaret Cameron
British, 1815–1879

Philip Stanhope Worsley, 1864–66
Albumen silver print from glass negative
30.4 x 25 cm (12 x 9⅞ in.)
Plate 35

Philip Stanhope Worsley (1835–1866) was an Oxford-educated poet who translated the *Odyssey* and part of the *Iliad* into Spenserian verse. Tubercular from childhood, he died at the age of thirty at Freshwater, where Julia Margaret Cameron also lived. The intensity of Worsley's intellectual life and something of its tragedy are vividly conveyed in Cameron's portrait. Isolating his face against an indistinct background, she placed his raised and baleful gaze at the very center of the picture. To her subject's hypnotic gravity she added intimations of sacrifice, swathing the body and engulfing the great head, rendered nearly life-size, in dramatic darkness. In powerful portraits such as this one, Cameron's ability to evoke an inner struggle presaged the next generation's morbid cult of subjectivity, with "each mind keeping as a solitary prisoner its own dream of a world."[8] [MMH]

39. Julia Margaret Cameron
British, 1815–1879

Vivien and Merlin, 1874
Albumen silver print from glass negative
30.9 x 25.9 cm (12⅛ x 10¼ in.)
Plate 36

In 1874, Julia Margaret Cameron was asked by her friend and neighbor Alfred, Lord Tennyson to illustrate a new edition of his *Idylls of the King*, a recasting of the Arthurian legend in which the poet laureate projected the downfall of Victorian society. Compared to earlier editions illustrated with drawings by Gustave Doré and by Edward Moxon, Cameron's folio, with twelve large original photographs and a frontispiece portrait of Tennyson himself, was decidedly extravagant. Cameron lavished great care on this, her last project, making 180 exposures of her family and friends posed as living embodiments of the moralizing episodes.

Here we see the photographer's husband, Henry Hay Cameron, posed as Tennyson's Merlin—"an old darling," according to Cameron—the magician whose purity was the wellspring of his power, and a girl, perhaps Agnes Chapman, playing the harlot Vivien, who enchants him. Mr. Cameron, very much in character as Tennyson's Merlin, stands before "the hollow oak" (carried in from Tennyson's property), "lost to life and use, and name and fame." The picture succeeds through the language of gesture: Vivien's turning, pointing attitude (which Cameron aptly termed "piquante") and Merlin's dreamlike trance make this the image incarnate of the casting of a spell.[9]

[MMH]

40. Pierre-Ambrose Richebourg
French, 1810–after 1893

Louis-Jacques-Mandé Daguerre, ca. 1844
Daguerreotype
8.9 x 7 cm (3½ x 2¾ in.)
Ex coll.: Nadar

Famed for his Diorama, a theatrical spectacle of painted illusion and manipulated light effects, Louis-Jacques-Mandé Daguerre (1787–1851) was an artist, a showman, and an entrepreneur. The invention and success of the first practicable photographic process resulted more from his relentless trial-and-error experimentation and shrewd business dealings than from learned chemical or optical research.

Unsuccessful in his earliest attempts to record images projected by the lens of the camera obscura, Daguerre learned in 1826 from his supplier of optical equipment, Charles Chevalier, that Joseph-Nicéphore Niépce (1765–1833) had obtained some measure of success in his own photographic experiments. In December 1829, after much cautious correspondence, Daguerre and Niépce entered into a partnership to refine and perfect Niépce's primitive process. But it was only in 1837, four years after the death of Niépce, that Daguerre felt a workable process to be at hand: a highly polished silver-plated copper sheet was sensitized with fumes of iodine, exposed in a camera, developed in mercury vapor, and fixed in a solution of salt or hyposulphite of soda. Viewed under proper light, the mirrorlike surface revealed an image that was extraordinary in its clarity, detail, and realism—wondrous to eyes that had never before seen a photographic image. Claiming the process to be an independent invention rather than a

refinement of Niépce's discovery, Daguerre applied his own name to the new medium: the daguerreotype.

Unable to find subscribers in 1838 for his still secret process, Daguerre showed his pictures privately to several artists and scientists, including François Arago, secretary of the Academy of Sciences. Arago was wildly enthusiastic. Recognizing the benefits of Daguerre's invention to science, industry, and the arts, and correctly calculating that the enforcement of patent rights would be difficult, Arago sought to have the French government buy Daguerre's process and present it to the world for the benefit of mankind. With the inventor's approval, he showed daguerreotypes to his fellow academicians on January 7, 1839, and during the next seven months led the legislative effort to grant annuities to Daguerre and the heirs of Niépce in exchange for public disclosure of the daguerreotype process.

On August 19, before a joint session of the Academies of Sciences and Fine Arts and an audience that overflowed the capacity of the Institut de France, Arago, on behalf of the stage-frighted Daguerre, presented three daguerreotypes and explained the apparatus, chemicals, and step-by-step operations required for their making. The photographic age had begun.

Fewer than a dozen daguerreotype portraits of the medium's inventor are known to have been made, and still fewer survive. Here, dressed in gentlemanly attire and decorated as an officer in the Legion of Honor, his head cocked with an air of self-assurance, Daguerre poses for a man he had personally instructed some five years earlier. Pierre-Ambrose Richebourg was among the first and most successful professional photographers, having become acquainted with the primary figures and principles of the new art through his employer, Vincent Chevalier, the father of Daguerre's lens maker, Charles. [MD]

41. Louis-Auguste Bisson
French, 1814–1876

Dog, 1841–49
Daguerreotype
7.6 x 10.3 cm (3 x 4 in.)
Ex coll.: Rosa Bonheur
Plate 42

In announcing the daguerreotype process to the public in August 1839, even so eager a promoter as François Arago felt compelled to admit that the process was unlikely ever to serve for portraiture, owing to the length of exposure, which in bright summer sun lasted four-and-a-half to eleven minutes and in subdued winter light an hour or

more. The free use of Daguerre's process, however, invited optical and chemical improvements that made portraiture feasible and widespread within a mere two years. Among those who enhanced the sensitivity of daguerreotype plates by new chemical means was Louis-Auguste Bisson, whose label on the verso of this work advertises "Daguerreotype portraits in shade, indoors, and in a few seconds, perfected." Even more than a standard portrait, this daguerreotype is a tour de force of instantaneity, for the panting dog, its tongue hanging out of its mouth, could neither be instructed to sit still nor be physically held in a metal neck brace, a common studio prop for immobilizing human sitters.

This unassuming portrait of a pet, humorously presented as if in his doghouse, was made by Bisson for his childhood neighbor and surrogate sister Rosa Bonheur (1822–1899). After the death of her mother, eleven-year-old Rosa had been welcomed into the home of Mme Bisson, the mother of Louis-Auguste and his two brothers, and there she earned her first wages as an artist coloring the heraldic engravings of M. Bisson. By the time she was in her twenties Bonheur was a highly acclaimed painter of animal scenes. No doubt part of the vast menagerie that she kept at her house, this dog is presented by Bisson in a familiar —even familial—way rather than as a photographic study intended to aid the artist's work. [MD]

42. Marie-Charles-Isidore Choiselat and Stanislas Ratel
French, 1815–1858; 1824–1893

The Pavillon de Flore and the Tuileries Gardens, 1849
Daguerreotype
15.2 x 18.7 cm (6 x 7⅜ in.)
Plate 2

Taken in September 1849 from a window of the École des Beaux-Arts, this daguerreotype exhibits the dazzling exactitude and presence that characterize these mirrors of reality. True to the daguerreotype's potential, stationary objects are rendered with remarkable precision; under magnification one can clearly discern minute architectural details on the Pavillon de Flore, features of statuary and potted trees in the Tuileries Gardens, even the chimney pots on the buildings in the background along the rue de Rivoli.

Daguerre himself had chosen a nearly identical vantage point in 1839 for one of his earliest demonstration pieces, and it may well have been with that archetypal image in mind that Choiselat and Ratel made this large daguerreotype a decade later. Choiselat and Ratel, among the earliest practitioners to utilize and improve upon Daguerre's process,

first published their methods for enhancing the sensitivity of the daguerreotype plate in 1840 and had achieved exposure times of under two seconds by 1843. Unlike Daguerre's long exposure, which failed to record the presence of moving figures, this image includes people (albeit slightly blurred) outside the garden gates, on the Pont Royal, and peering over the quai wall above the floating warm-bath establishment moored in the Seine. Still more striking is the dramatic rendering of the cloud-laden sky, achieved by the innovative technique of masking the upper portion of the plate partway through the exposure. [MD]

43. Anonymous

Nude, ca. 1850
Daguerreotype
9.1 x 6.9 cm (3⅝ x 3⅞ in.)
Plate 44

Photography, in the view of its earliest supporters, was destined to aid the other arts, nowhere more so than in the depiction of the human figure. Following the pattern of traditional drawn *académies*, daguerreotypes of the nude (most often female) provided the painter with a repertoire of poses accurately translated into two dimensions for easy consideration of contour, proportion, and foreshortening. Although produced by many leading daguerreotypists, photographic *académies* were rarely signed by their makers, for they often balance precariously between art and erotica.

This daguerreotype, and two others produced on the same occasion (the model stands in one, reclines in the other), was surely intended to serve artistic purposes, but the odd twist of the body and the strange relationship of the three visible limbs seem to render it inappropriate for artistic emulation. Such tension between an artistic ideal and realistic means—between the classicism of an academic pose and the awkwardness of the camera's rendering of human movement—seems emblematic of the dilemma faced by the nascent medium striving to be an art.

[MD]

44. A. Le Blondel
French, active 1842–92

Postmortem, ca. 1850
Daguerreotype
8.9 x 11.9 cm (3½ x 4⅝ in.)
Plate 43

In bequeathing to later generations a record of the faces of their ancestors, an entire class that had never before been able to afford portraiture was offered some small degree of immortality by the daguerreotype. That desire to preserve the memory of loved ones found poignant expression in the practice of postmortem photography, a final visual record of the deceased with the power to preserve the image of the mind's eye. Such daguerreotypes were seen as direct impressions of the deceased, as expressed on the label affixed to the verso of this example advertising "Portraits after death, death masks."

This particularly theatrical postmortem is artfully composed so as to present the dead child bathed in heavenly light, the folds of white drapery suggesting the ascension of the soul while the surrounding room and watchful father are shrouded in mournful shadow. The engraved signature, "Le Blondel Lille," confirms that the artist considered this a significant work, no mere run-of-the-mill product. [MD]

45. Hippolyte Bayard
French, 1801–1887

Windmills, Montmartre, 1839
Direct positive print
8.5 x 10 cm (3⅜ x 4 in.)
Plate 38

Even before the detailed processes of Talbot and Daguerre were revealed, a third inventor had successfully obtained photographic images using a process of his own creation. Hippolyte Bayard, experimenting in the hours left free from his civil service job, had brought his process from conception to fruition in the short space of a few months early in 1839. Like Daguerre's technique, Bayard's was a direct-positive process; like Talbot's, it produced photographs on paper. Each picture required some thirty minutes of exposure.

This photograph, inscribed on the verso "Essai de 1839 Avril Mai," is one of Bayard's earliest surviving prints and among the rarest of photographic incunabula. Its chemical stains and slight discoloration only heighten the modern viewer's sense of bearing witness to the magic that first enabled sensitized paper to retain an image thrown by the lens of a camera obscura.

The picturesque windmills of Montmartre, the outlying suburb that was becoming the bohemian quarter of Paris, were a frequent subject of Bayard's earliest photographs, and likely figured in some of the thirty pictures shown by the artist in the first public exhibition of photographs, held in Paris in July 1839. Remembering that occasion a dozen years later the critic Francis Wey wrote of the exhibited

works, "They resembled nothing I had ever seen. . . . One contemplates these direct positives as if through a fine curtain of mist. Very finished and accomplished, they unite the impression of reality with the fantasy of dreams: light grazes and shadow caresses them."[10]　　　　[MD]

46. Louis-Rémy Robert
French, 1810–1882

Henriette Robert, ca. 1850
Salted paper print from paper negative
22.1 x 14.8 cm (8¾ x 5⅞ in.)
Plate 41

Louis-Rémy Robert was head of the gilding and painting ateliers at the Sèvres porcelain works. Shortly after Talbot's paper negative process was demonstrated at the Academy of Sciences in 1847, Robert and Henri Regnault, the director of the manufactury, began experimenting with the new medium. Combining their knowledge of chemistry with their artistry, Robert and Regnault were among the first Frenchmen to make paper photographs that were both technically and aesthetically satisfying.

Many of their earliest photographs were portraits of family members, friends, and fellow artisans posed outdoors at Sèvres. In this image we see Robert's daughter, Victoire-Henriette-Caroline, born in 1834. Despite her girlish figure, reduced to a sculptural fragment by the strong light-and-dark contrasts, she seems a woman completely. If she appears both demurely self-protective and openly charming, it is perhaps because she was aware of the presence of both her father and her husband, the painter Emile Van Marcke, who, in another photograph, joins his new wife, leaning into the sunlight behind her chair.

[MMH]

47. Gustave Le Gray and O. Mestral
French, 1820–1882; active 1850s

The Ramparts of Carcassonne, 1851
Salted paper print from paper negative
23.5 x 33.2 cm (9¼ x 13⅛ in.)
Plate 39

In 1851 the Commission des Monuments Historiques, an agency of the French government, selected five photographers to make photographic surveys of the nation's architectural patrimony. These *missions héliographiques* were intended to aid the Paris-based commission in determining the

nature and urgency of the preservation and restoration work required at sites throughout France. Gustave Le Gray, already recognized as a leading figure on both the technical and artistic fronts of French photography, and O. Mestral, about whom very little is known, were among those selected for this first major act of government patronage of photography. Like the others chosen—Baldus, Bayard, and Le Secq—they were members of the fledgling Société Héliographique, the first photographic society.

The five photographers were sent in different directions, each with a list of monuments to be recorded. Le Gray was assigned the Loire Valley and the regions just to the south, toward Bordeaux; Mestral was to cover the southwest, from Bordeaux to Perpignan, and the Auvergne. But the two decided instead to travel together, sometimes photographing sites on one another's list and occasionally working in collaboration, as indicated by the inscription in Le Gray's hand at the lower right of this print, "Gustave Le Gray et Mestral."

No site on their itinerary yielded more dramatic images than the city of Carcassonne, its thirteenth-century fortifications an outstanding model of medieval military architecture. These photographs are of special interest to modern viewers as a rare pictorial record of Carcassonne just prior to the extensive reconstruction begun under the direction of Eugène Viollet-le-Duc.

Carcassonne's double walls, punctuated with towers, provided the photographers with a subject admirably suited to catching the nuances of light and shadow on geometric surfaces and one also resonant with historical import. Recalling an epoch long since vanished, the Tour de la Vade—the largest and most impregnable of the city's towers—dominates the picture, dwarfing in scale as it does in antiquity the simple grave markers near its base. Here Le Gray and Mestral present an essay on the place of man and his works in the passage of time. [MD]

48. Henri Le Secq
French, 1818–1882

Wooden Staircase at Chartres, 1852
Salted paper print from paper negative
32.7 x 23.4 cm (12⅞ x 9¼ in.)
Plate 40

Henri Le Secq was a learned and cultivated man, a painter and a passionate collector of old master prints and medieval ironwork. He counted among his close friends the peintre-graveur Charles Meryon and the photographers Charles Nègre and Gustave Le Gray (both colleagues from the studio of Paul Delaroche); from the latter he learned the process of paper-negative photography. In the early

1850s, Le Secq applied his artistic training to the production of photographs notable for their expressive interpretation of historic architecture, quiet landscapes, and intimate still lifes.

The Commission des Monuments Historiques was so impressed with the results of Le Secq's *mission héliographique* of 1851, which meticulously documented the cathedrals of Reims and Strasbourg, that they asked him to photograph Chartres cathedral in a similar manner. Le Secq fulfilled this second commission in 1852, producing more than forty views of the Gothic monument and its sculptural program. It was characteristic of Le Secq that he should also have explored the side streets of the pilgrimage town and made this view of the sixteenth-century spiral staircase of carved oak, known as the Staircase of Queen Berthe. [MD]

49. Em. Pec (Em. Peccarère?)
French, active early 1850s

Bourges, 1850–52
Salted paper print from paper negative
26.7 x 20.7 cm (10½ x 8⅛ in.)

One of the finest photographers of the early 1850s remains a mysterious figure. More than one hundred of his salted paper prints survive, many signed in the negative "Em. Pec," a name that is not found in any early photographic journals, records of photographic societies, or exhibition catalogues. It seems likely that this photographer was Em. Peccarère (inconsistently spelled Peccarrère, Pecarrère, Pecarère, and Pecarer), a lawyer who learned photography

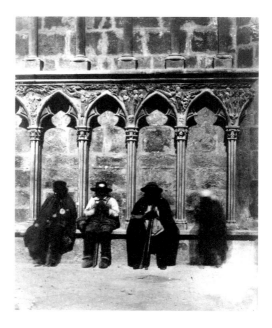

from Gustave Le Gray and was among the founding members of the Société Héliographique. The confusion over his identity is compounded by the fact that fifty photographs, many with titles that correspond in subject to Pec's surviving signed works, were shown at the Society of Arts in London in 1852, listed in the exhibition catalogue as the work of "Pecquerel." One can only surmise that this was a misunderstanding of the name "Peccarère" by the exhibition's British organizers, who saw photographs signed "Pec" but were more familiar with the French scientist and daguerreotypist Edmond Becquerel, also a member of the Société Héliographique.

Pec photographed throughout France and Italy in the first years of the 1850s. This view shows the north side of the mid-thirteenth-century royal portal of Bourges cathedral in central France. If the photographer knew the widely distributed topographic prints of the second quarter of the century he chose to depart from their pictorial conventions. Here, instead of incorporating small figures to animate the scene, provide picturesque detail, or give a sense of scale to the architecture, he elevated the relationship of figures to architecture. Framed by the shallow arcade like jamb figures, the four beggars (one of whom has moved during the long exposure of the paper negative) appear oddly hieratic. Seated alongside the central portal of the enormous edifice, theirs is a nearly ritualistic presence, just below the bas-relief scenes of the Creation and the Fall. [MD]

50. Em. Pec (Em. Peccarère?)
French, active early 1850s

Chartres, 1850–52
Salted paper print from paper negative
26.4 x 20.8 cm (10⅜ x 8⅛ in.)
Plate 54

This idiosyncratic view of the thirteenth-century figures on the south porch of Chartres cathedral reveals this artist's expressive use of the limitations of the camera's narrow field of vision and of the propensity of the paper negative to accentuate shadow and soften detail. Beneath a canopy of deep shadow, Saints Martin of Tours, Jerome, and Gregory the Great emerge between a "no littering" sign at the left and a pillar in the right foreground. This angled, partial view is more closely allied to the way one gradually perceives the world than to conventions of artistic description or architectural rendering.

An account in the May 1, 1852, issue of the photographic journal *La Lumière* reported that Peccarère had gone to Chartres with paper negatives prepared according to Le Gray's method and returned to Paris just one day later with

twenty-five exposures—not an inconceivable task for one whose pictorial practice was so closely linked to a natural way of seeing. Once thought "primitive" because of their deviation from pictorial traditions, such pictures are now prized for that very freedom of visual invention. [MD]

51. Joseph Vigier
French, died 1862

Path to Chaos, Saint-Sauveur, 1853
Salted paper print from paper negative
24.1 x 36.6 cm (9½ x 14⅜ in.)
Ex coll.: Duke de Montpensier

In the summer of 1853, Viscount Vigier spent two months photographing in the Pyrenees. He had learned the waxed paper process from Gustave Le Gray but preferred Talbot's original technique for its strong contrasts of light and dark.

When Vigier exhibited his views in London and Paris in 1854, they were highly acclaimed. These first photographs of the Pyrenees appealed to the English taste for the sublime and to the French romantic temperament. Their reception also benefited from the vogue for cures at mountain spas among the adventurous ailing. Few of the photographs in this rare album of twenty-four pages show tourist amenities, however; of the many views of gorges and peaks, the most impressive depict the Chaos of Gavarni, a vast, desolate amphitheater of raw rock.

This picture of sliding diagonals and unrelieved tension shows how powerfully Vigier could orchestrate his basic materials. He chose his vantage point so that the rock intruding on the footpath and the precarious boulder on the horizon would seem to be moving, still. Starkly contrasting sky and rock, Vigier's picture provides forceful evidence of a struggle so remote as to have occurred at the beginning of time—the geological chaos from which heaven and earth were born. [MMH]

52. Louis-Rémy Robert
French, 1811–1882

The Large Tree at La Verrerie, Romesnil, ca. 1852
Salted paper print from paper negative
26.4 x 31.9 cm (10⅜ x 12½ in.)
Plate 51

Robert made this and other rural studies at the family farm in Normandy. His subjects were similar to those of the naturalist landscape painters who worked in Barbizon and other sites in the environs of Paris, and indeed, Robert and his colleagues were friendly with the artists who frequented Sèvres, notably Constant Troyon and Camille Corot.

While the painters might sketch the trunk of an old beech to quickly note some visual incident or as a study for part of a more elaborate landscape composition, Robert could not abbreviate his subject in the same ways. Because a camera records everything visible within its range, photographs are de facto finished compositions, replete to the frame. In this picture that overall finish or completeness is obscured: the tones clump and swallow detail, and the granular texture (resulting from the use of a paper negative) emphasizes the coarse bark, the gnarled trough for animals, and the uneven, trampled ground around the great tree. Thus, though Robert could not make his photograph less complete (by omitting the stables and rows of paired poplars in the background, for example), he gave his picture the satisfying qualities of a painter's sketch; it is rough, familiar, and, in its reductive concentration, distinctly economical. [MMH]

53. Henri-Victor Regnault
French, 1810–1878

Gardens of Saint-Cloud, before 1855
Salted paper print from paper negative
41 x 35.7 cm (16⅛ x 14 in.)
Ex coll.: Henriette Robert
Plate 49

A famous physicist and early experimenter with the photographic process invented by Talbot, Victor Regnault was a prime mover in early French photography. With Delacroix, among others, he founded the Société Héliographique in 1851, was founding president of the subsequent Société Française de Photographie in 1854, and as director of the Sèvres porcelain factory from 1852 to 1871 made photography a central focus of technical and artistic experiment there.

This large photograph represents the gardens laid out by the seventeenth-century landscape designer André Le

Nôtre for the duc d'Orléans, the brother of Louis XIV, at Saint-Cloud. At the time the picture was made Saint-Cloud was an important locus of the glittering imperial court of Napoleon III. Yet Regnault probably did not choose to photograph there because it was in vogue, but because it adjoined the Sèvres factory and because the gardens owed their ornament to nearly the same moment as the traditional decorative schemes of Sèvres porcelain.

This print, which shows much evidence of handwork on the paper negative, was the sort praised by Paul Périer as being "broad and delicate at the same time, [possessing] detail without harshness, just the right amount of softness in the midgrounds, and finally, having a family resemblance with the best works of the great schools of painting."[11]

[MMH]

54. Julien Vallou de Villeneuve
French, 1795–1866

Reclining Nude, 1851–53
Salted paper print from paper negative
12.3 x 16.1 cm (4⅞ x 6⅜ in.)
Ex coll.: Bibliothèque Nationale, Paris; Samuel J. Wagstaff, Jr.
Plate 46

A lithographer of scenes of daily life, costume, and erotica in the 1820s and 1830s, Julien Vallou de Villeneuve reportedly took up photography about 1842. Because his early photographs have not been identified, it has been assumed that they depicted naked women, a subject for which it was too improper to acknowledge authorship. Although prurient lithographs of courtesans playing with animals and large salon paintings of Oriental odalisques and half-draped Romans could pass the censors, photographs of naked flesh were suspect. Unless they were veiled or adorned and posed to look like painted nudes, the women in the photographs were considered too titillating.

Between 1851 and 1855, Vallou made a series of small-scale paper photographs of naked women which he marketed (and legally registered) as models for artists. Whether they were intended solely for artists is arguable, but in order to sell the images openly the photographer had to work into his pictures the paraphernalia of the painter's studio —rugs, shawls, spears, beads, anklets, turbans, and the like. Despite these moderations Vallou's nudes were remarkable. Their flesh was tantalizingly real in both weight and texture; indeed, the photographs served Courbet as appropriately lifelike models.

This image is one of the most minimally camouflaged. Swiveled to reveal an amphora of thighs, groin, and torso, her extremities and face hazed with shadow, this mid-nineteenth-century Parisian model reclining in a photog-

rapher's studio recalls both Titian and Goya. Vallou gave amplitude and breadth to the perfect pose by visually suspending the model in empty space, like a dream between couch and curtain. [MMH]

55. Eugène Durieu
French, 1800–1874

Nude, ca. 1854
Albumen silver print from glass negative
17.3 x 11.9 cm (6¾ x 4⅝ in.)
Plate 62

A lawyer, an early experimenter with daguerreotypy, general director of the Administration des Cultes in 1848, and a member of the Commission des Monuments Historiques, Eugène Durieu was an important early advocate of photography in France. Almost certainly influential in organizing the *missions héliographiques*, he further assisted the artistic growth of photography by helping to found the Société Héliographique in 1851 and by subsequently serving as an officer of the Société Française de la Photographie.

In 1853–54, Durieu made a series of photographic studies of nude and costumed figures as models for artists. Delacroix helped him pose the figures and later praised the prints, from which he sketched, as "palpable demonstrations of the free design of nature."[12] While the painter saw the accurate transcription of reality as a virtue of photography, Durieu knew that a good photograph was not simply the result of the correct use of the medium but, more significantly, an expression of the photographer's temperament and vision. In an important article he emphasized the interpretative nature of the complex manipulations in photography and explained that the photographer must previsualize his results so as to make a "picture," not just a "copy."[13]

This photograph proves Durieu's point: through the elegant contours of the drapery, the smooth, somewhat flattened modeling of the flesh, and the grace and restraint of the pose, the picture attains an artistic poise that combines Delacroix's sensuality with Ingres's classicism, and rivals both. [MMH]

56. Nadar (Gaspard-Félix Tournachon)
French, 1820–1910

Seated Model, Partially Draped, ca. 1856
Salted paper print from glass negative
11.2 x 10.4 cm (4⅜ x 4⅛ in.)
Plate 60

The subject of this photograph is thought to be Antoinette Roux, the woman who served as Henri Murger's model for Musette, the consumptive heroine of his *Scènes de la vie de bohème* (1847–49), a story more widely known through Puccini's opera *La Bohème*. In the 1840s, many such women who served men not only as models were known as *lorettes*, for the quarter where they could be found near Notre-Dame-de-Lorette.

Félix Tournachon was one of the talented, penniless young Parisians who formed the original bohemian circle immortalized by Murger. His first photographic studio, at 113 rue Saint-Lazare, which he occupied from 1854 to 1859, was in the district of the church. Whether the subject of his photograph is Antoinette Roux, her sister, some other *lorette*, or, as has also been suggested, Mariette, the mistress of the critic Champfleury, her easy attitude suggests that she was unashamed of her body and used to the business of men. Her face reveals that she was also conscious—to a startling degree—that a vulnerable moment with a great photographer is a betrothal with posterity.

We do not know why, or for whom, Nadar took this astonishing picture, or why this signed print from the photographer's archive should have been the only one to survive. [MMH]

57. Nadar (Gaspard-Félix Tournachon)
French, 1820–1910

Alexandre Dumas, 1855
Salted paper print from glass negative
23.8 x 18.5 cm (9⅜ x 7¼ in.)

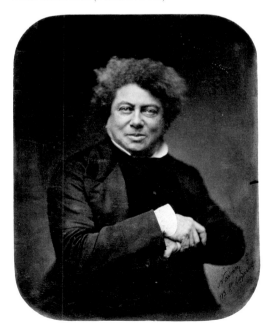

Félix Tournachon first met Alexandre Dumas (1802–1870) in the 1820s, when the young author brought manuscripts to his father, Victor Tournachon, to publish. After admiring Dumas's swashbuckling historical dramas at school, Félix became his friend in the 1840s, a period when he was working as a journalist, novelist, and caricaturist with the nom de plume Nadar. In 1855 the two men dreamed of writing a play together, but eventually they collaborated only on this portrait, made in November of that year.

Seated casually, his hands folded comfortably on his cane, Dumas addressed Nadar with a jovial vivacity suggesting the comraderie that was their wont. His lively expression surely owes something to the interest he took in his friend's conversation, but it also derives from Nadar's uncanny ability to draw from his sitters their most characteristic expressions. He avowed that although anyone could learn to photograph in a single session, what could not be taught was "a feel for light" and a quick intuition for "the moral comprehension of one's subject . . . which permits the most familiar and favorable resemblance, the intimate one." [14] [MMH]

58. Adrien Tournachon and Nadar (Gaspard-Félix Tournachon)
French, 1825–1903; 1820–1920

Charles Debureau, 1854–55
Gelatin coated albumen silver print from glass negative
26.5 x 20.8 cm (10⅜ x 8⅛ in.)
Plate 59

In late 1853, Félix Tournachon (Nadar) paid Gustave Le Gray to teach photography to his younger brother, Adrien, a painter of some talent frequently in his charge. At the same time Félix himself learned to use the camera from his friend Camille D'Arnaud. Promising to assist his brother, Félix set up a studio for him on the Boulevard des Capucines. Adrien worked alone until September 1854, then turned to Félix for help. The two brothers collaborated until January 1855, when competitive friction ruptured the arrangement and led to a lawsuit through which Félix recovered sole use of his pseudonym, Nadar.

During the time they worked together, the brothers made a series of large photographs of Charles Debureau, son of Baptiste Debureau, the famous mime of the Théâtre des Funambules. These photographs attracted much public attention and won the gold medal at the Exposition Universelle of 1855 in Paris.

Designed as an elaborate publicity campaign for the photographers, the suite of more than fifteen photographs of characteristic expressions forms an episodic visual narrative of the comical misadventures of the pantomime character Pierrot. This photograph shows Pierrot in an attitude of pursuit or flight. Despite the immobility required by the relatively long exposure, the simulated movement is wonderfully expressed. A static, splayed demonstration of action in a shallow space, the picture's content is as concise as a dictionary definition, its form as legible as that of a runner on a Greek vase. [MMH]

59. Adrien Tournachon
French, 1825–1903

Self-Portrait, ca. 1855
Gelatin coated salted paper print from glass negative
23.6 x 17.6 cm (9¼ x 6⅞ in.)
Plate 52

Because Adrien Tournachon's photography was enmeshed with that of his brother Félix (Nadar) from the beginning, and because the reports we have of his activities are principally the derogatory ones Félix made after the brothers' disagreement, Adrien's work has been largely dismissed. Clearly envious of the success of his charismatic older brother, Adrien appears to have been unreliable and manipulative, and alternately querulous and boastful. But despite an unfortunate character he possessed real talent, as witnessed by this striking self-portrait.

The photograph represents Adrien at about age thirty, when he was attempting to rival his brother. It shows a sensitive and curiously sly man—a poseur in an artist's sketching hat and smock. Disarming in its casualness, the portrait is also seductive, perhaps because the unforthcoming person who regards the viewer is simultaneously withholding and engaging—and consequently an enigmatic repository for reveries. [MMH]

60. Adrien Tournachon
French, 1825–1903

Emmanuel Frémiet, 1854–55
Gelatin coated salted paper print from glass negative
24.6 x 17.3 cm (9⅝ x 6¾ in.)
Plate 61

This photograph was printed by Adrien Tournachon in an unusual technique known as *vernis-cuir*, whereby a paper print is coated with layers of gelatin and tannin, giving it a heavy gloss the French likened to varnished leather.

Although Adrien used the process and this unique print is stamped with his mark ("Nadar j[eu]ne"), his brother Nadar also inscribed it (recto and verso) with the sitter's name. The original negative, now lost, may have been the product of the brothers' collaboration.

The portrait is of the sculptor Emmanuel Frémiet (1824–1910). Frémiet's acute observation of anatomical structure—sometimes carried out at the morgue—and his dexterous modeling of minute physiological details brought him fame in a period when naturalism was in the ascendant. Even without this information we might guess from the picture—which highlights the sensitive hand, fastidious gesture, and level, clear-eyed regard—that the subject practiced an aesthetic calling akin to surgery. [MMH]

61. Onésipe Aguado
French, 1831–1893

Woman Seen from the Back, ca. 1862
Salted paper print from glass negative
30.8 x 25.8 cm (12⅛ x 10⅛ in.)
Plate 45

A wealthy amateur photographer and a familiar figure at the French imperial court, Viscount Onésipe-Gonsalve Aguado de Las Marismas joined the Société Française de Photographie in 1858. That same year he exhibited photographs of models in which he explored foreshortening. With his better-known brother Olympe, a founding member of the Société, Onésipe Aguado was among the early practitioners of photographic enlargements, which he exhibited at the Société in 1858, 1859, and 1863. The two brothers also collaborated on tableaux vivants that depict with wit and playfulness the fads and amusements of elegant society.

This fascinating image expresses Aguado's whimsical mood, and is probably an extension of his work on foreshortening. Commanding the page with the authority of a Renaissance bust a woman, impeccably coiffed and wearing an evening gown, turns her back to the viewer, forever aloof in her challenge to our curiosity. Light modulates the head-on view, enhancing the textures of the layered fabrics and the outline of the massive chignon. The image, however, is strangely devoid of depth, as if the sitter was a cutout, a mere silhouette in a two-dimensional space. The reluctant figure seems to inhabit another reality, a world of the imagination, bringing to mind the haunting compositions of such painters as Caspar David Friedrich and René Magritte, both of whom made striking use of figures seen from the back.

The picture is at once a portrait, a fashion plate, and a jest. The elaborate chignon, obviously the handiwork of a skillful maid, the discreet jewelry, and the luxurious fabrics all indicate a woman of rank, the epitome of *comme il faut*. Although we may be curious to know who she is, the woman's identity may be of less import than the compelling sense of mystery that she projects. A companion image in the Braunschweig collection in Paris, showing the same woman in profile, reveals a troubled countenance and a receding chin. [PA]

62. Gustave Le Gray
French, 1820–1882

Forest of Fontainebleau, 1849–52
Salted paper print from paper negative
25.4 x 36.2 cm (10 x 14¼ in.)

A locus of artistic activity in the second quarter of the nineteenth century, the Forest of Fontainebleau—and in particular the small town of Barbizon that lay within it—was home and muse to dozens of plein-air painters, including Corot, Daubigny, Diaz, Millet, and Rousseau. Comprising forty thousand acres, the forest was crisscrossed by footpaths and horse tracks and dotted with ancient oaks and anthropomorphic boulders christened with heroic and fanciful monikers. In 1849 a new railroad line brought the forest within easy reach of bourgeois Parisians seeking a natural setting for picnics, promenades, and artistic inspiration. Among those who arrived that year was Gustave Le Gray.

Painters gravitated to Barbizon in retreat from urban, industrial life and in search of the spiritual and moral purity thought to be embodied in the natural countryside and in the manual labor of rural peasants. Trained as a painter, Le Gray followed in the footsteps of the Barbizon artists (and perhaps even in their company), surveying the slightly domesticated landscape and photographing sylvan

scenes in the Bas-Bréau and along the Route des Artistes, depicted here. One senses, however, that it was the medium itself, more than the purported subjects, that Le Gray was exploring. The vegetation of the forest floor, the lichen-covered rocks, and the gnarled oak that rises from their midst emerge only gradually from the overall pattern of light and dark, softly rendered by the waxed paper negative invented by Le Gray. Although within a few years Le Gray would use photography for more practical applications—portraiture, art reproduction, and architectural documentation—these early pictures, by their very lack of useful purpose, assert Le Gray's ability to exploit the medium for artistic ends. [MD]

63. Gustave Le Gray
French, 1820–1882

Forest of Fontainebleau, ca. 1856
Albumen silver print from glass negative
29.9 x 37.7 cm (11¾ x 14⅞ in.)
Plate 63

Le Gray returned to the Forest of Fontainebleau in the mid-1850s with a larger camera and glass negatives. In contrast to the flickering abstraction of his earlier view (no. 62), this picture translates the experience of moving through the forest into a boldly orchestrated composition. Following the sandy road straight back from the picture plane, the viewer progresses from impenetrable shadow (probably emphasized by some providential error in exposure) to the foliage at the right, past the massive tree trunks standing like primitive colossi and toward the crest of the road and bright sky. But more than recounting the experience of an incidental passage through a landscape, Le Gray's photograph is a powerful drama about darkness and light, palpable expression of the unknown and the ethereal. [MD]

64. Gustave Le Gray
French, 1820–1882

Mediterranean Sea at Sète, 1856–59
Albumen silver print from two glass negatives
32.1 x 41.9 cm (12⅝ x 16½ in.)
Plate 64

The dramatic effects of sunlight, clouds, and water in Gustave Le Gray's Mediterranean and Channel coast seascapes stunned his contemporaries and immediately

brought him international recognition. At a time when photographic emulsions were not equally sensitive to all colors of the spectrum, most photographers found it impossible to achieve proper exposure of both landscape and sky in a single picture; often the mottled sky of a negative was painted over, yielding a blank white field instead of light and atmosphere.

In many of his most theatrical seascapes, Le Gray printed two negatives on a single sheet of paper—one exposed for the sea, the other for the sky, sometimes made on separate occasions or at different locations. Although the relationship of sunlight to reflection in this example was carefully considered and the two negatives skillfully printed, one can still see the joining of the two negatives at the horizon. Le Gray's marine pictures caused a sensation not only because their simultaneous depiction of sea and heavens represented a technical tour de force, but because the resulting poetic effect was without precedent in photography. [MD]

65. Gustave Le Gray
French, 1820–1882

Cavalry Maneuvers, Camp de Châlons, 1857
Albumen silver print from glass negative
26.7 x 33 cm (10½ x 13 in.)
Plate 58

For six weeks in August, September, and October 1857, twenty-five thousand men from the French Imperial Guard, renowned for their victory in the decisive battle of the Crimean War two years earlier, conducted exercises under the command of Napoleon III to inaugurate a vast military camp at Châlons-sur-Marne. Le Gray was commissioned to take photographs of the camp, the inaugural events, and

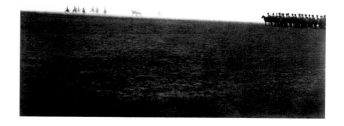

the officers. The pictures were later bound in albums and presented by the emperor to his highest-ranking officers.

The skillfully executed maneuvers, like the imperial celebrations, religious services, and elaborate entertainments that also marked the inaugural weeks, were intended as much for the pleasure of the emperor and the thousands of day-trippers who came to watch as for the improvement of the troops. Far from the chaos of real battle and the unfamiliarity of foreign terrain, the regiments of infantry and cavalry moved in precisely coordinated lines across some thirty thousand acres of flat countryside. Silhouetted on the horizon in the early morning mist, this highly trained and well-equipped military force could easily be mistaken for a battalion of toy soldiers. [MD]

66. Gustave Le Gray
French, 1820–1882

Group near the Mill at Petit-Mourmelon, 1857
Albumen silver print from glass negative
27.6 x 35 cm (10⅞ x 13¾ in.)

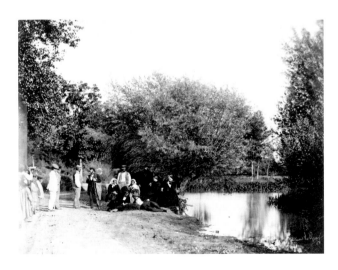

While at Châlons Le Gray also recorded scenes less formal than the military maneuvers, the celebration of Sunday mass, and the orderly encampments which are the subject of most of the pictures in this project. Here, perhaps on a Sunday afternoon, a few officers and their wives have shed military discipline for a relaxed encounter with the local populace of Petit-Mourmelon, directly adjacent to the camp.

Within weeks of the camp's establishment, this sleepy rural village and its slightly larger neighbor, Grand-Mourmelon, were transformed into the site of pleasure gardens, restaurants, cabarets, and firework displays for the amusement of the troops, their families, and the curious thousands who arrived by train from Paris. This photograph, however, and another made by Le Gray on the same outing at the village mill, depict a more casual recreation in which military man and local miller, Parisian lady and black-clad priest all mingle along the water's edge and pose—even mug—for the camera. True to the spirit of the occasion, Le Gray adopted a less structured composition than he had for his views of the military camp itself. [MD]

67. Louis-Pierre-Théophile Dubois de Nehaut
French, 1799–1872

Another Impossible Task, 1854
Salted paper print from glass negative
16.3 x 21.2 cm (6⅜ x 8⅜ in.)
Plate 56

Chevalier Dubois de Nehaut represents a type of amateur photographer of the 1850s whose work exemplifies some of the most striking technical and aesthetic advances achieved by the medium in its second decade. A judge at the magistrates' court in Lille, he left the bench and settled in Brussels in 1851, pursuing his interest in photography.

This image, as well as nos. 68 and 69, is from an album of thirty-two plates that the photographer dedicated in 1856 to the widow of a friend. The subjects, all of personal significance to the photographer, include self-portraits, portraits of friends and their children, views of the immediate vicinity of his house, train stations, and studies of the zoological garden in Brussels. The images, often annotated with the photographer's humorous comments about the subjects and about the quality of the prints and the technical difficulties he encountered, demonstrate Dubois de Nehaut's pursuit of the successful depiction of movement, his efforts to obtain images at various times of the day and under different weather conditions, and his predilection for photographing sites from a high vantage point so as to reveal surprising geometries not apparent at eye level.

In the caption to this photograph of the elephant Miss Betzy, the photographer tells us that it is his twelfth attempt—the first successful one—to photograph the elephant in motion. Miss Betzy had come to Brussels from India via the London Zoo, and was one of the first tenants of the newly built zoological garden. The photographer managed to catch something of her distinctive way of moving, with her bulk thrust forward onto one leg, a habit she developed while swaying with the movement of the boat during her arduous sea voyage from India. [PA]

68. Louis-Pierre-Théophile Dubois de Nehaut
French, 1799–1872

Promenade in Malines, 1854–56
Salted paper print from glass negative
16.6 x 21.4 cm (6½ x 8⅜ in.)
Plate 57

Dubois de Nehaut had a particular fondness for railway stations, photographing them throughout Belgium and France. This image is an unprecedented attempt to capture movement for its own sake. The blurred outlines of the passing wagons are not to be construed as a technical flaw; rather, they are a novel expression of motion, here contrasted with the surrealistic stillness of the surrounding scene.

A handwritten note on the mount states that the photograph was in fact taken by Pierre-Jean Maertens, Dubois de Nehaut's servant and photographic assistant. The photographer himself stands, hatless, on the right, conversing with the stationmaster, M. Carion, and an unidentified captain. [PA]

69. Louis-Pierre-Théophile Dubois de Nehaut
French, 1799–1872

View of the Square in Melting Snow, 1854–56
Salted paper print from glass negative
18 x 22.2 cm (7⅛ x 8¾ in.)

This view was taken in Brussels, from the balcony of No. 7, Place de Cologne, the residence of the photographer. It is one of several images Dubois de Nehaut made of the square from that vantage point, at various times of the

year. The tracks made by carriages and people on the melting snow have created a dynamic design of such compelling geometry that the photographer deemed it a worthy subject for a picture—an eccentric notion for the time. [PA]

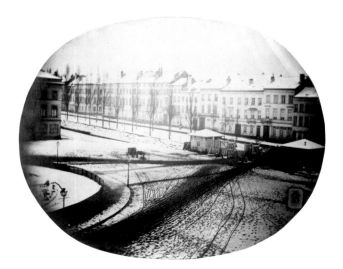

70. Édouard-Denis Baldus
French, born Prussia, 1813–ca. 1890

Lyons During the Floods of 1856
Two salted paper prints from paper negatives
Overall: 31.2 x 85.9 cm (12¼ x 33⅞ in.)
Plate 55

Torrential rains in mid- to late May 1856 caused rivers to swell and low-lying areas to flood throughout France. Nowhere was the devastation greater than in the Saône and Rhône valleys, where the flood waters peaked at nearly eight meters above normal and destroyed whole sections of Lyons, Avignon, Tarascon, and many smaller towns. So great was the destruction that Napoleon III and several of his ministers visited the flooded areas, touring the most heavily damaged sections of Lyons on June 3.

Four days later Édouard-Denis Baldus arrived in Lyons, dispatched by the government to photograph the catastrophic consequences of the floods. Baldus knew the Rhône valley well, having recorded its Roman and medieval monuments on his *mission héliographique* of 1851, and later for his own stock of architectural views. But on this occasion the character of the region was transformed, and the twenty-five negatives that Baldus produced in eight days of work speak of the force of nature rather than the ingenuity of man.

By the time Baldus arrived the river had largely returned to its banks, leaving him to record not the torrent itself but rather the ruinous shells of buildings and the eerily serene landscape of the postdiluvian city. This two-part panorama shows the hard-hit Brotteaux section of Lyons. Remaining true to his preferred subjects of landscape and architecture, Baldus was able to create a moving record of this natural disaster without depicting the human suffering left in its wake, as if the devastation had been of biblical proportions, leaving behind only remnants of a destroyed civilization. Sensing the dual nature of these pictures as both gripping historical documents and aestheticized pictures, the critic Ernest Lacan described his feelings as he examined the photographs of streets transformed into streams, houses overturned, and fields ravaged, all represented "with an exactitude unfortunately too eloquent." "They are very sad pictures," he concluded, "but beautiful too in their sadness."[15] [MD]

71. Édouard-Denis Baldus
French, born Prussia, 1813–ca. 1890

Group at the Château de la Faloise, 1857
Salted paper print from glass negative
27.8 x 38.2 cm (11 x 15 in.)
Ex coll.: Georges Sirot
Plate 50

This photograph and four others taken on the same occasion represent a rare foray for Baldus into the depiction of bourgeois leisure, a subject that would become a mainstay of Impressionist painting a decade later. Characteristically, even in a photograph that ostensibly depicts an informal garden scene, Baldus arranged the bench and chairs with near architectonic symmetry and posed the figures with great deliberateness. Given the artist's predilection for clarity of form and detail, one may wonder whether the elements most akin to the formal devices employed by the Impressionists—the flat white shapes of parasol and dress, for example—were intentional or accidental.

The photograph was made at the Château de la Faloise, the home of Frédéric Bourgeois de Mercey, the seated man in the white hat. De Mercey, a founding member of the Société Héliographique, was the director of the fine arts division in the Ministry of State, an agency whose patronage sustained Baldus throughout the 1850s. Baldus's presence at de Mercey's country home suggests ties of friendship between this influential government arts official and the photographer at the high point of his career. Baldus himself may be the standing gentleman seen here in black pants and top hat. [MD]

72. Léon Gérard
French, active 1857–61

Leonardo da Vinci, Drawing for Christ in "The Last Supper," 1857–61
Albumen silver print from paper negative
36.2 x 26.7 cm (14¼ x 10½ in.)
Plate 53

We know almost nothing of Léon Gérard. Probably an amateur and a man of means, he photographed in Nuremberg and Bamberg in 1857, and in the Rhine Valley, Switzerland, northern Italy, and the department of Loire-et-Cher in France prior to 1861, when he exhibited his work at the Société Française de Photographie.

The drawing in this photograph is related to the famous figure of Christ seated at the center of the table in the fresco Leonardo painted of the Last Supper in the convent of Santa Maria delle Grazie in Milan in 1495–98. Although

the way the image loses itself in the roughly textured surface suggests that it is the sinopia, or sketch, that underlies the fresco, it is in fact a preliminary drawing on paper, now in the Brera Gallery in Milan. The drawing was originally a delicate image in red and black chalk, but Leonardo's touch was all but lost when the contours were reinforced by other hands; the paper, badly abraded, was more than once restored and laid down on canvas. As Leonardo's masterly fresco began to deteriorate shortly after its completion, this drawing of its centerpiece assumed supreme importance. As a double relic, of Leonardo's inspiration and of the face that is the incarnation of Christian spirituality, the drawing was accordingly "saved" at all cost. The face is so well known that Gérard's photograph of this distant version of it works like a memory; insubstantial as smoke, yet distinct, the portrait hovers like that on Veronica's veil. [MMH]

73. Charles Nègre
French, 1820–1880

Spartan Soldier, 1859
Albumen silver print from glass negative
35.3 x 43.5 cm (13⅝ x 17⅛ in.)
Plate 48

Astonished on first seeing daguerreotypes (about 1844) and dreaming of the medium's potential, Charles Nègre immediately resolved to devote himself to the new art, experimenting first with daguerreotypy and, after 1847, with paper photography. Like Le Secq and Le Gray, Nègre had studied painting with Paul Delaroche, and his experience at the easel was the foundation for his photographic work of the early 1850s—genre scenes of Parisian street musicians, chimney sweeps, and vendors, as well as architectural views.

Despite his acknowledged talent Nègre failed time and again either to win government support for or to bring to fruition the grand projects he envisioned for the new medium. Bypassed by the Commission des Monuments Historiques in the assignment of *missions héliographiques*, Nègre produced some two hundred negatives for a self-initiated project entitled *Midi de la France*, only to abandon the publication after issuing two fascicles. Frustrated in his effort to reap any financial benefit from his remarkable photogravure process, he proposed in 1858 that the city of Paris underwrite a 200- to 250-plate photogravure series on the appearance and history of the capital and that the Ministry of State commission a still larger project portraying "the history of humanity" through the collections of the Louvre. Neither proposal was accepted.

Finally gaining official sponsorship in 1859 for a series of fifty photogravures depicting statuary in the Tuileries

Gardens, Nègre produced a group of large-format glass negatives. Characteristically, the project was stymied before completion, but a few unique prints of Nègre's heroic images survive, printed in reverse for translation into photogravure. Here, outlined against the theatrical backdrop of garden greenery and the central pavilion of the Tuileries Palace, Jean-Pierre Cortot's *Spartan Soldier* (1831) seems to rise toward the light. The fate of this soldier, who collapsed and died of exhaustion immediately after he had run to Athens to announce the rout of the Persian invaders at Marathon, seems an apt metaphor for Nègre's own foundering under the weight of his immense ability and ambition even as he heralded the triumphant potential of the medium. Nègre's unfulfilled project is among the last attempts at true artistry before the pressures of commercialism turned photography into a full-scale industry in the early 1860s. [MD]

74. Bisson Frères
(Louis-Auguste Bisson and Auguste-Rosalie Bisson)
French, 1814–1876; 1826–1900

Portal of Saint-Ursin, Bourges, ca. 1855
Albumen silver print from glass negative, 1864 or later
43.4 x 35.2 cm (17⅛ x 13⅞ in.)
Plate 37

Having learned daguerreotypy directly from its inventor, and having established one of the earliest professional portrait studios in Paris, Louis-Auguste Bisson and his

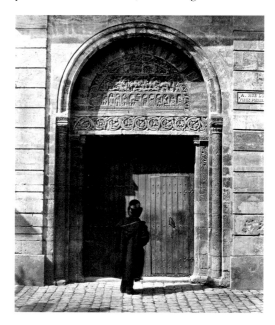

brother Auguste-Rosalie remained faithful to the process until the early 1850s. Bypassing the paper negative processes they began to use large-format glass-plate negatives about 1853 and quickly mastered the process, specializing in architectural views. In these they were rivaled only by Baldus.

The late-eleventh- or early-twelfth-century portal of Saint-Ursin, with a sculpted tympanum depicting episodes from fables, a hunting scene, and the labors of the months, is represented here with a clarity and rigor characteristic of their work. The result, however, is far from sterile. Instead, the photograph invites the viewer to enter, tread the paving stones, and assume the place of the anonymous gentleman in black cloak and top hat as he contemplates the carved entranceway. More than just a pictorial device to trigger an imaginary entry into the scene, however, this man's examination of the Romanesque portal embedded in the architecture of a later building and the fabric of a modern city speaks of a developing notion of the present as embracing vestiges of the past. It was this very concept that gave rise to the Bissons' architectural photographs.

This image appeared as plate 23 in a vast project entitled *Reproductions photographiques des plus beaux types d'architecture et de sculpture d'après les monuments les plus remarquables de l'antiquité, du moyen âge et de la Renaissance . . .*, which included 201 plates issued in fascicles from 1854 to 1862. This print was made by Eugène Placet, who bought the contents of the Bissons' studio in 1864 and continued to print from their negatives. [MD]

75. Édouard-Denis Baldus
French, born Prussia, 1813–ca. 1890

Entrance to the Donzère Pass, ca. 1861
Albumen silver print from glass negative
33.4 x 43.3 cm (13⅛ x 17⅛ in.)

In July 1861 the board of directors for the southern region of the Paris-Lyon-Méditerranée Railroad commissioned Baldus to produce an album of views of the rail constructions and principal sites served by the line between Lyons, Marseilles, and Toulon. This line, especially the section linking Lyons and Avignon, followed trade routes established in antiquity alongside the Rhône, the most powerful river in France, whose strong current made navigation always difficult and perilous, and at times impossible.

Perched on the very edge of the roadbed, Baldus photographed the track and the telegraph lines that ran parallel to it as they skirted along the east bank of the river at the Donzère Pass, the northern entrance to

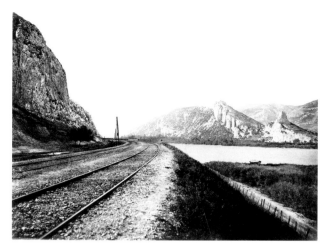

Provence. The ease with which the smooth rails recede into the distance and curve gently around the rugged cliff wall is an apt pictorial expression of the mastery of modern engineering over time and space.

The photograph appears in the album *Chemins de fer de Paris à Lyon et à la Méditerranée.* [MD]

76. Édouard-Denis Baldus
French, born Prussia, 1813–ca. 1890

Cloister of Saint-Trophîme, Arles, ca. 1861
Albumen silver print from glass negative
33.2 x 42.4 cm (13⅛ x 16¾ in.)
Plate 47

The twelfth-century cloister of the Church of Saint-Trophîme in Arles, noted for its richly carved capitals, ranks among the most important examples of French medieval architecture, and was among the sites that Baldus first photographed on his 1851 *mission héliographique*. In the context of the *Paris-Lyon-Méditerranée* album, this picture's tunneling perspective and the repetition of arches link the famous cloister to the achievements of Second Empire engineers—to the railroad tunnels and arched viaducts that are presented in a similar fashion elsewhere in the volume.

Proper exposure of a scene that included both shadowed interior and sunlit exterior presented a difficult task. Careful scrutiny of the print reveals that Baldus used thin tissue overlays on the most transparent sections of the glass negative so as not to lose all detail in the darkest parts of the print. In addition, light washes of watercolor or ink were used to give tone to some of the lightest areas and to define the cloister colonnade. [MD]

77. Auguste-Rosalie Bisson
French, 1826–1900

The Ascent of Mont Blanc, 1861
Albumen silver print from glass negative
39.6 x 23.6 cm (15⅝ x 9¼ in.)

While the transport of photographic equipment and the manipulation of chemical solutions for the wet collodion process was never an easy task, no more audacious challenge was undertaken in the early history of photography than the ascent of Mont Blanc and the making of views at the summit of the highest peak in the Alps. Attempted unsuccessfully by the Bisson Frères in 1860, the goal was achieved by the younger Bisson the following year, aided by an experienced guide and twenty-five porters carrying his plates, cameras, chemicals, and portable darkroom tent. Notwithstanding the paralyzing cold, a blinding snowstorm, avalanches, and the expected nausea and vertigo of high-altitude exploration, the team reached the 15,781-foot summit on July 25, 1861. Bisson exposed three negatives.

It was only after his primary goal had been achieved that Bisson halted his descent in order to set up the tent and cameras once again, pose the figures in positions emblematic of their climb, and make pictures of the "ascent" (though the team's tracks are visible on the high snowy slope in the background). Bringing his Parisian clientele a virtual experience few would ever realize in fact, Bisson was one of many photographers whose explorations of the globe dramatically expanded the known world for nineteenth-century urban audiences. [MD]

78. George Wilson Bridges
British, 1788–1864

Temple of Wingless Victory, Lately Restored, 1848
Paper negative
16.7 x 20.6 cm (6⅝ x 8⅛ in.)
Ex. coll.: Harold White
Plate 70

An Oxford-educated Englishman, the Reverend George Bridges lived comfortably in Jamaica until his wife abandoned him and his six daughters drowned in a boating accident. Thereafter Bridges and his son, William, traveled to Canada and the Mediterranean before returning in 1843 to England, where William enlisted in the Navy and Bridges took a curate's position in Gloucestershire. Bridges met Henry Talbot through a mutual friend in 1846 and took instruction in photography in preparation for further travel.

From 1846 to 1852, Bridges followed his son's ship around the Mediterranean from Malta to Sicily, Athens, Egypt, Algeria, Palestine, Constantinople, and Italy, producing some seventeen hundred negatives, many of them the earliest extant photographs of the sites. As Bridges never managed to print adequately from the negatives and his plans for publication came to naught, the important contribution of this early prolific practitioner and "way-worn wanderer," as he described himself, remains virtually unknown.

Ten years before this negative was made, photography did not exist; five years before, the temple it depicts did not exist. When Bridges arrived at the Acropolis, the Temple of Athena Nike had only just been reconstructed from the rubble of the Turkish bastion. First erected in 424 B.C., the beautifully proportioned little temple was dedicated to Wingless Victory, who, as described by Pausanias, had no wings in order that she might permanently reside in Periclean Athens. The British soldier lounging proprietarily on the steps of her former home is probably William Bridges. [MMH]

79. Anonymous

The Calf-Bearer and the Kritios Boy Shortly After Exhumation on the Acropolis, ca. 1865
Albumen silver print from glass negative
27.1 x 21.8 cm (10⅝ x 8⅝ in.)
Plate 71

From 1833, when the Turkish garrison was withdrawn, until 1882, when systematic excavations were begun, the Acropolis was the site of somewhat random investigation. As the Turkish buildings were cleared and the principal temples re-erected, the debris yielded inscriptions that were incorporated into the walls as they were reconstructed

and fragments of sculpture that were casually grouped together outdoors or in the Propylaea. In 1863 it was decided that a museum was required. While digging its foundation in 1864, workmen discovered additional fragments, among them a headless Athena (at the left in the photograph) and the Calf-Bearer (thought to be a goat-bearer until the animal's head was found). The torso of the Kritios Boy was uncovered the following year, although his head, like the feet of the Calf-Bearer, did not emerge until the late 1880s.

It is ironic that none of these statues would have been saved had the Persians not burned the Acropolis in 479 B.C. At first the Athenians could not bring themselves to rebuild, but they changed their minds and determined to make the place of the gods even more splendid than before. Making a clean sweep, they buried the debris in pits beneath the surface of the new temple compound. Thus, when the Calf-Bearer (ca. 570 B.C.) and the Kritios Boy (ca. 490 B.C.) were photographed, the sun had not shone upon them for some thirteen hundred years. The picture is about the excitement of their discovery—a jumbled and still-fragmentary revelation of the archaic antecedents of classical Greek art. [MMH]

80. Giacomo Caneva
Italian, 1812/13–1865

Carlotta Cortinino, ca. 1852
Salted paper print from paper negative
13.5 x 19.9 cm (5⅜ x 8 in.)
Plate 72

Giacomo Caneva was among the circle of Italian, French, and British artists who, beginning about 1850, exchanged ideas and information about their photographic work at informal meetings at the Caffè Greco, in Rome's Piazza di Spagna. Caneva's embrace of photography, first the daguerreotype and later the paper negative process, was a natural outgrowth of his training as a painter of perspective scenes. This close-up view of a model languorously posed in a studio setting is an exception to Caneva's prevailing subject matter, the architectural monuments of Rome and surrounding towns; its attribution, however, is confirmed by Caneva's large, flourished signature spread across the entire verso of the print. [MD]

81. Robert Macpherson
British, 1815/16–1872

Cloaca Maxima, 1858 or earlier
Albumen silver print from glass negative
31 x 37.2 cm (12¼ x 14⅝ in.)
Plate 73

After studying medicine in Edinburgh, Robert Macpherson left Scotland in the early 1840s and, for reasons of health, settled in Rome. Eventually abandoning medicine, Macpherson gained notoriety as a topographic painter, a connoisseur, and a dealer of art, enjoying a central role among the artists—and later photographers—who frequented the Caffè Greco. His striking appearance (tall and fair-skinned, with long red hair and blue eyes, rendered all the more exotic by the native Scottish kilt he customarily wore) and gregarious nature won Macpherson the friendship of fellow artists and the patronage of well-to-do travelers. Further contact with British writers and intellectuals came with his marriage in 1849 to Gerardine Bates, the favorite niece of the author and art historian Anna Jameson.

Hampered by lack of discipline rather than poverty of talent, Macpherson was only mildly successful as a painter. When introduced to photography in 1851, he abandoned the easel as rapidly as he had given up medicine a decade earlier and devoted himself wholly to the camera. In the next dozen years he produced more than three hundred large views of Rome and other nearby Italian sites.

Macpherson's photographs achieved immense popularity both in Britain and among his countrymen traveling in Italy, for he not only provided pictorial souvenirs of the Eternal City, he also tapped a vein of romantic interest in picturesque ruins, guided in subject and viewpoint by his experience as a topographic painter. In this photograph he recorded one mouth of the Cloaca Maxima (or great sewer), a vast system of arched canals built about 200 B.C. to drain the valleys between the Esquiline, Viminal, and Quirinal hills. As presented by Macpherson, the Cloaca Maxima could as easily be a British nineteenth-century garden grotto as the work of Roman engineers. [MD]

82. Robert Macpherson
British, 1815/16–1872

The Theater of Marcellus, from the Piazza Montanara,
1858 or earlier
Albumen silver print from glass negative
41.9 x 27.4 cm (16½ x 10¾ in.)
Plate 74

Like geological strata laid bare to reveal the earth's development, the walls of the Theater of Marcellus bear witness to the various transformations of the ancient Roman monument. Begun by Julius Caesar and completed about 12 B.C. by Augustus, despoiled in the fourth century, fortified in the eleventh, and converted into a palace in the sixteenth, the theater housed apartments and the shops of artisans by the mid-nineteenth century. Macpherson's photograph presents the antique theater in fragmen-

tary form, partially shrouded in shadow—less a field for archaeological investigation than for philosophical meditation on the weight of history on the lives of Rome's modern citizens. [MD]

83. Maxime Du Camp
French, 1822–1894

Westernmost Colossus of the Temple of Re,
Abu Simbel, 1850
Salted paper print from paper negative
22.8 x 16.5 cm (9 x 6½ in.)
Ex coll.: Eugène Viollet-le-Duc
Plate 65

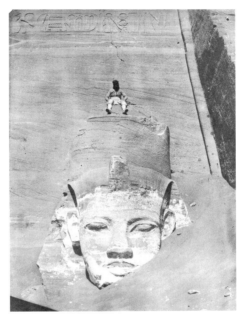

Maxime Du Camp's mission to Egypt and the Near East in 1849–51 to make a photographic survey of monuments and sites is well documented in his writings and in those of his fellow traveler, Gustave Flaubert. After an initial stay in Cairo, the two friends hired a boat to take them up the Nile as far as the second cataract, after which they descended the river at leisure, exploring the archaeological sites along its banks. In July 1850 they left Egypt for Palestine, Turkey, and Greece before they parted in Italy the following April. Du Camp's album *Egypte, Nubie, Palestine et Syrie,* published in 1852 and containing 125 photographs printed by Blanquart-Evrard, brought its author instant fame. In addition to the published edition, Du Camp arranged for a private printing of a few portfolios, such as the one in the Gilman collection, which numbers 174 images particularly noteworthy for their warm color and luminescence. Possibly printed in Gustave Le Gray's studio, the present portfolio is thought to have been in the collection of the architect Eugène Viollet-le-Duc.

A journalist with no experience in photography, Du Camp learned the craft from Le Gray shortly before his departure for Egypt. By the time he came to Abu Simbel in March 1850 to explore the rock-cut temples built by Ramesses II (reigned 1292–1225 B.C.), Du Camp was thoroughly at ease with the medium. Always in search of a neat, documentary clarity, he preferred a frontal view and midday light. For this picture of one of the colossal effigies of Ramesses II (plate 49 in the portfolio), he had the lower portion of the face unearthed and his assistant climb atop the crown to indicate scale. By coincidence, on March 29, the day the energetic Du Camp made this image unabashedly saluting the tourist with his camera as the new ruler of the land, the more reflective Flaubert voiced in his diary his irritation at being cast in such a role: "The Egyptian temples bore me profoundly. Are they going to become like the churches in Brittany, the water-falls in the Pyrenees? Oh necessity! To do what you are supposed to do; to be always, according to the circum-stances . . . what a young man, or a tourist, or an artist . . . is supposed to be!"[16]　　　　　　　　　　　　　　　　[PA]

84. Maxime Du Camp
French, 1822–1894

House and Garden in the Frankish Quarter, Cairo, 1850
Salted paper print from paper negative
21.2 x 14.9 cm (8⅜ x 5⅞ in.)
Ex coll.: Eugène Viollet-le-Duc

Gustave Flaubert (1821–1880) arrived with Maxime Du Camp in Cairo at the end of November 1849. The two friends stayed at the Hôtel du Nil for two months before embarking on their journey to Upper Egypt. They enjoyed the local color, dressed as Egyptians, smoked the nar-ghile, and indulged in all the pleasures available to well-to-do uninhibited young men in search of new experiences.

　　The twenty-seven-year-old Flaubert had started the journey in a state of depression over his friends' negative response to his first literary effort, the initial draft of *The Temptation of Saint Anthony*. During the voyage he would seem to Du Camp bored and aloof, though he was willing to help the photographer prepare his plates. Flaubert staunchly refused, however, to be photographed, and Du Camp was able to take only one picture of him, on January 9, 1850, brooding in the garden of the hotel in a white Nubian cotton shirt, his shaved head adorned with a bright red tarboosh. Du Camp would write later that, to Flaubert, the Egyptian temples all seemed alike and the mosques and landscapes all the same. Despite his seem-ing indifference, however, Flaubert was amassing a wealth of impressions that would later find their way into such

works as his Carthaginian novel *Salammbô* (1862) and the final version of *The Temptation of Saint Anthony* (1874). It was also during this voyage that Flaubert first started to imagine "some deep, great intimate story. . . a passion like a sickness . . ." which would take place in an obscure French provincial town.[17] It was on a cliff overlooking the second cataract at the southernmost part of the journey that he came up with the name of his heroine, Emma Bovary, suggested by the name of M. Bouvaret, one of the owners of the Hôtel du Nil.　　　　　　　　　　　　　[PA]

85. Félix Teynard
French, 1817–1892

Abu Simbel, 1851–52
Salted paper print from paper negative
24.3 x 30.8 cm (9⅝ x 12⅛ in.)
Ex coll.: Marquis du Bourg de Bozas Chaix d'est-Ange
Plate 69

A civil engineer based in Grenoble, Félix Teynard traveled to Egypt in 1851–52 with the express purpose of updating the standard architectural reference on Egypt, *Description de l'Egypte*, a lavish publication of oversized engravings issued by Napoleon's team of savants between 1809 and 1829. Teynard's survey, 160 salted paper prints with accompanying text, was published from 1853 to 1858 as *Egypte et Nubie, sites et monuments les plus intéressantes pour l'étude de l'art et de l'histoire.* . . . Fewer than a dozen complete sets have survived.

　　Teynard photographed the sites from Cairo to Nubia with evident wonder at the engineering skills of the

ancient architects and builders. He worked from multiple vantage points and had an uncommon grasp of the physicality of man-made constructions—their size and placement in space, their materials and decoration, and their state of conservation. His approach was graphically innovative, as is seen in one of his twelve views of Abu Simbel. This detail of the great temple shows the encroaching desert in the foreground and two of the four sixty-five-foot colossi—the largest in Egypt—cut into the sandstone cliffs. From a twentieth-century vantage point, the daring cropping of the head seems decidedly modern, a condition that Teynard acknowledged in the note accompanying the plate: "The vantage point was too low to allow inclusion of the head of the preserved colossus without distortion. For this reason, we preferred to take only the lower parts of the colossi, which can be completed by means of the next photograph, since they all depict the same person."[18]

Virtually all of Teynard's known photographs are affixed to mounts that credit his printmaker, H. de Fonteny, on the lower left margin. This photograph, however, is one of several rare examples stamped with Teynard's own name. It suggests that the photographer may himself have printed a set of negatives to complete the publication after de Fonteny's firm closed in 1854. [JLR]

fibers softened the picture's resolution. The best practitioners of the technique, however, turned its faults to advantage and organized their pictures around masses of deep shadow and suffused light, recognizing that a few well-chosen details could give dramatic relief to architectonic structures. This photograph is a masterpiece of the genre. It represents a Middle Kingdom rock-cut tomb at Beni-Hasan (ca. 1900 B.C.), 105 miles upriver from Cairo.

Within the bold composition of light and dark, Teynard placed the delicate form of a European bentwood cane against the column. Like a surveyor's measure, the cane indicates scale. It also functions as Teynard's personal signature, but unlike the graffiti to the right, it was temporary and did not deface the monument. [JLR]

87. Félix Teynard
French, 1817–1892

Colossus and Sphinx, Es-Sebua, 1851–52
Salted paper print from paper negative
23.9 x 31.1 cm (9⅜ x 12¼ in.)
Ex coll.: Marquis du Bourg de Bozas Chaix d'est-Ange

86. Félix Teynard
French, 1817–1892

Portico of the Tomb of Amenemhat, Beni-Hasan, 1851–52
Salted paper print by H. de Fonteny from paper negative
24.3 x 30.6 cm (9⅝ x 12 in.)

By the time Teynard set out for Egypt with a large-format camera, he was thoroughly accomplished in the waxed-paper negative technique, which had been perfected only the year before in Paris by Gustave Le Gray. One of the drawbacks of using paper negatives was that the paper

These two desert friends engaged in an ancient conversation were discoverd by Teynard on a sand-swept avenue leading to one of two New Kingdom (1400–1200 B.C.) temples at the site of Es-Sebua, in Nubia. [JLR]

88. John Beasley Greene
American, active France, 1832–56

The Nile, 1853–54
Salted paper print from paper negative
22.3 x 30.2 (8¾ x 11⅞ in.)
Plate 67

John Greene was an archaeologist, the well-to-do son of a banker from Boston who lived in Paris, and a photographer. By 1853 the twenty-one-year-old Greene had learned to use Le Gray's waxed-paper process, the technique of choice for traveling Frenchmen. That same year he made the first of two expeditions to Egypt and Nubia, bringing back more than two hundred negatives of monuments and landscapes, some ninety-four of which, printed by Blanquart-Evrard in 1854, comprise the album *Le Nil, monuments, paysages, explorations photographiques par J. B. Greene.* So rare are these albums that we assume that Greene published them at his own expense. On his second trip, in 1854–55, he not only photographed but also excavated, especially at Medinet-Habou. During an archaeological and photographic expedition to Algeria the following winter, this exceptionally talented young man died of an undisclosed illness.

Greene's Egyptian landscapes are startlingly barren. Coalescing from large, softly nuanced tonal planes, the views seem to shimmer above the page almost to the point of evaporating, like distant desert mirages. Generally, Greene placed the geological or archeological structure of these pictures at a distance, surrounded by sand and sky. This, the most minimal of his visions, sums up the Egyptian landscape. Stretching between the great river and the endless expanse of sky, and between the great river and the desert, is a thin band of fertile earth—the ligament of life that gave rise to a great civilization. That the picture functions like a diagram may owe to Greene's knowledge of hieroglyphics; the Egyptian pictograph for "country" is a flat, floating disk, hardly more than a horizontal line.

This photograph and no. 89 were not printed by Blanquart-Evrard, but, it would seem, by the photographer himself. [MMH]

89. John Beasley Greene
American, active France, 1832–56

Dakkeh, 1853–54
Salted paper print from paper negative
23.4 x 30.3 cm (9¼ x 11⅞ in.)
Plate 68

While Greene was a member of the Société Asiatique and a serious archaeologist (the results of his excavations were published in *Fouilles exécutées à Thèbes dans l'année 1855, hiéroglyphiques et documents inédits)*, his photographs denote a sensibility more poetic and philosophical than scientific. This photograph represents the Ptolemaic temple at Dakkeh in Nubia. If intended as a useful record of the inscriptions and decoration, the photograph is downright perverse, for the Horus figures, cartouches, and

even the king are mostly swallowed up by the jagged shadow. But if intended as an homage to the drama of the daily transit of the sun in a blazing, rainless land, the picture is an unqualified success.

As the ancient Egyptians believed that the sun is the source of life and darkness the equivalent of death, Greene's photograph also expresses a cosmological system that perhaps had personal resonance. Temporarily in good health following his stay in the desert, Greene eventually succumbed to the ailment that evidently worsened whenever he left sunny Egypt and returned to Northern Europe. The haunting sense of man's vulnerability and the ephemerality of his labors is deeply imbedded in Greene's unflinching, profoundly existential images. [MMH]

90. Auguste Salzmann
French, 1824–1872

Jewish Sarcophagus, Jerusalem, 1854
Salted paper print from paper negative
23.3 x 32.7 cm (9⅛ x 12⅞ in.)

Ridiculed by fellow scholars for contending that many architectural fragments examined on an 1850 expedition to Jerusalem dated from the period of David and Solomon, Félicien Caignart de Saulcy was further accused of having provided fanciful and inaccurate site drawings to support his thesis. Auguste Salzmann, an artist and archaeologist, entered this scholarly fray late in 1853, setting off for Jerusalem to study and photograph the disputed monuments; after four months' work, he returned to Paris with at least 150 negatives. For Salzmann, the conclusive power of his photographs was self-evident; simple examination of the visual evidence they provided proved de Saulcy correct. With obvious satisfaction, de Saulcy wrote of having been vindicated by "a most able draftsman, in truth, and one whose good faith would be difficult to question, . . . the sun."[19]

In contrast to the more generalized architectural views produced by other exploratory photographers in the Middle East, Salzmann's photographs often depict planar masonry surfaces or isolated architectural details. Although guided in his understanding of light and texture by his artistic training, Salzmann chose his subjects and vantage points to fulfill a scholarly, scientific mission; the results are often appealing to the modern eye for their minimalism and for their divergence from artistic convention.

Salzmann's photographs of Jerusalem were printed in 1854 for private distribution and published for commercial sale two years later under the title *Jérusalem: Étude et reproduction photographique des monuments de la ville sainte depuis l'époque judaïque jusqu'à nos jours.* The 1856 edition, from which this print is taken, included 174 plates and an accompanying text. [MD]

91. Louis de Clercq
French, 1836–1901

Tripoli, 1859
Two albumen silver prints from three paper negatives
Overall: 19.7 x 82.2 cm (7¾ x 32⅜ in.)

In August 1859, twenty-three-year-old Louis de Clercq was invited to accompany the young historian Emmanuel-Guillaume Rey on a government-sponsored expedition to the crusader castles of Syria and Asia Minor. Aware of the potential contribution of photography to archaeological research, as demonstrated by Auguste Salzmann's earlier project, Rey thought that de Clercq would prove a valuable travel companion for his skill as a photographer as well as for his friendship.

Among the sites visited by Rey's team was Tripoli (in present-day Lebanon), a major intellectual and trading center for northern Syria before and during its control by Frankish crusaders from 1109 to 1289. In addition to individual plates that record Tripoli's remaining crusader fortifications, de Clercq produced this three-part panorama showing the general aspect of the town's port, a view more interesting for its animated roofscape and shipyard than for its archaeological data.

After returning to Paris in 1860, de Clercq published 222 of his views in six volumes. This plate appears in the first volume, *Voyage en Orient. Villes, monuments, et vues pittoresques de Syrie.* Together, the six volumes include virtually all of de Clercq's known photographs, though Rey's writings indicate that de Clercq was already an experienced photographer before the expedition. On later trips to the Middle East, de Clercq's passion for the region would find expression in the formation of a collection of historical artifacts that is now an important part of the Department of Oriental Antiquities at the Louvre. [MD]

92. Louis de Clercq
French, 1836–1901

Entrance Portal, Dendera, 1860
Albumen silver print from paper negative
21.6 x 28.4 cm (8½ x 11⅛ in.)
Plate 66

Parting with Rey's expedition in Jerusalem in December 1859, de Clercq, a young man who had independent means and influential family connections, continued on his own to photograph sites of historical and archaeological interest in Palestine and Egypt. This view shows the principal gate to the sanctuaries at Dendera, constructed during the Roman period under the reign of Domitian (A.D. 81–96). Here, more than in any of his other photographs, de Clercq used the intense desert light and the highly geometric character of Egyptian architecture to dramatic effect. Confronted with this startling interplay of positive and negative forms, the viewer may wonder whether the artist cut and pasted these flat forms like an abstract collage, or whether it is the legerdemain of ancient architects and the folly of time that have suspended these massive stones over a void seemingly more solid and substantial than the architecture itself.

This plate appears in de Clercq's fifth volume of photographs, *Voyage en Orient. Monuments & sites pittoresques de l'Egypte.* The set of volumes in the Gilman collection was presented by de Clercq to the Count de Tanlay, a

91

career military officer who led a division of the Imperial Guard in important battles of the war against Austria and in support of Italian unification in 1859. One may speculate that de Clercq knew de Tanlay through his own service during the same period as a courier between Paris and the imperial court at the battlefront.　　　[MD]

93. Louis de Clercq
French, 1836–1901

The Tower of Gold, Seville, 1860
Albumen silver print from paper negative
20.4 x 28.5 cm (8 x 11¼ in.)
Plate 78

Wishing to compare the Islamic architecture of Spain with the Arab sites he had just seen in Syria, Palestine, and Egypt, de Clercq returned to Paris by way of the Iberian Peninsula. In Seville he photographed the Tower of Gold, a twelve-sided tower built in 1220 as part of the defensive structure of the Alcazar, its name deriving from the color of the glazed tiles that had once covered its exterior.

Whereas de Clercq depicted the massive crusader castles of Syria in compositions that convey a sense of weight and solidity and the antiquities of Egypt in starkly abstract terms, he responded to the complex and delicate details of Islamic architecture with lighting and compositions of a more painterly cast. Instead of presenting the Tower of Gold close up and in isolation, de Clercq showed it from afar, situated on the sloping bank of the Guadalquivir River, flanked on one side by trees and on the other by the masts and rigging of docked boats, making it but one element in a dreamlike vision.

This plate appeared in the sixth and final volume of de Clercq's publication, *Voyage en Espagne. Villes, monuments & vues pittoresques*.　　　[MD]

Spain, enjoying the patronage of Queen Isabella II, as well as that of the dukes of Frías, Monpensier, and Osuna. He documented royal tours throughout the provinces, large-scale programs of public works, and the royal collection of armor, but is best known for his affecting and rather unorthodox photographs of the architecture, decoration, and costume that were Spain's distinctive heritage.

This photograph is one of his most remarkable. The image of Saint Bruno, founder of the Carthusian order, was sculpted by Mañuel Peyreras in the seventeenth century. In the 1850s it stood in a small lateral chapel of the dilapidated monastery church, surrounded by a clutter of sculptures and reliquaries of little merit. Clifford evidently had the statue moved to the front door, where he had sufficient light and space to do it justice. Perfectly in tune with the verisimilitude of the life-sized statue, Clifford provides for the viewer a natural and immediate approach: lifting our eyes as we mount the steps, we come upon Bruno splendidly isolated against the cavernous dark interior, in the midst of his miraculous vision.　　　[MMH]

94. Charles Clifford
British, 1821–1863

Statue of Saint Bruno in the Carthusian Monastery of Our Lady of Miraflores, Burgos, 1853
Albumen silver print from paper negative
33.9 x 28.4 cm (13⅜ x 11⅛ in.)
Plate 3

Born in London, Charles Clifford had established a photographic studio in Madrid by 1850. From 1852 through January 1, 1863, when he died of a cerebral hemorrhage, Clifford was the most important foreign photographer in

95. Charles Clifford
British, 1821–1863

Courtyard of the House Known as Los Infantes, Zaragoza, 1860
Albumen silver print from glass negative
30.8 x 42.5 cm (12⅛ x 16¾ in.)
Ex coll.: Duc de Montpensier
Plate 75

This print is from an album of fifty-six plates entitled *Photographic Memories of the Trip of Their Majesties and Highnesses to the Balearic Islands, Catalonia and Aragon*, which originally belonged to Antoine d'Orléans, duc de Montpensier, a great collector and patron of photographers and the brother-in-law of Queen Isabella II.

The photograph represents the patio balcony in the house where the infante Luis Antonio, a son of the eighteenth-century king of Spain, Philip V, was forced to retire after marrying a woman beneath his station. Not long after Clifford's visit, many pieces of the extraordinary plateresque decoration were removed and sold abroad. While the photograph documents the deteriorated state of the house, its unsettling quality emanates less from desuetude than from the mysterious curtain at the right, which in effect decapitates the knight in the cartouche below. In the work of a photographer whose ideal was complete and generalized description, the curtain in the dark-cornered vignette might be considered a mistake. But as Clifford consistently constructed telling images from selected details, the eccentric picture may well be a poignant commentary on the demise of the noble arts and on the personal obscurity of the banished infante.

[MMH]

96. Charles Clifford
British, 1821–1863

The Walnut Tree of Emperor Charles V, Yuste, 1858
Albumen silver print from glass negative
41.8 x 30 cm (16½ x 11¾ in.)
Plate 76

In May 1858, Clifford accompanied the Duke of Frías on a trip to Toledo and Extremadura. One of the principal goals of the excursion was the remote town of Yuste, where the king of Spain, Charles I (better known as the Holy Roman Emperor, Charles V), had retired. During the eighteen months prior to his death in 1558, the former ruler of the largest empire the world had ever known resided there at the Hieronymite monastery. Perhaps in homage to his death three hundred years earlier, Clifford made two darkling views of the ruinous monastery in which gloomy, hooded monks appear. He also made this photograph, of a magnificent old tree, known as the Emperor's Walnut Tree, whose branches trap the sun, creating a sanctuary of shade. Whether the emperor had some historic relation to it, or whether the association arose from the natural parallel between the ancient, still-powerful tree and the living power of a legend is debatable, but in either case Clifford's image is manifestly a portrait of greatness.

[MMH]

97. Roger Fenton
British, 1819–1869

Dome of the Cathedral of the Assumption
in the Kremlin, Moscow, 1852
Salted paper print from paper negative
17.9 x 21.6 cm (7 x 8½ in.)
Plate 79

Since its victory over Napoleon, Russia was viewed as the rising power of nineteenth-century Europe. Foreigners knew little of the immense empire outside the capital, the thoroughly Western St. Petersburg. But Moscow, with its multitude of gilded domes and the profile of its Kremlin towers, was an exotic sight, announcing Asia. In 1852, Roger Fenton traveled to Russia with Charles Blacker Vignole to document Vignole's building of a suspension bridge across the Dnieper in Kiev. Fenton soon left Vignole to travel to Moscow and St. Petersburg, returning to London in time to show three of his Russian views in the "Exhibition of Recent Specimens of Photography," at the Society of Arts, in December 1852. These were the first photographs of Russia to be seen by the British public.

Fenton photographed the cupolas of the Cathedral of the Assumption at eye level, from the lower bell arcade of the Ivan the Great Bell Tower, the city's highest building, looking west over Cathedral Square toward the churches of Terem Palace. The view shows, behind the cathedral, the modest Church of the Deposition of the Robe as it looked before a twentieth-century restoration would revive its original design. The Cathedral of the Assumption, built in 1475–79 by the Bolognese Rodolfo (Aristotle) Fioravanti for Grand Prince Ivan III, was the focal point of Russian religious life, where czars were crowned and patriarchs interred. Combining medieval Russian features with the harmonious geometry of the early Italian Renaissance, the church symbolized Moscow's ambition to be recognized as "the third Rome," replacing Constantinople, fallen to the Turks in 1453, as the center of Orthodox Christianity. Photographing from above and showing only portions of buildings and roofs, Fenton infused the composition with an exhilarating sense of airiness and light, the memorable image taking on the power of the architecture itself to proclaim the spiritual aspirations of a people.

[PA]

98. Roger Fenton
British, 1819–1869

Landing Place, Railway Stores, Balaklava, 1855
Salted paper print from glass negative
27.9 x 36.4 cm (11 x 14⅜ in.)

In 1853 war broke out between Turkey and Russia over Russia's expansionist policies in the Balkans, still under Turkish rule, and the status of Orthodox minorities within the Ottoman Empire. England and France allied themselves with Turkey against Russia in 1854. The allies already controlled the seas, but in order to force a resolution of the conflict they laid siege to Sebastopol, the capital of the Crimea on the Black Sea. The city held out for nearly a year, falling in September 1855. The next year the Treaty of Paris effectively contained Russian ambitions in Eastern Europe.

The Crimean War was the first large-scale conflict documented by photography. At the urging of the British government, Roger Fenton was commissioned by the publishers T. Agnew and Sons to record the theater of the war in photographs to be sold by subscription. The images were intended to reassure the British at home, alarmed by reports of a harsh winter, squalid conditions, outbreaks of cholera, and inadequacies in leadership, that their troops were not suffering undue hardship. Fenton spent four months covering the war and returned with more than 350 negatives. Enjoying official patronage and mindful of the

commercial aspect of his mission, he made landscapes, portraits, and scenes of camp life. He did not photograph scenes of actual battle, whose successful depiction in fact lay beyond the technical grasp of the camera, nor did he photograph casualties and suffering, which would have been considered beyond the boundaries of good taste. This view of Balaklava, the narrow harbor used as a landing place by the English, shows the chaotic disruption that was imposed on the placid Crimean village by modern warfare.

Fenton was received by both Queen Victoria and Emperor Napoleon III for private showings of the photographs, which were later exhibited at the Gallery of the Water Colour Society in London, in September 1855. Despite its critical success, the series sold poorly; the war was unpopular and would end a few months later. Agnew disposed of the unsold material at public auction in 1856.

[PA]

99. Roger Fenton
British, 1819–1869

Sebastopol from Cathcart's Hill, 1855
Salted paper print from glass negative
21.8 x 34.7 cm (8⅝ x 13⅝ in.)

Cathcart Hill, named for the British general whose grave lay nearby, was the observation point from which the allied commanders of the Crimean War gathered to follow the progress of the siege of Sebastopol. This image is an interesting example of Fenton's pursuit of his own pictorial agenda, regardless of the avowed purpose of his mission. Sebastopol is barely visible in the distance. The vast, desolate emptiness seems hardly worth a battle; the picture is really about the tenuous hold of man over an indifferent terrain.

[PA]

100. Anonymous

Women Grinding Paint, Calcutta, ca. 1845
Daguerreotype
9.4 x 14.4 cm (3¾ x 5⅝ in.)
Plate 82

With the invention of photography, the eighteenth-century British passion for recording exotic flora and fauna and for making ethnological studies of the peoples in India was given new impetus. The earliest photography on the continent dates from 1840 in Calcutta, the political center of British India. Paradoxically, the first photographs made there by officers of the British Army were daguerreotypes, a French process; photography on paper, the British invention, arrived in India in the late 1840s.

Although the original paper mat on the verso of this daguerreotype is inscribed "Women Grinding Paint," the subjects could be performing one of any number of tasks: grinding indigo, for example, or beetlenut, or spices for curry. All that is certain is that the man in the turban to the right is a follower of the god Shiva, the sustainer-dissolver of the universe. Holy ash, or *bhasma*, marks his forehead, while around his neck is a *mala* of *rudraksha*

beads, sacred to Shiva. It seems likely that the photographer moved the group outside from a workshop nearby, carefully posing them in the shaft of sunlight that emerged through the slatted canopy. The setting—a quiet alley free of human, animal, or commercial distractions—is artificial even for India in the 1840s. The isolation of the figures, however, together with the respectful, low position of the camera, was employed by the photographer to great advantage. [JLR]

101. John Murray
British, 1809–1898

Main Street at Agra, 1856–57
Salted paper print from paper negative
37.4 x 46.5 cm (14¾ x 18¼ in.)
Plate 81

John Murray was a doctor from Aberdeen who specialized in treating cholera. He served in the East India Company Army from 1832, became the officer in charge of the medical school at Agra, and ultimately the inspector general of hospitals in the northwest provinces. Like many Englishmen living in India, he took up photography as a hobby, apparently about 1849. But compared to the views made by most of his contemporaries, Murray's are exceptional: they are very large, beautifully printed exhibition-quality pictures whose subject is not the British presence or Indian archaeology, but the visual flavor of the place. His view of the principal street in Agra manages to convey the heat of the day and the activity of the street through the deep shadow and the blurred pedestrians, whose passage reads like dust accumulated during the long exposure. With ground-floor shops shaded from the sun and second-story loggias open to the air, the buildings—each different in size, scale, and decoration—shoulder each other and jostle for space like so many individuals in the stream of people shimmering below.

Murray's photographs were recommended to Queen Victoria by Lady Charlotte Canning, the wife of the governer general of India (see no. 104) and a former lady-in-waiting to the queen. In November 1857 she wrote, "I think it is possible that Your Majesty has lately seen some photographs of Dr. Murray of Agra. He left 800 negatives with Hogarth to print and has just returned here."[20] Thirty-five of Murray's photographs were exhibited at Hogarth's in London in December 1857, followed by thirty more in 1858. The exhibitions were timely, for the Indian Mutiny was then raging. If the queen saw Murray's photographs, she learned nothing of the progress of war from them (the doctor did not depict battles); but the evocative magnificence of the pictures may have reminded her of what there was to fight for. In 1858, after the uprising was quelled, Queen Victoria assumed full sovereignty of the Indian people. [MMH]

102. John Murray
British, 1809–1898

The Taj Mahal from the Bank of the River, Agra, ca. 1858
Albumen silver print from paper negative
39.9 x 44 cm (15¾ x 17⅜ in.)
Plate 80

The Taj Mahal, built by Shah Jahan as a mausoleum for his favorite wife, Mumtaz Mahal, between 1632 and 1645, is considered one of the most beautiful buildings in the world. Perhaps the finest example of late Indian Muslim architecture, the white marble tomb sits in a walled garden, its domes serenely reflected in an oblong pool. Next to it stands its mirror image, a virtual replica repeated for symmetry. Characteristically, Murray did not choose the axial point of view, so dear to visitors, which diplays the Taj and its reflected image to full advantage. Instead, he made several views that describe its actual context. In one, the building looms up beyond the garden of a paper factory; here, it appears sandwiched between the neighboring mosques. Seen from a crumbling parapet above the Jumna River, and wholly ignored by the two men squatting there, the pavilions appear as fantastic remnants of Mughal glory, a sublime architectural parade stranded in the middle of the nineteenth century. [MMH]

103. Linneaus Tripe
British, 1822–1902

The Pagoda Jewels, Madurai, 1858
Albumen silver print from glass negative
21.9 x 30.1 cm (8⅝ x 11⅞ in.)

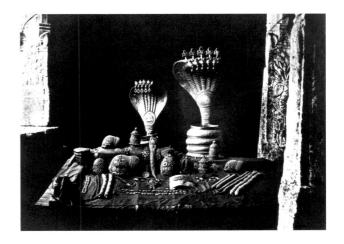

Linneaus Tripe enlisted in the army of the East India Company at the age of seventeen. While in England on furlough in 1851 and 1853, he purchased cameras and photographic apparatus. The views he made of ancient temples in Hullabede and Belur in 1854 attracted the

attention of the directors of the company, who in 1855 requested that the Indian presidencies use photographers rather than draftsmen to record regional antiquities. The following year Tripe was appointed government photographer to the Madras presidency, and in 1857–58 he made an extended photographic tour of the southern districts, producing six volumes of handsome photographs, most of them of temples, in 1858.

This photograph is plate 11 in the third section of the Madurai volume. One of several photographs taken at the Great Temple of Madurai, it represents the special adornments for the idols and their mounts which were ceremoniously carried through the temple compound in festival processions. In addition to the richly jeweled crowns, necklaces, and forehead ornaments, there are stirrups of gold and bridles of pearls and coral. The large ornaments in the background embellished the lingam, the phallic symbol of the god Shiva. Placed over the lingam, the cobra would coil around it, raising its hood in an exorbitant display of protective majesty. The principal lingam resided in the innermost temple, forbidden to foreigners. Tripe's picture is thus about a ceremony he could not photograph and the absent symbol of a god he could not see. [MMH]

104. Anonymous

The Earl Canning, Barnes Court, Simla, 1861
Albumen silver print from glass negative
26.3 x 22 cm (10⅜ x 8⅝ in.)
Plate 83

Charles John, Viscount and later Earl Canning (1812–1862), assumed his role as governor general of India in 1856 and had the difficult task of dealing with the Indian Mutiny against British rule the following year and pacifying the country after the insurrection. In 1858, Queen Victoria appointed him the first viceroy of the subcontinent. Even in a private moment, looking out over the countryside from the terrace of Barnes Court, his Gothic-style summer residence in Simla, Lord Canning exudes the authority of his rank and displays in his dress the same fastidious style that characterizes his dispatches. Tall and stately in bearing, with a cold, handsome face, Lord Canning was reserved and uncommunicative, though as an administrator he had the reputation of being a stickler for fairness. British residents who opposed his policy of reconciliation in the aftermath of the mutiny gave him the nickname Clemency Canning.

Both Lord Canning and his wife, Lady Charlotte, were major patrons of photography in India, and Lady Canning was herself an amateur photographer. The elegant album, bound in green morocco, that includes this image comprises 117 photographs which offer a close look at the life of the Cannings from 1858 and 1861. It revolves in great

measure around the personality and interests of Lady Charlotte Canning (1817–1861), a fabled beauty in her youth and a former lady-in-waiting to Queen Victoria, with whom she maintained a lively correspondence (see no. 101).

Lady Canning's unexpected death left her husband inconsolable. A view of the gardens at her favorite country house at Barrackpur, near Calcutta, is among the last pictures in the album; it is dated November 18, 1861, the day of her death. [PA]

105. Samuel Bourne
British, 1834–1912

The Manirung Pass, 1866
Albumen silver print from glass negative
23.7 x 29.6 cm (9⅜ x 11⅝ in.)

After some initial success as a professional photographer in England, Samuel Bourne sailed to India in 1863 and soon after his arrival opened a studio in Simla. From there he embarked on three successive photographic expeditions to the Himalayas, which brought him wide recognition and which he described in the pages of the *British Journal of Photography* in issues dating from 1864 to 1870.

This photograph of the Manirung Pass was made in 1866 on the last and most strenuous of the expeditions, the destination of which was the source of the Ganges. Accompanied by the botanist and geologist G. R. Playfair, Bourne enlisted a team of eighty porters who drove a live food supply of sheep and goats and carried boxes of chemicals, glass plates, and a portable darkroom tent. Crossing the pass at an elevation of 18,600 feet, Bourne succeeded in taking three views before the sky clouded over, setting a record for photography at high altitudes. After near-fatal hardships, the expedition reached the ice

cave at the foot of Gangotri Glacier, where the Ganges originates, and returned safely to Simla. It was through such feats of physical courage, as well as the obstinate pursuit of the highest artistic standards, that Bourne earned his reputation as a peerless photographer-explorer.

By the time Bourne left India in 1870 to return to England, he had produced over 2,500 views, mostly of architecture and landscapes, which, distributed by his partner Charles Shepherd, constitute the most exhaustive record made in India by a single photographer. Bourne's carefully thought-out, meticulously crafted images were collected by tourists, archaeologists, and botanists alike. The album of 131 images from which this view is taken includes 68 photographs by Bourne. With a few exceptions all the other images, ranging from cricket games to amateur theatricals and shipwrecks, were made in India. A richly informative document on the subcontinent as viewed through British eyes, the album was probably assembled by a British resident in India in the late 1860s.

[PA]

106a. John Thomson
British, 1837–1921

His Majesty Prabat Somdet Pra paramendr Mahá Mongkut, First King of Siam, in State Costume, 1865
Albumen silver print from glass negative
22 x 17.2 cm (8⅝ x 6¾ in.)

John Thomson, a Scotsman who settled in Singapore in 1863, was only beginning his ten-year career as one of the greatest travel photographers of the Far East when he arrived in Bangkok in 1865. Received at the court of King Mongkut, who ruled Thailand as Rama IV from 1851 to 1868, Thomson spent several months in the country, making an excursion to the ruins of Angkor, which he photographed in January 1866, a few months before the arrival of the French photographer M. Gsell (see no. 107). From 1868 to 1872, Thomson assembled his masterly documentation on China, published after he returned to Britain as *Foochow and the River Min* (1873) and the four-volume *Illustrations of China and Its People* (1873–74).

A religious reformer who had spent twenty-seven years as a monk, a student of languages, history, and astronomy, and a progressive monarch who set his nation on the path of modernization, King Mongkut is, ironically, better known in the West as the archetypal Oriental despot of the Rodgers and Hammerstein musical *The King and I*. Thomson related in the accounts of his travels his meeting with King Mongkut and described how, on October 6, 1865, he was granted permission to make these two portraits. As the religious leader of his country, the king chose first to be seen as a man of God and, appearing in a spotless white robe, requested to be photographed in prayer. Then he suddenly changed his mind and left the room without explanation. Perplexed by his departure, Thomson appealed to his guide and was told that "the King does everything which is right, and if I were to accost him now, he might conclude his morning's work by cutting off

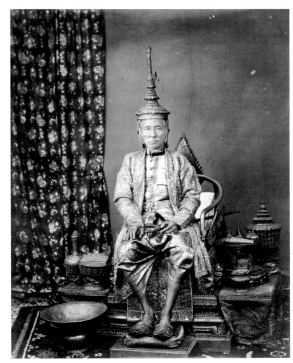

106a

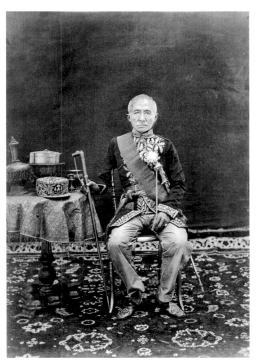

106b

my head!"[21] In fact, the king had simply decided that he preferred to be photographed in military uniform, in the manner of a Western monarch, and he soon returned dressed as a French field marshal. Thomson thereupon made a second picture, showing him in traditional court regalia (106b).

These two portraits are the first images in an album of nearly three hundred pictures of Asia assembled by Franklin Blake, a young American from Massachusetts who, as the representative of the Boston trading company Augustine Heard & Co., was a resident of Bangkok at the time of Thomson's visit. [PA]

106b. John Thomson
British, 1837–1921

First King of Siam, 1865
Albumen silver print from glass negative
23.1 x 15.9 cm (9⅛ x 6¼ in.)

In Thailand the title First King was the designation of the reigning monarch; Second King was an honorific title given to a relative of the king. [PA]

107. M. Gsell
French, active 1860s–70s

Angkor Wat, Cambodia, 1866
Albumen silver print from glass negative
22.7 x 17.7 cm (9 x 7 in.)
Ex coll.: Empress Eugénie
Plate 85

The conquest of Saigon in 1859 by Admiral Rigault de Genouilly and the ensuing spread of French influence through Indochina and Cambodia was the first colonial success of the Second Empire. To commemorate the achievement the admiral, having become minister of the Navy, presented Empress Eugénie in 1867 with this luxuriously bound album of photographs entitled *Cochinchine et Cambodge*. Comprising twenty-six images of Indochina and twenty-one of Cambodia, the album includes fifteen views of the ruins of Angkor. The photographs were made by M. Gsell, a Frenchman stationed in Saigon, of whom nothing more is yet known except that in June 1866 he accompanied the naval captain Doudart de Lagrée on a scientific mission along the Mekong River. The mission began with a photographic survey of Angkor.

Reports of an abandoned city in the jungle had reached Europeans in 1850, and in 1863 de Lagrée conducted the first archaeological exploration of the ruins. The finest and most extensive of all Khmer monuments, Angkor Wat was built early in the twelfth century as a temple symbolizing Mount Meru, the cosmic mountain at the center of the Buddhist and Hindu universe. It had been abandoned in the eighteenth century, and by the time this photograph was made many of its buildings had been overtaken by the forest. Gsell's photographs of the main temple, its surrounding wall, and moat are rather straightforward documents that show little concern for the dramatic territorial struggle between architecture and nature embodied in the ruins. This image, however, of a corner of a court within the temple, manages to convey in its dramatic lighting and obsessive piling up of identical architectural details something of the mystery and bewildering vitality of the huge stone structure. Reminiscent in its dreamlike effect of engravings by Rodolphe Bresdin and Gustave Doré, the image was among the views chosen to illustrate, as a woodcut, the first installment of Francis Garnier's *Voyage d'Exploration en Indo-Chine, 1866–7–8*, which appeared in the periodical *Le Tour du Monde* in 1870. [PA]

108. Felice Beato
British, born Venice (?) ca. 1825–ca. 1907

After the Capture of the Taku Forts, 1860
Albumen silver print from glass negative
25.9 x 29.9 cm (10¼ x 11¾ in.)
Plate 84

One of the first professional photographers to create an extensive documentation of China and Japan, Felice Beato was also a pioneer war photographer, reporting on scenes of massacre and devastation with a graphic matter-of-factness unknown prior to his images. Having opened a studio in Istanbul with his brother-in-law James Robertson, Beato covered with him the last battles of the Crimean War after the departure of Robert Fenton (see nos. 98 and 99). The two photographers went on to India to document the Indian Mutiny; their photographs made in 1858, after the siege of Lucknow, were perhaps the first to show actual corpses on the battlefield. During the Second Opium War in China in 1860, Beato, now on his own, created a memorable indictment of war's senseless slaughter at Fort Taku. War continued to hold a peculiar fascination for Beato throughout his career. After settling in Yokohama, where he completed his major life's work documenting the rural landscapes and traditional Japanese customs and ways of life, Beato went to Korea in 1871 to document an American punitive expedition, and as late as 1885 he covered the colonial war in the Sudan. Beato ended his days as an antiques dealer in Burma.

The capture of the Taku forts of Peking by Anglo-French troops, led by Lord Elgin and Baron Gros, was the decisive battle in a war that was but one episode in the long struggle by the Western nations to open China to trade. The Anglo-French soldiers stormed the forts on August 21, 1860, after an explosion destroyed the powder magazine of the Great North Fort; the Chinese defenders fought to the last man. Beato's photographs, made inside the fort, show the carnage with a brutal directness. Less than two months later he would take probably the only photographs ever made of the interior of the summer palace north of Peking, before it was destroyed by fire, by order of Lord Elgin. [PA]

109a. Attributed to Raimund von Stillfried
Austrian, 1839–1911

Actor in Samurai Armor, 1870s
Albumen silver print with applied color
from glass negative
24.6 x 18.9 cm (9⅝ x 7½ in.)

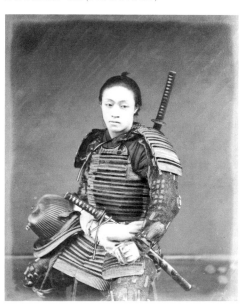

An adventurous officer hailing from the Austro-Hungarian Empire, Baron Raimund von Stillfried-Rathenitz was a painter and photographer who at times served as a diplomat and reporter; he set up a photographic studio in Japan in 1872. Hugely successful, Stillfried bought Felice Beato's establishment in 1877 and taught several of the first generation of Japanese photographers, bequeathing his operation to the most gifted of them, Kusakabe Kimbei, in 1885.

Stillfried's portraits and genre scenes are a continuation of Beato's studies of the country's traditional ways. Imbued with a sentimental charm, they catered to Western-

ers' insatiable appetite for things Japanese and satisfied the increasing demand by tourists for images of a timeless Japan. Stillfried's pictures nevertheless reveal a country moving toward Westernization. Whereas Beato's samurai was a warrior who exuded the pride and disciplined ferocity of his caste, Stillfried's samurai is actually an actor. He wears the martial trappings of a feudal class abolished in the early years of the Meiji Restoration (1868). Following Beato's practice of coloring photographs to please local taste, Stillfried had the image heavily tinted, probably by a painter attached to the photographic studio solely for that purpose.

The picture is one of a group of forty-eight images that offer a rather conventional sampling of Japanese characters and genre scenes by various photographers. Roughly captioned in English, they were inserted into an elegant album of Chinese photographs captioned in French (see no. 109b). [PA]

109b. Anonymous

Interpreter for the Austro-Hungarian Legation, 1870s
Albumen silver print with applied color
from glass negative
23.7 x 19.2 cm (9⅜ x 7½ in.)
Plate 86

This portrait by an as yet unidentified photographer conveys the dignity and exquisite sensitivity of the sitter. Delicately tinted in watercolor, the image is housed in an album with forty-seven other portraits and genre studies from China; neatly captioned in French, these are obviously the work of a single photographer. Unlike the depersonalized types usually found in such a collection, these portraits—be they of soldiers, young women, prosperous merchants, or old beggars—display the same remarkable understanding of and empathy with their subjects. They were probably bought as a group by a discriminating tourist in China in the 1870s. Photographs of Japan were mounted on the verso of each album page. [PA]

110. Désiré Charnay
French, 1828–1915

Raharla, Minister to the Queen, 1863
Albumen silver print from glass negative
19.4 x 12 cm (7⅝ x 4¾ in.)

An archaeologist-adventurer who had gained recognition for his photographic exploration of pre-Columbian Mexican ruins, Claude Joseph Désiré Charnay spent three

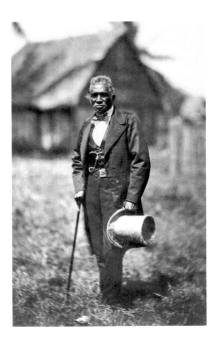

months in Madagascar in 1863 as a diarist and photographer for a French scientific expedition. Because of both political upheaval and the xenophobic stand taken by the new government of the island, the mission was an abortive one, its only result being Charnay's photographs and the account he wrote of his stay for the periodical *Le Tour du Monde* in 1864, illustrated with wood engravings based on his photographs.

The portraits Charnay made of the Madagascans were conceived as a catalogue of ethnic types rather than as a gallery of individuals. By placing his figures full-length in the middle of the frame and having them face his camera squarely, Charnay emulated the detached, impersonal stance of an anthropologist. He was, however, sensitive to the intelligence and poise of Raharla, minister to the queen, whom he photographed on two occasions, contrasting in crisp detail the textures of his elaborate Western clothes against the blurred background of his unprepossessing surroundings. Indeed, in his article, which was otherwise critical of the anti-French ruling class, Charnay wrote with a certain admiration about the British-educated minister and the ease with which he wore his European attire. [PA]

111. Désiré Charnay
French, 1828–1915

Family Group, 1863
Albumen silver print from glass negative
21.5 x 17 cm (8½ x 6¾ in.)
Plate 77

Because of the lack of cooperation he received from the government, run by the Hova, the most powerful ethnic group in Madagascar, Charnay's exploration of the island was limited to a few excursions around the port of Tamatave, on the east coast. This photograph of a Betsimitsaraka family was taken on Nossi-Malaza, the Island of Delights on Lake Nossi-Be, a lagoon south of Tamatave. Charnay noted the warm welcome he received there, the lanky beauty of the women, and the general air of affluence. He described the women's braided hair and their graceful costume: a shoulder wrap, a shirt of silk or cotton, and a long printed skirt imported from India. The woman in the photograph wears such garments, indicative of her high status; her son, on the right, is simply wrapped in a *lamba*, or cotton shawl, while the young man on the left, wearing pants, shows the European influence. Charnay's directness and clarity of style show to particular advantage in this image, his sympathetic rendering belying his normally more clinical approach. He was obviously drawn by the sitters' composure, the strength of their family bond, and the harmonious ensemble they presented to the camera. [PA]

112. Samuel F. B. Morse
American, 1791–1872

Portrait of a Young Man, 1840
Daguerreotype
5 x 4.2 cm (2 x 1⅝ in.)
Plate 89

Samuel Morse, the celebrated portrait painter and inventor of the electric telegraph, traveled to Paris in the fall of 1838 to secure the French patent for his new invention. He was soon introduced to Louis Daguerre and in March 1839 became one of the first Americans to have a firsthand demonstration of the new medium. Morse was especially impressed with the daguerreotype, as he had failed to fix the images made by a camera obscura more than thirty years earlier.

Morse returned to New York in April but had to wait five months to learn the specifics of the process. By September 28, he exhibited a study (now lost) of a church taken from his window. Soon thereafter, with his colleague the physicist John William Draper, Morse attempted portraiture, something Daguerre had thought was not possible. In a specially designed glass structure on the roof of his workshop, Morse's first subjects sat for ten to twenty minutes in direct sunlight. They kept their eyes closed, both because of the sun's glare and because of the need to blink. None of these early photographs survive, although a woodcut based on an 1839 portrait of Morse's daughter and a friend was reproduced in Marcus A. Root's 1864 pub-

lication *The Camera and the Pencil*. In the woodcut the eyes were reopened by the illustrator.

This simple portrait of a young man is probably the only extant photograph by Morse and one of the earliest daguerreotypes made in America. The gilt oval window mat set in a miniature leather case is stamped in block letters SFB MORSE. The subject, perhaps the Methodist Episcopal clergyman Reuben Nelson, first president of the Wyoming Seminary, stares directly at the camera, straining to keep his eyes open. The strength of this portrait is in the young man's rapt expression, which seems to reflect a subtle awareness of his participation in a grand endeavor. This mindful sitter is one of the first in photography to return the gaze of the viewer. [JLR]

113. John Adams Whipple
American, 1822–1891

Hypnotism, ca. 1845
Daguerreotype
13.3 x 18.4 cm (5¼ x 7¼ in.)
Plate 88

During the early years of the daguerreotype hypnosis was extensively practiced by reputable physicians in Europe and America. Although hypnotism eventually became associated with black magic and the supernatural, scientific interest in the phenomenon dates back to the late sixteenth century. Its therapeutic use both as a form of anesthesia and as a cure for disease was known from the 1830s. In 1848 the anesthetic properties of chloroform ended widespread medical practice of hypnotism, and it soon drifted back to marginal uses and quackery.

This curious daguerreotype shows a doctor, or operator, standing and staring at the camera, and four subjects, seated with their eyes closed and hands clasped in supplication. The doctor palms the head of the male sitter, who in turn is linked elbow to elbow to the three women. The photograph demonstrates the procedural method and medical theory of magnetic sleep, which held that a magnetic fluid emanated from an operator to a patient; through it suggestions could be made directly to the subject's mind and indirectly through the mind upon the body. Whipple's composition suggests an electric battery made up of human cells; the viewer completes the circuit by returning the gaze of the hypnotist.

John Whipple, a Boston scientist, was one of the first suppliers of chemicals to American daguerreotypists. By 1843, for health reasons, he had abandoned the manufacturing process and established himself as a photographer. Whipple is most celebrated for his detailed views of the moon taken between 1849 and 1851 through a telescope at the Harvard College Observatory. [JLR]

114. Anonymous

Hutchinson Family Singers, 1845
Daguerreotype
14.4 x 19.7 cm (5⅝ x 7¾ in.)
Plate 91

The original members of the Hutchinson Family Singers were thirteen of the sixteen children of Jesse and Mary Hutchinson of Milford, New Hampshire. The eleven sons and two daughters made their singing debut in the late 1830s and at first sang sentimental, patriotic tunes celebrating the virtues of rural life. In 1842, however, they began to associate closely with the abolitionists, and soon their repertory of songs championed such reformist causes as temperance, women's rights, and above all, the abolition of slavery. Both praised and vilified by the press and public, America's first group of social protest folk singers performed throughout the country for more than fifty years.

This whole plate (6½ x 8½ inches) daguerreotype shows ten of the eleven brothers (from left to right): Asa, Andrew, Jesse, Joshua, David, Caleb, Noah, Judson, Zephaniah, and John. It is a near-perfect graphic representation of musical harmony. The physical likeness and attitude of the sitters in the composition produce a unity of effect, a consonance, much like a tuneful song. The eye glides effortlessly across the plate, first reading the brothers' faces, then their individual postures—in particular the expressive, fraternal placement of their hands. In contrast to the rigid, posed studio photographs typical of the medium's first decade, this lively portrait is a welcome departure. [JLR]

115. Anonymous

Abolitionist Button, 1840s–50s
Daguerreotype
Diameter 1.6 cm (⅗ in.)
Plate 101

This daguerreotype button with an abolitionist motif may be one of the first political buttons made in America to incorporate a photograph. Believed to be unique, the miniature daguerreotype shows two hands held together, one black, one white, resting on a book assumed to be the Bible. The photograph is set into a two-piece gold-washed brass frame with a loop on the reverse for sewing to a garment. The case design with its simple, raised ornamental border is typical of the gilt-metal buttons mass-produced from 1830 to 1850 in several New England factories such as the Scovill Manufacturing Company in Waterbury, Connecticut, which also manufactured daguerreotype plates. The button was discovered in the early 1980s in a flea market in Massachusetts.

Like the piecework quilts made by women's antislavery societies, this button may have been produced to raise money for the abolitionist cause and sold at one of the popular antislavery fairs organized by women. The first such fair took place in 1834 in Boston, the center of the abolitionist movement. Although the fairs accepted "all well-made, useful, and ornamental products," the organizers preferred textiles and other items that incorporated political texts, such as a needlebook inscribed "May the point of our needles prick the slave owner's conscience."

The use of buttons for political purposes in the United States began in the 1700s with buttons that proclaimed "Independence," as the goal of the oppressed colonists, and "Long Live the President," in honor of the inauguration of George Washington. But it was not until the 1828 presidential campaign of Andrew Jackson, just twenty years before the likely date of this photograph, that the button became a regular part of American elections. From "Jackson—True Standard" to "I Like Ike," the political button, both with and without pictures, developed into a characteristically American means of both political advertising and personal expression. [JLR]

116. Albert Sands Southworth
American, 1811–1894

Self-Portrait, ca. 1848
Daguerreotype
14.1 x 10.8 cm (5½ x 4¼ in.)
Ex coll.: Edward Hawes; Arthur Siegel
Plate 93

Fascinated by François Gouraud's demonstrations in Boston of Daguerre's new invention Albert Southworth, a pharmacist in Cabotville (now Chicopee), Massachusetts, went to New York in 1840 to study the technique with Samuel Morse. Within a year he had opened a daguerreotype studio in Boston with Morse's assistant, Joseph Pennell, who had been Southworth's roommate in preparatory school. When Pennell left the firm in 1843, Josiah Johnson Hawes took his place, and the celebrated nineteen-year partnership of Southworth and Hawes was born. The firm was known around the world for its aesthetic accomplishments and technical finesse.

The artistic ambitions of Southworth and Hawes are clearly demonstrated in this eccentric half plate daguerreotype of Southworth in the guise of a classical bust. Although in all probability a self-portrait, there has been some speculation that it may have been made by Hawes, who devised a popular vignetting technique. The hand coloring was probably applied by Southworth's sister,

Nancy, who joined the firm in 1841 and married Hawes in 1849. The portrait is unusual in that, with few exceptions, American daguerreotypists rarely even hinted at nudity.
[JLR]

117. William Langenheim and Frederick Langenheim
American, born Germany: 1807–1874; 1809–1879

Frederick Langenheim, ca. 1848
Daguerreotype
25 x 19.9 cm (9⅞ x 7⅞ in.)

In 1841–42, William and Frederick Langenheim opened a daguerreotype studio in Philadelphia. Known for their technical innovations the former journalists were not the city's first but were certainly its most celebrated photographers. The brothers pioneered a technique of hand-coloring daguerreotypes (1846), purchased Henry Talbot's United States patent for paper photography (1849), invented a system of making negatives and positives on glass (1848–50), and introduced stereoscopic photography to the American public (1850).

This mammoth plate daguerreotype is one of the very few to have survived. It served perhaps to advertise or promote the firm, a convincing example of the Langenheims' professional mastery. The stylistic simplicity—the use of a black backdrop and the absence of accessories—focuses the viewer's attention on the sitter's somber yet amiable expression, and the slight turning away of the sitter's face from his own camera reveals a shyness that belies the self-admiration often implicit in self-portraiture.
[JLR]

118a–g. William Langenheim and Frederick Langenheim
American, born Germany: 1807–1874; 1809–1879

Eclipse of the Sun, May 26, 1854
Seven daguerreotypes
a, b, f, g: 7.2 x 5.9 cm (2⅞ x 2⅜ in.)
c, d, e: 3.2 x 2.5 cm (1¼ x 1 in.)
Plate 97

On May 26, 1854, the Langenheim brothers made eight sequential photographs of the first total eclipse of the sun visible in North America since the invention of photography. Although six other daguerreotypists and one calotypist are known to have documented the event, only these seven daguerreotypes survive. In the northern hemisphere the moon always shadows the sun from right to left during a solar eclipse; these images therefore seem odd because they are, like all uncorrected daguerreotypes, reversed laterally as in a mirror.

It is noteworthy that these daguerreotypes are quite small, three exceptionally so. In order to produce any kind of image at all, the Langenheims were forced to use the smallest cameras available since smaller cameras require proportionally less light and there was virtually no available light when the disk of the new moon eclipsed the largest part of the sun. The missing eighth image was probably made on the smaller plate size and showed nothing at all —a total eclipse. [JLR]

119. Anonymous

Two Men Playing Checkers, 1850–52
Daguerreotype
13.3 x 18.3 cm (5¼ x 7¼ in.)

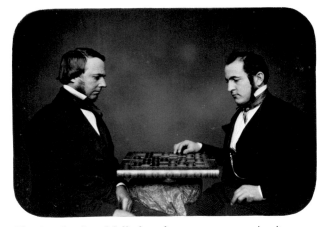

This hand-colored full plate daguerreotype retains its original bright orange paper mat. Probably intended as an exhibition piece, the photograph shows two well-dressed men engaged in a game of checkers—the complex contest of skill today often regarded as child's play. At the beginning of the daguerreian era, however, checkers was considered an exceptional tool to train the mind, one that demanded acute concentration, previsualization, and intuition.

This photograph is a virtuoso example of daguerreotypy at the height of its practice in America. Like a game of checkers it demonstrates the importance of direct observation. A checkerboard is always positioned so that both players have a black square at their near left corner, yet in this study the black square appears to be in the opposite corner, at the near right. It is not the players who have inverted the rules, but the daguerreotype itself. [JLR]

120. John H. Fitzgibbon
American, born England, 1816?–1882

Kno-Shr, Kansas Chief, 1853
Daguerreotype
17.9 x 14.8 cm (7 x 5⅞ in.)
Plate 87

From 1846 to 1860, John Fitzgibbon operated one of America's most prominent daguerreian establishments in the frontier city of Saint Louis, Missouri. Fitzgibbon learned photography in 1839 while apprenticed as a saddler in Philadelphia, but he is best known for his studio portraits and scenes of regional life in the territories west of the Mississippi River.

This daguerreotype of Kno-Shr, a Kansa, is one of the few dated pre–Civil War portraits of a Native American whose name and tribe are known. The chief is shown bare-chested, wearing a traditional grizzly bear claw necklace, the most coveted of all Plains Indian body ornaments. Several details are hand colored with red paint, the color of strength and success and a powerful agent to ward off evil spirits. Made during the height of the country's territorial expansion beyond the Mississippi, the photograph is remarkable as a document of a Native American before assimilation. According to an inscription of 1892 found inside the daguerreotype case, Kno-Shr's tribe had a population of 1,560 in 1831; by 1886, a Congressional report recorded their population at a mere 225. [JLR]

121. Robert H. Vance
American, died 1876

The Great Man Has Fallen, 1856
Daguerreotype
13.5 x 18.8 cm (5⅜ x 7⅜ in.)

Robert Vance was the premier daguerreotypist of California and the mining communities near San Francisco, where gold was first discovered in 1848. In 1851 he exhibited in New York City more than three hundred views of the nation's newest state. Unfortunately these photographs, acquired first by Jeremiah Gurney and later by John Fitzgibbon, have been lost since the early years of this century.

This whole plate daguerreotype is a fascinating document of frontier history. It memorializes the cruel death of James King of William, the editor of the San Francisco *Evening Bulletin*, and the public lynching of his murderer, James P. Casey. On the evening of May 14, 1856, King of William (he had legally added "of William" to distinguish himself from other James Kings), a muckraking journalist who fought local vice and corruption, was shot outside his office by Casey, a local politician and rival editor of the *Sunday Times*. In that day's editorial King of William had accused Casey of election fraud and of being an ex-convict who had served time in New York at Sing Sing for robbing his mistress. The city rose up in arms, and several days later, when King of William died, a mob of vigilantes removed Casey from the sheriff's office and lynched him from gallows erected on an abandoned liquor warehouse.

The photograph thus documents the success of the city's second Committee of Vigilance (the first dated to 1851). In the early years of westward expansion it was customary for reputable men to organize vigilance committees to aid in the suppression of crime. Lynching was the typical penalty for transgressions that called for the most extreme form of punishment. In both 1851 and 1856, periods of wild disorder in San Francisco were ultimately terminated by the action of such groups. Smiley, Yerkes & Company, auctioneers and commission merchants, was located at the corner of Sacramento and Sansome Streets, just one block from Vance's Sacramento and Montgomery Street studio. T. J. L. Smiley was a charter member of the 1851 Committee of Vigilance.

[JLR]

122. Mathew B. Brady
American, 1823/24–1896

Commodore Matthew Calbraith Perry, 1856–58
Salted paper print from glass negative
33.1 x 28.4 cm (13 x 11⅛ in.)
Ex coll.: Frederick Hill Meserve

Mathew Brady was a skilled daguerreotypist, having learned the technical aspects of the process from the American pioneers of the medium, Samuel Morse and John Draper. Other qualities, however, set him apart from competing daguerreotypists who operated in New York in 1844, the year that Brady opened his first studio: artistry in his sense of lighting and in the way he posed his sitters; a personal manner that set his clientele at ease in sumptuously appointed quarters; and a frankly elitist conception of both the business and the social mission of this most democratic medium.

Early on Brady set himself the task of photographing the nation's leading figures—presidents and military men, business leaders and stars of the stage, writers and artists. Each daguerreotype of a man or woman of mark, displayed in the studio's reception room, attracted new clients and bore witness to the skill, art, and social standing of "Brady of Broadway" as much as it did to the taste and station of the sitter.

Sometimes coaxing notable personalities to sit before his camera with the offer of a free daguerreotype from among the several he would make at a single sitting, Brady amassed an impressive collection of portraits. Keen on distributing his pictures of luminaries to a wider audience, Brady published in 1850 *The Gallery of Illustrious Ameri-*

cans, a finely executed series of twelve prints copied from his daguerreotypes by the French-born lithographer Francis D'Avignon.

Another way to reproduce daguerreotypes for public sale was provided in the mid-1850s by the introduction in America of collodion-on-glass negatives, or wet plates. Indeed, some of Brady's early daguerreotype portraits are now known only through salted paper print copies. Soon the glass negative and paper print replaced the daguerreotype altogether as the means by which Brady gathered and distributed the faces of his time.

Here, the imposing figure of Commodore Matthew Perry (1794–1858), whose quasi-military diplomatic mission of 1852–54 opened Japan to the West, commands the viewer's attention. The Old Bruin, as the sailors called him, was photographed in dress uniform toward the end of his life, his nearly fifty years of Navy service weighting his features like the epaulettes on his shoulders. [MD]

customer Brady sought to attract and one whose portrait session he would surely have directed personally. As a young woman she had been one of the belles of the capital, and as the wife of Congressman James J. Roosevelt during the 1842–43 term, she had brought about a social revolution by hosting dinner and evening parties with her husband at which President John Tyler attended as an unassuming guest. In New York, where she resided for most of her life, she was a central figure in the social world, respected as much for her intellectual conversation and dignified manner as for the splendor and refinement of her entertainments.

Dressed in a tiered skirt of silk taffeta, a pagoda-sleeved bodice, and black lace shawl, Cornelia Roosevelt presents herself in the highest fashion of the mid- to late 1850s; only her hair, in a style more typical of the 1840s, harks back to her more youthful days. Brady, sensing his subject's ability to hold her own, posed Mrs. Roosevelt full-length in a broad space. No studio props, save a large swag of drapery, are present to compete with her ample presence and numerous personal accessories. [MD]

123. Mathew B. Brady
American, 1823/24–1896

Cornelia Van Ness Roosevelt, ca. 1860
Salted paper print from glass negative
45.1 x 38 cm (17¾ x 15 in.)
Plate 90

Brady was never much engaged in the manipulation of plates and chemicals, preferring to use the assistance of skilled operators for the mechanical aspects of the process while he, as the artist of the studio, occupied himself with the selection of lenses and cameras, the arrangement of the picture, the physical and psychological comfort of his sitters, and the promotion of his business. For expertise with wet plates Brady relied on Alexander Gardner, an experienced publisher, businessman, and photographer from Glasgow who emigrated to the United States in 1856. Gardner began working for Brady the same year. Two years later he was placed at the helm of the newly established Brady studio in Washington, D.C.

The introduction of glass negatives was important to Brady's business because they offered the possibility of limitless prints from a single sitting. In addition, the process allowed for the enlarging of negatives to yield life-sized portraits that could be heavily retouched with watercolor, ink, crayon, or oils to flatter the sitter and to add both an artistic aura to the print and a substantial surcharge to the price. Brady dubbed the large prints, which measured 17 x 21 inches and cost $50 to $500 each, "imperials."

Cornelia Van Ness Roosevelt (1810–1876), shown in this salted paper print imperial, was precisely the type of

124. Mathew B. Brady
American, 1823/24–1896

Portrait of a Man, ca. 1857
Salted paper print from glass negative
24.9 x 20.2 cm (9¾ x 8 in.)
Ex coll.: Frederick Hill Meserve
Plate 94

The identity of this soberly dressed man is unknown, but Brady's careful artistry suggests a man of intellect and faith. In the darkly lit space of the studio it is the young man's visage—and by extension, his mind—that is the focus of the picture, not stylish clothing or studio decor. Apart from a simple but tastefully elegant chair and two vertical lines vaguely suggesting some spare architectural element, the space he occupies is immaterial.

This salted paper print was meticulously retouched with india ink to sharpen and darken the shadows around the buttons and lapels of the coat, the tie, and the details of the chair back. Like those of Commodore Perry and Senator and Mrs. Lane (nos. 122 and 125), this portrait came from the collection of Frederick Hill Meserve (1865–1962). Though a businessman by profession, Meserve's greatest energy for more than sixty years was devoted to the collection, preservation, and study of Civil War photographs. He had a particular passion for Mathew Brady's work, amassing a vast quantity of prints and more than 15,000 glass negatives made by the Brady studio. [MD]

125. Brady Studio

Senator and Mrs. James Henry Lane, 1861–66
Albumen silver print from glass negative
22.4 x 19.7 cm (8⅞ x 7¾ in.)
Ex coll.: Frederick Hill Meserve
Plate 95

This portrait, made in Mathew Brady's Washington studio with its usual accoutrements, would appear formulaic were it not for the force of character of Senator James H. Lane of Kansas (1814–1866). While his wife is fashionably (if somewhat demurely) dressed, the jagged silhouette of Lane's military overcoat, the loosely fastened tie, and, most of all, his haggard features, deep-set eyes, and flamboyantly unkempt hair reveal a rebellious spirit. More often seen in a woolen shirt, bearskin overcoat, and straw hat, Lane had been the fiercest leader of the Free State movement in Kansas in the 1850s, bringing various anti-slavery forces together to form a unified party. He led military campaigns against proslavery towns with such effectiveness and brutality that "the very name of Lane was a terror," earning him the sobriquet the Grim Chieftain of Kansas. Elected as one of the first two senators when Kansas was granted statehood, Lane was unparalleled as an orator, a master of sarcasm and invective whose broad gestures and rasping voice commanded undivided attention. His impassioned speech on behalf of his close friend Abraham Lincoln is credited with having swayed the National Convention to nominate Lincoln for a second term as president.

Alexander Gardner, the manager of Brady's Washington studio, recognized the growing market for smaller, less expensive photographs of national leaders just prior to the Civil War. In a move wholly antithetical to Brady's elitist conception of the medium but extremely beneficial financially, Gardner offered more modestly scaled photographs such as this portrait of the Lanes, and also carte-de-visite portraits of ordinary citizens and of national leaders. The smaller photographs (3½ x 2⅛ inches) sold for ten to twenty-five cents apiece. [MD]

126. Samuel G. Szabó
Hungarian, active America ca. 1854–61

Rogues, a Study of Characters, ca. 1860
Five salted paper prints from glass negatives
Left: 11.5 x 8.8 cm; right, each: 8.8 x 6.6 cm
(4½ x 3½ in.; 3½ x 2⅝ in.)
Plate 96

Lifter, wife poisoner, forger, sneak thief; cracksman, pickpocket, burglar, highwayman; murderer, counterfeiter,

abortionist—each found a place in this gallery of rogues. Photography was first put to service for the identification and apprehension of criminals in the late 1850s. In New York, for example, 450 photographs of known criminals could be viewed by the public in a real rogues' gallery at police headquarters, the portraits arranged by category, such as "Leading pickpockets, who work one, two, or three together, and are mostly English."

Little is known of Samuel G. Szabó, his methods or his intentions. He appears to have left his native Hungary in the early or mid-1850s by necessity, but the reason for his exile remains a mystery. In the United States Szabó moved frequently. Between May 1857 and his return to Europe in July 1861 he traveled to New Orleans, Cincinnati, Chicago, Saint Louis, Philadelphia, and New York, settling for a brief period in Baltimore, where he was listed in the city directory as a daguerreotypist. His whereabouts when he made this album are unknown. One may speculate that Szabó made these portraits while working for, or with the cooperation of, the police, and some of the 218 prints in the album appear to be copy prints made from other photographic portraits.

But this is more than a collection of mug shots; it is a study of characters by a "photogr[aphic] artist," as Szabó signed the title page of this album. Just as Mathew Brady believed that portraits of America's great men and women held clues to the nobility of their character and could serve as moral and political exemplars to those who contemplated them, others attempted to discern in photographs such as Szabó's physical characteristics of the criminal psyche. Yet, as in Hugh Diamond's portraits of the insane (no. 30), the reading of individual portraits is not always self-evident. Would the serious young man in the overcoat and silk top hat appear roguish without the caption "John McNauth alias Keely alias little hucks / Pick Pocket" below his portrait? [MD]

127. James Wallace Black
American, 1825–1896

Boston, as the Eagle and the Wild Goose See It,
October 13, 1860
Albumen silver print from glass negative
18.5 x 16.7 cm (7¼ x 6⅝ in.)

After Southworth and Hawes, the partnership of John Whipple and James Black was the most important in Boston. Black's career began humbly in 1845 as chief plate polisher in two local daguerreian studios. By 1852 he was apprenticed to Whipple, and within four years he was a partner in the firm. Between 1857 and 1860, Black managed the business single-handedly, while Whipple

completed a three-year scientific exploration of celestial bodies at the Harvard College Observatory. Less interested in astronomy or abstract science, Black left Whipple in 1859 to focus the camera on his own planet.

Best known for his photographs of Boston after the devasting fire of 1872, Black launched his solo career in 1860 with the production of a series of aerial photographs taken from Samuel King's hot-air balloon the *Queen of the Air*. Black's views of Boston were the first aerial photographs made in America; two years earlier the Frenchman Nadar had made history making similar views of Paris.

Black's photographs caught the attention of Oliver Wendell Holmes, a poet and professor of medicine at Harvard, who gave this photograph its title. In July 1863, Holmes wrote in the *Atlantic Monthly*: "Boston, as the eagle and the wild goose see it, is a very different object from the same place as the solid citizen looks up at its eaves and chimneys. The Old South [Church] and Trinity Church [left center and lower right] are two landmarks not to be mistaken. Washington Street [bottom] slants across the picture as a narrow cleft. Milk Street [left center] winds as if the old cowpath which gave it a name had been followed by the builders of its commercial palaces. Windows, chimneys, and skylights attract the eye in the central parts of the view, exquisitely defined, bewildering in numbers. . . . As a first attempt [at aerial photography] it is on the whole a remarkable success; but its greatest interest is in showing what we may hope to see accomplished in the same direction."[22] Only two years later the Union Army would use balloon photography to spy on Confederate troops during the Peninsular Campaign in Virginia. [JLR]

128. Anonymous

Portrait of a Youth, 1850–60s
Salted paper print from glass negative
31.8 x 27.2 cm (12½ x 10¾ in.)
Plate 100

This highly unusual formal portrait of an African-American youth came to light in a Boston auction in the 1980s. As the spiritual center of the abolitionist movement, Boston is a likely source for this large salted paper print. The carefully posed composition and the size of the picture suggest the work of one of Boston's finest photographers: John Whipple, James Black, Albert Southworth, or Josiah Hawes.

The young boy, whose identity remains unknown, sits with studied composure like a visiting prince. The photographer presents his subject as destined for prominence, an apt embodiment of the abolitionist cause. The boy's self-possession and dignity recall the description of the runaway slave and abolitionist Frederick Douglass by William Lloyd Garrison, abolitionist editor of *The Liberator*: "There stood one, in physical proportion and stature commanding and exact—in intellect richly endowed—in natural eloquence a prodigy—in soul manifestly 'created but a little lower than the angels'—yet a slave, ay, a fugitive slave."[23] [JLR]

129. William Marsh
Nationality and dates unknown

Abraham Lincoln, 1860
Salted paper print from glass negative
19.9 x 14.5 cm (7⅞ x 5¾ in.)
Plate 104

This photograph, made in Springfield, Illinois, on May 20, 1860, was the first portrait taken of Abraham Lincoln after he had received the nomination for president at the Republican National Convention in Chicago. It is one of five photographs taken by William Marsh for Marcus L. Ward, a delegate from Newark, New Jersey. Although many in the east had read Lincoln's impassioned speeches, few had actually seen the senator from Illinois.

At fifty-one years old, Lincoln appears much younger in this photograph, innocent as yet of the great toll the presidency would take on him. His face is an odd contradiction of parts: his right eye typically wanders, his large right ear flaps behind a high cheekbone and sunken cheek, and his hair, described by Sir William Howard Russell as a "thatch of wild Republican hair," is loosely combed. He did not grow his characteristic beard until October 1860. The first president of the United States to

wear a beard, Lincoln appears cleanshaven in only one-third of the more than one hundred known photographs.

Yet Lincoln is ruggedly handsome. Marsh presents the face of the prairie lawyer from the backwoods of Kentucky, the man who declared, "A house divided against itself cannot stand"; the man who only two years after this photograph was made would author the Emancipation Proclamation, and who, in his second inaugural address in 1865, spoke of reconstructing a vital, new country from the ashes of the South, "With malice toward none; with charity for all." [JLR]

130. Alexander Gardner
American, born Scotland, 1821–1882

Antietam Battlefield, 1862
Albumen silver print from glass negative
9.1 x 11.8 cm (3⅝ x 4⅝ in.)
Ex coll.: General Albert Ordway; Frederick Hill Meserve
Plate 106

At the outbreak of the Civil War Alexander Gardner was appointed to General George McClellan's staff with the honorary rank of captain. Initially he and a small corps of photographers copied maps and charts for the Secret Service, which were distributed as photographic prints to both field and division commanders. For two years, while he retained his position as manager of Mathew Brady's Washington, D.C., studio, Gardner worked as a field photographer. He left Brady in November 1862 and established his own business, taking with him many of Brady's most experienced staff.

The Battle of Antietam took place on September 17, 1862. On a small creek near Sharpsburg, Maryland, the Army of the Potomac met the advancing Army of the Confederacy. Although more than twenty-six thousand soldiers were killed or wounded in fierce fighting, Robert E. Lee's first invasion of the North was soundly repelled by McClellan and the Confederate general was forced back into Virginia.

Long considered the only known Civil War view of a battle in action, Gardner's photograph actually shows reserve artillery east of Antietam the day after the battle. What was thought to be the smoke of guns covering the fields in the center and right distance is fog or early morning mist. During the Civil War most photographers worked with the collodion-on-glass negatives, which required delicate and laborious procedures even in the studio. When the photographer was ready for action, a sheet of glass was cleaned, coated with collodion, partially dried, dipped carefully into a bath containing nitrate of silver, then exposed in the camera for several seconds and

processed in the field darkroom tent—all before the silver collodion mixture had dried. Given the danger of their situation and the technical difficulty of their task, front-line photographers rarely if ever attempted action scenes. Printed from one half of a stereo negative, this small view served as a memorial to the single bloodiest day of the war.
 [JLR]

131. Andrew Joseph Russell
American, 1830–1902

Slave Pen, Alexandria, Virginia, ca. 1863
Albumen silver print from glass negative
25.6 x 36.5 cm (10⅛ x 14⅜ in.)
Plate 105

Better known for his later views commissioned by the Union Pacific Railroad, A. J. Russell, a captain in the 141st New York Infantry Volunteers, was one of the few Civil War photographers who was also a soldier. As a photographer-engineer for the U.S. Military Railroad Construction Corps, Russell's duty was to make a historical record of both the technical accomplishments of General Herman Haupt's engineers and the battlefields and camp sites in Virginia. This view of a slave pen in Alexandria guarded, ironically, by Union officers shows Russell at his most insightful; the pen had been converted by the Union Army into a prison for captured Confederate soldiers.

Between 1830 and 1836, at the height of the American cotton market, the District of Columbia, which at that time included Alexandria, Virginia, was considered the seat of the slave trade. The most infamous and successful firm in the capital was Franklin & Armfield, whose slave pen is shown here under a later owner's name. Three to four hundred slaves were regularly kept on the premises in large, heavily locked cells for sale to Southern plantation owners. According to a note by Alexander Gardner, who published a similar view, "Before the war, a child three years old, would sell in Alexandria, for about fifty dollars, and an able-bodied man at from one thousand to eighteen hundred dollars. A woman would bring from five hundred to fifteen hundred dollars, according to her age and personal attractions."[24]

Late in the 1830s Franklin and Armfield, already millionaires from the profits they had made, sold out to George Kephart, one of their former agents. Although slavery was outlawed in the District in 1850, it flourished across the Potomac in Alexandria. In 1859, Kephart joined William Birch, J. C. Cook, and C. M. Price and conducted business under the name of Price, Birch & Co. The partnership was dissolved in 1859, but Kephart continued operating his slave pen until Union troops seized the city in the spring of 1861. [JLR]

132. Myron H. Kimball
American, active 1860s

Emancipated Slaves, 1863
Albumen silver print from glass negative
13.2 x 18.3 cm (5¼ x 7¼ in.)
Plate 103

In December 1863, Colonel George Hanks of the 18th Infantry, Corps d'Afrique (a Union corps composed entirely of African-Americans), accompanied eight emancipated slaves from New Orleans to New York and Philadelphia expressly to visit photographic studios. A publicity campaign promoted by Major General Nathaniel Banks of the Department of the Gulf, and by the Freedman's Relief Association of New York, its sole purpose was to raise money to educate former slaves in Louisiana, a state still partially held by the Confederacy. One group portrait, several cartes de visite of pairs of students, and numerous portraits of each student were made.

When this photograph was published as a woodcut in *Harper's Weekly* of January 30, 1864, it was accompanied by the biographies of the eight emancipated slaves, which served successfully to fan the abolitionist cause. Two are quoted below.

AUGUSTA BROUJEY is nine years old. Her mother, who is almost white, was owned by her half-brother, named Solamon, who still retains two of her children.

WILSON CHINN is about 60 years old. He was "raised" by Isaac Howard of Woodford County, Kentucky. When 21 years old he was taken down the river and sold to Volsey B. Marmillion, a sugar planter about 45 miles above New Orleans. This man was accustomed to brand his negroes, and Wilson has on his forehead the letters "V. B. M." Of the 210 slaves on this plantation 105 left at one time and came into the Union camp. Thirty of them had been branded like cattle with a hot iron, four of them on the forehead, and the others on the breast or arm.

In his negative, Kimball retouched the brand on Wilson Chinn's forehead to make the initials appear more visible on the print. [JLR]

133. Timothy H. O'Sullivan
American, born Ireland, 1840–1882

Field Where General Reynolds Fell, Battlefield of Gettysburg, 1863
Albumen silver print, by Alexander Gardner, from glass negative
17.8 x 22.7 cm (7 x 9 in.)
Plate 108

Timothy O'Sullivan was one of the many photographers who began their careers as apprentices to Mathew Brady.

When the early events of the Civil War suggested no immediate resolution of the conflict, O'Sullivan abandoned the Washington, D.C., gallery for four years in the field. He worked constantly, producing outstanding views of bridges, encampments, hospitals, and battlefields which he sent back to Washington, first to Brady and then to Alexander Gardner, whose studio he joined officially in the winter of 1862–63.

This photograph of the aftermath of the Battle of Gettysburg appears in the two-volume opus *Gardner's Photographic Sketch Book of the War* (1865–66). Gardner's publication is egalitarian. Offended by Brady's habit of obscuring the names of his field operators behind the deceptive credit "Brady," Gardner specifically identified each of the eleven photographers in the publication; forty-four of the one hundred photographs are credited to O'Sullivan.

Gardner titled the plate *Field Where General Reynolds Fell, Battlefield of Gettysburg*. But the photograph, its commemorative title notwithstanding, relates a far more common story: six Union soldiers lie dead, face up, stomachs bloated, their pockets picked and boots stolen. As Gardner described the previous plate, aptly titled *The Harvest of Death*, this photograph conveys "the blank horror and reality of war, in opposition to its pageantry."

[JLR]

134. Anonymous

Family Group, 1861–65
Salted paper print from glass negative
28.9 x 39.5 cm (11⅜ x 15½ in.)
Plate 99

Although Civil War photography has been much studied, there are still important photographs about which little is known. This formal portrait of a well-to-do family with two military guards and a black servant is a good example. The slight tension and awkwardness detectable in the group, as well as the presence of the guards, points to the absence of the father. One guard wears a Union Army belt buckle inscribed "U.S.," and the architecture suggests the elegant homes of Alexandria, Virginia, and the Georgetown district of Washington, D.C. But what occasioned this solemn image remains a mystery.

In an era dominated by routine albumen silver prints, this exceptionally large salted paper print suggests the work of one of the better New York or Washington studios. A likely photographer is Alexander Gardner, whose portrait work for Mathew Brady was often executed in salted paper prints rivaling those made by the best European photographers. Perhaps the inscription, "No 5," at the bottom center of the print will ultimately help solve the mystery of this haunting photograph. [JLR]

135 a, b, c. Anonymous

The Wilderness Battlefield, 1865–67
Albumen silver print from glass negative
12.5 x 7.9 cm; 12.5 x 8.3 cm; 12.5 x 9.1 cm
(4⅞ x 3⅛ in.; 4⅞ x 3¼ in.; 4⅛ x 3⅝ in.)
Ex coll.: Frederick Hill Meserve
Plate 110

The Battle of the Wilderness was fought May 5–7, 1864, in the same Virginia forest disputed a year before in the Chancellorsville campaign. When the soldiers took their positions in the woods, the ground was already littered with

135b

135c

skulls. The densely wooded landscape made conventional field warfare impossible. Artillery was all but useless. Musketry fire splintered and gnawed the young trees. The thick undergrowth of thorny brambles, thickets, and roots, which made earthen defenses hard to build, could not itself stop stray bullets. Fighting virtually blind, soldiers often mistook their own forces for the enemy. Unable either to attack or to defend themselves, the armies of Robert E. Lee and Ulysses S. Grant fought to a bloody draw. Although no statistics of Confederate losses are known, Union losses at Wilderness were staggering: 2,246 killed, 12,137 wounded, and 3,383 missing—second only to Gettysburg in their numbers.

These three scenes were probably made after the war's end, when cleanup operations were under way. Formerly attributed to Alexander Gardner, these views are drawn from a group of twenty-eight that appear illuminated by an unearthly light. Printed from negatives that were probably unintentionally solarized during development, the photographs are tonally reversed, the black sky becoming an appropriate symbol for the terrible place called Wilderness.

[JLR]

136. Thomas C. Roche
American, 1826/27–1895

Ordnance Wharf, City Point, Virginia, 1865
Albumen silver print from glass negative
21.7 x 25.5 cm (8½ x 10 in.)

Very little is known of the early career of Thomas C. Roche. During the Civil War he worked for E. and H. T. Anthony, New York publishers of cartes de visite and stereoscopic views and distributors of photographic supplies. In early April 1865, near the war's end, Roche received special orders from Anthony to work for General Montgomery Meigs. As quartermaster of the Union Army, Meigs was

responsible for the procurement and transportation of everything from bootlaces to artillery. He was also an amateur photographer and recognized the military usefulness of documentary photography.

This view shows the ordnance wharf on the James River at City Point, Virginia, and exemplifies military order and efficiency. Guarded by two armed soldiers from the Corps d'Afrique, one carefully silhouetted against the river, the wharf supports a long line of limbers, the detachable two-wheeled vehicles behind which gun carriages are towed. A single railroad track used to expedite the unloading of supply ships runs the length of the wharf. Built by Meigs in 1864, City Point was the Union Army's major supply base for the ten-month seige of Petersburg, the last major campaign of the war. A small village with a population of only several hundred when it was taken over by the military, it became in one year the busiest port in the world.

[JLR]

137. Thomas C. Roche
American, 1826/27–1895

Depot Field Hospital, City Point, Virginia, 1865
Albumen silver print from glass negative
22.1 x 28.8 cm (8¾ x 11⅜ in.)

The Depot Field Hospital at City Point, Virginia, was opened on June 17, 1864. Situated about a mile from the supply wharf (see no. 136), it comprised six separate hospitals serving the Second, Fifth, Sixth, and Ninth Corps of the Army of the Potomac, a cavalry division, and the Corps d'Afrique. Set up in seventy-two hours, it received on its first day of operation 3,700 patients from the war front. Within one month it had treated more than 15,000 wounded soldiers, often 5,000 at a time. As a depot hospital it was an intermediate facility between the front-line field hospitals and the permanent hospitals in Washington, Baltimore, Philadelphia, and New York.

The composition of Roche's carefully distant view—showing orderly tents receding to the horizon—demonstrates his commission by the quartermaster general's office. Eschewing detail for design Roche constructed his picture to describe the camp's antiseptically clean, official appearance. With 1,200 tents City Point was a model for all semipermanent field hospitals and a tribute to General Meigs's unprecedented logistical genius. The photograph does not, however, even hint at what was going on inside the tents. Although the Union medical corps had less than one hundred doctors at the start of the war, it numbered in total more than 11,000 by the war's end. Yet, of the 600,000 deaths in the Civil War, Union and Confederate combined, only one in four soldiers died from wounds in battle. The rest died from infections or diseases acquired in the camps and hospitals.

[JLR]

138. Anonymous

Broadside for Capture of Booth, Surratt, and Herold, April 20, 1865
Printed sheet with three albumen silver prints
Sheet: 61 x 31.6 cm; each print 8.6 x 5.4 cm
(24 x 12½ in.; 3⅜ x 2⅛ in.)
Plate 111

On the night of April 14, 1865, just five days after Lee's surrender to Grant at Appomattox, John Wilkes Booth shot Lincoln at Ford's Theatre in Washington, D.C. Within twenty-four hours, Secret Service director Colonel Lafayette Baker had already acquired photographs of Booth and two of his accomplices. Booth's photograph was secured by a standard police search of the actor's room at the National Hotel; a photograph of John Surratt, a suspect in the plot to kill the president and the secretary of state, was obtained from his mother, Mary (soon to be indicted as a fellow conspirator), and David Herold's photograph was found in a search of his mother's carte-de-visite album. The three photographs were taken to Alexander Gardner's studio for immediate reproduction. This bill was issued on April 20, the first such broadside in America illustrated with photographs tipped onto the sheet.

The descriptions of the alleged conspirators combined with their photographic portraits proved invaluable to the militia. Six days after the poster was released Booth and Herold were recognized by a division of the 16th New York Cavalry. The commanding officer, Lieutenant Edward Doherty, demanded their unconditional surrender when he cornered the two men in a barn near Port Royal, Virginia. Herold complied; Booth refused. Two Secret Service detectives accompanying the cavalry, then set fire to the barn. Booth was shot as he attempted to escape; he died three hours later. After a military trial Herold was hanged on July 7 at the Old Arsenal Prison in Washington, D.C.

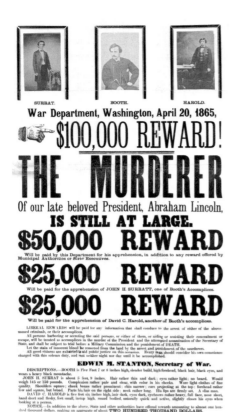

Surratt escaped to England via Canada, eventually settling in Rome. Two years later a former schoolmate from Maryland recognized Surratt, then a member of the Papal Guard, and he was returned to Washington to stand trial. In September 1868 the charges against him were nol-prossed after the trial ended in a hung jury. Surratt retired to Maryland, worked as a clerk, and lived until 1916.

[JLR]

139. Alexander Gardner
American, born Scotland, 1821–1882

Lewis Paine, April 27, 1865
Albumen silver print from glass negative
22.3 x 17.5 cm (8¾ x 6⅞ in.)
Plate 112

At roughly the same time that John Wilkes Booth shot President Lincoln, Lewis Paine attempted unsuccessfully to murder William Seward, Secretary of State. The son of a Baptist minister from Alabama, Paine (alias Wood, alias Hall, alias Powell) was one of at least five conspirators who planned with Booth the simultaneous assassinations of Lincoln, Vice-President Andrew Johnson, and Seward. A tall, powerful man, Paine broke into the secretary's house, struck his son Frederick with the butt of his jammed

pistol, brutally stabbed the bedridden politician, and then escaped after stabbing Seward's other son, Augustus.

Four days later Paine was caught in a sophisticated police dragnet and arrested at the H Street boarding house of fellow conspirator Mary Surratt. Detained aboard two iron-clad monitors docked together on the Potomac, Paine and seven other presumed conspirators were photographed by Alexander Gardner on April 27. Gardner made full-length, profile, and full-face portraits of each of the men, presaging the pictorial formula later adopted by law-enforcement photographers. Of the ten known photographs of Paine, six show him against a canvas awning on the monitor's deck, the others against the dented gun turret. In this portrait Paine, towering more than a head above the deck officer, appears menacingly free of handcuffs. He was twenty years old.

[JLR]

140. Alexander Gardner
American, born Scotland, 1821–1882

Execution of the Conspirators, July 7, 1865
Albumen silver print from glass negative
16.8 x 24.2 cm (6⅝ x 9½ in.)
Ex coll.: Frederick Hill Meserve
Plate 113

Alexander Gardner's intimate involvement in the events following President Lincoln's assassination would have challenged even the most experienced twentieth-century photojournalist. In just short of four months Gardner documented in hundreds of portraits and views one of the most complex national news stories in American history. The U.S. Secret Service provided Gardner unlimited access to individuals and places unavailable to any other photographer. Free to retain all but one of his negatives—a portrait of Booth's corpse—Gardner attempted to sell carte-de-visite and large format prints of the whole picture story. America, still wounded from the four-year war, was less than interested.

The photographs of the execution of Mary Surratt, Lewis Paine, David Herold, and George Atzerodt on July 7, 1865, were, however, highly sought after by early collectors of Civil War ephemera beginning in the 1880s. This photograph, formerly in the collection of Frederick Hill Meserve, shows the final preparations on the scaffolding in the yard of the Old Arsenal Prison. The day was extremely hot and a parasol shades Mary Surratt, seated at the far left of the stage. (She would become the first woman in America to be hanged.) Two soldiers stationed beneath the stage grasp the narrow beams that hold up the gallows trapdoors. The soldier on the left would later admit he had just vomited, from heat and tension. Only one noose is visible, slightly to the left of Surratt; the other three nooses moved during

the exposure and are registered by the camera only as faint blurs. Members of the clergy crowd the stage and provide final counsel to the conspirators. A private audience of invited guests stands at the lower left. Minutes after Gardner's exposure the conspirators were tied and blindfolded and the order was given to knock out the support beams. [JLR]

141a, b, c. Alexander Gardner
American, born Scotland, 1821–1882

Grand Army Review, Washington, D.C., 1865
Albumen silver print from glass negative
8.5 x 9.9 cm; 8.5 x 10.6 cm; 8.5 x 10.3 cm
(3⅜ x 3⅞ in.; 3⅜ x 4⅛ in.; 3⅜ x 4 in.)
Ex coll.: Frederick Hill Meserve

On May 23 and 24, 1865, two weeks after the president of the Confederacy, Jefferson Davis, was taken prisoner in Georgia, more than 150,000 jubilant soldiers marched up Pennsylvania Avenue as part of the Grand Army Review. To the sounds of bands playing "When Johnny Comes Marching Home," the armies of the Potomac, Tennessee, and Georgia were feted in a victory parade to celebrate the end of the war. Traveling from the newly completed Capitol (seen in the distance) to the main reviewing stand in front of the Executive Mansion, row after row of men passed before Alexander Gardner's stereoscopic camera, positioned just above the heads of the crowd.

Posted opposite the Willard Hotel, at Pennsylvania Avenue and 14th Street, Gardner and several assistants worked to document the event with relatively fast, small plate cameras. The resulting views, in which the soldiers and horses are blurred, were taken from the spectators' level rather than from an ideal vantage point, thus anticipating by twenty years the contingent look of street photography made with hand-held cameras. Statistics would later reveal that four times the number of men who marched in the Grand Army Review had died in the war. [JLR]

142. Brady Studio

Andersonville Still Life, 1866
Albumen silver print from glass negative
22.1 x 18.9 cm (8¾ x 7½ in.)
Plate 109

Clara Barton, the first president of the American Red Cross, began her philanthropic career by distributing

141a

141b

141c

supplies for the relief of wounded soldiers during the Civil War. At its close, she organized in Washington, D.C., the first bureau of records to aid in the search for missing men. In connection with this work, Barton identified and marked the graves of more than 12,000 soldiers in the National Cemetery at Andersonville, Georgia. The site of the most notorious Confederate prison, Andersonville was one of the most deadly places in the war. Of the more than 40,000 Union soldiers imprisoned, 13,000 died of starvation and disease—a ratio of one in three.

To support her effort for proper burial of the Andersonville dead and to raise money for veteran relief in general, Barton displayed and sold souvenirs of Andersonville. As early as 1866, the year this photograph was copyrighted by Brady, Barton discovered that veterans had already begun to collect relics of the war. Carefully identified by descriptive labels and placed on a crudely built stepped display, the artifacts are a heinous spectacle, a brutal tableau composed for the camera to attract alms from survivors. The largest item for sale was a portion of the infamous Dead Line, a wooden fence that prisoners were prohibited from crossing on pain of death. [JLR]

143. William Bell
American, born England, 1831–1910

Private George Ruoss (Partially Consolidated Gunshot Fracture of the Upper Third of the Right Femur), 1867
Albumen silver print from glass negative
16.6 x 21.7 cm (6½ x 8½ in.)
Plate 107

Raised by family friends in Abington, Pennsylvania, William Bell began his career in photography as a daguerreotypist in Philadelphia. A veteran of both the Mexican and Civil Wars, Bell was appointed chief photographer of the Army Medical Museum in 1865. The museum had been created by the Surgeon General in April 1862 "to improve the care of the sick and wounded soldier by making available for study pathological specimens of war wounds and diseases." Generally considered the greatest medical legacy of the Civil War, the museum continues today as the Armed Forces Institute of Pathology. Bell's photographs served two purposes: as clinical photographs they made medical history by educating physicians as no textbook could, and as patient records they became invaluable evidence used in future cases of disability compensation. Beginning in 1865, 350 albumen prints were published in the museum's seven-volume *Photographic Catalogue of the Surgical Section*. This photograph is one page from that first effort to create a visual medical library of disease and treatment in photographs.

According to the medical history on the verso of this photograph, "Private George Ruoss, Co. G, 7th New York Volunteers, aged twenty-seven years, was wounded at the South Side Railroad, near Petersburg, Virginia, on March 31st, 1865, by a conoidal musket ball, which struck the anterior and outer aspect of the right thigh . . . comminuting portions of the upper and middle thirds of the femur, and passed out posteriorly about the middle of the gluteal fold." Ruoss was taken to the corps hospital at City Point (see no. 137) and after one week transferred to a general hospital in Washington. Two and one half years later Ruoss was still in "generally feeble condition," a patient at the Post Hospital.

Before the use of antiseptics infection was considered a normal part of the healing process. During the Civil War, however, five infections were recognized as abnormal: tetanus, hospital gangrene, pyemia, erysipelas, and osteomyelitis. While the first four had a fatality rate of over ninety percent, with death occurring within weeks of infection, osteomyelitis, a chronic bone infection, lasted for years. Slowly eating away at the bones of the patient, the infection was responsible for the majority of amputations after the war. This photograph shows the ravages of osteomyelitis. Although his complete medical history is unavailable Private Ruoss, fortunate not to have contracted one of the four fatal hospital infections, apparently survived his extended hospital stay. [JLR]

144. Anonymous

Ku Klux Klansman, ca. 1869
Tintype
8.1 x 4.9 cm (3¼ x 1⅞ in.)
Plate 102

Almost immediately after the Civil War, hundreds of secret societies were established in the South by ex-Confederates to oppose radical Reconstruction and to maintain white supremacy over liberated blacks. Denied the right to bear arms, the former soldiers feared insurrection by newly armed blacks who, in 1868 and 1870, respectively, would also be given citizenship and voting rights in the Fourteenth and Fifteenth Amendments. The best-known of these vigilante societies was the Ku Klux Klan, organized in 1865 in Pulaski, Tennessee. The Klan adopted strange disguises, used mysterious language, and made regular nighttime raids on the black communities. To play upon the fears and superstitions of their sworn enemy, the Klan often muffled their horses' hooves and covered themselves in white robes. With their faces also concealed behind white masks, they posed as spirits of the Confederate dead returned from the battlefields to haunt their former slaves.

The Klan was so effective in systematically keeping blacks away from the polls that ex-Confederates regained political control in most of the Southern states within five years of the war's end.

Believed to be one of the earliest known portraits of a Klansman in costume, the photograph was probably made before 1870, the date that marks the disbandment of the Klan's first central organization. The insidious intimidation of blacks had proven so effective that Klan activity remained largely underground until the 1910s.

In their early days Klan societies did not wear only one costume, and there is much stylistic variation documented in contemporary illustrations. The fabric pooling around the feet of this Klansman was, however, a common stylistic embellishment. Although impractical for walking, the long cut was designed for night-riding to fully drape the horseman's feet and stirrups, further emphasizing the grotesque and ghoulish.

The presentation of the image in its decorated wrapper is perversely quaint. The photograph is a tintype, a cheap and extremely popular technique used by photographers in rural communities from the mid-1850s into the twentieth century. [JLR]

145. Attributed to Alfred Rudolph Waud
American, born England, 1828–1891

A Woman in an Interior, ca. 1870
Tintype
13.8 x 10.6 cm (5⅜ x 4⅛ in.)
Plate 92

Alfred R. Waud was an important illustrator of mid-nineteenth century America. After studying at the Royal Academy in London Waud moved to Boston in 1850 and began a successful career supplying woodcuts to engravers and publishers. During the Civil War he was employed as a Special Artist for *Harper's Weekly* and covered the four-year campaign of the Army of the Potomac. Waud's battlefield sketches show charging brigades, dust, smoke, and falling soldiers—the live action that was absent in photographs of the war.

After the war Waud became a free-lance illustrator. He worked in the South and the West and began to use a camera to record the prominent details of his chosen subjects. It is believed that one of his battlefield colleagues —Mathew Brady, Alexander Gardner, or Timothy O'Sullivan—taught Waud photography, though he could easily have learned rudimentary tintypy from the many itinerant photographers who followed the armies and supplied cheap portraits to soldiers. This portrait, perhaps of the artist's wife, Mary Jewett Waud, may have been made before Waud left for New Orleans in 1871 to report on life in the

Mississippi delta for *Every Saturday*, a short-lived illustrated journal. The peaceful, softly illuminated study is far more ambitious than the smaller, more common tintypes destined for family albums. Waud's early training at the Royal Academy seems to have served him well. With a raking light from a lateral window, reminiscent of the paintings of Vermeer, and a languid pose that recalls the portraits by his fellow countryman Sir Peter Lely, Waud created a warm ambience and an unusually intimate study. [JLR]

146. Attributed to Henry Rhorer
Nationality and dates unknown

View of Cincinnati, 1865–66
Four albumen silver prints from glass negatives
30.9 x 151.5 cm (12⅛ x 59⅝ in.)
Plate 98

Henry Rhorer's ambitious four-part panorama of Cincinnati was executed from the pinnacle of the southern tower of John A. Roebling's suspension bridge, seen here across the Ohio River. Begun before the Civil War, in 1856, the bridge had a clear span of 1,057 feet, the greatest ever attempted. Under construction until 1867, it was a successful test of Roebling's skill and a working model for his designs for the even more ambitious Brooklyn Bridge.

The view itself is typical of American panoramic photography in the 1860s. From St. Louis to San Francisco, photographers generally selected a city's highest vantage point to compose their surveying pictures. Using large 14 x 17-inch wet plates Rhorer photographed the expanse of the city, its generous port, and the gentle embrace of the river with what must be called civic pride. The whole picture, nearly five feet in length, shows more than the eye can see in one glance, and with sufficient detail to allow an easy reading of all the businesses at the burgeoning waterfront. A kind of visual city directory, it documents America at the close of the Civil War as it changed from a mostly rural, agrarian society to an urban society dependent on new technologies of transportation and communication. [JLR]

147. Attributed to Edric L. Eaton
American, ca. 1836–1890s

Sky Chief, ca. 1867
Albumen silver print by William Henry Jackson
from glass negative
18.6 x 13.3 cm (7⅜ x 5¼ in.)
Plate 120

This portrait of Sky Chief (Tirawahut Resaru), a Pawnee, has long been attributed to the frontier photographer William Henry Jackson (1843–1942). Between 1867 and 1869, Jackson acquired two photography studios in Omaha, Nebraska. With one of the businesses, that of Edric Eaton, came a large stock of negatives of Pawnees including the one from which this print was made. Eaton shows the Pawnee chief dressed in a typical late-1860s mix of U.S. military and traditional Native American clothing. Sky Chief, a close ally of the federal government in its persistent struggle against the Dakota, an enemy of the Pawnee, wears an officer's frock coat with V-shaped cuffs over brightly striped leggings. Around his neck hangs a large, glinting U.S. peace medal, while in his left hand he holds a tomahawk-pipe, a ritual symbol of war and peace.

Sky Chief would live only five years after this studio visit. In August 1871 the Dakota murdered his wife, leaving him in charge of his only son. Two years later, after a devasting crop loss, Sky Chief led a small band of hunters into Dakota territory in desperate search of buffalo. The party was attacked by nearly one thousand Dakota warriors and Sky Chief was shot. Before dying, he reportedly slew his three-year-old son so that the child would not be scalped alive, as he himself was, moments later. [JLR]

148. Charles William Carter
American, born England, 1832–1918

Mormon Emigrant Train, Echo Canyon, ca. 1870
Albumen silver print from glass negative
5.9 x 10.3 cm (2⅜ x 4 in.)
Ex coll.: Frederick Hill Meserve
Plate 118

Born in London, Charles Carter learned photography as a soldier in the British Army. In 1859 he moved to Salt Lake City in the Territory of Utah and soon joined the studio of his countryman and fellow Mormon Charles Roscoe Savage. Shortly thereafter he opened Carter's View Emporium, which catered to the rapidly growing Mormon community in Brigham Young's theocratic State of Deseret. From 1850 to 1870 the population of Salt Lake City grew on the average an astonishing 33 percent each year; by 1870 there were 86,000 residents, an increase of more than 75,000 people in two decades.

This view of a train of Conestoga wagons, or prairie schooners as they were known, is typical of the work Carter produced for sale to the Mormon pioneers. Urged by the church to emigrate to Utah, and partially aided by Young's Perpetual Emigration Fund, thousands of new converts in search of a better life set out across the country in covered wagons. Of the many trails leading west, the

Mormon Trail played the largest role in the growth of population along the frontier. In the background of Carter's photograph are several telegraph poles, confirmation that even early western communication followed the settlers. Echo Canyon is one of the two mountain passes at the very end of the trail, just outside Salt Lake City, through which Young first directed his small band of followers in the summer of 1847. [JLR]

149. Anonymous

A Frontier Home, 1860s–1870s
Albumen silver print from glass negative
19.0 x 24.3 cm (7½ x 9⅝ in.)
Plate 116

The Homestead Act of 1862 provided that any citizen or applicant for citizenship who was either the head of a family or twenty-one years of age (or, if younger, had served in wartime not less than fourteen days in the U.S. Army or Navy) could apply for ownership of 160 acres of unappropriated public land, and would acquire title to the land by residing on and cultivating the land for five years. An addendum to this act provided that after six months the land title could be acquired by paying $1.25 per acre.

Somewhere in the Great Plains a family sits on the porch of their new home, taking the late afternoon breeze. The father tilts back in his chair with an air of satisfied ownership, and the mother shows off their child. In the raw expanse of the West, they are comforted by a bit of millwork gingerbread on the barn and by a slender white-washed fence picketing their small yard. The photograph focuses on the essential relationship between family, shelter, and the land, and is a rare view of formative domesticity in the American West. [JLR]

150. Timothy H. O'Sullivan
American, born Ireland, 1840–1882

The Humboldt Hot Springs, 1868
Albumen silver print from glass negative
21.8 x 29.1 cm (8⅝ x 11½ in.)
Ex coll.: Alfred R. Waud
Plate 115

By the close of the Civil War twenty-five-year-old Timothy O'Sullivan had had seven years' experience in wet plate photography, five of them working from a van on or near the

battlefield. His technical proficiency under adverse conditions and his strong constitution recommended him as a photographer for the Geological Exploration of the Fortieth Parallel, the first of several exploratory surveys of the American West. Clarence King, an enterprising geologist from Yale, had convinced the government to implement a study of the geological structure and natural resources of the region west of the Great Plains and east of California, the so-called Great American Desert. From 1867 to 1872, King and his corps of young scientists mapped and described a band one hundred miles wide by three hundred miles long lying roughly along the route of the railroad that would link the east and west coasts in 1869.

The Humboldt Sink was perhaps the most desolate landscape studied by the expedition. Known locally as the "worst place between Missouri and Hell," the mountain-rimmed salt marsh was blisteringly hot, mosquito infested, and rank with sulfur and rotting vegetation. King went temporarily blind there, and fever prostrated most of the men. But O'Sullivan continued to work. In this photograph his portable developing box is visible in the left foreground; in the middle ground his van (a converted ambulance), dwarfed by the vastness, establishes scale and articulates the emptiness of the space.

The print is inscribed on the verso "Valley 5,000 ft. above sea, East of East Humboldt Range. Group of Salt Geyser Springs/Salt Marsh Valley/97 percent salt 3 borax."
[MMH]

legislation, the establishment of reservations, and, on occasion, slaughter.

As an exploratory visitor rather than an exploitative settler, O'Sullivan met little hostility from Native Americans. If some of his subjects were reluctant to pose for the "shadow-catcher," the thirteen Shoshoni depicted here seem resolute and patient. Expressed as a pyramid, the group's corporate solidarity appears as permanent as an ancient cairn, in contrast to the American and expeditionary flags, tents, and distant plain which, through the photographer's choice, are rendered as flat and insubstantial as his own shadow.
[MMH]

152. Timothy H. O'Sullivan
American, born Ireland, 1840–1882

Black Cañon, Colorado River, Looking Below from Big Horn Gap, 1871
Albumen silver print from glass negative
20.2 x 27.6 cm (8 x 10⅞ in.)

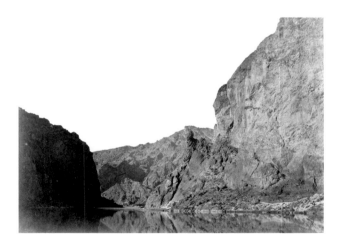

151. Timothy H. O'Sullivan
American, born Ireland, 1840–1882

Shoshoni, 1867–72
Albumen silver print from glass negative
22.9 x 29 cm (9 x 11⅜ in.)
Ex coll.: Alfred R. Waud
Plate 117

The homeland of the Shoshoni covered large tracts of the Great Basin—portions of Nevada, Oregon, Idaho, and Utah. O'Sullivan photographed in their territory in 1867–69 and 1872 with Clarence King, and in 1871 with Lieutenant George Wheeler. Many of the men in the photograph are wearing U. S. Army hats and shirts, paraphernalia probably acquired through barter at the Army's trading posts.

When O'Sullivan made the picture, the delicate ecology of the Shoshoni's food sources (buffalo, small game, roots, berries, and grass seed) had been virtually destroyed over the preceding thirty years by the heedless practices of emigrant white settlers. The resulting degradation and the marauding, murderous retaliation of the Shoshoni and associated tribes became known as the "Indian question," which the U.S. government attempted to resolve through

An engineer graduated from West Point, Lieutenant George Wheeler wanted to find inland passage for troops from Idaho and Utah southward to Arizona. In 1871 he was commissioned with the fourth U.S. Survey to map the topography of that region in view of strategic transit and future settlement. To his original corps of scientists Wheeler added the son of a prominent Boston family, to publicize the expedition in the Eastern press, and Timothy O'Sullivan, to provide a visual record.

As O'Sullivan's experience was unequaled in the field, it is not surprising that Wheeler placed great confidence in him from the outset, providing him with a roving commission and a boat of his own on the Colorado River. Although Wheeler's boats progressed slowly (they had to

be rowed, sailed, and hauled upriver against the current), O'Sullivan's was tardier still. Exploring the astonishing photographic possiblities of the canyons from his boat, *Picture*, he meandered, tacked, and stopped as he studied how to turn to advantage the sun and shade, the sheer cliffs, and their reflection in the water and profile against the sky.

Individually, the Black Canyon photographs have exquisite resolution. In sequence, they constitute the pictorial voyage of a reflective, visionary artist who knew how to orchestrate his experience of place. As one turns the pages of the album the shifting perspectives of river and cliff move in stately progression as, effectively as a diorama, they carry the viewer deep into the very heart of the canyon, where, Wheeler wrote, "a stillness like death creates impressions of awe."[25]

This photograph appears in an album of fifty photographs, of which thirty-five are by O'Sullivan and fifteen by William Bell, entitled *Photographs Showing Landscapes, Geological and other Features, of Portions of the Western Territory of the United States . . . Seasons of 1871, 1872, and 1873.* [MMH]

153. William Bell
American, born England, 1831–1910

Cañon of Kanab Wash, Looking South, 1872
Albumen silver print from glass negative
28.2 x 20.2 cm (11⅛ x 8 in.)
Plate 123

By the time the government's appropriations for George Wheeler's 1872 expedition were made, Timothy O'Sullivan had already signed up with Clarence King's survey for the season. Wheeler therefore asked William Bell, the photographer who had worked for the American Medical Museum, to take O'Sullivan's place in his corps.

Unlike O'Sullivan, who regarded the problem of landscape as a rational arrangement of vacancy and mass, Bell perceived landscape dramatically and vertically, related to the upright posture of man. Whereas O'Sullivan composed in a planar and lapidary fashion, carving out powerful blocks of tone, Bell composed in depth, setting off the plunging perspectives of the Grand Canyon against the rocks in the foreground. Here, from the shadow of the slanting overhang of a cliff, the viewer sees the blare of sun on the canyon's opposite wall like dawn's curtain rising.

This photograph is part of the Colorado River Series in a rare album of thirty-five prints of Bell's photographs for Wheeler's 1872 season. A companion volume of thirty-five prints of O'Sullivan's photographs for Wheeler's 1871 season is in the collection of The Metropolitan Museum of Art. The prints in both albums probably were made by

O'Sullivan in the winter of 1872–73, either to encourage appropriations for the next season or as prototypes for the composite albums of the Wheeler surveys that the government would publish in 1874–75 (see no. 152). [MMH]

154. Timothy H. O'Sullivan
American, born Ireland, 1840–1882

Fissure Vent of Steamboat Springs, Nevada, 1867
Albumen silver print from glass negative
21.9 x 28.8 cm (8⅝ x 11⅜ in.)
Plate 114

For some of the most mesmerizing photographs made for ostensibly documentary purposes, we have only clues to elucidate the original intention. This picture has been published as both *Steam Rising from a Fissure near Virginia City, Nevada* and *Ruby Valley, Nevada*; Clarence King titled it as cited above. None of the titles clarifies the picture's mystery. Surely the shadowy figure is on the edge of an abyss, but whether he is to be swallowed up by it or has just risen from it is unclear. Maybe the point is his very ambiguity in the infernal, Dantean space. Or perhaps he is the anchor in a depiction of an amorphous geological event—the familiar entity by which all things are measured, including the density of vapor and the passage of time.
 [MMH]

155. Timothy H. O'Sullivan
American, born Ireland, 1840–1882

Miner at Work 900 ft. Underground, Gould and Curry Mine, Virginia City, Nevada, 1868
Albumen silver print from glass negative
16.4 x 13.7 cm (6½ x 5⅜ in.)

The usefulness of King's work for the government depended especially on his survey of the mining industry. Following the first season, the expedition did not return east but wintered over in Nevada—King and the three geologists at Virginia City, O'Sullivan and the others at Carson City. In February 1868, King asked O'Sullivan to come to Virginia City to document the activities at the Savage and the Gould and Curry mines on the Comstock Lode, the richest silver deposit in America.

Working nine hundred feet underground by the light of a burning magnesium wire, O'Sullivan photographed the miners in tunnels, shafts, and lifts and in the aftermath of a cave-in. His pictures were not the first taken underground in America—photographs had been made in Mammoth Cave the year before—but they were the first to show the appalling conditions of miners at work.

O'Sullivan always composed his photographs with care. When he worked on the battlefields of the Civil War he arranged limbs to create more telling pictures, and one

time went so far as to drag a fallen soldier to a preferred site. In this series, too, he subjected reality to his critical method and artfully deployed the props. With one exception he chose not to depict the miners full length; instead, he cornered, truncated, and overpowered them beneath heavy masses of rock. (The shape at the right is the thigh and arm of a second miner with a sledge hammer.) The feeling of claustrophobia in this picture is further heightened by the rough timbers at the left and by O'Sullivan's unstable jerry-rigged arrangement of tools, which suggests the precarious nature of the men's labor. These highly un-

comfortable pictures were not reproduced in *Mining Industry*, the first volume of the expedition's official report to the government.[26] [MMH]

156. Carleton E. Watkins
American, 1829–1916

The Grisly Giant, Mariposa Grove, Yosemite, 1861
Albumen silver print
52.3 x 40.7 cm (20⅝ x 16 in.)
Plate 4

When he was twenty-one Carleton Watkins left Oneonta, New York, for California, following the example of Collis P. Huntington, another Oneonta native who had moved to California to make his fortune. After a stint in Huntington's store in Sacramento, Watkins moved to San Francisco where he chanced into an apprenticeship with Robert Vance, the famous daguerreotypist. By 1858 Watkins had established an independent practice, photographing mining operations and land claims for financiers who were building their careers in the lap of the new state.

In 1861 Watkins traveled with one of his patrons, Trenor Park, entrepreneur of the Mariposa gold mine, on a family excursion to Yosemite, an extraordinarily beautiful valley surrounded by cliffs three thousand feet in height. Unknown to white settlers until 1849, the valley was twenty hours by stage and mule from San Francisco. But word spread fast at the Mariposa mine, and by 1858 there were land claims, a better road, and tourists enough to support a hotel. In 1859 C. L. Weed photographed the valley, and by 1861 easterners had come to know of the awe-inspiring site from articles in the Boston *Evening Transcript* written by the Unitarian minister Thomas Starr King.

The thirty mammoth plate (22 x 18 inches) and one hundred stereo views that Watkins took in Yosemite in 1861 were among the first photographs of the valley sent back East. Through Starr King, Oliver Wendell Holmes and Ralph Waldo Emerson received copies, and in 1862 the photographs excited further interest when they were exhibited at Goupil's New York gallery. It was partly on their evidence that President Lincoln signed a bill in 1864 declaring the valley inviolate and leading the way to the National Parks system.

The giant sequoia tree in Watkins's photograph is eighty-six feet in circumference, two hundred twenty-five feet high, and some three thousand years old. Grisly Giant, as the tree is known, helped clinch the notion that Yosemite was a relict of Eden in North America.

[MMH]

157. Carleton E. Watkins
American, 1829–1916

Sugar Loaf Islands, Farallons, 1868–69
Albumen silver print from glass negative
52.1 x 39.7 cm (20⅛ x 15⅝ in.)
Ex coll.: San Francisco Mercantile Library; University
Club, New York
Plate 125

Watkins's technical virtuosity was honed in Yosemite, first
in 1861 and again in 1865–66, when he returned as the
official photographer for Josiah Whitney's California State
Geological Survey. By the end of his extended stay he had
mastered the manipulation of the cumbersome camera
(three feet long when extended) and the mammoth glass
plates, which had to be sensitized and developed in a dark-
room tent, often with water hauled by mules over long
distances. Upon returning to San Francisco, Watkins
printed his large negatives by laying them directly on
albumen printing-out paper in the sun. His uncommon
talent was recognized locally by Whitney, Clarence King,
and others of the scientific community, nationally by the
photographic press, and internationally through an award-
winning display at the Exposition Universelle in Paris in
1867.

In 1868–69, Watkins visited the Farallon Islands thirty
miles west of San Francisco, rocky outcrops inhabited by
seals and sea birds. Although the islands were visited
regularly by fishermen and commercial collectors of bird
eggs, in this photograph Watkins avoided any reference to
man. Isolated from the neighboring islands, the triangular
rock is depicted as if on the fifth day of Creation when, the
dry land having emerged from the swirling sea, the waters
brought forth swarms of living creatures. [MMH]

158. Carleton E. Watkins
American, 1829–1916

Multnomah Falls Cascade, Columbia River, 1867
Albumen silver print from glass negative
40 x 52.4 cm (15¾ x 20⅝ in.)
Plate 124

In 1867, Watkins made a four-month trip to Oregon and the
Columbia River. Josiah Whitney accompanied him for the
first month and helped finance the excursion.

Watkins had photographed the Nevada, Vernal, and
Yosemite Falls before he went to Oregon; on those occasions
he either described the waterfalls as elements within
broader landscapes (on the mammoth plates) or made
close-up shots of the water roaring over the rocks (for
stereo viewing). In this marvelously minimal photograph
he seems to have applied the simplicity of effect he usually
reserved for stereographs to the monumental mammoth
plate; boldly reducing the cascade to its essentials, white
water cleaves dark rock in a single stroke, like liquid
lightning. [MMH]

159. Carleton E. Watkins
American, 1829–1916

Cape Horn near Celilo, 1867
Albumen silver print from glass negative
40 x 52.4 cm (15¾ x 20⅝ in.)
Ex coll.: San Francisco Mercantile Library; University
Club, New York
Plate 122

When Watkins traveled up the Columbia River he pho-
tographed both the natural and manmade landmarks—the
rocky outcrops and cascades, and the small towns, mills,
and docks along the way. His path followed that of the
Oregon Steam Navigation Company, and as he photographed
not only the company's route but also its facilities, he may
have been working either on commission or with a specu-
lative eye for the company's business. It would be easy to
surmise that the centrality of the rails in this photograph is
evidence of Watkins's business agenda. But in the absence
of confirming data, one might instead interpret the picture
as a visual metaphor for Manifest Destiny, the belief that
the United States was destined to span the continent with
its sovereignty. The artful balance Watkins achieves between
nature and man's incursion into nature—between the
valley etched in the land by the river and the railroad laid
down alongside it—suggests that whether he saw Cape
Horn as a commercial opportunity or as a symbolic
representation of a national doctrine, he also recognized it
as a providential place of aesthetic and moral harmony
that provided the opportunity for a pictorial expression of a
perfect state of grace.

One hundred miles upstream from Portland, Celilo was
the farthest reach of Watkins's travels during the four-
month excursion. The superb self-confidence of this col-
location of sky, river, and land suggests the artist's intuition
that this, his last picture on the Columbia before turning
back, might balance the distance covered with the distance
still to go, demonstrating with crystalline clarity how
arrival merges with departure and achievement runs to
further challenge. [MMH]

160. Carleton E. Watkins
American, 1829–1916

Strait of Carquennes, from South Vallejo, 1868–69
Albumen silver print from glass negative
40.3 x 52.5 cm (15⅝ x 20⅝ in.)
Ex coll.: San Francisco Mercantile Library; University
Club, New York
Plate 121

When Watkins exhibited his mammoth prints in 1869 a
critic remarked, "They justly deserve the encomiums
passed upon them. For clearness, strength, and softness of
tone, these picturesque views are unexcelled; and while
they present truthful representations of the scene chosen,
they are an earnest of the artistic skill of the photographer."[27]
Of the photographs that earned such praise, surprisingly
few exist today. Those that survive in pristine condition
generally come from a group of albums made in 1872,
before Watkins's business collapsed and his plates were
acquired by the photographer I. W. Taber. Although
Watkins continued to photograph, he limited his use of the
unwieldy and expensive mammoth plates mostly to pictures
of Yosemite. Taber reprinted some of Watkins's earlier
views (no. 156), but not those of sites that were neither
grand enough nor on the tourist route (nos. 157–59).
Indeed, Watkins himself printed such unconventional
pictures only when he had the luxury of composing large
presentation albums.

The subjects of these photographs are not famous; they
are noteworthy largely because of the way Watkins saw
them. In this sense the pictures are intrinsically his most
original. This rare print of Carquinez Strait, near San
Francisco, is exquisite testimony to the triumph of artistic
necessity, without regard for practicality, profit, or cost.

[MMH]

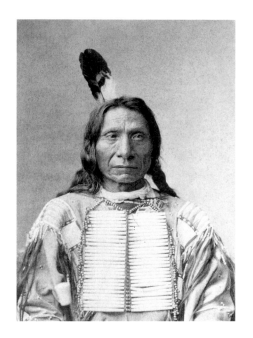

Nebraska Territory. He was one of the few Native American
leaders to win a military campaign against the U.S. Army,
successfully resisting in 1865–66 the government's
development of the Bozeman Trail. A signatory of many
treaties and a frequent visitor to the capital, Red Cloud
sat for this portrait in June 1880 as part of a special dele-
gation investigating the treatment of students at the
Carlisle Indian School in Carlisle, Pennsylvania.

This cabinet card (6½ x 4¼ inches) portrait shows Red
Cloud wearing an animal-skin shirt and a breastplate of
bones, called hair-pipes, edged with brass beads. He also
wears a single feather from a golden eagle. No other
creature flew so high or matched its swiftness and majesty.

[JLR]

161. Charles Milton Bell
American, 1848–1893

Red Cloud, 1880
Albumen silver print from glass negative
14 x 9.8 cm (5½ x 3⅞ in.)

Throughout the nineteenth century, the U.S. government
invited hundreds of Native American delegations to Wash-
ington, D.C., in an effort to seek peace, negotiate treaties,
and acquire tribal land. Delegation photography was a
routine part of any state visit, and many portrait studios,
including that of Charles M. Bell, profited from the
business.

Red Cloud (Mahpiua Luta, 1822–1909), the principal
chief of the Oglala Dakota, was born on the Platte River in

162. Anonymous

Five Members of the Wild Bunch, ca. 1892
Tintype
8.4 x 6.2 cm (3¼ x 2½ in.)
Ex coll.: Camillus S. Fly
Plate 119

The Wild Bunch was the largest and most notorious band
of outlaws in the American West. Led by two gunmen
better known by their aliases, Butch Cassidy (Robert
LeRoy Parker) and Kid Curry (Harvey Logan), the Wild
Bunch was an informal trust of thieves and rustlers that
preyed upon stagecoaches, small banks, and especially
railroads from the late 1880s to the first decade of the
twentieth century.

This crudely constructed tintype portrait of five members of the gang dressed in bowler hats and city clothes shows, clockwise, from the top left, Kid Curry, Bill McCarty, Bill (Tod) Carver, Ben Kilpatrick, and Tom O'Day. Without their six shooters and cowboy hats the outlaws appear quite civilized and could easily be mistaken for the sheriffs and Pinkerton agents who pursued them in a "Wild West" already much tamed by the probable date of this photograph. Gone was the open range—instead, homesteads and farms dotted the landscape and barbed-wire fences frustrated the cattleman's drive to market. Gone too was the anonymity associated with distance, as the camera and the telegraph conspired to identify criminals. Bank and train robbery were still lucrative, but the outlaw's chances for escape gradually shifted in favor of the sheriff's chances for arrest and conviction.

By 1903 the Wild Bunch had disbanded. A few members of the gang followed Butch Cassidy to South America, while the majority remained in the West, trying to avoid capture. McCarty was shot dead in 1893, in a street in Delta, Colorado, after a bank robbery; Carver died in prison; Kilpatrick was killed during a train robbery in 1912; Tom O'Day was captured by a Casper, Wyoming, sheriff in 1903; and Kid Curry died either by his own hand in Parachute, Colorado, in 1904, or, as legend has it, lived until he was killed by a wild mule in South America in 1909.

The photograph comes from the collection of Camillus S. Fly, a pioneer photographer in Tombstone, Arizona, in the 1880s and sheriff of Cochise County in the 1890s.

[JLR]

163. William H. Rau
American, 1855–1920

Cayuga Lake, Elbow Curve, 1895–1900
Albumen silver print from glass negative
43 x 51.9 cm (16⅞ x 20⅜ in.)

Although William Rau is perhaps best known for his photographs commissioned by the Pennsylvania railroads, he began his career at age nineteen as a photographer on the 1874 U.S. government expedition to document the Transit of Venus. A rare celestial event, each passage of the planet before the sun allows scientists to recalculate the distance of the earth from the sun. After this first commission Rau traveled to the western United States to photograph the Rocky Mountains and to Egypt to photograph the monuments. He never lost his wanderlust, but in 1885 he established a successful society portrait studio in Philadelphia with his father-in-law, the photographer William Bell.

In 1895 Rau was contracted by the Lehigh Valley Railroad to photograph along its new route from New York City to Niagara Falls. He made hundreds of landscape

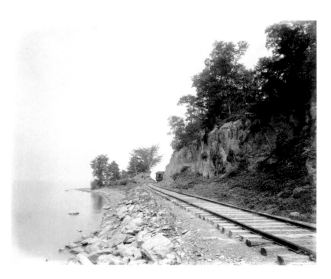

views that demonstrate the somewhat contradictory simultaneity of the late-nineteenth-century American faith in progress and technology and its love of grand scenery. This photograph shows the rail line's freshly laid track passing a formerly secluded beach on one of the large lakes north of Ithaca, New York. Although Rau's railroad work stands as the last significant nineteenth-century record of the American landscape, the Eastern scenery surveyed was already domesticated; Cayuga Lake was not a wilderness but a recreation site, popular with students and faculty at Cornell University, which had been founded at the foot of the lake in 1868. Furthermore, Rau's use of the large plate camera was virtually anachronistic as the hand-held roll-film Kodak had been invented in 1888.

[JLR]

164. Peter Henry Emerson
British, born Cuba, 1856–1936

Poling the Marsh Hay, 1886
Platinum print
23.2 x 28.9 cm (9⅛ x 11⅜ in.)

P. H. Emerson's book *Life and Landscape on the Norfolk Broads*, in which this image was one of forty plates, was the artist's first demonstration of the naturalism that he advocated for photography. While seeking the same goal as his ideological opposite, H. P. Robinson—recognition of photography as a fine art—Emerson drew his subjects not from literary narratives, but rather from an examination, at once both highly personal and anthropological, of the environment and daily rituals of rural life in East Anglia, the marshy coastal region northeast of London. Adamantly, even vociferously, opposed to Robinson's artificial manipulation of the medium, Emerson admitted into his own photographic vocabulary only selective focus and the careful gradation of tones, subtly rendered

here by the platinum process. He looked to the work of painters for his aesthetic models, Jean-François Millet and Jules Bastien-Lepage in France and, at home, the painters of the New English Art Club, including his collaborator on *Life and Landscape*, Thomas Goodall. In breaking the existing molds of ambitious photography—sharp, straight-forward documentation and contrived tableaux—and opting for a more impressionist vision, Emerson blazed the trail that would be followed by the American Pictorialists, the Photo-Secession, and modern photography.

Emerson immersed himself in the life and work of East Anglia, passing on his expertise in more than a half-dozen books illustrated with platinum prints or photogravures during his ten-year photographic career. But *Poling the Marsh Hay* is more than just an accurate depiction of the means by which Norfolk peasants transported their harvest over ground too sodden to traverse with carts; it is an essay on the nobility of manual labor and a meditation on nature and mortality. Below ominous dark clouds the assertive strong-bodied woman in the foreground and the shadowed figure behind pole their hay as if carrying a funeral litter.

[MD]

165. Giuseppe Primoli
Italian, 1851–1927

Monte Mario—Who Are They?, 1889
Gelatin silver print
5.2 x 13.5 cm (2 x 5⅜ in.)
Plate 128

Count Giuseppe Primoli was born in Italy, though he spent his youth in Paris. After the fall of the Second Empire, he divided his time between Rome and Paris, leading the fashionable life of an aristocrat and maintaining long friendships with such literary personalities as Théophile Gauthier, Alexandre Dumas fils, Guy de Maupassant, and Gabriele d'Annunzio. An amateur photographer from an early age, Primoli entertained the idea of becoming a writer but soon gave in to his mania for photography; he left over fifteen thousand images, most of which are now at the Primoli Foundation in Rome.

Primoli was among the first amateurs to devote himself almost exclusively to the instantaneous images that the new hand-held camera made possible in the late 1880s. Seldom venturing anywhere without his lens, he developed a sure eye for the uncommon angle, the amusing juxtaposition, the incongruous detail. A man of wide culture and interests who had access by birthright to the most exclusive social circles, Primoli was in a unique position to compile an original, often irreverent chronicle of his time. Announcing modern reportage, his work foreshadows that of Jacques-Henri Lartigue, Henri Cartier-Bresson, and Erich Salomon.

In his portrayals of the pastimes of the aristocratic families of Rome—their balls, charity events, horse races, and fox hunts—Primoli displays a detachment tinged with irony. This view of a hunt in the countryside holds our attention by the barren beauty of the vast, grassy landscape, rendered with the delicacy of a miniature and which the elegant silhouettes of the hunters punctuate with the crisp precision of notes on a sheet of music.

[PA]

166. William James Mullins
American, 1860–1917

Children Fishing, ca. 1900
Platinum print
9.1 x 25.7 cm (3⅝ x 10⅛ in.)

William Mullins, of Franklin, Pennsylvania, was a minor member of the Photo-Secession. He was included in the Philadelphia Photographic Salon at the Pennsylvania Academy of Fine Arts in 1898, the first exhibition of photography in America held at a recognized fine arts institution. Juried by two painters and three photographers, including Alfred Stieglitz, the show was the first to exhibit photographs solely for their artistic merit, completely abandoning specific categories such as genre, landscape, or portraiture. Mullins's work appeared in the October 1901 issue of *Camera Notes*, but his greatest public achievement was the display of twelve of his photographs in the International Exhibition of Pictorial Photography, at the Albright Art Gallery in Buffalo, New York, in 1910.

Water was nature's living mirror to members of the Photo-Secession, a reflective, ever-changing surface that served as a perfect test of an artist's pictorial skills. Elegant distortions caused by surface ripples appear in picture after picture from the period, but few photographs are as well constructed as this one of children fishing. By

cropping his print to a narrow rectangular strip, Mullins emphasized the uninflected expanse of placid water. The low camera position relates the anglers to the distant shore—a line of trees as irregular as their bamboo poles—while their heads float above the horizon like bobbers on the lake's surface. [JLR]

This image is a collotype, made through a photomechanical printing process of such refinement that it is often taken for a direct imprint of a negative. It is one in a series of pictures that Wright made of the Hillside Home School—its buildings and landscapes and the activities of its students—in the years 1893 to 1900, perhaps with the idea of including them in a publication about the school. [PA]

167. Frank Lloyd Wright
American, 1869–1959

Romeo and Juliet, ca. 1900
Collotype on Japanese tissue
21.7 x 8.9 cm (8½ x 3½ in.)
Plate 158

In 1896, Frank Lloyd Wright was asked by his aunts Ellen and Jane Lloyd-Jones to devise a windmill that would stand in harmony with the building he had designed for them ten years earlier, the Hillside Home School, his first executed work. Set among the rolling hills of the Wisconsin countryside, Wright's structure combined the functions of a windmill and a belvedere. The plan comprised a diamond-shaped column wedged into an octagonal structure, which suggested to the architect the lovers Romeo and Juliet in embrace. Built of wood on a heavy stone foundation, the sixty-foot structure was still standing in 1990, when it was taken down to be built anew.

There is no photographic precedent for Wright's striking manner of presenting this building. The architect's thorough knowledge of Japanese art clearly informs the spare aesthetic of the image, in which he strives for his often stated ideal of "the elimination of the insignificant." Graphically binding shapes into a bold upward thrust, the composition integrates building and machine and prefigures a major theme of twentieth-century architecture, one that would be fully explored in the 1920s.

168. Edward Steichen
American, born Luxembourg, 1879–1973

The Pond—Moonlight, 1904
Multiple gum bichromate print
40 x 49.4 cm (15¾ x 19½ in.)
Plate 146

His native talent honed in four years' work at a lithography firm in Milwaukee, Wisconsin, and through an avid absorption of *Camera Notes, The Studio,* and other art magazines, Edward Steichen became one of the best amateur artist-photographers in America by the age of twenty-one. In 1900 he moved to Paris to study painting, stopping en route to visit Alfred Stieglitz. On a return trip to New York in 1902, he became a founding member of the Photo-Secession, and for the duration of the group's existence he was the very embodiment of the successful Pictorialist photographer—a handsome, cosmopolitan artist of high ambition who happened to use photography as his preferred expressive vehicle.

In fact, Steichen was more a painter than a photographer in the years before World War I, but he lent his exceptional abilities to photography so willingly and so well that he was a major instrument in the transformation of the public's perception of the medium. Before his prints, the notion of photography as a mere hobby withered and an appreciation for an art closely resem-

bling painting blossomed. Steichen's technical means were many, and like a master chef he combined his ingredients according to intuition rather than rule. His prints are seductive and delectable, but mysterious in their constitution.

This view of a pond in the woods at Mamaroneck, New York, with the edge of the moon lipping the rise, is as subtly colored as Whistler's *Nocturnes*, and like them, it is a tone poem of twilight, indistinction, and suggestiveness. Reviewing such pictures in 1910, Charles H. Caffin wrote in *Camera Work*: "It is in the penumbra, between the clear visibility of things and their total extinction in darkness, when the concreteness of appearances becomes merged in half-realised, half-baffled vision, that spirit seems to disengage itself from matter to envelop it with a mystery of soul-suggestion."[28] [MMH]

169. Edward Steichen
American, born Luxembourg, 1879–1973

Rodin—The Thinker, 1902
Gum bichromate print
39.6 x 48.3 cm (15⅝ x 19 in.)
Plate 143

When Edward Steichen arrived in Paris in 1900, Auguste Rodin (1840–1917) was regarded not only as the finest living sculptor but also perhaps as the greatest artist of his time. Steichen visited him in his studio in Meudon in 1901 and Rodin, upon seeing the young photographer's work, agreed to sit for his portrait. Steichen spent a year studying the sculptor among his works, finally choosing to show Rodin in front of the newly carved white marble of the *Monument to Victor Hugo*, facing the bronze of *The Thinker*. In his autobiography, Steichen describes the studio as being so crowded with marble blocks and works in clay, plaster, and bronze that he could not fit them together with the sculptor into a single negative. He therefore made two exposures, one of Rodin and the *Monument to Victor Hugo*, and another of *The Thinker*. Steichen first printed each image separately and, having mastered the difficulties of combining the two negatives, joined them later into a single picture, printing the negative showing Rodin in reverse.

Rodin—The Thinker is a remarkable demonstration of Steichen's control of the gum bichromate process and the painterly effects it encouraged. It is also the most ambitious effort of any Pictorialist to emulate art in the grand tradition. The photograph portrays the sculptor in symbiotic relation to his work. Suppressing the texture of the marble and bronze and thus emphasizing the presence of the sculptures as living entities, Steichen was able to assimilate the artist into the heroic world of his creations. Posed in relief against his work, Rodin seems to contem-

plate in *The Thinker* his own alter ego, while the luminous figure of Victor Hugo suggests poetic inspiration as the source of his creativity. Recalling his response to a reproduction of Rodin's *Balzac* in a Milwaukee newspaper, Steichen noted: "It was not just a statue of a man; it was the very embodiment of a tribute to genius."[29] Filled with enthusiasm and youthful self-confidence, Steichen wanted in this photograph to pay similar tribute to Rodin's genius.
[PA]

170. Eugène Druet
French, 1868–1917

The Clenched Hand, before 1898
Gelatin silver print
29.9 x 39.5 cm (11¾ x 15½ in.)
Plate 145

Throughout his career Rodin made constant use of photographs to analyze his work, but by the 1890s his interest had extended beyond their purely utilitarian function. Rodin recognized in Eugène Druet, an amateur photographer who owned a bar across the street from his studio, a talent for interpreting his art, and the two began a productive collaboration in the late 1890s. The retrospective of Rodin's sculpture, held in his personal pavilion at the Exposition Universelle in Paris in 1900, included seventy-one images by the photographer. Relations between the two artists were not, however, without strain, and after 1903 their collaboration all but ceased.

Fascinated by the expressive power of the human hand, Rodin created many works where the hand, as an independent form, becomes a sculptural statement. *The Clenched Hand*, made about 1885, is a smallish bronze, 18½ inches in height. The photographs Druet made of it about ten years later are a characteristic, albeit extreme, example of his theatrical, often somber staging of Rodin's sculpture. In the series, the hand seems to emerge from the folds of a white flannel blanket, as if from an invalid's gown. The sculpture's material and subject are sometimes hardly recognizable; this particular image suggested to Rodin and his secretary, René Cheruy, some antediluvian monster crawling over desert sands. That it is also a severed hand in final spasm is suggested by its juxtaposition to a partially visible photograph of another, seemingly amputated, figure waving a deformed limb. This puzzling image within an image is Druet's study of Rodin's *Monument to Victor Hugo*. As was customary with Druet, the image of *The Clenched Hand* is an enlargement. The resulting slightly blurred focus and washed-out grayish tint accentuate the unsettling, morbid atmosphere. In its cold light, the image is almost hallucinatory.

Rodin's signature, inscribed on the negative beside that of Druet, makes the photograph an extension of his own work.
[PA]

171. Anonymous

Study of a Sculpture, ca. 1900
Gelatin silver print
39.7 x 29.8 cm (15⅝ x 11¾ in.)
Plate 142

This study of an academic sculpture by an unidentified
artist may have been made by Eugène Druet, who worked
with several sculptors besides Rodin.

As was common practice in record photography, the
white plaster nude has been set against an opaque black
background. The lateral lighting plays across the sculp-
ture, giving the chalky plaster the sensuousness of human
flesh. Despite this added dimension, the picture would not
hold our attention but for the inclusion of the wrapping
material, chain, and tackle at the left. The presence of
these disturbing elements invests the image with an
ominous tension, the ordinary trappings of a sculptor's
studio transformed into sinister instruments of torture
ambiguously related to the languorous figure lost in solip-
sistic reverie. [PA]

172. Clarence White
American, 1871–1925

The Orchard, 1902
Platinum print, 1907
24 x 19.1 cm (9½ x 7½ in.)
Plate 126

Made in the year that the Photo-Secession was formed,
Clarence White's *The Orchard* perfectly embodies the
tenets of Pictorialism: expressive, rather than narrative or
documentary, content; craftsmanship in the execution of
the print; and a carefully constructed composition allied to
the paintings of the Impressionists and the American
tonalists, and to the popular prints of Japan. White was a
founding member of the Photo-Secession, a friend of
Alfred Stieglitz and F. Holland Day, and a highly praised
contributor to (and occasional juror for) photographic
exhibitions at home and abroad. He participated in the
group exhibitions of the Photo-Secession and was featured
in issue number 23 of the group's influential and exqui-
sitely printed journal *Camera Work* (1908). After moving to
New York in 1906, White taught photography, first at
Columbia University and later at the Clarence White
School, exerting influence in his later years more as a
teacher than as an active artist.

White's best work, however, was produced far from the
medium's center of gravity, when he lived in the small
Ohio town of Newark, supporting himself and his family as
a grocery store bookkeeper. His photographs from this
time, pastoral odes of a sort, stemmed from a vision

nurtured by and dependent on the customs and values of
small-town life. The three women depicted here, his wife
Jane, her sister Letitia Felix, and their friend Julia
McCune, were his most frequent models. White's intimacy
with his subjects—nature, women, and domestic life—
allowed him to find sentiment in the commonplace. These
women, dressed in costumes that, already in 1902, sig-
naled a remove from the modern, urban world, are embod-
iments of feminine grace. Neither genre scene nor narrative
tableau, White's photograph is a retreat into domesticized
nature. [MD]

173. George H. Seeley
American, 1880–1955

Winter Landscape, 1909
Gum bichromate and platinum print
43.7 x 53.8 cm (17¼ x 21¼ in.)
Plate 144

A native of Stockbridge, Massachusetts, George Seeley
studied painting at the Massachusetts Normal Art School
in Boston for three and a half years beginning in 1897.
During his time there he met F. Holland Day, an eccentric
aesthete and early advocate of photography as a fine art
(see no. 191). Seeley returned home as a dedicated
artist-photographer in 1902. When his work was exhibited
in the First American Photographic Salon in New York in
December 1904, Alfred Stieglitz immediately recognized
the young man's talent and invited him to join the Photo-
Secession. From 1906 to 1910, Seeley was an active if
somewhat isolated Fellow, the admired newcomer of the

group, who lived with his family in the Berkshires and sent soft-focused photographs of willowy maidens in white to Stieglitz for exhibition and for reproduction in *Camera Work*. On the occasion of his second exhibition at 291 in 1908, Seeley visited New York and saw for the first time original prints by his colleagues.

Winter Landscape, a large varnished gum print dated 1909, would seem to be Seeley's response to the work of Edward Steichen, which had especially impressed him. Boldly simplified in tone, its whip-line contours in perfect accord with the sinuosity of the forms of Art Nouveau, Seeley's impressively grand and gloomy scene, for all the world an enlarged detail from a painting by Edvard Munch, demonstrates his valid claim on a frozen corner of the terrain of art for art's sake. [MMH]

174. Paul Strand
American, 1890–1976

Winter, Central Park, New York, ca. 1915
Platinum print
25.7 x 28.4 cm (10⅛ x 11⅛ in.)

Paul Strand studied photography at the Ethical Culture School in New York with Lewis Hine in 1907, and was introduced to pictorial photography the same year on a school outing to the Little Galleries of the Photo-Secession. After graduating, Strand made the Camera Club of New York his home; availing himself of the darkroom, the library, and the technical know-how of other club members, he became an exceptional printer at a very young age. Beginning in 1913 he frequented Stieglitz's gallery, absorbing the lessons of modern European and American art, and in 1915, on a visit to the Pan-American Exposition in San Francisco, he was impressed by Japanese wood-block prints.

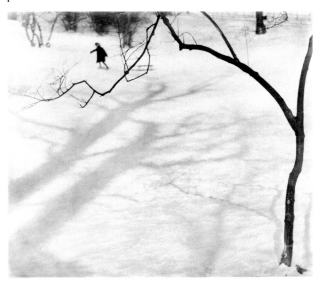

In the manner of the prints, Strand flattened and tilted his space, using the snow as a flat field upon which the trees could draw their delicate tracery. Although the child at the top of the picture is at some distance from the photographer, the space, tonal range, and pictorial incidents are so compressed that the child seems to be pulling the slender tree into an arc, his sled having momentarily snagged in the web of branches. The tensile energy of this drawing belies the winter idyll that is the nominal subject of the picture. [MMH]

175. Alfred Stieglitz
American, 1864–1946

Two Men Playing Chess, 1907
Autochrome
8.2 x 10.9 cm (3¼ x 4¼ in.)
Plate 134

Hailed as the first generally accessible rendering of color in photography, the autochrome process was made public by Auguste and Louis Lumière in 1904, and became commercially available in the form of glass transparencies in 1907. Binding a mosaic of dyed specks of potato starch with the black-and-white emulsion of the photographic plate, the autochrome retrieved natural colors in a muted palette and registered light with the diffuse, grainy quality of a pointillist painting. Pictorialist photographers—Edward Steichen, Frank Eugene, Adolph de Meyer, and Heinrich Kühn, among others—eagerly experimented with the new process, as did numerous amateur photographers around the world. The emergence of color gave rise to one of the most ambitious projects in the history of photography, the French philanthropist Albert Kahn's *Archives of the Planet* (1910–30), a visual record of mankind and his artifacts as they appeared at the beginning of the twentieth century, comprising no fewer than 72,000 plates. Autochromes were used until 1930, but because they required a relatively long exposure time, had to be viewed in transparency, and were unique objects difficult to reproduce, they remained an essentially private mode of expression.

Stieglitz was introduced to the autochrome process by Edward Steichen in Paris in the summer of 1907, and he experimented with it while on vacation with Frank Eugene in Tutzing, Bavaria. This image, made that summer, shows, on the right, the photographer's friend Dr. Raab playing chess with an unidentified man, perhaps Herr Götz of the Bruckmann printing firm in Munich, who was working on the reproductions of Steichen's autochromes for publication in *Camera Work*. Faithful to his direct approach to subject matter, Stieglitz's image preserves the naturalness of the snapshot within a tight but unobtrusive

formal structure. Unlike many of the Pictorialists, especially Steichen, Stieglitz did not try to use the autochrome process to create a particular stylistic effect; instead, he knowingly applied the autochrome's most attractive feature, the vibrant, atmospheric quality of its light. Stieglitz was so enthusiastic about the process that, on his return to New York that fall and without waiting for Steichen, he called a press conference to introduce the autochrome to America. [PA]

176. Heinrich Kühn
German, 1866–1944

On the Hillside (A Study in Values), before 1910
Gum bichromate print
23.2 x 29.2 cm (9⅛ x 11½ in.)
Plate 129

A leader of Pictorialist photography in Europe, Heinrich Kühn was a major figure of the Vienna Camera Club and a member of the Kleeblatt, a trio of photographers that included Hans Watzek and Hugo Henneberg. Exhibiting together until 1903, they perfected the gum bichromate printing process and made large pictures composed of broad, rich tonal masses that involved a high degree of handwork; their photographs took on the appearance of mezzotints, aquatints, and other traditional processes of graphic art. Kühn was elected in 1896 to the progressive British photographic society The Linked Ring, and his international reputation was confirmed in major exhibitions such as that of the Munich Secession in 1898. Stieglitz, with whom he started a long correspondence the following year, published his photographs as photogravures in *Camera Work*.

On the Hillside belongs to the later part of Kühn's photographic career when, without sacrificing the breadth of his vision, he moved away from the oversized, public scale of his moody landscapes of the 1890s and turned to more intimate motifs—portraits, domestic still lifes, and views of the countryside surrounding Innsbruck. Members of his family resting, hiking, or at play in the open spaces of the Tyrolean hills were among his favorite subjects. With their hazy outlines and sensitive rendering of changing patterns of light and shade, these bucolic images belong to the world of late Impressionism. Here, the figure of Lotte, Kühn's youngest child, picking flowers on the incline of a hill, has been flattened into a luminous graphic shape, light and immaterial, whose delicate simplicity demonstrates the artist's superb eye for tonal values. Indeed, Kühn gave the picture the parenthetical title *A Study in Values* when he sent a photogravure version of this print to the International Exhibition of Pictorial Photography at the Albright Art Gallery in Buffalo in 1910. [PA]

177. Heinrich Kühn
German, 1866–1944

The Artist's Umbrella, 1908
Gum bichromate and platinum print
22.6 x 28.7 cm (8⅞ x 11¼ in.)
Plate 152

Kühn always acknowledged his debt to painters and advised photographers, if they were to become artists, to look at paintings. In this photograph, the motif of nude children on the shore may have been suggested to Kühn by the work of Max Lieberman, a painter of the Munich Secession. The bold, graphic treatment is, however, purely photographic, closely suggesting a snapshot. From his vantage point, Kühn organized the scene into what appears to be an amusing rebus in which the white octagonal shape of the umbrella effectively hides the main protagonist from view. Combining the gum and platinum processes, the image is delicately printed in a soft palette of middle tones, which harmonize with its subdued humor. [PA]

178. Heinrich Kühn
German, 1866–1944

Flowers in a Bowl, 1908–10
Autochrome
16 x 22.1 cm (6¼ x 8¾ in.)
Plate 132

Kühn began to experiment with the autochrome process in 1907 after meeting with Stieglitz, Steichen, and Frank Eugene in Tutzing, Bavaria. Obsessed with the process during the next few years Kühn, alone among these photographers, created a significant body of work in color. *Flowers in a Bowl*, in which the textures of petals, glass, and water melt into a glowing pellucid surface, was probably made rather early in Kühn's use of autochrome, when he sought subjects whose immobility allowed for a better control of the process. [PA]

179. Heinrich Kühn
German, 1866–1944

Miss Mary and Edeltrude Lying on the Grass, ca. 1910
Autochrome
16.8 x 23 cm (6⅝ x 9 in.)
Plate 131

In his work in black and white, Kühn had attempted to suggest color by skillfully playing off one another large areas of a single tone. He applied the same approach to

his autochromes, building his images in blocks of a single hue and reveling in their accrued luminosity. Here, Edeltrude, the second of Kühn's children, is seen resting on the grass by her governess, Mary Warner, who had entered the Kühn household in 1904.

Psychological characterization was at the heart of Kühn's approach to portraiture. The delightful closeness of the two figures suggests comfort, ease, and trust, and exemplifies the photographer's skill in selecting the unguarded pose and subtle gesture that would reveal the exact tenor of the affective rapport. [PA]

180. Heinrich Kühn
German, 1866–1944

Miss Mary and Lotte (?) at the Hill Crest, ca. 1910
Autochrome
22.7 x 16.9 cm (9 x 6⅝ in.)
Plate 130

Miss Mary is seen here probably in the company of Lotte. In the airy openness of the Tyrolean landscape, accentuated by the low angle of vision, the bent silhouette of the governess seems to call out in concern to the half-visible little figure who has ventured over the crest of the hill. Vertical cloud formations discreetly echo the figures' connectedness. All simplicity and allusion, the image is among Kühn's most felicitous. [PA]

181. Adolph de Meyer
American, born France, 1868–1946

Tamara Karsavina, 1911–14
Autochrome
8.2 x 11.1 cm (3¼ x 4⅜ in.)
Plate 133

Born in Paris, Baron Adolph de Meyer settled in London in 1896. With his wife, Donna Olga Caraciollo, he joined the elegant set surrounding the Prince of Wales, later Edward VII, Olga's godfather. The pleasures of a fashionable life did not prevent de Meyer from thorough dedication to his photographic work. Aligning himself with leading Pictorialists, particularly the Americans Edward Steichen, George Seeley, and Alvin Langdon Coburn, de Meyer produced exquisite prints characterized by soft focus and inventive lighting. His portraits, still lifes, flower studies, and architectural views were featured in Stieglitz's exhibitions at the Photo-Secession galleries in New York from 1907 to 1912 and published in *Camera*

Work. Known for his portraits of society figures and celebrities, de Meyer revolutionized fashion photography when he joined *Vogue* magazine in New York during World War I, infusing the aesthetic tenets of Pictorialism into a genre that until then had been little more than pedestrian description of clothes. De Meyer left *Vogue* for *Harper's Bazaar* in 1923. He was unable, however, to adjust his style to the harsher realities of the next decade, and by the mid-1930s his career as a photographer had come to an end.

De Meyer enthusiastically embraced the autochrome process at its inception in 1907, writing to Stieglitz the following year that his work in black and white no longer satisfied him. An ardent admirer of Diaghilev's Ballets Russes, de Meyer created this image of Tamara Karsavina (1885–1978), a leading dancer and partner to Nijinsky, during one of the company's visits to England. The photographer chose a background of bellflowers and arranged a brocaded shawl to enhance the exotic elegance of the dancer. The autochrome, which retains in its minuscule prisms the particular luminosity of a misty English day in summer, was thought to represent the Marchioness of Ripon in her garden at Coombe, in Surrey. An early patron of de Meyer, Lady Ripon was also a staunch supporter of Diaghilev, bringing the Ballets Russes to London in 1911. She frequently entertained Karsavina and Nijinsky at Coombe, where they danced for Alexandra, the queen consort, and de Meyer dedicated to her his album documenting Nijinsky's production of *L'Après-midi d'un faune.* A companion image to this autochrome is in the collection of the Victoria and Albert Museum in London. [PA]

182. Emile Joachim Constant Puyo
French, 1857–1933

Puyo, Robert Demachy, and Paul de Singly with Model, 1909
Platinum print
6.9 x 8.1 cm (2¾ x 3¼ in.)
Plate 127

A career officer in the French Army, Commandant Puyo was, with Robert Demachy, a major figure of French Pictorialism. Together, they were among the founders, in 1894, of the Photo Club de Paris and the organizers of its first salon. A skilled technician, Puyo designed new soft-focus lenses for portraits and adjustable ones for landscapes; he perfected the gum bichromate and oil transfer printing processes, writing widely on the subject; and with Demachy, who had revived the gum bichromate print, he published a treatise on photographic printing.

Mostly decorative, with a nod to a modish symbolism, Puyo's work is permeated with a Gallic joie de vivre and a fondness for beautiful women. Women appear in various

guises: figure studies, nudes, portraits of professional models or elegant demimondaines; they are also seen simply, and more successfully, in pastoral landscapes as graceful silhouettes in vaporous, flowing dresses. Women gathering fruit or flowers was a favorite subject of the Pictorialists, who saw in the motif an agreeable enrichment of a feminine ideal. In a rare view of the photographer actually at work, this image of Puyo, Demachy, and their friend Paul de Singly reveals, not without irony, the photographers as hunters converging on their prey. [PA]

stage in front of a complex set of mirrors and whose magic was entirely dependent on lighting. Here, the strange shapes, reminiscent of chalices and butterflies, take form, incongruously, in the middle of an urban park, through the efforts of a short, stout figure. Arrested in crude natural light, they still retain, however, their spellbinding energy. Part of a group of thirteen photographs complemented by six others in the Musée d'Orsay, Paris, these images belonged to the sculptor Théodore Rivière (1857–1912) and were previously thought to have been made by him. They have now been reattributed to Samuel Joshua Beckett, a photographer working in London. [PA]

183a, b, c. Samuel Joshua Beckett
Nationality and dates unknown

Loie Fuller Dancing, ca. 1900
Three gelatin silver prints
10.2 x 13.3 cm (4 x 5¼ in.); 10 x 12.4 cm (4 x 4⅞ in.);
7.9 x 10.2 cm (3⅛ x 4 in.)
Ex coll.: Théodore Rivière
Plates 135a, b, c

The American dancer Loie Fuller (1862–1928) conquered Paris on her opening night at the Folies-Bergère on November 5, 1892. Manipulating with bamboo sticks an immense skirt made of over a hundred yards of translucent, iridescent silk, the dancer evoked organic forms —butterflies, flowers, and flames—in perpetual metamorphosis through a play of colored lights. Loie Fuller's innovative lighting effects, some of which she patented, transformed her dances into enthralling syntheses of movement, color, and music, in which the dancer herself all but vanished. Artists and writers of the 1890s praised her art as an aesthetic breakthrough, and the Symbolist poet Stéphane Mallarmé, who saw her perform in 1893, wrote in his essay on her that her dance was "the theatrical form of poetry par excellence."[30] Immensely popular, she had her own theater at the 1900 Exposition Universelle in Paris, promoted other women dancers including Isadora Duncan, directed experimental movies, and stopped performing only in 1925.

Loie Fuller's whirling, undulating silhouette, which embodied the fluid lines of Art Nouveau, inspired many images, from the portraits of Toulouse-Lautrec and the posters of Jules Chéret and Alphonse Mucha to the sculptures of Pierre Roche and Théodore Rivière, as well as the photographs of Harry C. Ellis and Eugène Druet. The three pictures shown here depict movements from such dances as *Dance of the Lily* and *Dance of Flame*. These images do not pretend to evoke the otherworldly effect of the performance, which took place on a darkened

184. Otto (Otto Wegener)
French, born Sweden, 1849–1922

Countess Greffulhe, 1899
Gelatin silver print
69 x 39.8 cm (27⅛ x 15⅝ in.)
Plate 136

Otto Wegener, known as Otto, went to live in Paris in his late twenties. He opened a photographic studio on the Place de la Madeleine in 1883 and became well known for his elegant portraits of women and children. Celebrated as the supreme beauty of her day, Countess Elisabeth Greffulhe (1860–1952) was the triumph of Parisian society when Marcel Proust made her acquaintance in 1892. Proust pursued her with requests for a photograph, which she staunchly refused. Nonetheless, the countess would inspire Proust's fiction, becoming a prototype for the glamorous Duchesse de Guermantes in *A la recherche du temps perdu* (1913–27). In this puzzling image, the countess is seen embracing her own double. As was Otto's custom, the image is heavily reworked in the negative, emphasizing the contrast between the two figures, the white expanse of lace bodice and billowing skirt shown against the dark taffeta of the dress. Heightening the effect of a ghostly apparition, the countess's eyes, to which Proust ascribed the whole mystery of her beauty, are, unexpectedly, closed or averted; indeed, the image is less a portrait than a dreamlike evocation of a woman's private self.

Portraits in which the sitters appear to be conversing with their doubles were not unusual in the 1890s. They were achieved by making several exposures on the same photographic plate. The idea for this composite portrait, which combines two negatives, probably originated with the countess, who had studied photography with Paul Nadar and who shared with many eminent figures of the

day an abiding interest in spiritualism and the paranormal. The photograph brings to mind images of spectral phenomena obtained at séances.

A keen observer of the effect she produced on others, and not herself unmoved by her own beauty, Countess Greffulhe was not, however, oblivious to the ravages of time, and wrote of the day that the mirror would no longer be kind. Was this photograph intended to be the mirror that would not betray? Perhaps not coincidentally, the photograph hung in the countess's private apartments until her death. It has not been seen publicly until now. [PA]

swell of her breasts. The position of the right arm shows off her elbow, whose firmness and fullness were compared to a particularly prized peach, while the left arm rests on the dress as if detached from her body, a marvelous piece of sculpture. A cool eroticism permeates the image, the countess offering herself for our contemplation—confident, enticing, yet aloof. Fascinated by her persona, a poet and esthete of a later generation, Count Robert de Montesquiou, collected no fewer than 433 photographs of her (now in the collection of the Metropolitan Museum) and wrote a book dedicated to her memory. He titled this photograph, which he once owned, *The Gaze*. [PA]

185. Pierre-Louis Pierson
French, 1822–1913

Countess de Castiglione (*The Gaze*), ca. 1857
Albumen silver print
8.9 x 6.4 cm (3½ x 2½ in.)
Ex coll.: Count Robert de Montesquiou; Romaine Brooks
Plate 147

Unlike Nadar, who found his public among the cultural elite, the firm of Mayer & Pierson catered to personalities famed for their notoriety, to the socially prominent, and to the court. Established in 1855 by combining the interests of Pierre-Louis Pierson with those of Léopold Ernest Mayer and his brother Louis Frédéric, the firm specialized in portraiture and became the most sought-after studio of the Second Empire. In 1862, Mayer and Pierson were appointed photographers to Napoleon III.

Virginia Oldoini, Countess Verasis de Castiglione (1837–1899), created a sensation when she appeared in Paris in 1855, having been sent by the Italian statesman Cavour to win Napoleon III over to the cause of Italian unity by "any means she chose."[31] A statuesque beauty with a flair for drama, the countess was the mistress of Napoleon III and a much-talked-about ornament of the lavish balls so prevalent during the period. After the fall of the Second Empire in 1870, she led an increasingly secluded existence, which gave rise to fantastic speculation as to her affairs.

The countess's raging narcissism found in photography the perfect ally; the firm of Mayer & Pierson produced over seven hundred different images of her. In a reversal of roles, the sitter would direct every aspect of the picture, from the angle of the shot to the lighting, using the photographer as a mere tool in her pursuit of self-absorbed, exhibitionistic fantasies.

This image, in which the countess, seen from above emerging from a gown of black tulle, her hair braided in a diadem, was made during the first years of her collaboration with Pierson. The gown, whose décolletage she has exaggerated, reveals the full line of her shoulders and the

186. Pierre-Louis Pierson
French, 1822–1913

Rose Trémière, from *Série des roses*, ca. 1895
Albumen silver print
14.3 x 9.9 cm (5⅝ x 3⅞ in.)
Plate 148

In the last years of her life, Countess de Castiglione, now a prematurely aged, toothless, and bald recluse, invited her former collaborator Pierre-Louis Pierson, himself over seventy years old, to photograph her in the various attires of her youth. Two identical sets of ten images, each assembled in booklet form, show her in a ball gown, striking different poses as in the tableaux vivants she had composed thirty years earlier. In one of the booklets, she disguised her girth with pinned-down slivers of paper indicating where the negative should be retouched. The countess described her outfit on the cover as a dress of "pompadour pink silk, peignoir of black gauze, real roses, and a curly blond wig." She named the set *Série des roses*, giving each image a title appropriate to its mood. The countess called this portrait *Rose Trémière*, or hollyhock, which in France is associated with the grave. [PA]

187. Napoleon Sarony
American, born Canada, 1821–1896

Oscar Wilde, 1882
Albumen silver print
30.4 x 18.4 cm (12 x 7¼ in.)
Plate 140

Napoleon Sarony, an acknowledged master of celebrity photographs, succeeded Mathew Brady as the best-known portrait photographer in New York. Opening his first

studio on Broadway in 1866 and moving to more elaborate premises on Union Square in 1871, Sarony took full advantage of the growing fascination with the theater that swept America in the aftermath of the Civil War. His inexpensive cartes de visite and more upscale cabinet cards, produced in the thousands, satisfied both the need of actors for publicity and the public's mania for collecting their images.

When this photograph was taken in January 1882, Oscar Wilde had not yet written *The Picture of Dorian Gray* (1891) and the plays that would make him famous in the next decade. Twenty-seven years old, he had to his credit only an unproduced melodrama, *Vera*, and a controversial book of verse. He had, however, created a position for himself in London society as a wit and a dandy, promoting the cause of the English aesthetic movement through his dazzling conversation. Wilde went to America in 1882 at the invitation of the New York producer Richard D'Oyly Carte to give a series of lectures on the English Renaissance to promote the opening of D'Oyly Carte's production of the Gilbert and Sullivan operetta *Patience*, in which aestheticism and Wilde himself were brilliantly satirized. Posing as the ultimate aesthete, or, rather, a caricature of one, Wilde was warmly received and enjoyed tremendous social success. To mock with his appearance the seriousness of the very ideals he was championing was, of course, characteristic of Wilde's fondness for paradox.

Wilde appeared in Sarony's studio dressed in the attire he would wear at his lectures: a jacket and vest of velvet, silk knee breeches and stockings, and slippers adorned with grosgrain bows—the costume he wore as a member of the Apollo Lodge, a Freemason society at Oxford. Sarony took many photographs of Wilde, in a variety of poses. Here, his features not yet bloated by self-indulgence and high living, Wilde leans toward the viewer as though engaging him in dialogue, the appearance and calculated pose of the dandy secondary to the intelligence and spontaneous charm of the conversationalist. [PA]

188b

188a, b. Frederick H. Evans
British, 1853–1943

Aubrey Beardsley, ca. 1894
Platinum print
13.6 x 9.7 cm (5⅜ x 3⅞ in.)
Photogravure
12.3 x 9.5 cm (4⅞ x 3¾ in.)
Plate 141

A major figure in British Pictorialism and a driving force of its influential society The Linked Ring, Frederick Evans is best known for his moving interpretations of medieval cathedrals rendered with unmatched subtlety in platinum prints. Until 1898, Evans owned a bookshop in London where, according to George Bernard Shaw, he was the ideal bookseller, chatting his customers into buying what he thought was right for them. In 1889, Evans befriended the seventeen-year-old Aubrey Beardsley, a clerk in an insurance company who, too poor to make purchases, browsed in the bookshop during lunch hours. Eventually, Evans recommended Beardsley to the publisher John M. Dent as the illustrator for a new edition of Thomas Malory's *Le Morte d'Arthur*. It was to be Beardsley's first commission and the beginning of his meteoric rise to fame.

Evans probably made these two portraits of Beardsley (1872–1898) in 1894, at the time the young artist was achieving notoriety for his scandalous illustrations of Oscar Wilde's *Salomé* and *The Yellow Book*, two publications that captured the irreverent, decadent mood of the European fin de siècle. A lanky, stooped youth who suffered from tuberculosis and would die of the disease at the age of twenty-five, Beardsley, conscious of his awkward physique, cultivated the image of the dandy. Evans is reported to have spent hours studying Beardsley, wondering how best to approach his subject, when the artist, growing tired, finally relaxed into more natural poses. In the platinum print on the left, Evans captured the inward-looking artist lost in the contemplation of his imaginary world, his beaked profile cupped in the long fingers of his sensitive hands. In contrast, in the photogravure on the right, Beardsley peers out from under his smoothly combed fringe as if scrutinizing himself in an unseen mirror. Evans presented the portraits mounted as a diptych in a folder. Produced in an edition of twenty, the sets were probably issued as a commemorative tribute following the artist's death on March 16, 1898. [PA]

189. Adolph de Meyer
American, born France, 1868–1946

Lady Ottoline Morrell, ca. 1912
Platinum print
23.4 x 17.5 cm (9¼ x 6⅞ in.)
Plate 138

Adolph de Meyer's portrait of Lady Ottoline Morrell, eccentric hostess to Bloomsbury, is a stunning summation of the character of this aristocratic lady who aspired to live "on the same plane as poetry and as music."[32] Rebelling against the narrow values of her class, Lady Ottoline Cavendish Bentinck (1873–1938) married Philip Morrell, a lawyer and liberal Member of Parliament, and surrounded herself in London and on their estate at Garsington with a large circle of friends, including Bertrand Russell, W. B. Yeats, D. H. Lawrence, T. S. Eliot, Katherine Mansfield, Lytton Strachey, Virginia Woolf, Aldous Huxley, and E. M. Forster. Tall, wearing fantastic, scented, vaguely Elizabethan clothes, Lady Ottoline made an unforgettable impression. With her dyed red hair, patrician nose, and jutting jaw, she could look, according to Lord David Cecil, at one and the same moment beautiful and grotesque. Henry James saw her as "some gorgeous heraldic creature—a Gryphon perhaps or a Dragon Volant."[33]

De Meyer made several portraits of Lady Ottoline. None went as far as this one in conjuring up the sitter's flamboyant persona, capturing, through dramatic lighting and Pre-Raphaelite design, her untamed, baroque quality. "Her long, pale face, that she carried lifted up, somewhat in the Rossetti fashion, seemed almost drugged, as if a strange mass of thoughts coiled in the darkness within her."[34] D. H. Lawrence's inspired description of the character based on Lady Ottoline in *Women in Love* finds a vivid counterpart in the photographer's art. [PA]

190a, b. Lady Ottoline Morrell
English, 1873–1938

Cavorting by the Pool at Garsington, ca. 1916
Two gelatin silver prints
8.8 x 6.2 cm (3½ x 2⅜ in.); 8.8 x 6.3 cm (3½ x 2½ in.)
Ex coll.: Dorothy Brett
Plates 151a, b

From 1915 to 1928, Lady Ottoline Morrell and her husband, Philip, entertained a brilliant circle of friends on their estate at Garsington, near Oxford. An Elizabethan manor surrounded by magnificent gardens embellished with Italian statuary, peacocks, and a pool, Garsington became during these years an informal meeting place for poets, artists, writers, aristocrats, and politicians. Lady Ottoline was an avid photographer, often seen stalking her

famous subjects with a small Kodak or Rolleiflex. Her favorite quarries seem to have been Virginia Woolf, Aldous Huxley, Bertrand Russell, W. B. Yeats, and Siegfried Sassoon, as well as Lytton Strachey and André Gide.

These two images of an improvised dance by the pool at Garsington belong to an altogether exceptional group of twelve photographs taken about 1916, which show young girls and women cavorting in the garden. They are mostly snapshots of Lady Ottoline's daughter, Julian, at age ten, and her slightly older companions, though Lady Ottoline appears in the nude in one of the shots. These images of a naked dance, pagan in its exuberance, reflect the emancipated attitudes of Lady Ottoline's circle, the artists and writers of Bloomsbury. The uninhibited movements of the young girls exhibit an awareness of their bodies quite at variance with the puritanical prejudices of the time. The flaws of a crude photographic technique only add to the freshness of the images, which seem to pulsate with the raw energy of youth.

Bathing in the nude at Garsington is mentioned in the correspondence of Dorothy Brett, a young rebel who, estranged from her family, spent three years on the estate, and may have taken some of the photographs.[35] A painter and protégée of Lady Ottoline, Dorothy Brett later followed D. H. Lawrence to Taos, New Mexico, where she eventually settled. These photographs were originally part of her collection. [PA]

191. F. Holland Day
American, 1864–1933

Self-Portrait, ca. 1897
Platinum print
24.2 x 18.8 cm (9½ x 7⅜ in.)
Plate 137

F. Holland Day was an avid bibliophile and co-founder, with Herbert Copland, of the Boston publishing firm of Copland and Day, modeled on William Morris's Kelmscott Press. A friend and admirer of Oscar Wilde and a collector of Aubrey Beardsley's work, Day brought out the American edition of Wilde's *Salomé* (1894) and *The Yellow Book*. He began experimenting with photography in 1886 and developed into a proficient portraitist, a daring apologist for the male nude, and a controversial illustrator of Christian themes. In 1896, Day was elected to The Linked Ring, and in 1898 a one-man exhibition at the New York Camera Club clearly established him as a leading American Pictorialist.

In 1896 and 1897, Day produced his famed Nubian Series, photographs of his black chauffeur, Alfred Tanneyhill, posing as a draped Ethiopian chief or in the nude in allegorical compositions. These provoking studies

of the black male nude were brilliant demonstrations of the delicate tonal nuances obtainable in the platinum print, and were generally greatly admired; two of them were reproduced in Stieglitz's *Camera Notes*.

Day probably created this self-portrait at the time of the Nubian Series, in 1896–97. The photographer appears in this image very much the refined aesthete, clad in the Turkish robe he affected in the studio, wearing a cravat and a pince-nez and holding a cigarette. Behind him, the barely visible figure of a nude black man echoes with a pensive pose the elegant gesture of the photographer. A soft focus enhances the dreamlike effect: muse, alter ego, or erotic phantasm, the shadowy presence seems a creation of the photographer's mind. Private, nearly confessional, the image was entrusted to the care of the artist's good friend Clarence White, and has remained unknown until now. [PA]

192. Rudolf Balogh
Hungarian, 1879–1944

Nijinsky in *Le Spectre de la rose*, 1912
Gelatin silver print
23.1 x 17.4 cm (9⅛ x 6⅞ in.)
Plate 149

Rudolph Balogh is best known for the romanticized studies he made in the 1920s and 1930s of the landscape and peasant life of Hungary. He probably photographed Nijinsky, the lead dancer of Sergey Diaghilev's Ballets Russes, during the company's March 1912 season in Budapest.

Vaslav Nijinsky (1889–1950), the mesmerizing dancer who brought a hitherto unknown glamour to male roles and created the first modernist ballets, was also particularly admired for his total immersion in the characters he portrayed. In *Le Spectre de la rose*, a short ballet choreographed by Michel Fokine for Nijinsky and Tamara Karsavina (see no. 181) and set to Carl Maria von Weber's *Invitation to the Dance*, Nijinsky's performance had such an aura of otherworldliness that it transformed a conventional pas de deux into a transcendent experience. As the spirit of a rose appearing in the dream of a young girl half-asleep after a ball, Nijinsky wore a leotard covered with petals of pink, red, and purple silk designed by Léon Bakst. To help convey the unhuman sweetness of a floral being, he created makeup that blurred his features, his eyebrows vaguely suggesting an insect, his mouth, rose petals. This identification with an ethereal spirit reached its climax in the famous final leap, when Nijinsky, defying gravity, flew through an open window and disappeared from view. A revealing, nearly indiscreet close-up, Balogh's photograph allows us to watch the artist in his metamorphosis from an

athletic young man into a sexless, leafy being, ephemeral and self-contained. The Spectre de la Rose, created in 1911, was to be Nijinsky's most popular role. [PA]

193. Alphonse Mucha
Czech, 1860–1939

Study for a Decorative Panel, 1908
Gelatin silver print
12.4 x 9.9 cm (4⅞ x 3⅞ in.)
Plate 150

The graphic art of the Czech artist Alphonse Mucha was the embodiment of the curvilinear aesthetic of Parisian Art Nouveau. Enshrining woman, his posters, calendars, theater programs, and decorative panels feature sensuous yet ethereal maidens caught in decorative swirls of unloosed tresses, flowing gowns, and floral arabesques. An amateur photographer early in his career, Mucha used photographs of carefully posed models to supplement preliminary sketches for larger works.

This photograph is a study for *Tragedy*, a decorative panel Mucha created in 1908 for the short-lived German Theater in New York; it was to be his last major undertaking in the Art Nouveau style before he redirected his efforts to history painting. Intended as a compositional study of two models, the image in close-up is invested with a powerful erotic charge, making it a psychological study of a couple. Like her sisters in Mucha's posters, the woman in the photograph remains detached and free, while the young man, her lover, appears in enthralled surrender. The position of the woman's hand, so characteristic of Mucha, expresses a sphinxlike knowingness. Construed as a vision of a new, inconstant Eve rising from the flank of a prostrated Adam, or as an illustration of the male-female component within the psyche, the image poses a tantalizing riddle. [PA]

194. Grand Duchess Xenia Alexandrovna of Russia and Others
Russian, 1875–1960

Outings at Gatchina, 1905
Twenty-three gelatin silver prints of various sizes on two album leaves, each 33.1 x 40.2 cm (13 x 15⅞ in.)
Plate 139

The invention of the hand-held Kodak in 1888 not only popularized the making of photographs but also generated a new type of image, artless and improvised. Capturing

the spontaneous and the ephemeral, these images offer a sometimes irreverent glimpse into the intimacies of private lives. Grand Duchess Xenia Alexandrovna, the sister of Emperor Nicholas II, took up photography after the example of her mother, the empress dowager, and her aunt, Queen Alexandra of England, both distinguished amateurs. An avid photographer in her youth, the grand duchess brought her camera to family picnics and excursions, as well as to formal gatherings and military reviews. In this album, she compiled no fewer than 1,120 images to document a single year in the life of her family, from June 13, 1904, to June 6, 1905.

For the imperial family, whose status forbade any display of familiarity outside its own circle and whose public appearances were governed by a stringent etiquette, moments away from the public eye held a particular savor. The album celebrates these moments of freedom from the constraints of duty, lovingly detailing picnics, tea parties, strolls in the woods, automobile excursions, or just scenes of carefree fun. Some images refer obliquely to the momentous events then affecting the country, such as the disastrous Russo-Japanese War of 1904–5. The photograph of the emperor blessing the troops as they leave for the front in the presence of the dowager empress becomes in this context an intimate shot of a brother and mother. Scenes of battleship launchings and hospital visits are included, but the album is, as a whole, the chronicle of a large, closely knit family. Only the compulsive gathering of so many lighthearted memories at a time of such portentous events as Bloody Sunday, January 9, 1905, when a civilian protest was tragically crushed by the Army, perhaps betrays a subliminal awareness of the ominous new climate affecting the country.

The pages devoted to the outings of May 28 and May 29 at Gatchina, the empress dowager's estate near St. Petersburg, juxtapose the horse-drawn jaunting car and the automobile, which in 1905 was still an exciting novelty. On May 29, on what was truly a photographic safari, the

party brought along no fewer than four cameras. The panoramic image in which the grand duchess is seen on the left with her husband, Grand Duke Alexander Mikhailovich, and their daughter Irina, later Princess Yusupov (see no. 239), is an elegant and dignified commemoration of the outing; the snapshots of the grand duchess and her husband frolicking on the grass or the image of the road where two little dogs are caught in mischief have the freshness of the unexpected.

Grand Duchess Xenia was not the sole author of these photographs. But it was her eye that determined the design of the pages, arranged the delightful sequence of the images, and gave the album the extemporaneous charm of a personal diary. [PA]

[Plate 139 represents a rearrangement of the photographs on the two album pages. The reproductions on this page show the actual layout of the photographs in the album.]

195. Paul and Prosper Henry
French, 1848–1905; 1849–1903

A Section of the Constellation Cygnus (August 13, 1885)
Albumen silver print from glass negative
25.8 x 21.2 cm (10⅛ x 8⅜ in.)
Plate 154

Astronomers at the Paris Observatory, the brothers Paul and Prosper Henry inherited in 1872 a project begun twenty years earlier—the mapping of the heavens by means of painstaking observation, calculation, and notation. In a dozen years they charted nearly fifty thousand stars. When, in 1884, their survey approached the Milky Way, the Henry brothers found that the cluster of stars proved far too dense and complex to chart by eye, and they

constructed a photographic telescope to produce an exact, objective record of the sky.

That photography might serve astronomy was evident from the very beginning. Daguerre's standard-bearer François Arago, director of the Paris Observatory, declared in July 1839 that the daguerreotype would eventually accomplish with ease the most delicate and difficult astronomical tasks, such as mapping the surface of the moon. Indeed, before the Henry brothers' first use of the medium, other photographers had successfully charted lunar geology, solar and lunar eclipses, the transit of Venus, sunspots, the surface of Mars, the rings of Saturn, and the relative position of the brightest stars.

No one, however, had yet recorded stars so distant and faint that they were not visible to the eye. This the Henry brothers achieved in 1885 by constructing a still more powerful photographic telescope, with an extraordinarily precise mechanism for tracking the stars across the night sky during exposures as long as one hour. The resulting photographs, each seemingly infinite expanse showing but a three-degree section of the firmament, remain among the most sublime conceptions of scientific photography. [MD]

196. Jacques-Henri Lartigue
French, 1894–1986

The Grand Prix of the A.C.F., 1912
Gelatin silver print
11.5 x 17.1 cm (4½ x 6¾ in.)
Plate 156

A painter who considered photography a hobby, Jacques-Henri Lartigue grew up in the privileged environment of an attentive well-to-do family and was seven years old when his father, himself an accomplished amateur photographer, presented him with his first camera. From the start, the process of making pictures held for Lartigue an essential element of play. In it the boy saw a magical way of storing and intensifying the most pleasurable of his visual experiences, fashioning the snapshot into a perfect tool to capture the fun and excitement of his daily life: the reckless jumps and bicycle falls of his cousin Bichonnade, or the hairpin turns of racing bobsleds, and the mishaps of huge gliders built by his inventive older brother, the daredevil Zissou. Later, as a timid adolescent, he went on to capture, with the same humor, the brisk walk and knowing smiles of the elegant ladies parading in fantastic hats on the avenues of the Bois or at the racetrack. And all along, as he grew up, he would be fascinated by the fast progress and changing shapes of the automobile, and by the soaring flight of the airplane.

Preserving his images from childhood on in album after album, Lartigue created an inordinately rich chronicle, but one that, like his diaries, remained essentially private.

Until 1963, when a show at the Museum of Modern Art in New York revealed Lartigue as a major photographer, his work was known only to a group of friends. Now, however, the images of Lartigue's childhood are widely known; indissolubly associated with the Belle Epoque, that confident, prosperous, carefree childhood of the century, they have become emblematic of its optimistic energy and vanished grace.

Lartigue loved everything about cars—their intriguing look, the accoutrements of the driver, the eventual flat tire. The 1912 Grand Prix of the Automobile Club de France is among the photographer's most memorable images; this print is a rarity, having been made by Lartigue prior to his public recognition, in his customary intimate scale.

The Grand Prix was run in 1912 on the circuit of Dieppe, and while No. 6, a Delage, was a favorite, it was actually the Peugeot, with the ace driver Georges Boillot at the wheel, that won, at speeds reaching over one hundred miles an hour. Swinging his camera parallel to the road in a movement that followed the car, Lartigue barely managed to catch the speeding machine in his frame. Sweeping trees and spectators in its wake, the car rushes onward with the single-minded urgency of the new age. [PA]

197. Anonymous

Alfred Stieglitz Photographing on a Bridge, ca. 1905
Gelatin silver print
10.4 x 8 cm (4⅛ x 3⅛ in.)
Ex coll.: Edward Steichen
Plate 155

From 1902, when he founded the Photo-Secession, through 1904, Alfred Stieglitz was largely occupied with the publi-

Edward Steichen
Photo-Secession poster, 1905
Woodcut in two colors, with gold foil
18.3 x 6.7 cm (7¼ x 2⅝ in.)
The Metropolitan Museum of Art,
New York (57.627.36)

cation of the group's quarterly, *Camera Work*, with contacting pictorial photographers abroad, and with organizing a score of exhibitions in Pittsburgh, Washington, D.C., and across Europe. In 1905, Edward Steichen persuaded Stieglitz that the Secessionists must show in New York as well. Arranging for Stieglitz to rent three small rooms next to his at 291 Fifth Avenue, Steichen refurbished them as the Little Galleries of the Photo-Secession. They would become the laboratory where Stieglitz urged Pictorialist photographers toward modernism under the catalyst of recent European art, introduced to America for the first time in these very rooms.

In connection with the inauguration of the galleries in the fall of 1905, Steichen created a poster showing a photographer silhouetted against a green field beneath a golden orb. His quintessential fin-de-siècle design suggests that the frock-coated photographer stalking by moonlight has a vaguely mystical quest. Surprisingly, Steichen's source was neither pastoral nor crepuscular—it was a snapshot of Stieglitz with a Graflex on a bridge (also in the Gilman collection), a photograph taken just moments before or after this one. The disjunction between the romantic connotations of the poster and the urban, industrial setting of the snapshot reflects the dichotomy between Steichen's late-nineteenth- and Steiglitz's early-twentieth-century styles.

Like the poster, the photograph is also utopian, but in a more modern idiom. Amid passing pedestrians, the wind-buffeted machine-age hero has perched temporarily on a steel girder in an effort to close the gap between art, everyman, and modern life. By deftly capturing a highly symbolic stance, position, and activity, the unidentified author of this picture managed to suggest Stieglitz's progressive ideals, his crusade for modern art, and his growing perception of photography as a spontaneous, instinctive apprehension of life—an art of pure seeing no longer in need of Pictorialist camouflage. [MMH]

198. Minor B. Wade
American, 1874–1932

Lynching, Russellville, Kentucky, 1908
Gelatin silver print
11.8 x 9.1 cm (4⅝ x 3⅝ in.)
Plate 159

From the first year of Reconstruction to the early 1940s, lynching was the primary means of maintaining white supremacy in the American South. Considered by the federal government a normal condition of post–Civil War race relations, lynching was used not only as a specific act of summary "justice" but also as a symbol to further intimidate and degrade blacks. The magnitude of recorded mob violence between 1880 and 1940 almost defies description,

involving more than five thousand men, women, and children in ritualized murder, often before an invited public. Two-thirds of the victims were African-American men.

Kentucky was the site of some of the most vicious racial violence, perhaps because of its unique position as a slave-holding state that had remained loyal to the Union. The state was never "reconstructed," and thus former Confederates were easily able to preserve the racist society that had characterized the antebellum period, with little or no interference by the government.

This photograph is brutal testament to racial terrorism in America. The facts of the case are drawn from a small article that appeared in the *New York Times* on August 2, 1908, the same day the photograph was made by a local journalist. On the previous night, one hundred white men had entered the Russellville, Kentucky, jail and demanded that four black sharecroppers who had been detained for "disturbing the peace" be turned over to them. The men were accused by the mob of expressing sympathy for a fellow sharecropper who, in self-defense, had killed the white farmer for whom he worked. The jailer complied, and Virgil, Robert, and Thomas Jones and Joseph Riley were taken to a cedar tree and summarily lynched. The text of the note pinned to one of the bodies was also inscribed on the verso of the photograph: "Let this be a warning to you niggers to let white people alone or you will go the same way." [JLR]

199. William Mayfield
American, 1896–1974

Orville Wright, 1913 or later
Gelatin silver print
19.6 x 24.1 cm (7¾ x 9½ in.)
Plate 157

Wilbur and Orville Wright (1867–1912; 1871–1948) were keenly aware of the importance of documenting their work photographically; they themselves took pictures of their early experiments with gliders, their first successful flight at Kitty Hawk, North Carolina, on December 17, 1903, and subsequent events in the evolution of flying machines. It was inevitable, too, that from the moment of their earliest public demonstration flights in 1908, thousands of spectators would take amateur photographs as proof of the amazing performances they had witnessed.

One can well imagine the excitement with which thirteen-year-old William Mayfield, outfitted with his first camera, witnessed the triumphal homecoming of the Wright brothers as they returned to Dayton, Ohio, in 1909, after touring their Flyer throughout Europe. Only a year later Mayfield would ride alongside Orville Wright and make the first photograph from an airplane, looking down on Huffman Prairie, where the brothers had first flown a practicable

airplane in 1905. In the years that followed, Mayfield would photograph many events in the early history of aeronautics as a staff photographer for the *Dayton Daily News*.

This photograph shows Orville at the controls of a Wright Model E, a lightweight single-seat aircraft with one propeller behind the wings, first built in 1913 and used especially for exhibition purposes. Mayfield's view of the plane and pilot against a white sky, with no horizon line to provide a sense of orientation, conveys the aircraft's liberation from the laws of gravity in strikingly modern visual terms. [MD]

200. Lewis Hine
American, 1874–1940

A Sleeping Newsboy, 1912
Gelatin silver print
11.5 x 16.8 cm (4½ x 6⅝ in.)
Plate 161

The extensive career of Lewis Hine falls into three interrelated bodies of photographs: immigrants at Ellis Island, studies of child labor, and industrial workers. The last series came to be known as Men at Work, a documentation of the positive side of work which focuses on the construction of the Empire State Building and the men who built it. While his predecessor, the social reformist newspaper reporter Jacob Riis (1849–1914), had no interest in artistic photography, Hine taught camera courses, took his students to Alfred Stieglitz's gallery, and argued that good aesthetics would make persuasive propaganda. A trained sociologist, Hine was a student of the history of photography and used the camera as a vehicle to communicate his intended message.

In 1908, Hine accepted a position as chief investigator and photographer for the National Child Labor Committee (NCLC), a private organization founded in 1904 whose mission was to promote legislation to protect children from exploitation by American industry. At the time, children as young as four years old labored in a variety of trades eight to twelve hours a day in factories, tenements, and on the streets. For sixteen years Hine worked for the NCLC, often traveling incognito as an insurance inspector, to gain access to the work environment. He photographed throughout the country in mines, farms, canneries, tenement sweatshops, and on the street, ultimately producing more than five thousand negatives of child labor. Small contact prints with rudimentary captions were distributed in large numbers to the press, made into glass slides for projection, and reproduced in books and NCLC bulletins, reports, and pamphlets.

Newspaper sellers, or newsies, fit into the category of street trades, a subject that engendered some of Hine's most lyrical photographs. Although Hine usually recorded the child's age, name, and work habits, he did not disturb this young boy, clearly exhausted from a long day's work. Instead, he captioned the photograph, made in New York City: "A sleeping newsboy found after midnight in the vestibule of a railroad station—newspapers for a pillow." But in fact the picture needs no caption, for the meaning of the scene is clearly stated, the child's hidden face and flattened body a metaphor for all that Hine and the NCLC tried to abolish. Asleep on his unsold goods, the boy is old news, left at the station and forgotten after the departure of the last train. [JLR]

201. Eugène Atget
French, 1857–1927

Organ-grinder, 1898–99
Albumen silver print from glass negative, 1920s
22.4 x 17.6 cm (8⅞ x 6⅞ in)
Ex coll.: Maurice Utrillo
Plate 162

Although he trained as an actor at the National Conservatory in Paris, Eugène Atget's love of the theater served him best when he abandoned the stage and took up the camera. In the late 1880s he began photographing whatever artists needed as models for their work, and by 1898 he had established his practice in Paris. While his principal clientele would change, Atget continued to frequent artists' ateliers and cafés until the end of his life, selling documents, as he modestly called his pictures, to those most able to see their intrinsic worth.

This photograph was purchased from Atget in the 1920s by Maurice Utrillo, the painter of the streets of Montmartre. Although the image was recently printed, the negative had been made decades earlier, as part of a series of photographs devoted to the rapidly vanishing street trades, or *petits métiers*, of Paris. Posed in the street with the attributes of their trades, the knife-sharpener, breadboy, and fishwife were portrayed as stock characters acting generic roles. This image, the masterpiece in the series, broke all the rules. Street musicians cut close to Atget's bone; these are not types but vividly portrayed individuals, and their engaging performance is to the pose as the hurdy-gurdy's music is to silence. [MMH]

202. E. J. Bellocq
American, 1873–1949

Nude with a Mask, ca. 1912
Gelatin silver print from glass negative
12.7 x 17.9 cm (5 x 7 in.)
Plate 153

E. J. Bellocq was a commercial photographer of French Creole extraction who worked in New Orleans in the first decades of the century. In 1958 eighty-nine glass negatives of prostitutes in Storyville, the city's red-light district, were discovered in a chest. The negatives were eventually acquired and printed by the photographer Lee Friedlander, and comprise Bellocq's only known work other than a series of photographs for a World War I shipbuilding company. No prints from Bellocq's lifetime were found with the plates. In 1980 this photograph and two other vintage prints were discovered in New Orleans with the effects of Louis Danzig, a former cameraman for Pathé and Movietone News. Although it has not been documented, it is believed that Danzig knew Bellocq and received the prints directly from the photographer.

Jazz may not have been born in Storyville, but it was incubated in its extravagant palaces and saloons. Between 1897 and 1917 Basin Street, the district's main drag, flourished, as did the country's only truly indigenous music. A woman who worked in a brothel was a jazz belle, her customer a jazz beau. The finer establishments were decorated with Oriental carpets, gilded mirrors, and crystal chandeliers, and guests were entertained with nightly music by the likes of Buddy Bolden, Ferdinand "Jelly Roll" Morton, and King Oliver. By day, however, Storyville was quiet—a fact not lost on Bellocq, who worked with available light in the district's off-hours.

Bellocq's portraits show the women in various poses and degrees of undress, comfortable with their nudity and at ease in front of the camera; a few appear fully clothed, showing off their finest lace dresses and favorite pets. None of the photographs depict sexual acts or even suggest the presence of a man other than the photographer, whose pictures convey respect rather than voyeurism. This portrait is one of the most sexually frank of the series. The model's face and legs are masked, her pubic area exposed. She smiles, inviting the viewer for a ride on the raft of her chaise longue. [JLR]

203. Stanislaw Ignacy Witkiewicz
Polish, 1885–1939

Self-Portrait, 1912
Gelatin silver print
17.3 x 12.3 cm (6¾ x 4⅞ in.)
Plate 160

Raised in an environment of intellectual and aesthetic stimulation, Stanislaw Ignacy Witkiewicz exhibited artistic, literary, and musical interests at a very young age. Much of his education took place at home, for his tyrannical father believed that formal schooling produced mediocrity and conformity, certainly not the end he envisioned for his only son, who was expected to follow in his footsteps as

an exceptional artist and writer. Both because of and in spite of the high expectations set for him, Witkacy (the name the young artist adopted to distinguish himself from his father) went on to make prolific expressionistic contributions to philosophy, drama, literature, painting, and photography. He is equally well remembered for his bohemian lifestyle and eccentric personality, so much so that he has become something of a legendary figure in Polish cultural history.

In the early 1920s, Witkacy renounced painting. Portraiture, however, continued to hold a special fascination for him. At the S.I. Witkiewicz Portrait Firm, the one-man enterprise that he established in 1924, he made sketches of clients, often projecting onto them his own drug-induced fantasies. Witkacy did not exclude himself from his own scrutiny; he made hundreds of self-portraits—sketches, paintings, and photographs—throughout his life. The image seen here is typical of the penetrating photographic portraits he made from 1912 to 1914. Taken with a view camera with its lens extended by a rain pipe, the portrait is cropped to the features and focuses on the eyes. If the eyes are the windows to the soul, the soul we glimpse here is a vulnerable and troubled one. Witkacy's life was seared by existential anguish, particularly in the years preceding World War I, as were the lives of so many of his contemporaries. His fiancée killed herself in 1914, and he himself committed suicide on the eve of World War II.

[VH]

204. Eugène Atget
French, 1857–1927

Versailles, The Orangerie Staircase, 1901
Albumen silver print from glass negative
16.9 x 21.7 cm (6⅝ x 8½ in.)
Plate 165

Of the thousands of sites Atget photographed in Paris and its environs, Versailles was his chief obsession. He worked there from 1901 until his death, not only because the royal palace was historically preeminent, but because he discovered many truths in the vast gardens. He came to see that they embodied the essence of French civilization—the characteristic combination of elegance, order, and baroque excess which repeats as art the dichotomies of nature. He also learned that the photographer's main problem, like that of the landscape architect, is to establish a point of view which directs the movement of the imagination.

This photograph, taken during Atget's first summer at Versailles, demonstrates his precocious aptitude. The expansive avenue and stately flight of steps proceed grandly and with increasing expectancy up to nothing but the dimensions of a myth. [MMH]

205. Eugène Atget
French, 1857–1927

Café, Avenue de la Grande-Armée, 1924–25
Silver print from glass negative
17.8 x 22.7 cm (7 x 9 in.)
Plate 169

Atget's interest in the texture of old Paris—in the animate, intimate air of places much lived in—ran counter to the prevailing popular taste for the Eiffel Tower, the Opéra, and other famous monuments and promenades. Characteristically, he never photographed the Champs-Elysées, though he did make one exposure on the avenue that extends it beyond the Arc de Triomphe, the Avenue de la Grande-Armée. Here, selecting an empty café bathed in early morning light and poised in readiness for the day's clientele, he managed to suggest the habits of the habitués, in absentia. [MMH]

206. Eugène Atget
French, 1857–1927

Rue Asselin, 1924–25
Silver print from glass negative
22.9 x 17.6 cm (9 x 6⅞ in.)
Plate 166

In 1921, Atget was asked by the illustrator André Dignimont to photograph brothels for a book he planned to publish (but never did) called *La Femme criminelle*. Initially, Atget photographed the facades of the houses with the prostitutes standing or seated before them. After additional prodding by Dignimont, he also made several pictures of the undressed women inside. It would be hard to imagine that the voluptuous forms in those images could be the women in the calico frocks shown here were it not for their attitude of frank, slightly bemused complicity. Atget enhanced the sense of companionable relationship between them by repeating the compressed triad of their stance in the compositional structure of his picture.
 [MMH]

207. Anton Giulio Bragaglia
Italian, 1890–1960

Change of Position, 1911
Gelatin silver print
12.8 x 17.9 cm (5 x 7 in.)
Plate 186

The Italian Futurist movement was heralded in 1909 with the publication of the poet F. T. Marinetti's *Foundation and Manifesto of Futurism*, which espoused a love of danger, the beauty of speed, the glory of war, and the destruction of museums and libraries. A year later painters who had gathered around Marinetti had worked out the implications of these tenets in a manifesto of their own. The works they began to create shortly thereafter ignored conventional subject matter and modes of representation and drew inspiration instead from the dynamic vitality of the industrial city. This ideology pervaded all areas of modern art and life, and manifestoes were written setting forth the principles of dynamism that were to govern not only painting and sculpture but also cinema, music, men's clothing—even the reconstruction of the universe.

The Rome-based theater director, set designer, and cinematographer Anton Giulio Bragaglia was one of those influenced by Marinetti's theories. In his essay "Futurist Photodynamism," written in 1911 and published two years later, Bragaglia extended the concept of dynamism to photography. Like the painters who attempted to reproduce the sensation of dynamism rather than to create a fixed moment, Bragaglia sought to replace the objective reality of a subject captured in an instantaneous snapshot with a projection of the subject's interior essence, which he identified as pure movement. In this photodynamic study of a man changing from a seated position with his hands clasped on crossed legs to one where he is leaning forward with his fists at his temples, it is neither the beginning of his action nor its conclusion—nor any stage in between—that is significant, but rather the trajectory created by the sweeping arc of continuous, fluid motion, resulting in the dissolution, or dematerialization, of the subject. Bragaglia described the trajectory of motion as "that which exerts a fascination over our senses, the vertiginous lyrical expression of life, the lively invoker of the magnificent dynamic feeling with which the universe incessantly vibrates."[36] [VH]

208. Anonymous

X Ray, 1916
Gelatin silver print
40 x 29.8 cm (15¾ x 11¾ in.)
Plate 176

In 1895 the German physicist Wilhelm Konrad Röntgen (1845–1923) discovered an invisible form of radiant energy which he called X rays. While these rays could pass through certain materials, such as flesh, they were partially stopped by denser matter, such as bone. Standard photographic film was responsive to the invisible radiation, and X rays were put to immediate use by the international scientific and medical communities. In 1901, Röntgen was awarded the first Nobel Prize in physics.

This photograph, inscribed *Dargent Gosselin* and dated November 14, 1916, is a print from a large X-ray negative of a severely fractured femur. It shows the soft tissue of the patient's buttocks, the faint shadow of an undergarment, the bone broken in three sharp pieces, and the wire mesh sling used to immobilize the injured area. Although the patient's sex cannot be determined, the date suggests a soldier wounded in World War I.

The frequent reproduction of X-ray pictures in both newspapers and scientific journals soon caught the attention of avant-garde artists and theorists fascinated by any new variety of image-making. Rendering visible what was invisible, the X ray stretched photography beyond its most obvious limit to the delight of László Moholy-Nagy, who would include four X rays in his Bauhaus publication *Painting, Photography, Film* (1925). He related the cameraless shadow-pictures to both photograms and photographs of lightning and captioned an X-ray picture of a frog: "Penetration of the body with light is one of the greatest visual experiences."[37] [JLR]

209. Paul Strand
American, 1890–1976

Pears and Bowls, 1916
Platinum print
25.7 x 28.8 cm (10⅛ x 11⅜ in.)
Plate 180

The two most significant early influences on Paul Strand were Lewis Hine and Alfred Stieglitz. In his course at the Ethical Culture School in New York, which Strand attended, Hine encouraged photographic documentation in the service of social reform. And Alfred Stieglitz, Strand's mentor for many years, viewed photography as a means to aesthetic reform. Strand channeled the sense of moral commitment to the photographic medium shared by both these men into his own photographs of everyday life, in which he attempted to combine social consciousness with aesthetic concerns by placing the city dweller within the context of the formal geometry of urban architecture. In 1916 and 1917, Stieglitz devoted the last two issues of *Camera Work* to Strand's photographs, proclaiming them the most original then being made in America. Critics praised the images for their directness, honesty, and objectivity and for the elimination of technical manipulation and handwork—all characteristics that have come to define the term "straight photography."

Strand began in 1916 to explore the structural principles of pictorial abstraction that he had absorbed from the Cubist works exhibited at 291 and other New York galleries. Summering at Twin Lakes, Connecticut, he incorporated porch furniture and kitchenware—materials readily at

hand in a summer house—into his still-life compositions. These were the first photographs intentionally constructed as abstractions. The tightly framed, close-up investigation of domestic objects seen here is divested of the symbolic and allegorical underpinnings traditionally associated with still life, asserting instead the geometry of black-and-white tones juxtaposed as planar surfaces. [VH]

210. Charles Sheeler
American, 1883–1965

Dan Mask, ca. 1919
Gelatin silver print
24.2 x 18.2 cm (9½ x 7⅛ in.)

When Charles Sheeler took up the camera sometime in 1910–11, he was already a modestly accomplished painter. He began to photograph domestic architecture in the Philadelphia area, and within three years he had a successful sideline documenting fine private and public American collections of Chinese bronzes, Meso-American pots, and modern painting and sculpture by Cézanne, Picasso, and Duchamp. Through this work Sheeler met Walter Arensberg, Alfred Stieglitz, and other important collectors and dealers; to a few of them he sold his paintings.

The rigorous demands of detailed record photography soon influenced his painting as the direct, generally frontal assessment of both an object's form and structure retrained and refined his eye. By 1916, Sheeler had begun to paint from photographs and also to pursue photography as an end in itself. With his first exhibition of photographs, a three-person show with Paul Strand and

Morton Schamberg at Marius de Zayas's Modern Gallery in 1917, Sheeler emerged as one of America's few prominent artists equally skilled with brush and camera.

This photograph of a Dan mask from Ivory Coast may have been commissioned by John Quinn, a New York lawyer, collector of African art, and patron of the avant-garde. The ceremonial mask emerges from virtual obscurity, filled with mystery, its highly polished wood surface animated by a raking, angular light. The photograph functions as a fetish, speaking with its own voice, commanding our attention, and even, it would seem, judging our response.

This photograph was published in the March 1923 issue of *The Arts*, in an article by de Zayas entitled "Negro Art."

[JLR]

211. Alfred Stieglitz
American, 1864–1946

Marsden Hartley, 1915–16
Gelatin silver print
24.8 x 19.8 cm (9¾ x 7¾ in.)

Alfred Stieglitz tirelessly promoted emerging modern American painters at his gallery, 291, most notably Marsden Hartley, John Marin, Max Weber, Arthur Dove, and Georgia O'Keeffe. These artists gained first-hand exposure to avant-garde European painting, drawing, and sculpture either through study abroad or through Stieglitz's active exhibition program, which included art other than photography from 1907 on.

Stieglitz gave Hartley (1877–1943) his first one-man exhibition in May 1909, and in 1912 he helped finance Hartley's first trip to Paris, where the painter experimented with the compositional structure of Cézanne and the Cubists and the palette of Matisse and the Fauves. Withdrawn and melancholic by nature, Hartley felt ill at ease in Paris and soon moved to Germany, where he found the mysticism of Kandinsky and other Blue Rider painters and the pageantry of the orderly imperial society more to his liking. In Germany, Hartley also began to come to terms with his homosexuality; feeling alienated from the moral strictures of his own country and the fickleness of the New York art world, he chose to live as an expatriate in Berlin.

In this portrait of Hartley, made during a return trip to the United States in December 1915, Stieglitz succeeded in capturing both the inner torment and the vitality of his subject. The glowing eyes suggest the mystical intensity of Hartley's spirit; the heavy, abstract symmetry of the composition conveys something of the painter's own bold, heraldic style at this time; and the tight framing and closely wrapped coat, scarf, and hat underscore his extreme self-consciousness.

[VH]

212. Alfred Stieglitz
American, 1864–1946

Georgia O'Keeffe, 1918
Palladium print
24.4 x 19.6 cm (9⅝ x 7¾ in.)
Plate 185

Stieglitz began exhibiting the work of Georgia O'Keeffe (1887–1986) in 1916. Following her first one-woman show in 1917, Stieglitz closed the gallery and began to collaborate with O'Keeffe on an extended photographic portrait of her. In February 1921, Stieglitz mounted a retrospective exhibit of his work at the Anderson Galleries, which reassessed his entire photographic production and marked his return as an active artist. His decision to include forty-five intimate studies of O'Keeffe was motivated both by his passion for the subject (whom he would marry in 1924) and his conviction that these images were among his greatest accomplishments. The exhibition created a stir in the New York art world, eliciting a critical response that underscored Stieglitz's initial assessment of O'Keeffe's work in terms of female eroticism. Although O'Keeffe objected strongly to the sexual reading of her work, Stieglitz's photographs and O'Keeffe's paintings continue to be confused in the public's mind.

This photograph, one of over three hundred images Stieglitz made of O'Keeffe between 1917 and 1937, is part of an extraordinary composite portrait. Portraiture, Stieglitz

believed, concerns more than the face; it should be a record of a person's life experience—a mosaic of expressive movements, emotions, and gestures that would function collectively to evoke a life. "To demand *the* portrait that will be a complete portrait of any person," he claimed, "is as futile as to demand that a motion picture be condensed into a single still."[38] This study of O'Keeffe's hands suggests mating or fighting birds, or perhaps another agitated, primal dance. [VH/MMH]

213. Alfred Stieglitz
American, 1864–1946

Georgia O'Keeffe, 1919
Palladium print
23.5 x 19.3 cm (9¼ x 7⅝ in.)
Plate 172

To take this picture, Stieglitz had O'Keeffe stand on a radiator before a window draped with patterned white cloth. Although the logistics may have made the model uncomfortable, they afforded the photographer a superb filtered light and an elevated point of view.

The result is one of the finest female nudes in the classical mode in photography. Worthy of Phidias, the subtly modeled torso is cut, like many Greek statues that have come down to us, above the knees and at the shoulders. Firmly supported on muscular legs, the body, though stationary, seems to stride forward in the direction of the outstretched arm—swelling thigh, crested hip, and breast in the forefront, powered by the incurved tensile contour of the back side.

The grace and assertive confidence of O'Keeffe's pose denote a modern woman, while the authority of the male gaze recalls the long lineage of the female nude since the birth of art. Had Stieglitz and O'Keeffe left us nothing of their talents but this sublime image, alone—like the anonymous masterpieces of the ancients—it would claim a privileged place in the history of Western art. [MMH]

214. Man Ray
American, 1890–1976

Woman, 1918
Gelatin silver print
43.7 x 33.5 cm (17¼ x 13¼ in.)
Ex coll.: Tristan Tzara
Plate 182

Man Ray began his career as a painter. He took up photography in 1915 when, finding no one who could make photographic reproductions of his paintings to his satisfaction, he decided to make his own. Soon he was making photographs of objects not unlike Marcel Duchamp's "readymades," ordinary objects elevated to the status of art because so designated by the artist, and "assisted readymades," objects that the artist "assisted," or altered, by combining them with others.

Parodying the sequence of the creation of Adam and Eve, Man Ray made *Woman* after he made *Man*. *Man* is a photograph of a rotary eggbeater, its handle and beaters forming a visual metaphor of the male genitals. For *Woman*, Man Ray assembled equipment from his darkroom —two spherical metal reflectors and six clothespins attached to a plate of glass—in such a way as to suggest the breasts, ribs, and spine of a woman. In that *Man* and *Woman* subvert traditional perceptions of the nude in art, they constitute an essentially Dada gesture. Once photographed, the objects ceased to exist as "man" and "woman"; they were dismantled, their component parts returned to their original use.

The two photographs appeared in *Dadaglobe*, a journal edited by the Rumanian poet Tristan Tzara (1886–1963), one of the founders of the Dada movement in Zurich in 1916. They were exhibited in the *Salon Dada, Exposition International*, held at the Galerie Montaigne in Paris in June 1921, shortly before Man Ray moved to Paris from New York. [VH]

215. Man Ray
American, 1890–1976

Marcel Duchamp, ca. 1920
Gelatin silver print
28.5 x 22.7 cm (11¼ x 9 in.)
Plate 184

Marcel Duchamp (1887–1968), whose *Nude Descending a Staircase* had caused an uproar at the New York Armory Show in 1913, was introduced to Man Ray by Walter Arensberg, the collector and host of informal salons for avant-garde artists at his West 67th Street apartment, soon after Duchamp moved to New York in 1915. Throughout their lives, the two artists remained close friends, accomplices in their assault on traditional art-world ideologies and art-making practices. Man Ray made dozens of portraits of Duchamp, documenting the latter's often changing persona. Here, in a fittingly ironic tribute to the iconoclasm of both artists, Man Ray presents Duchamp's profile in the softly focused, classicizing style of traditional commercial studio portraiture. [VH]

216. Man Ray
American, 1890–1976

Rayograph, 1922
Gelatin silver print
23.9 x 17.8 cm (9⅜ x 7 in.)
Ex coll.: Arturo Schwartz
Plate 7

Man Ray was never much interested in the chemical or optical nature of photography, though he championed several experimental darkroom techniques—solarization, overdevelopment, and overenlargement. His best-known innovation was, in fact, a new application of an old idea, the photogram: a cameraless picture formed by the action of light on an object in direct contact with light-sensitive material. The simple process dates back to the medium's earliest days in Henry Talbot's photogenic drawings (see nos. 1 and 2).

May Ray made his first photogram in 1921, and Tristan Tzara termed the result a rayograph. Within the year he and Tzara had published twelve rayographs in a limited-edition portfolio entitled *Champs délicieux*. Tzara described the magical effect of Man Ray's new pictures in the preface: "When everything we call art had become thoroughly arthritic, a photographer . . . invented a force that surpassed in importance all the constellations intended for our visual pleasure. . . . Is it a spiral of water or the tragic gleam of a revolver, an egg, a glistening arc or the floodgate of reason, a keen ear attuned to a mineral hiss, or a turbine of algebraic formulas?"[39]

For Man Ray the photogram was a window on the realm of fantasy, an indefinable place where he could concoct all manner of dreams from traces of objects interacting with light. Although any attempt to deconstruct a photogram into its component parts is largely irrelevant to this concept and often logistically impossible, it is worth noting that this rayograph includes the hand and profile of Man Ray's lover, Kiki. The Belle of Montparnasse sang at the Jockey nightclub and modeled not only for Man Ray but also for such painters as Soutine, Kisling, and Foujita. With the addition of an egg and a wine glass, Man Ray composed a surrealist love poem to the woman of his dreams. [JLR]

217. Man Ray
American, 1890–1976

Rayograph, 1923–28
Gelatin silver print
49 x 39.8 cm (19¼ x 15⅝ in.)
Plate 181

Profound indeterminacy characterizes most of Man Ray's art. Through motion, ambiguity, and visual punning, Man Ray created objects in a variety of media that defy the viewer to discover their meaning. No medium was better suited to advance his theories than the photogram. Unlike photographs printed from negatives, each photogram is unique, unrepeatable, and to a degree uncontrollable. The artist cannot know precisely how the selected object will be recorded, especially if he varies and moves his light source; thus the process is inherently unfixed and dynamic and produces results that are similarly defined.

Like Man Ray's *Object to Be Destroyed* (1922–23), a metronome with a photograph of a woman's eye attached to its swinging arm, this untitled rayograph is constructed of wedge-shaped elements that seem to oscillate around a relatively fixed base, the central white square. The dark background is itself a liquid world of chemical experimentation, which flows throughout the picture like a primordial sea. As his friend the Surrealist poet Robert Desnos wrote in 1923, Man Ray "succeeded in creating landscapes which are foreign to our planet, revealing a chaos that is more stupefying than that foreseen by any Bible."[40]

The majority of Man Ray's photograms are on 8 x 10-inch sheets of paper, which he used for his portrait commissions. This rayograph is four times that size, and one of the most mesmerizing of the very few larger photograms. It appears on a painting easel in the photographer's studio in the 1928 photograph of Man Ray filming Desnos reading his poem "Etoile de mer" for the short film of the same name.[41] [JLR]

218. Man Ray
American, 1890–1976

Jacqueline Goddard, 1930
Gelatin silver print
29.2 x 22.5 cm (11½ x 8⅞ in.)
Plate 173

Man Ray had been one of the instigators of Dada in New York in the 1910s. Soon after his arrival in Paris in 1921, the randomness and irrationality of Dada began to be replaced by the fantasy and incongruity of Surrealism. Neither movement had been motivated by the production of visual artifacts; rather, both sought to give expression to the unconscious. Through his innovative use of the photographic medium, Man Ray carved a niche for himself in the Surrealist circle and contributed a distinct visual character to a movement that was firmly grounded in literary and psychoanalytic theory.

In this image, the photographer defamiliarized his subject—one of his favorite models, Jacqueline Goddard—by means of several reversals of the norm: black has become white, shadows glow, and gravity is defied. While explained easily enough in terms of technique—this is a

negative print rotated ninety degrees toward the bottom edge of its original exhibition mount—the image remains nonetheless disorienting and disquieting. What kind of creature is this woman, who at one moment appears triumphant in her state of suspension and at the next seems to slide silently into a dark underworld—an imaginary water nymph, or a very real femme fatale? Is it the yearning for a higher spiritual realm that buoys her up, or is it the carnal world of sexuality into which she slides?

[VH]

219. Berenice Abbott
American, 1898–1991

James Joyce, 1926
Gelatin silver print
23.3 x 17.4 cm (9⅛ x 6⅞ in.)

Berenice Abbott opened a photographic portrait studio in Paris in 1926 after having worked for three years as an assistant to Man Ray, whom she had met in New York. Although her Paris portraits are indebted stylistically to Man Ray's, she brought to them a sympathetic eye that was very much her own. Her portraits of women are notable for their empathic understanding of her subjects, but she reached a depth of expression in her photographs of James Joyce (1882–1941). Abbott photographed Joyce on two occasions, the first in 1926 at his home, the second in 1928 at her studio, as was her more customary practice. In spite of Abbott's annotation on the back of the print, this portrait belongs to the earlier session, when Joyce was photographed both with and without the patch over his

eye, worn because of his sadly degenerating sight. For this particular exposure Joyce removed the patch and held it, with his glasses, in his right hand; his forehead still bears the diagonal impression of the ribbon. This intimate portrait, with its softly diffused lighting, suggests the complex, introverted character of Joyce's imagination. It is with good reason that Abbott's are considered the definitive portraits of the author of *Ulysses* and *Finnegan's Wake*.

[PA]

220. Edward Weston
American, 1886–1958

Nude, 1925
Gelatin silver print
14.8 x 23.4 cm (5⅞ x 9¼ in.)
Ex coll.: Rockwell Kent
Plate 179

Edward Weston is considered by many the primary exponent of straight photography in America. The numerous awards, honors, and successes he enjoyed before 1920 place his early work firmly within the Pictorialist tradition. By 1920, however, his increased exposure to avant-garde developments in the visual arts prompted his break with Pictorialism, a break that culminated in the years 1923 to 1926, which he spent in Mexico, a locus as liberating for Weston in the achievement of his mature style as Paris was for other artists at that time.

This photograph was taken in 1925, probably during Weston's eight-month return visit to California during his Mexican period. The model may have been Miriam Lerner, who is known to have posed at least twice for Weston during these months. The image presents a radically reduced formal vocabulary. Almost unrecognizable as a nude and equally legible as a landscape or sculpture, the smooth contours of the androgynous form can be appreciated for the integrity and rhythm of their abstract qualities, suggesting the influence of Constantin Brancusi, whose inspiration Weston readily acknowledged. [VH]

221. Edward Weston
American, 1886–1958

Nahui Olín, 1923
Gelatin silver print
23.3 x 17.8 cm (9⅛ x 7 in.)

This portrait of Nahui Olín belongs to a series of photographs that Weston referred to as "heroic heads." Sitters were chosen from among the circle of intellectual friends

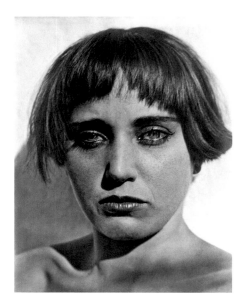

with whom he and his companion, Tina Modotti, associated during his years in Mexico. Here, the sitter is Carmen Mondragón (1896–1978), a Mexican poet and painter who grew up in Paris and who, upon her return to Mexico, took an Indian name meaning "four movements of the sun." Nahui Olín posed for Weston in November 1923, and the portrait was exhibited in his second show at the Aztec Land Gallery in Mexico City the following year.

In his *Daybooks*, Weston recorded that Nahui Olín was annoyed by the revealing nature of the portrait; he himself considered it, together with others from the same sitting, to be among the best pictures he had made in Mexico. It proved to be one of the most popular images in the exhibition and probably inspired these lines in a prose poem review by Francisco Monterde García Icazbalceta: ". . . cruelly, [Weston] prefers to guillotine heads in the noon sun: unreal necks and martyred eyes in harsh, insolent light."[42] Flattering or not (and flattery would not have been Weston's concern), the image is a powerful expression of the photographer's piercing eye, a confrontational face-off between two equally strong personalities.

[VH]

222. Edward Weston
American, 1886–1958

Excusado, 1925
Gelatin silver print
24.2 x 19.2 cm (9½ x 7½ in.)

About this image, made in Mexico, Weston wrote in his *Daybooks* on October 21, 1925:

For long I have considered photographing this useful and elegant accessory to modern hygienic life, but not until I actually

contemplated its image on my ground glass did I realize the possibilities before me. . . . Here was every sensuous curve of the "human form divine" but minus imperfections.[43]

Typically, Weston's response is to form; ironically, it is the form of the most profane, the most functional of objects: a toilet. With *Excusado*, Weston replaces the modernist canon "form follows function" with the notion of pure form—that is, form extracted from its function and related instead to the sensuous curves of the female body.

For two weeks Weston studied and photographed the ordinary plumbing fixture from different angles. For this version he dispensed with the tripod, rested his 8 x 10-inch Seneca view camera on the floor, and directed the lens upward, lending unexpected volume and monumentality to his subject. He wrote that the "swelling, sweeping, forward movement of finely progressing contours" reminded him of the Victory of Samothrace.[44]

[VH]

223. August Sander
German, 1876–1964

Raoul Hausmann, 1927–28
Gelatin silver print
24 x 16.8 cm (9½ x 6⅜ in.)
Plate 187

As a boy August Sander worked in a mine in the Siegen area east of Cologne. His enthusiasm for photography was sparked when he had the opportunity to assist a photographer who was visiting the area. After training in Trier and Linz, he opened his own studio in Cologne in 1910. By 1920 his main focus had become a portrait atlas entitled

Citizens of the Twentieth Century, which was to be a collective image of the German people. By allowing dress, gesture, environment, and tools of the trade to define his sitters as much as their physiognomies, and by organizing the portraits according to the sitter's profession or social status, Sander arrived at a classification of social types. Even the sitter's identification was limited to profession or social standing—peasant woman, pastry cook, upper-class family, bohemian, and so forth. This vast project occupied Sander until it was brought to an abrupt halt by the Nazis in 1934.

When the first installment of sixty photographs was published in 1929 under the title *Face of the Time*, it met with great critical acclaim. The head-on views, the absence of retouching, and the resulting unadorned images allied Sander with the "new objectivity" advocated by other contemporary artists. The book remains an exemplar of a new kind of publication that emerged in the 1920s, in which photographic images were not seen simply as illustrations but as autonomous works of art.

This portrait, taken in Berlin, of the Dadaist Raoul Hausmann, wearing only a beret, a monocle, and loose pants, defines him as an artist of the intellectual avant-garde, his surly mouth and confidently poised body revealing something of his domineering personality. Hausmann is so clearly an individual, performing for the camera as the Dadasoph, or resident theorist of the movement, that the generic caption "artist" would hardly have sufficed. Perhaps it was for this reason that the portrait was not included in *Face of the Time*, though paradoxically Sander had traveled to Berlin specifically at the suggestion of his publisher in order that the book include some well-known figures to give it more popular appeal. [VH]

the darkroom. In effect, he edited his archive—and, by extension, the human body—in an effort to define and classify types. This image was printed from a 5 x 7-inch glass plate that shows a full view of a young man's head. Two other prints from the same negative show that Sander progressively enlarged the image, omitting facial features until the eye alone filled the frame.

That Sander would make an image of an eye is hardly coincidental; rather, it was only appropriate that an artist of the machine age would marvel at the human eye once he had mastered its analogue, the camera's mechanical eye. Sander depicted the left eye of his son Gunther, whom he had trained to assist him in the studio and darkroom—an eye that served him, like the camera's eye, as an extension of his own. [VH]

224. August Sander
German, 1876–1964

Eye of an Eighteen-Year-Old Young Man, 1925–26
Gelatin silver print
18.4 x 24.5 cm (7¼ x 9⅝ in.)

This image belongs to a series of photographs that occupied Sander periodically from the 1920s until the 1950s. Entitled *The Organic and Inorganic Tools of Man*, the series was to include pictures of prosthetic devices and parts of the human body. Although the series was never realized in book form, the August Sander Archive in Cologne ascribes to it some forty or fifty images; of these, only one depicts a prosthetic device, a mechanical hand that enabled a wounded soldier to write.

For the series Sander made close-up studies of facial features and certain parts of the body. He also recycled old negatives by cropping and enlarging individual details in

225. Albert Renger-Patzsch
German, 1897–1966

Snake Head, 1927
Gelatin silver print
16.9 x 23.1 cm (6⅝ x 9⅛ in.)

If Edward Weston was a champion of straight photography in America, August Sander and Albert Renger-Patzsch were its champions in Germany, where it was labeled "new objectivity" (*Neue Sachlichkeit*). There were, however, differences between the approaches of these two German photographers. In his 1933 essay "A Short History of Photography," the German critic Walter Benjamin praised the scientific basis of Sander's physiognomic studies in *Face of the Time*, while he condemned photographs which proposed that "the world is beautiful," a barely disguised criticism of Renger-Patzsch's 1928 publication bearing this title. Benjamin's reproach of Renger-Patzsch was valid to the extent that comparisons between natural and man-made objects in the book do tend to draw attention to their formal structure.

It is, however, an injustice to reduce Renger-Patzsch's aesthetic to a superficial interest in cataloguing the forms of the objects that inhabit our world. Rather, like Weston, his was a search for the underlying essence and universality of those objects. About this image of a grass snake, one of the hundred photographs included in *The World Is Beautiful*, Carl Georg Heise wrote in the introduction: "The head of the snake fits into the coils of its body in such a way that the page seems filled with a decorative pattern of scales, a pattern which the viewer's imagination extends uncannily into infinity. Thus, above and beyond the single snake, the picture presents the entire species."[45]

[VH]

226. Alexander Rodchenko
Russian, 1891–1956

Asphalting a Street in Moscow, 1929
Gelatin silver print
24.4 x 30 cm (9⅝ x 11¾ in.)
Plate 192

Alexander Rodchenko was one of the founding members of Russian Constructivism. After the October Revolution of 1917, he became increasingly involved with government-sponsored organizations that advocated the integration of art with everyday life, which led him and other like-minded artists to reject traditional art forms such as easel painting and to search for more utilitarian expressions. Rodchenko's own initial explorations included nonobjective paintings and constructions, followed by photomontage. By 1925 he had renounced painting as elitist, embracing the photographic medium as the revolutionary tool that would enable the masses to discover the modern world of science and technology. Conventional, straight-on shots "from the navel" could not, he believed, revolutionize perception; rather, vantage points from above, from below, and on the diagonal were the means by which to surprise the viewer into discovering the world anew.

By 1928, Rodchenko's exclusive use of these strategies had elicited criticism that he had become trapped in aesthetic formalism, and three years later his membership in the leftist organization the October Group was revoked on charges that the nature of his work alienated the proletariat. Shortly thereafter, the Soviet Union would suppress the Constructivist principles propagated by Rodchenko and his colleagues, and promote instead Social Realism as its official style.

Asphalting a Street in Moscow, made in 1929, provides some insight as to why Rodchenko's work was disparaged, since the tilted horizon line, rapidly receding diagonals, and low vantage point may be regarded as a purely formal statement. In addition, these devices encourage the viewer to identify with the machinery which seems ready to steamroll the shadows of the bystanders, suggesting that the inevitable path of technology is one of destruction rather than construction.

[VH]

227. Alexander Rodchenko
Russian, 1891–1956

Morning Wash, 1930
Gelatin silver print
41.9 x 29.2 cm (16½ x 11½ in.)
Plate 174

In 1935, after four years of being ostracized for his innovative graphic formalism, Rodchenko was reaccepted by his peers and included in the Moscow exhibition "Masters of Soviet Photography." This print of a child bathing—the artist's five-year-old daughter Varvara Alexandrovna—was selected as one of the twenty-four photographs by Rodchenko included in the show. Although the image did not overtly contribute to the betterment of Soviet life and thus fell short of the official party mandate, it compensated by its humanity, defined both by the subject's physical vulnerability and by her comic gesture; the child mimics the artist's pose—hand camera held to the eye—as seen in the shadow cast on the floor.

[JLR]

228. Alexander Rodchenko
Russian, 1891–1956

Foxtrot, 1935
Gelatin silver print with applied color
20.6 x 14.3 cm (8⅛ x 5⅝ in.)
Plate 175

Between 1926 and 1932, in addition to his activities as a photographer, poster artist, and teacher, Rodchenko de-

signed costumes and sets for both the theater and the cinema. This photograph is one of three prints that relate to his design commission for Leonid Obolenskii's film *Albidum* (1928). It was probably printed from a projection copy, or film positive, rather than from the original film negative, and its values are reversed, producing a negative print. The graphic impact of the reversal charged the dancers with a pulsing energy and allowed Rodchenko to apply color to the costumes, which he had designed. The iridescent aura, in effect, returns the dynamic dance to "living color."

Foxtrot was most likely printed in 1935 for the exhibition "Masters of Soviet Photography," which included *Rumba*, another negative print of dancers from *Albidum*.

[JLR]

229. El Lissitzky
Russian, 1890–1941

Self-Portrait, 1924–25
Gelatin silver print
17.3 x 12.1 cm (6⅞ x 4¾ in.)
Plate 191

Before the outbreak of World War I and his return to Russia, El (Lazar Mordukovich) Lissitzky studied architecture and engineering in Germany and traveled in Europe absorbing the new imagery of Cubism, Futurism, and Expressionism. In 1919 he began teaching in Vitebsk, where he worked closely with Kasemir Malevich. From this rich ground emerged his *Proun* paintings (1919–23), imaginary free-floating quasi-architectural constructions clearly informed by Suprematist and Constructivist principles.

One of Lissitzky's most famous works is a photographic self-portrait entitled *The Constructor*, which superimposes the artist's eye and his hand holding a compass onto graph paper, with the implication that the artist is a visionary engineer—a notion common among avant-garde artists of the 1910s and 1920s. This self-portrait was made during the same period as *The Constructor* and is similarly composed of multiple photographic and photogram elements. The portrait of Lissitzky wearing a bandage or surgical cap floats between the open branches of a photogrammed compass and above three circles labeled London, Paris, and Berlin. These symbols of urban life are also a photogram, made from a portion of Lissitzky's typographical design for Vladimir Mayakovsky's 1923 poem *For the Voice*. The shimmering strip superposed on his lips is illustrated in Lissitzky's 1925 essay, "A[rt]. and Pangeometry." Rotated on an axle, the strip would produce the illusion of a circular disk, "that is to say a new expression of space which is there for as long as the movement lasts and is therefore imaginary." The strip thus suggests potential movement and the new fluid imaginary space that Lissitzky thought necessary for a new art and which he successfully created in this image.[46]

In 1924 Lissitzky went to Switzerland to recover from tuberculosis. Despite the fact that one lung had been removed, he was immensely productive during his recuperation. If this self-portrait reflects at once the vulnerability of the body and an uncompromising vision, it is perhaps because it is the image of a convalescing constructor of a brave new world.

[VH/MMH]

230. László Moholy-Nagy
American, born Hungary, 1895–1946

Decorating Work, Switzerland, 1925
Gelatin silver print
50.6 x 40.2 cm (19⅞ x 15⅞ in.)
Plate 163

László Moholy-Nagy played a key role at the Bauhaus in both Weimar and Dessau from 1923 to 1928, and at the New Bauhaus (later the Institute of Design) in Chicago from 1937 until his death in 1946. Early in his career he was associated with Constructivism in Vienna and the Dada movement in Berlin. His major contribution to avant-garde photography was the new vision (*das neue Sehen*), in which he advocated a new approach to the medium, proposing the use of such techniques as the

manipulation of light in cameraless photograms; negative prints, sharply angled points of view, and radical cropping in camera images; and the introduction of drawn elements, text, and mass-produced images in photomontages.

Decorating Work, Switzerland, also referred to as *Disembodied House*, shows the photographer's allegiance to several Constructivist principles, including a floating, unfixed perspective and its plastic configuration of space, such that a house painter, seen from below, becomes but one design element in a geometric composition. While the image is playful in the mode of Bauhaus student photographers, it poses an interesting question: Would Moholy-Nagy, who adhered to the stripped-down industrial style of the Bauhaus, have taken the photograph a day or two later, when the quaint painted decoration of the windows had been completed? [VH]

231. László Moholy-Nagy
American, born Hungary, 1895–1946

Dolls on the Balcony, 1926
Gelatin silver print
23.5 x 17.5 cm (9⅜ x 6⅞ in.)
Plate 177

Moholy-Nagy took this photograph in 1926 while on holiday in Ascona, Switzerland, with Oscar Schlemmer, a fellow instructor at the Bauhaus, and the Schlemmer family. It was published in 1927 in the second revised and English editions of Moholy's *Painting, Photography, and Film* with the caption, "The organisation of the light and shade, the criss-crossing of the shadows removes the toy into the realm of the fantastic." The image projects a Constructivist organization of space in the way vertical and horizontal surfaces are unified in a single plane by an overall pattern of light and shade. The insistent presence of the grid conveys a deeply ominous feeling, the disjunction between its shadows and the vulnerable bodies of the two caged dolls creating a sense of foreboding violence more typical of Surrealism than of the mechanized utopias of Constructivist art. [VH/MMH]

232. Lux Feininger
American, born Germany, 1910

Eurythmy, or *Jump Over the Bauhaus*, 1927
Gelatin silver print
11.2 x 8.3 cm (4¾ x 3¼ in.)
Plate 189

Lux Feininger, born Theodore Lucas, was the third son of the American painter Lyonel Feininger, a master instructor at the Bauhaus in Weimar, Dessau, and Berlin. Raised in the fertile environment of the renowned art school established by Walter Gropius to integrate art and technology, the young Feininger began his studies in the theater workshop at age sixteen; other interests included jazz, painting, and photography. He was given the nickname Lux ("light") because he carried a camera at all times, a simple box camera for glass negatives coveted by fellow students who believed that it was responsible for his spontaneous, energetic photographs. But of course it was the young artist's personal vision, shaped by the utopian ideals and communal life of the Bauhaus, that created his buoyant expressions of student life.

The image seen here exemplifies this sense of unrestrained playfulness—as do its two alternative titles—although the chaotic cutting loose that is pictured can hardly be described as eurythmy, body movement characterized by proportional balance and rhythmic harmony. Feininger placed the wildly leaping youths in the foreground and chose a low vantage point, which so greatly diminishes the scale of Gropius's International Style buildings that they become easily surmounted hurdles, perhaps suggesting that it is youthful energy rather than the school's theoretical principles that will ultimately transform modern art and society. [VH]

233. Umbo (Otto Umbehr)
German, 1902–1980

Night in a Small Town, ca. 1930
Gelatin silver print
29.2 x 21.9 cm (11½ x 8⅝ in.)
Plate 196

Otto Umbehr began his studies at the Weimar Bauhaus in Johannes Itten's preliminary course in 1921. Two years later he moved to Berlin, where he worked on Walter Ruttmann's innovative film *Berlin, Symphony of a Great City* (1926). He began to experiment with photography, making expressionistic portraits of friends and eventually teaching at Itten's private art school for two years. In addition, Umbo worked as a photojournalist for the Berlin picture agency DEPHOT from 1924 until its dissolution in 1933.

Umbo's work has an uncanny, surreal edge that pushes it beyond simple documentation, less the result of experimental darkroom practices than of his exploration of the psychological parameters of photographic description. This photograph of Salzburg at night was taken with a long exposure from a high vantage point. The solid, volumetric mass of an apartment block is compressed into a flattened silhouette, while the path of a solitary car, delineated by

the parallel tracings of its headlights, is etched into the street below. The mood is one of impenetrable darkness and impending doom, strongly expressionistic in its vertiginous projection of a nightmare. [VH]

234. Gyorgy Kepes
American, born Hungary, 1906

Shadow of a Policeman, 1930
Gelatin silver print
8.5 x 11 cm (3⅜ x 4⅜ in.)
Plate 195

Gyorgy Kepes began a traditional program of study in painting at the Academy of Fine Arts in Budapest in 1924. Subsequent involvement with Munka, a politically active group of artists and writers, introduced him to avant-garde ideas, leading him in 1928 to reject painting and the Academy in favor of more progressive and socially relevant forms of art, specifically film and photocollage. Seeking advice on opportunities to work as a film maker, Kepes wrote to his fellow countryman László Moholy-Nagy, recently resigned from the Bauhaus in Dessau, who asked him in 1930 to come to Berlin as his assistant. For two years they collaborated on commissions in advertising, graphic design, and stage design. In 1937, Kepes followed Moholy-Nagy to the New Bauhaus in Chicago, where he headed the Light and Color Workshop and continued his own experimentation with photograms, micro- and macrophotography, and the cliché-verre process. His artistic interests were in fact so wide-ranging that he never considered himself primarily a photographer.

While in Berlin, Kepes produced a number of straight photographs, many of which incorporated the dramatic vantage points, shadows, and diagonals characteristic of the new vision. *Shadow of a Policeman* exemplifies this approach, captivating the viewer with its ambiguity: Is the graphic choreography between the poised foot and its shadow a purely formal occurrence or, during this period of mounting economic and political uncertainty, did Kepes intend to suggest imminent menace in his portrayal of the long shadow of the law? [VH]

235. Aenne Biermann
German, 1898–1933

Rubber Tree, ca. 1927
Gelatin silver print
47 x 35.6 cm (18½ x 14 in.)

While it may have been her privileged financial and social status as the wife of a prosperous textile manufacturer that

initially gave Aenne Biermann the freedom to pursue photography as a hobby, it was her own initiative that marked the progression from informal snapshots of her growing children to serious object studies that would be featured in virtually every major European photography exhibition of the period. Biermann's work was clearly informed by the numerous photographic publications of the day, but her ability to articulate a unique aesthetic within the varied output of new vision photographers won her the support of Franz Roh, who published a monograph on her work in 1930. Entitled *60 Fotos*, this second book in Roh's Fototek series opened with *Ficus elastica*, or *Rubber Tree*, as its first plate.

In its close-up examination of lustrous leaves this print, in all probability made for exhibition, recalls both Karl Blossfeldt's earlier, more famous plant studies of 1900–1930 and László Moholy-Nagy's principle of photography as the modulation of light. Yet, this is neither a clinically isolated plant form nor a theoretical study of light; rather, it is the observation of the play of light on a common houseplant. Perhaps it is appropriate that Biermann, both a homemaker and a photographer, should have granted us privileged access to the formal beauty of domesticated nature on its own terms. [VH]

236. Mieczyslaw Berman
Polish, 1903–1975

Lindbergh II, 1927
Photocollage
70 x 50 cm (27½ x 19⅝ in.)
Plate 190

Mieczyslaw Berman studied graphic design and typography at the School of Decorative Arts in Warsaw. His exposure to Russian Constructivist poster design and to collages and photomontages by László Moholy-Nagy, Kurt Schwitters, and Hannah Höch provided sources of inspiration for the Constructivist collages he began to make in 1927. In 1930, when he discovered the political photomontages of John Heartfield published in *AIZ* (*Arbeiter-Illustrierte-Zeitung*), his interest shifted from the Constructivist potential of photocollage, the medium in which he worked exclusively, to its potential as a political tool.

In his early works Berman often used his own response to actual events as a point of departure. The photocollage *Lindbergh II* captures the excitement of the first transatlantic crossing by the American pilot Charles Lindbergh. On top of a map that delineates the course of the flight, Berman placed two photomechanically reproduced elements whose juxtaposition suspends Lindbergh's plane precariously above the ocean and beneath the clouds, thereby re-creating the 33½-hour solo flight. Paris, Lindbergh's final destination, is cupped by applauding hands. The scattering of his name in various typefaces represents the roar of celebratory kudos with which the exhausted but elated twenty-five-year-old hero was greeted upon his landing. [VH]

237. Charles Sheeler
American, 1883–1965

Upper Deck, ca. 1928
Gelatin silver print
25.3 x 20.2 cm (9½ x 7⅝ in.)

After the initial success of his photographs in the art world (see no. 210), Charles Sheeler for a time exhibited his photographs with his paintings, indicating his belief that his work in each medium shared the same status. In 1923 he reviewed an exhibition of Stieglitz's photographs, criticizing his former mentor's use of platinum paper. The article caused a rift between the two men, following which Sheeler's photographic work became more visible in commercial than in art circles. His most important commercial commission was for the Ford Motor Company in 1927. At the River Rouge plant he produced images that focused on industry as the most significant expression of the modern age, almost as a form of lay religion.

Sometime during the following year, Sheeler was presumably commissioned to photograph the *S.S. Majestic*, though the exact details of the commission remain unclear. Three of the photographs have survived, yet none seems to have been published. Like the River Rouge photographs, the image seen here celebrates the machine—in this case an ocean liner, referred to as "a machine for living" by the French architect Le Corbusier in his book *Toward a New Architecture* (1923). Sheeler did not display his subject in its entirety; instead, he focused on the ship's motors, ventilator stacks, and exhaust fans—symbols of its mechanical power. In general he sought to reveal underlying abstract structure, even in pictures realistically conceived; and indeed, this image is at once abstract and highly realistic. The vantage point accentuates the geometry and repetition of the forms, reducing this floating wonder to a few crisply lit, carefully composed, precisely observed details. A year later, Sheeler would use the photograph as the basis for a painting of the same name.
 [VH]

238. Edward Steichen
American, born Luxembourg, 1879–1973

Self-Portrait, 1917
Gelatin silver print
24.5 x 19.8 cm (9⅝ x 7¾ in.)

In 1917, after the United States had entered World War I, Edward Steichen volunteered for the U.S. Army. He made this self-portrait shortly before his commission as leader of a team of aerial reconnaissance photographers and his departure for France in late November. Steichen presents himself, posed with his apparatus, as a self-confident professional. The photograph is a prelude to his modernist postwar photographs—especially the theatrical commercial portraits and product advertisements commissioned by Condé Nast beginning in 1923 (see no. 237). It also articulates the new status that studio photographers would achieve after the war. As the highest-paid photographer at

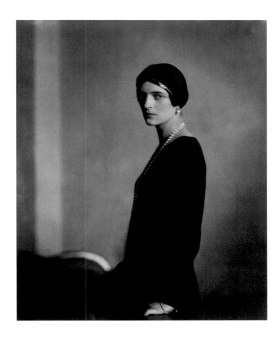

Vanity Fair, Steichen became New York's most celebrated packager of personalities—a man who wielded truly cult-like influence.

Unlike Steichen's earlier Photo-Secessionist photographs, this print shows no evidence of darkroom manipulation. As a transitional work, however, it is signed and dated in the manner of his earlier prints, with his name in capital letters inscribed over the date, which appears in Roman numerals. Steichen's inclusion of the camera as his chosen attribute seems to presage his imminent decision to abandon the brush for the lens. [JLR]

239. Edward Steichen
American, born Luxembourg, 1879–1973

Princess Yusupov, 1924
Gelatin silver print
24.9 x 20 cm (9¾ x 7⅞ in.)
Plate 5

Edward Steichen made this portrait of Princess Yusupov in New York in 1924, during his second year as chief photographer at Condé Nast. Although the photograph is dramatic and glamorous in the manner characteristic of Steichen's commercial portraiture, an unexpected sadness tempers the sitter's beauty and proud bearing. Princess Irina Alexandrovna Yusupov (1895–1970) was the daughter of Grand Duchess Xenia Alexandrovna and the niece of Emperor Nicholas II (see no. 194). In 1914 she married Prince Felix Yusupov, best remembered as the murderer of Rasputin, the controversial monk whose association with the Russian imperial family discredited the monarchy in

its last years. Having seen many of her relatives killed during the Revolution, Princess Yusupov was active on behalf of Russian refugees. She was in New York with her husband to patronize charity events when this photograph was made; it appeared in the April 15, 1924, issue of *Vogue*. [PA]

240. Harold Leroy Harvey
American, 1899–1971

Self-Portrait with Camera and Model, ca. 1930
Gelatin silver print
30.2 x 20.2 cm (11⅞ x 8 in.)
Plate 183

Harold Leroy Harvey exhibited at the San Francisco Salon of 1916 when he was only seventeen. He is believed to have studied with Man Ray in the early 1920s, and the two men did in fact share similar interests in experimental printing techniques. Harvey's invention of various film developers and toners led eventually to the founding of his own company, the Harvey Chemical Company, in New Jersey. In addition to working as a commercial photographer, he was a painter and an illustrator.

This image, photographed in a mirror, comments on the dynamics of photographic portraiture. Primary placement is given to the model, behind her is the camera, and in the background, beyond the camera's narrow depth of field and hence out of focus, is the photographer himself. The lens of the camera may replace the right eye of the photographer, but it is his exposed, almost hypnotic left eye that embodies his creative vision—the vision that

orchestrated the balanced and subtly lit composition and elicited the model's perfect composure. Here is Pygmalion in reverse—the living model re-created by the artist as a work of art. Still as a statue, she even provides her own graceful pedestal. [VH]

241. Paul Outerbridge
American, 1896–1959

Self-Portrait, ca. 1927
Gelatin silver print
38.5 x 28.3 cm (15⅛ x 11⅛ in.)
Plate 171

Paul Outerbridge's oeuvre reveals something of a dichotomy, oscillating between Cubist-derived abstractions of commonplace objects, executed as platinum prints in the early 1920s, and fetishistic female nudes, rendered in the technologically advanced Carbro color process beginning in 1929. This self-portrait seems to combine both these obsessions. It exhibits a modernist sensibility in the interplay of black-and-white geometric shapes and in the repetition of form; it also suggests the decadence and voyeurism associated with the subject matter of his later work. Outerbridge made this image about 1927, at the height of his success as a commercial photographer in Paris and at the midpoint of his four-year stay in Europe.

The "improvements" Outerbridge has made to his black-tie attire dehumanize him, transforming him into an automaton, at once elegant and sinister, powerful and emasculated. His body is completely sheathed, except for the gap of his mouth, reinforced under the heavy mustache and left open not so much to allow him to breathe as to smoke, his cigarette poised between his legs. Mustache and cigarette become "signifiers of masculinity,"[47] the self a projection of a fetish. [VH]

242. Bill Brandt
British, born Germany, 1904–1983

Madam Has a Bath, 1934
Gelatin silver print
23.1 x 19 cm (9⅛ x 7½ in.)
Plate 170

Bill Brandt's career, which spanned nearly sixty years, reveals two distinct phases. His work from 1928 until 1945 can be described as a kind of social documentation that delineated the sharp contrasts that existed among the many strata of British society. And the subject matter he took up after World War II, portraits of literary figures, landscapes, and studies of the nude, reflects the recurrent influence of Surrealism, to which he was exposed during his brief tenure as Man Ray's assistant in Paris in 1929.

The son of a British father and a German mother, Hermann Wilhelm Brandt spent his childhood and early adult years primarily in Germany. Thus, when he settled in London in 1931, he was able to cast an objective, if not critical, eye on the customs of the society. The photographs in his first two publications, *The English at Home* (1936) and *A Night in London* (1938), suggest two important influences from his childhood years: Jugendstil poster design, with its stark graphic contrasts and silhouetted figures, and English nursery-book illustrations, with their characterizations of British types in the context of their social roles. Brandt attempted to re-create these roles in his early photographs, often enlisting members of his own family to pose for those scenarios that took place in upper-class milieus. In the image seen here, for example, which appears as plate 4 in *A Night in London*, Brandt directed Pratt, a maidservant in the employ of his banker uncle, to draw a bath for "Madam," who is shown leaving for a party in plate 5. [VH]

243. André Kertész
American, born Hungary, 1894–1985

Afternoon Constitutional of M. Prudhomme, Retired, 1926
Gelatin silver print
31.2 x 22.9 cm (12¼ x 9 in.)
Plate 167

Joseph Prudhomme was a character invented by the French caricaturist Henry Monnier in 1830. Emblematic of an entire class of French society, Prudhomme was the perfect bourgeois: set in his respect for institutions and conventions, rigid in his posture, and banal in his statements. In French, the name bears the connotations of both a prudent and a prudish man, and Kertész carries on the tradition in this portrayal. M. Prudhomme, now retired, is seen taking his afternoon constitutional, perhaps less for its beneficial effects to his health than out of adherence to convention. We observe the meticulously dressed gentleman along the Quai d'Orsay, bowler in place, cane in tow, feet firmly planted on the ground, his attitude suggesting a wary aloofness of the two approaching proletarians.

Kertész might have led a similarly bourgeois life in Budapest had he continued his career begun in 1912 as a clerk in the stock exchange. That same year, however, he purchased his first camera, and rapidly developed an

idiosyncratic style based on spontaneous yet analytic observation of fleeting, commonplace occurrences. In 1925, at the age of thirty-six, he emigrated to Paris, where his contributions to leading European newspapers and illustrated magazines signaled his new career. He became the first serious photographer to master the recently introduced 35mm Leica, initiating a style that would prove to be inspirational to Brassaï, Henri Cartier-Bresson, Robert Capa, and other artists and photojournalists to follow. [VH]

244. Brassaï (Gyula Halász)
French, born Transylvania, 1899–1984

Lesbian Couple at The Monocle, 1932
Gelatin silver print
27.7 x 21.7 cm (10⅞ x 8½ in.)
Plate 168

Born in Brasso, Transylvania, Gyula Halász took the name of his birthplace as a pseudonym in 1932, when he had lived in Paris for six years working as an illustrator and correspondent for Hungarian and German newspapers. In 1929, after accompanying the expatriate Hungarian photographer André Kertész on assignment, Brassaï decided to take up photography himself. His economic situation was dire: occasionally, after writing an article, he would pawn his typewriter, which he would later redeem with his camera after he had illustrated the piece. Despite such difficulties, Brassaï managed to master French during this time, and to become friends with many artists and with the writers Léon-Paul Fargue and André Queneau, in whose company or alone he would wander the city at night.

Brassaï's best photographs of the 1930s describe the nocturnal atmosphere of the French capital and the people who existed on the fringes or in the shadows—vagrants under bridges, streetwalkers and their clients in brothels, thugs and pimps in the alleys and dance halls. A true bohemian, and something of a chameleon and diplomat as well, Brassaï was accepted everywhere. He was so comfortable with his subjects and they with him that they would willingly assume natural poses for his camera. This photograph, taken at a bar owned by Lulu de Montparnasse on the rue Edgar-Quinet, is thus not the least sensationalistic. The evening is well advanced, the couple is easy and relaxed, the woman dreamily leaning against her partner, who tenderly touches her arm. Perhaps because he felt the journalist's need for an explanatory caption, Brassaï titled the photograph *Lesbian Couple at The Monocle*, suggesting, despite the comfortable comportment, that he also considered the women exotic anthropological material.
 [MMH]

245. Brassaï (Gyula Halász)
French, born Transylvania, 1899–1984

Pont Marie, Île Saint-Louis, ca. 1932
Gelatin silver print
28.9 x 20.9 cm (11⅜ x 8¼ in.)
Plate 164

Paris by Night, a book of Brassaï's photographs of nocturnal Paris, was published in the winter of 1932–33, and quickly sold out. This photograph did not appear in it, most likely because the publisher preferred prettier pictures with narrative elements. Three photographs of bridges were included: one of vagabonds warming themselves by a fire under the Pont Neuf and another of the same bridge with houseboats and tugboats "sleeping on the smooth water of the Seine," as its caption notes; the third photograph, like this one, shows an arch of stones "eaten and washed by the rain," a reassuring street lamp gleaming on the parapet above it, and a barge moored in the lamplight beyond.

This photograph, by contrast, with its heavy Piranesean vault, intense blackness, and unrelieved axial perspective, is infernal and mesmerizing. Nothing is in focus; our eye plunges through the tunnel, the stained stones blurring in the rush. We emerge on the far side into a glaring electric fog, where the double arch of a second bridge stares back, like eye sockets in a hallucinatory mask. Even the most agile imagination cannot coax this River Styx back into the banks of the Seine.

Brassaï did not much care where, in the real world, the picture was made, and incorrectly identified the bridge as the Pont Louis-Philippe. Yet he fully understood that the surrealism of such a picture was not unreal; it was, as he wrote, the "actual rendered fantastic by vision." [MMH]

246. Henri Cartier-Bresson
French, born 1908

Seville, Spain, 1933
Gelatin silver print
19.6 x 29.4 cm (7¾ x 11⅝ in.)

In 1927, Henri Cartier-Bresson enrolled in André Lhote's academy in Montparnasse to study the technique and theory of Cubist painting. The son of a wealthy textile merchant, he extricated himself from his conservative bourgeois upbringing and entered the bohemian world of the avant-garde. In 1930 he embarked on a year of solitary travel in Africa, further distancing himself from the established patterns of Western culture. The following year, after he had recovered from blackwater fever, Cartier-Bresson picked up the camera.

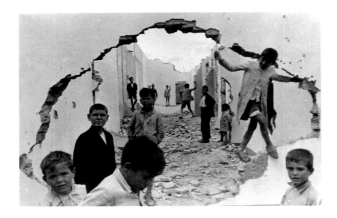

His earliest photographs were made in Paris and Eastern Europe and reveal the influence of both Cubism and Surrealism—bold, flat planes, collagelike compositions, and spatial ambiguity—as well as an affinity for society's outcasts and the back alleys where they lived and worked. First with an unwieldy box camera, then in 1932 with a small 35mm Leica, Cartier-Bresson traveled to Italy, Spain, Morocco, and Mexico, developing what would become the hallmark of twentieth-century photographic style. In his 1952 monograph *The Decisive Moment*, he defined his philosophy: "To me, photography is the simultaneous recognition, in a fraction of a second, of the significance of an event as well as of a precise organization of forms which gave that event its proper expression."[48]

This photograph of children playing amid ruins is typical of Cartier-Bresson's early work. A masterpiece of photographic surrealism, the image is filled with surprises that challenge even the most acutely observant viewer. A small army of children play in a very unchildlike environment; some address the camera, others continue their activities undisturbed. The picture's space is intentionally ambiguous; the breached foreground wall acts both as a window to the background drama and as a stage or backdrop for the foreground actors. The photograph seems at first glance to be a collage of cut-out elements rather than a photograph made with a single exposure. The white paint on the stuccoed wall even blends with the photograph's white borders, suggesting that the four boys closest to the camera have literally broken out of their world by tearing a hole in the print itself. [JLR]

247. Henri Cartier-Bresson
French, born 1908

Valencia, Spain, 1933
Gelatin silver print
19.6 x 29.2 cm (7¾ x 11½ in.)
Plate 194

The advent of small, fast, hand-held cameras allowed photographers to work with spontaneity, intuition, and accuracy. It also encouraged access to locations previously too dangerous or too difficult to enter with larger, slower cameras. The bull ring was one such environment, from which even the most adventurous and athletic photographers had steered clear.

This photograph shows the inside doors of the Valencia arena from the vantage point of the bull; to make this picture of an attendant watching the action from a small rectangular window, Cartier-Bresson entered the ring. The complex composition reflects the influence of Cubism on the artist's work. All the major structural elements are fragmented: the arena doors are ajar, splitting the concentric rings into arcs and the number 7 into two abstract forms; the foreground figure is, in effect, beheaded by the door, his body linked to a faceless counterpart wearing identical clothing; even the attendant's circular glasses are awry, one lens catching the light, the other remaining transparent. The picture as a whole illustrates the avant-garde theory of simultaneous multiple vision and is a sophisticated critique of the bull's-eye school of photographic composition.

Through photographs such as this one, Cartier-Bresson forces the viewer to accept the disjunctive and mysterious as part of the modern experience of the world; we can never close the door, align the rings, reconstruct the numeral, or clear the attendant's vision. [JLR]

248. Martin Munkacsi
American, born Hungary, 1896–1963

Fun During Coffee Break, 1932
Gelatin silver print
29.4 x 23.5 cm (11⅝ x 9¼ in.)
Plate 188

Martin Munkacsi began his photographic career in 1921 taking pictures for a daily sports journal in Budapest. In 1927 he moved to Berlin, where he gained international recognition as a photojournalist, particularly for his work at Ullstein-Verlag, publisher of the weekly illustrated newspaper *Berliner Illustrierte Zeitung* and magazines such as *Die Dame* and *Uhu*. In 1934, Munkacsi emigrated to the United States, where he was hired by *Harper's Bazaar*. As chief fashion photographer he removed models from the confines of studio settings, photographed them out of doors in bold poses, and encouraged spontaneity and movement. His images revolutionized the fashion industry. Energized both by motion and active surface design, they capture—with faster, more light-sensitive film and the split-second shutter speeds of hand-held cameras—the very flexibility and freedom of modern life.

Munkacsi's photograph of the dancers Tibor von Halmay and Eva Sylt appeared in a November 1932 issue of *Die Dame*. The picture is enlivened by the man's acrobatics, his morning coffee presumably having jolted him with a burst of energy. His partner's nonplused self-absorption, her oblivion to the odd goings-on above her head, and the electrical cord that snakes up the wall infuse the picture with a quirky, surrealistic incongruity. [VH]

249. Robert Capa
American, born Hungary, 1913–1954

Falling Loyalist Soldier, 1936
Gelatin silver print
24.7 x 34 cm (9¾ x 13⅜ in.)

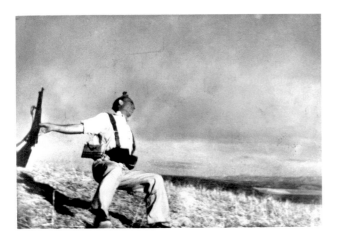

Possibly the most famous of war photographs, this image is all but synonymous with the name of its maker, Robert Capa, who was proclaimed in 1938, at the age of twenty-five, "the greatest war photographer in the world" in the British magazine *Picture Post*. Taken at the beginning of the Spanish Civil War and showing the moment of a bullet's impact on a Loyalist soldier, this photograph has become an emblem of the medium's unrivaled capacity to depict sudden death. It is also prototypical of the style of photojournalism that came to define the work of Capa and his colleagues at the picture press agency Magnum Photos in the late 1940s.

If such images have etched themselves into the public's mind, it is not because of their existence as original prints, but rather because of their proliferation through newspapers and magazines. This mounted and varnished print is thus an anomalous rarity: signed by Capa himself, it appears to have been made in the late 1940s or early 1950s for public exhibition.

Although the scene depicted is specific to an event now temporally distanced, the image nevertheless seems strangely familiar and retains its powerful impact. Its expressive charge recalls another, equally famous image of war in Spain, Francisco Goya's *The Third of May, 1808* (1814). Capa's image excludes Goya's narrative elements—the executioners, stark backdrop, and dramatic nocturnal light—and instead zeroes in on the instant of death forever anticipated in the painting. [VH]

250. Dorothea Lange
American, 1895–1965

Demonstration, San Francisco, 1933
Gelatin silver print
12 x 14.1 cm (4¾ x 5½ in.)
Plate 193

Dorothea Lange is most widely known for a single photograph, *Migrant Mother*, a portrait of a troubled farmer surrounded by her three children, an iconic image that to many represents the essential tragedy of the Great Depression. The picture was made in a California migrant camp in March 1936, while Lange was working under federal contract for President Roosevelt's Resettlement Administration (RA), later the Farm Security Administration. Lange was the first of eleven photographers to join the RA, a New Deal agency whose purpose was to document the plight of the rural poor and the efforts made by the government to assist the needy populace.

When she was eighteen, Lange trained to be a portrait photographer in New York City with, among others, Arnold Genthe, a Pictorialist best known for his studies of Isadora Duncan. In 1918, Lange moved to San Francisco and soon opened her own portrait studio, which she operated for more than ten years. It was only after the stock market crash in 1929 and the onset of the Depression that Lange began to photograph unemployed laborers—the documentary work that eventually secured her position with the RA in the summer of 1935.

In 1932, Lange left her studio to photograph what was just outside her door, a rapidly growing population of homeless, mostly migrant workers crowding the streets of the city. Within the year she had virtually abandoned her commercial work to make what her first husband, Maynard Dixon, described as photographs of the forgotten man. Lange photographed labor strikes and other mass demonstrations with an uncanny ability to isolate individuals without losing the context of the crowd. Placards that advocate everything from "Defend the Chinese Soviets" to "Down with Sales Tax" dominate her pictures, which collectively document the causes of the American left in the 1930s. Although Lange was never a Communist, her best work of this period has all the graphic power and emotional charge of Bolshevik poster art: bold strokes, expressive type, and universal symbolism.

This photograph was made in 1933, most likely on May Day, the traditional day for international labor rallies. A man looks away from the camera, his back to a banner that identifies his cause. The low viewpoint creates a sense of monumentality, thrusting the worker against the sky and boldly sculpting his head. The exclamation point painted on the banner strikes the same chord as the daggerlike shadow that cuts across it, spearheading the emphatic and desperate imperative: FEED US! [JLR]

251. Walker Evans
American, 1903–1975

Votive Candles, New York City, 1929–30
Gelatin silver print
21.9 x 17.2 cm (8⅝ x 6¾ in.)
Plate 178

Walker Evans dropped out of college in 1923 and moved to New York with the ambition of becoming a writer. Three years later he was in Paris auditing classes in modern art and literature at the Sorbonne, concentrating on the work of Flaubert and Baudelaire. He returned to New York in 1927, and, suffering from writer's block, began to make photographs. "I was a passionate photographer, and for a while somewhat guiltily. I thought it was a substitute for something else—well for writing for one thing."[49]

Evans's earliest photographs are direct observations of street life—snapshots of electric signs, street peddlers, and Coney Island bathers—and abstract, geometric compositions of construction sites, sewer gratings, and the shadows cast by elevated train platforms. His method of documenting the city combined the concerns of the historian and anthropologist with the talents of a graphic artist. Creating an exhaustive visual catalogue of significant, if ordinary, facts, he forged a new idiom from the American vernacular. Concise in form and poetic in a prosaic way, this idiom of the neglected and the commonplace would change the direction of American photography.

Evans's interest in street signs, both commercial and handcrafted, shows the influence of Eugène Atget, specifically his photographs of Parisian shopwindows that had been admired by the Surrealists. This photograph of a crudely constructed sidewalk advertisement for religious articles was probably made in an Italian neighborhood on the lower East Side of Manhattan. In the printing stage, Evans cropped the negative at both the bottom and top to eliminate the heads of pedestrians and to hang the votive candles and offerings from the top of the picture, much as his contemporary Joseph Cornell might have placed them in a box. In a brilliant assessment of the scene, Evans superimposed graphic signs onto textual signs, a conflation that represents one of his first attempts to merge pictures with words. [JLR]

252. Walker Evans
American, 1903–1975

Coal Dock Worker, 1933
Gelatin silver print
17 x 12.3 cm (6¾ x 4⅞ in.)
Ex coll: Ben Shahn

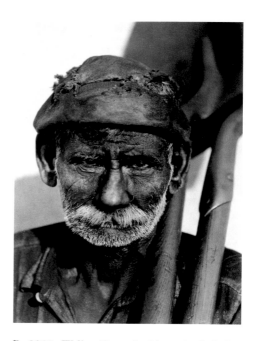

By 1933, Walker Evans had been included in several important group and solo exhibitions, at the Harvard Society of Contemporary Art (1930), the John Becker Gallery (1931), the Julien Levy Gallery (1932), the Brooklyn Museum (1932), and the Museum of Modern Art (1933). His photographs had also been published in art and architectural journals, as well as in two literary publications; three photographs of the Brooklyn Bridge appear in a limited edition of Hart Crane's poem *The Bridge* (1930), and thirty-one photographs were printed in *The Crime of Cuba* (1933). The latter was an exposé by Carleton Beals of the conditions under which Cubans lived during the oppressive regime of Machado y Morales, a dictatorship covertly supported by the U. S. State Department. Evans neither read the book nor had any interest in its politics: "I simply went around everywhere I could get. I interviewed, and was helped by, Cuban revolutionaries as well as government officials."[50]

For the Cuban project Evans spent two to three weeks in Havana, prowling the streets with a folding roll-film camera. While most of the photographs are snapshots, a few, like this portrait, were made on 6½ x 8½-inch sheet film. In 1930, Evans had purchased a tripod and a used box camera still fitted for plates. This camera, with larger negatives, enabled him to capture more of the subject—its texture and other physical nuances—and to follow the

working methods of August Sander and Eugène Atget. Having reviewed their work in 1931 in the avant-garde journal *Hound and Horn*, Evans had absorbed the notion that serious photography was done on glass negatives with cameras that stood on their own feet.

While in Havana, Evans encountered twelve coal dock-workers as he wandered around the port. Fascinated by the colliers' faces and the black dust enshrouding them, he returned with the box camera to make a series of single and group portraits. Placing the men flat against a plain white wall—a sort of studio backdrop to go along with the studio camera—Evans defined a new genre that lies somewhere between the mug shot and the informal portrait. This man, holding not one but two shovels, was the oldest of the workers and the central figure in all the group portraits. He does not appear in *The Crime of Cuba*, but was later included by Evans in *American Photographs*, the 1938 monograph that accompanied his second exhibition at the Museum of Modern Art. [JLR]

geance: even the unbeliever must feel their force. These buildings are primitive, if the term may be used without its shade of condescension . . . country churches of fading, weatherworn wood, with touches of old color on the trim. In these, the rewarding features are belfry and tower, sporting all variety of shingle play and dancing line. Amplified by understatement, consecration here speaks tenfold over such labored glorifications as Saint Patrick's Fifth Avenue or the Cathedral of St. John the Divine."[51]

[JLR]

253. Walker Evans
American, 1903–1975

Negro Church, South Carolina, 1936
Gelatin silver print
23 x 18.6 cm (9 x 7⅜ in.)
Plate 6

Walker Evans received formal notice of his appointment to the Resettlement Administration in the summer of 1935. Although he was avowedly apolitical, he accepted the position of information specialist knowing that it would provide him with a regular income and allow him to do what he most wanted to do—make photographs. For two years he traveled, mostly in the South, producing the extensive body of work that secured his reputation as America's preeminent photographer: pictures of roadside architecture, small churches, Main Streets, junkyards, and the famous portraits of tenant farmers in Hale County, Alabama, that were later included in the book *Let Us Now Praise Famous Men* (1941), made in collaboration with his friend James Agee.

This photograph of a country church is mounted to a sheet of heavy paper used by the artist in his maquette for the 1938 Museum of Modern Art catalogue *American Photographs*. It was also the print copied for the book's reproduction. If the catalogue was bound in bible cloth, which the artist insisted upon, then this print is as rare as a piece of the true cross.

Rural churches also inspired the writer in Evans. More than twenty years later, in an article entitled "Primitive Churches," he wrote: "Out-of-the-way churches . . . comprise the most unnoticeable ecclesiastical architecture in the U.S. But they are unnoticeable with a ven-

Notes

NOTES TO THE ESSAYS

Picturing Victorian Britain

1. Letter from Laura Mundy to Talbot, December 12, 1834, cited in Gail Buckland, *Fox Talbot and the Invention of Photography* (London: Scolar Press, 1980), p. 27.
2. Elizabeth Gaskell, *North and South* (1854–55; New York: Penguin Books, 1986), p. 217.
3. The notion that pictures could have such social utility was clear to Charles Kingsley, who wrote of the National Gallery in 1848: "Picture-galleries should be the townsman's paradise of refreshment. . . . There [he] may take his walk . . . through green meadows, under cool mellow shades and overhanging rocks, by rushing brooks, where he watches and watches til he seems to *hear* the foam whisper, and to *see* the fishes leap; and his hard-worn heart wanders out free, beyond the grim city-world of stone and iron, smoky chimneys, and roaring wheels, into the world of beautiful things." Quoted in Walter E. Houghton, *The Victorian Frame of Mind, 1830–1870* (New Haven and London: Yale University Press, 1985), p. 80.
4. John Ruskin, *The Stones of Venice*, vol. 3, *The Fall* (London: Smith, Elder and Co., 1853), p. 52, cited in Robert L. Herbert, ed., *The Art Criticism of John Ruskin* (New York: Da Capo, 1964), p. 4.

Photography as Art in France

1. It was Talbot who referred to Daguerre's process this way. See Beaumont Newhall, *Latent Image: The Discovery of Photography* (Garden City: Doubleday, 1967), p. 101.
2. Jules Janin, writing in *L'Artiste*, September 1, 1839, following a demonstration in Daguerre's studio at 17, Boulevard St. Martin; quoted in Newhall, *Latent Image*, p. 97.
3. Helmut Gernsheim and Alison Gernsheim, *L. J. M. Daguerre: The History of the Diorama and the Daguerreotype*, 2d ed. (New York: Dover, 1968), p. 96.
4. This discussion of calotype draws greatly on the pioneering work of André Jammes and Eugenia Parry Janis, *The Art of French Calotype, with a Critical Dictionary of Photographers, 1845–1870* (Princeton: Princeton University Press, 1983).
5. See Eugenia Parry Janis, *The Photography of Gustave Le Gray* (Chicago: Art Institute of Chicago, 1987), pp. 39–40, and André Rouillé, ed., *La Photographie en France: Textes et controverses; une anthologie, 1816–1871* (Paris: Macula, 1989), pp. 97–99, 120–21.
6. Janis, *Photography of Gustave Le Gray*, p. 38.
7. Ibid., p. 35.
8. Charles Rosen and Henri Zerner, "The Romantic Vignette and Thomas Bewick," reprinted in *Romanticism and Realism: The Mythology of Nineteenth-Century Art* (New York: Viking Press, 1984), pp. 73–96. Certain of the photographers had worked previously as illustrators for Romantic books. See Jammes and Janis, *Art of French Calotype*, pp. 13, 48–52.
9. Charles Baudelaire, *The Painter of Modern Life, and Other Essays*, translated and edited by Jonathan Mayne (London: Phaidon Press, 1964).
10. Ibid., p. 31.
11. Edmond Duranty, *La Nouvelle Peinture: A propos du groupe d'artistes qui expose dans les galeries Durand-Ruel*, new ed., with introduction and notes by Marcel Guérin (1876; Paris: Librarie Floury, 1946), p. 42.

Extending the Grand Tour

1. Bridges cited in Nissan N. Perez, *Focus East: Early Photography in the Near East (1839–1885)* (New York: Abrams, 1988), p. 50.
2. John Ruskin, *The Stones of Venice*, vol. 2, *The Sea-Stories* (London: Smith Elder and Co., 1853), p. 156.
3. Quoted in Kenneth Hudson, *A Social History of Archaeology: The British Experience* (London: Macmillan, 1981), p. 71.
4. Du Camp received his commission on October 20, 1849. For details see Michel Dewachter and Daniel Oster, eds., *Un Voyageur en Égypte vers 1850: "Le Nil" de Maxime Du Camp* (Paris: Sand/Conti, 1987), pp. 14ff.
5. Letter from Flaubert to his mother, January 5, 1850, Cairo, cited in Francis Steegmuller, trans. and ed., *The Letters of Gustave Flaubert, 1830–1857* (Cambridge, Mass.: Harvard University Press, 1981), p. 109.
6. Tripe's case is exemplary. When the British government replaced the East India Company following the Mutiny, Tripe's position as official photographer for the Madras presidency came under review. His work as a photographer, initially undertaken for the company, was judged exorbitant by the government; consequently, Tripe was relieved of his position and returned to active duty. See Janet Dewan and Maia-Mari Sutnik, *Linnaeus Tripe: Photographer of British India, 1854–1870* (exhib. cat., Toronto: Art Gallery of Ontario, 1986), p. 17.
7. Samuel Bourne, writing in *British Journal of Photography*, March 18, 1870, pp. 28–29.

America: An Insistent Present

1. Ralph Waldo Emerson, "Memory" (1857), cited in Michael Kammen, *Mystic Chords of Memory: The Transformation of Tradition in American Culture* (New York: Knopf, 1991), p. 43, n. 10.
2. See James M. McPherson, *Battle Cry of Freedom: The Civil War Era* (New York: Oxford University Press, 1988), pp. 6, 12.
3. Morse writing in the New York *Observer*, April 20, 1839, and Poe writing in *Alexander's Weekly Messenger*, January 15, 1840, p. 2; both cited in Alan Trachtenberg, *Reading American Photographs: Images as History—Mathew Brady to Walker Evans* (New York: Hill and Wang, Noonday Press, 1989), p. 15.
4. On the connotations of enchantment and wizardry, as well as other perceptions about daguerreotypes, see Alan Trachtenberg, "Photography, the Emergence of a Keyword," in Martha A. Sandweiss, ed., *Photography in Nineteenth-Century America* (Fort Worth: Amon Carter Museum; New York: Abrams, 1991), pp. 17–47.
5. Bradford Torrey and Francis H. Allen, eds., *The Journal of Henry D. Thoreau, 1837–1846* (Boston: Houghton Mifflin, 1949), vol. 1, p. 89, entry for February 2, 1841, quoted in Trachtenberg, "Photography, the Emergence of a Keyword," p. 22.
6. Herman Melville recognized this early on: "For he considered with what infinite readiness now, the most faithful portrait of any one could be taken by the Daguerreotype, whereas in former times a faithful portrait was only within the power of the moneyed, or mental aristocrats of the earth. How natural then the inference, that instead of, as in old times, immortalizing a genius, a portrait now only *dayalized* a dunce. . . . For if you are published along with Tom,

Dick, and Harry, and wear a coat of their cut, how then are you distinct from Tom, Dick and Harry?" Herman Melville, *Pierre; or The Ambiguities* (1852), edited by Harrison Hayford, Hershel Parker, and G. Thomas Tanselle (Evanston: Northwestern University Press, 1971), p. 254.

7. Walt Whitman, "Pioneers! O Pioneers!" *Leaves of Grass*, edited by Emory Holloway (Garden City: Doubleday, 1926), pp. 194–97.

8. Turner spoke at a meeting of the American Historical Association in Chicago at the time of the Columbian Exposition of 1893. See Richard Hofstadter, *The Progressive Historians: Turner, Beard, Parrington*, 2d ed. (Chicago: University of Chicago Press, 1979), pp. 47–54.

Turn of the Century: Chrysalis of the Modern

1. Dallet Fuguet, "Truth in Art," *Camera Notes* 3 (April 1900), p. 190.

Modern Perspectives

1. Richard Huelsenbeck, "Collective Dada Manifesto," in Robert Motherwell, ed., *The Dada Painters and Poets* (New York: Wittenborn, Schultz, 1951), pp. 242–43.

2. Charles Sheeler, "Brief Note on the Exhibition," in *Charles Sheeler: Paintings, Drawings, Photographs* (exhib. cat., New York: Museum of Modern Art, 1939), p. 11.

3. T. S. Eliot, "The Dry Salvages" (1941), in *T. S. Eliot: The Complete Poems and Plays* (New York: Harcourt, Brace, 1952), p. 133.

NOTES TO THE CATALOGUE

1. William Henry Fox Talbot, "Introductory Remarks," in *The Pencil of Nature* (London: Longman, Brown, Green, & Longmans, 1844), unpaginated.

2. Horatio Ross, "Introduction," in Alexander MacRae, *A Handbook of Deer-Stalking* (Edinburgh and London: William Blackwood and Sons, 1880), p. i.

3. Hugh Welch Diamond, "On the Application of Photography to the Physiognomic and Mental Phenomena of Insanity" (paper read before the Royal Photographic Society, May 22, 1856), reprinted in Sander L. Gilman, ed., *The Face of Madness: Hugh W. Diamond and the Origins of Psychiatric Photography* (Secaucus, N.J.: Citadel Press, 1976), p. 20.

4. John Stuart Mill, *On the Subjection of Women*, edited by Susan Moller Okin (Indianapolis: Hackett Publishing, 1988), p. 37.

5. Julia Margaret Cameron, "Annals of My Glass House" (1874), reprinted in Helmut Gernsheim, *Julia Margaret Cameron* (Millerton, N.Y.: Aperture, 1975), p. 182.

6. Gernsheim, *Julia Margaret Cameron*, p. 120.

7. Virginia Woolf, *To the Lighthouse* (1927; reprint, New York: Harcourt, Brace and World, 1968), p. 64.

8. Walter Pater, conclusion of 1868, in *The Renaissance: Studies in Art and Poetry* [6th ed.] (London: Macmillan, 1907), p. 235.

9. Many details about the making of the photographs are contained in Mrs. Cameron's letters to Sir Edward Ryan, November–December 1874, now in the Gilman Paper Company Collection, New York.

10. André Jammes and Eugenia Parry Janis, *The Art of French Calotype, with a Critical Dictionary of Photographers, 1845–1870* (Princeton: Princeton University Press, 1983), p. 4.

11. *Bulletin de la Société Française de Photographie*, 1855, p. 200.

12. A letter from Delacroix to Constant Dutilleux, March 7, 1854, quoted in Van Deren Coke, *The Painter and the Photograph; from Delacroix to Warhol* (Albuquerque: University of New Mexico Press, 1964), p. 9.

13. Durieu's report on the first exhibition of the Société Française de la Photographie, held in 1855, reprinted in André Rouillé, ed., *La Photographie en France: Textes et controverses; une anthologie, 1816–1871* (Paris: Macula, 1989), pp. 279–81.

14. Quoted in Jean Prinet and Antoinette Dilasser, *Nadar* (Paris: Armand Colin, 1966), p. 116.

15. Ernest Lacan, "Photographie historique," *La Lumière*, July 21, 1856, p. 97.

16. Francis Steegmuller, *Flaubert in Egypt: A Sensibility on Tour* (Chicago: Academy Chicago Limited, 1979), p. 142.

17. Ibid., p. 135.

18. *Félix Teynard: Calotypes of Egypt, a Catalogue Raisonné*, with essay by Kathleen Stewart Howe (New York: Hans P. Kraus, Jr.; London: Robert Hershkowitz Ltd.; Carmel: Weston Gallery, Inc., 1992), p.102.

19. Félicien-Joseph Caignart de Saulcy, "Exploration photographique de Jérusalem par M. Auguste Salzmann," *Le Constitutionnel*, March 24, 1855, pp. 2–3, reprinted in Rouillé, *Photographie en France*, p. 140.

20. Quoted in Frances Dimond and Roger Taylor, *Crown and Camera: The Royal Family and Photography, 1842–1910* (New York: Viking Press, 1987), p. 124.

21. John Thomson, *The Straits of Malacca, Indo-China and China; or Ten Years' Travels, Adventures and Residence Abroad* (London: Sampson Low, Martson, Low and Searle, 1875), p. 93.

22. Oliver Wendell Holmes, "Doings of the Sunbeam," *Atlantic Monthly* 12, no. 69 (July 1863), p. 12.

23. "Preface," in Frederick Douglass, *Narrative of the Life of Frederick Douglass, an American Slave, Written by Himself*, edited by Benjamin Quarles (Cambridge, Mass.: Harvard University Press, 1960), unpaginated.

24. Alexander Gardner, *Gardner's Photographic Sketch Book of the Civil War*, 2 vols. (Washington, D.C.: Philip & Solomons, 1865–66), vol. 1, pl. 2.

25. Quoted in Richard A. Bartlett, *Great Surveys of the American West* (Norman: University of Oklahoma Press, 1962), p. 346.

26. Alan Trachtenberg, *Reading American Photographs: Images as History—Mathew Brady to Walker Evans* (New York: Hill and Wang, Noonday Press, 1989), pp. 144–54.

27. "Mechanics' Industrial Fair," *Illustrated San Francisco News*, October 9, 1869, p. 107, quoted in Peter Palmquist, *Carleton E. Watkins, Photographer of the American West* (Albuquerque: University of New Mexico Press, 1983), p. 37.

28. Charles H. Caffin, "The Art of Eduard J. Steichen," *Camera Work*, no. 30 (April 1910), p. 34.

29. Edward Steichen, *A Life in Photography* (Garden City, N.Y.: Doubleday, 1963), unpaginated.

30. Stéphane Mallarmé, "Considérations sur l'art du ballet et la Loïe Fuller," *National Observer*, March 13, 1893, quoted in Margaret Haile Harris, *Loïe Fuller: Magician of Light* (exhib. cat., Richmond: Virginia Museum, 1979), pp. 28–29.

31. A letter from Cavour to Castiglione, quoted in Alain Decaux, *La Castiglione, dame de coeur de l'Europe* (Paris: Le Livre contemporain, 1959), p. 91.

32. Quoted in Lord David Cecil, "Introduction," in *Lady Ottoline's Album: Snapshots and Portraits of Her Famous Contemporaries (and of Herself), Photographed for the Most Part by Lady Ottoline Morrell* (New York: Knopf, 1976), p. 3.

33. Ibid., p. 7.

34. D. H. Lawrence, *Women in Love* (New York: Viking Press, 1960), pp. 9–10, quoted in Jeffrey Meyers, *D. H. Lawrence* (New York: Vintage Books, 1992), p. 160.

35. Letter to Brett's father, May 1916, quoted in Sean Hignett, *Brett: From Bloomsbury to New Mexico* (New York: Franklin Watts, 1983), p. 81.

36. Anton Giulio Bragaglia, "Futurist Photodynamism," reprinted in Umbro Apollonio, ed., *Futurist Manifestos*, translated by Robert Brain et al. (New York: Viking Press, 1973), p. 45.

37. László Moholy-Nagy, *Painting, Photography, Film*, translated from the 2d ed. of 1927 by Janet Seligman (Cambridge, Mass.: MIT Press, 1969), p. 69.

38. Quoted in Dorothy Norman, *Alfred Stieglitz: Introduction to an American Seer* (New York: Duell, Sloan and Pearce, 1960), p. 35.

39. Tristan Tzara, Preface, in Man Ray, *Champs délicieux: Album de photographies* (Paris, 1922), reprinted in "Les Champs délicieux: Man Ray, 1922," *Aperture*, no. 85 (1981), p. 63.

40. Robert Desnos, "The Work of Man Ray," *Transition* 15 (February 1929), pp. 264–66, translated by Maria Mc D. Jolas in Beaumont Newhall, *Photography: Essays and Images* (New York: Museum of Modern Art, 1980), p. 230.

41. Billy Klüver and Julie Martin, *Kiki's Paris: Artists and Lovers, 1900–1930* (New York: Abrams, 1989), p. 184.

42. Francisco Monterde García Icazbalceta, "La exposición de Edward Weston," *Antena*, no. 5 (November 1924), pp. 10–11, reprinted in Amy Conger, *Edward Weston in Mexico, 1923–1926* (Albuquerque:

University of New Mexico Press, 1983), pp. 32–33.

43. Nancy Newhall, ed., *The Daybooks of Edward Weston*, vol. 1, *Mexico* (Rochester, N.Y.: George Eastman House, 1961), p. 132.

44. Ibid.

45. Carl Georg Heise, Introduction, in Albert Renger-Patzsch, *Die Welt ist schön* (Munich: Kurt Wolff, 1928), p. 9.

46. *El Lissitzky: Experiments in Photography* (New York: Houk Friedman, 1991), p. 28.

47. David Mellor, "The Watchmen: Or, Notes on the Imaginary Male Self in 20th Century Photography," in *Staging the Self: Self-Portrait Photography, 1840s–1980s* (exhib. cat., London: National Portrait Gallery, 1986), p. 82.

48. Henri Cartier-Bresson, *The Decisive Moment* (New York: Simon & Schuster, 1952), unpaginated.

49. Leslie Katz, "Interview with Walker Evans," *Art in America* 59 (March–April 1971), pp. 83–84.

50. Carleton Beals, *The Crime of Cuba* (Philadelphia and London: Lippincott, 1933), jacket copy.

51. Walker Evans, "Primitive Churches," *Architectural Forum* 115, no. 6 (December 1961), p. 103.

Index

Man Ray's use of technique of, 222; pl. 7, xiv; no. 216, 352

The Open Door, pl. 12, 13; no. 7, 267

The Pencil of Nature (book), no. 5, 266–67; no. 7, 267; no. 9, 268; no. 14, 269

The Reading Establishment (with Henneman; attribution), no. 4, 265–66

A Scene in a Library, no. 5, 266–67

Trees with Reflection, pl. 10, 10–11; no. 10, 268

Vase with Medusa's Head, pl. 11, 12; no. 3, 265

View of the Boulevards at Paris, no. 9, 267–68

talbotypes. *See* calotypes

Tamara Karsavina (de Meyer), pl. 133, 186; no. 181, 337

Tanneyhill, Alfred, portraits of, no. 191, 341–42

Temple of Re (Abu Simbel, Egypt), pl. 65, 85; no. 83, 295–96

Temple of Wingless Victory, Lately Restored (Bridges), pl. 70, 96; no. 78, 294

Temptation of Saint Anthony, The (novel), no. 81, 296

Tennyson, Lord (Alfred, Lord Tennyson), no. 36, 277

"The Beggar Maid," pl. 28, 338; no. 107, 306

Idylls of the King, 7; pl. 34, 38; no. 39, 278

Teynard, Félix, 87, 88

Abu Simbel, pl. 69, 95; no. 85, 296–97

Colossus and Sphinx, Es-Sebua, no. 87, 297

Portico of the Tomb of Amenemhat, Beni-Hasan, no. 86, 297

theater and stage, photographs of

Actor in Samurai Armor (attributed to Stillfried-Rathenitz), no. 109a, 307

Charles Debureau (Adrien Tournachon and Nadar), pl. 59, 76; no. 58, 286

Loie Fuller Dancing (Beckett), 177; pl. 135, 188; no. 183, 338

Nijinsky in *Le Spectre de la rose*, 177; pl. 140, 204; no. 192, 342

Study for a Decorative Panel (Mucha), 177; pl. 150, 205; no. 193, 242

Theater of Marcellus, from the Piazza Montanara, The (Macpherson), 86; pl. 74, 101; no. 82, 295

Theatricals

St. George and the Dragon (Carroll), pl. 29, 33; no. 32, 276

"*She Never Told Her Love*" (Robinson), 7; pl. 20, 22–23; no. 29, 274–75

Vivien and Merlin (Cameron), 7; pl. 34, 38; no. 39, 278

Thereza (Llewelyn), pl. 16, 18; no. 15, 270

Thomson, John

First King of Siam, no. 106b, 306

His Majesty Prabat Somdet Pra parameñdr

Mahá Mongkut, First King of Siam, in State Costume, no. 106a, 305–6

Through the Looking Glass and What Alice Found There (book), no. 31, 275

tintypes

Five Members of the Wild Bunch, pl. 119, 164; no. 162, 329–30

Ku Klux Klansman (anonymous), pl. 102, 145; no. 144, 322–23

A Woman in an Interior (attributed to Waud), pl. 92, 130; no. 145, 323

Tournachon, Adrien

Charles Debureau (with Nadar), pl. 59, 76; no. 58, 286

Emmanuel Frémiet, pl. 61, 78; no. 60, 286–87

Self-Portrait, pl. 52, 67; no. 59, 286

Tournachon, Gaspard-Félix. *See* Nadar

Tournachon, Victor, no. 57, 286

Tower of Gold, Seville, The (de Clercq), pl. 78, 106; no. 93, 300

Tree (Ross), pl. 19, 21; no. 28, 274

Trees (Keith), 6; pl. 17, 19; no. 16, 270

Trees with Reflection (Talbot), pl. 10, 10–11; no. 10, 268

Tripe, Linneaus, 90

The Pagoda Jewels, Madurai, 89; no. 103, 303–4

Tripoli (de Clercq), no. 91, 299

Tuileries Gardens (Paris)

daguerreotype of, pl. 2, ii–iii; no. 42, 280

Spartan Soldier in, pl. 48, 62; no. 73, 291–92

Two Men Playing Checkers (anonymous), no. 119, 311

Two Men Playing Chess (Stieglitz), pl. 134, 187; no. 175, 335–36

Tzara, Tristan, 221; no. 214, 351; no. 261, 352

U

Ullstein-Verlag (Berlin), no. 248, 364–65

Umbo (Otto Umbehr), *Night in a Small Town*, pl. 196, 261; no. 233, 358–59

Upper Deck (Sheeler), 222–23; no. 237, 360

V

Valencia, Spain (Cartier-Bresson), pl. 194, 258–59; no. 247, 364

Vallou de Villeneuve, Julien, Reclining Nude, 48; pl. 46, 59; no. 54, 284–85

Vance, Robert H., no. 156, 327

The Great Man Has Fallen, no. 121, 311–12

Vanity Fair (periodical), 225; no. 238, 361

Vase with Medusa's Head (Talbot), pl. 11, 12; no. 3, 265

vernis-cuir technique, no. 60, 286–87

Versailles, The Orangerie Staircase (Atget), pl. 165, 228–29; no. 204, 347

Victoria and Albert Museum (London), no. 34, 277

Vienna Camera Club, no. 176, 336

View of Cincinnati (attributed to Rhorer), pl. 98, 136–39; no. 146, 323

View of the Boulevards at Paris (Talbot), no. 9, 267–68

View of the Square in Melting Snow (Dubois de Nehaut), no. 69, 290

Vigier, Joseph, *Path to Chaos, Saint-Sauveur*, no. 51, 283

Vignole, Charles Blacker, no. 97, 301

Viollet-le-Duc, Eugène, no. 47, 282; no. 83, 295; no. 84, 296

Vivien and Merlin (Cameron), 7; pl. 34, 38; no. 39, 278

Vogue (magazine), no. 181, 337; no. 239, 361

Votive Candles, New York City (Evans), 223; pl. 178, 242; no. 251, 366

Voyage en Espagne (album), no. 93, 300

Voyage en Orient (album), no. 91, 299; no. 92, 299

W

Wade, Minor B., Lynching, Russellville, Kentucky, pl. 159, 216; no. 198, 345

Walnut Tree of Emperor Charles V, Yuste, The (Clifford), pl. 76, 104; no. 96, 301

Watkins, Carleton E., 123–24, 172

Cape Horn near Celilo, pl. 122, 167; no. 159, 328

The Grisly Giant, Mariposa Grove, Yosemite, pl. 4, vii; no. 156, 327

Multnomah Falls, Columbia River, pl. 124, 169; no. 158, 328

Strait of Carquennes, from South Vallejo, pl. 121, 166; no. 160, 329

Sugar Loaf Islands, Farallons, pl. 125, 170–71; no. 157, 328

Watzek, Hans, no. 176, 336

Waud, Alfred Rudolph, no. 150, 324; no. 151, 325

A Woman in an Interior (attribution), pl. 92, 130; no. 145, 323

Weed, C. L., no. 156, 327

Wegener, Otto. *See* Otto

Westernmost Colossus of the Temple of Re, Abu Simbel (Du Camp), pl. 65, 85; no. 83, 295–96

Weston, Edward

Excusado, 223; no. 222, 354

Nahui Olín, no. 221, 353–54

Nude, 223; pl. 179, 243; no. 220, 353

Westward migration, *Mormon Emigrant Train, Echo Canyon* (Carter), pl. 118, 164; no. 148, 324

wet plates. *See* glass plates

Wharfe and Pool Below the Stride, The (Fenton), 6; pl. 8, 2; no. 19, 271–72